The Most beautiful place in the world.
1. Photography, Artistic. I. Maisel, Jay, 1931-
TR654.M667 1986 779'.092'2 86-2208
ISBN 0-914919-06-7

THE MOST BEAUTIFUL

PLACE IN THE WORLD

IMPRESSIONS OF TEN MASTER PHOTOGRAPHERS

EDITED BY JAY MAISEL

This has been a collaborative work. It's been a pleasure to be able to work with photographers of this caliber and to have a part in presenting some of their favorite photos of their favorite places.

I'd be remiss if I didn't thank the other photographers who I couldn't include, not because of any lack on their part, but simply because we couldn't fit in all the fine work that we saw. Special thanks to Stu Waldman and Marty Goldstein who conceived this book and who were provocative and encouraging.

Joe Suplina, in his design, resisted the temptation of cleverness. His layout

respects and enhances the differences in each photographer's attitude.

My most heartfelt thanks to Emily Vickers of my staff who let me ramble on about who and what I needed and then went out and contacted, cajoled, coordinated, interviewed and finalized everything. She put up with delayed mail, delayed decisions (my own ambivalence) and completed the enormous number of details necessary for this book. She was essential if not indispensable to this project.

My final thanks to you, the reader, who allowed us to bring this quality of seeing to an eager audience.

Jay Maisel

EASTERN SIERRA

VENICE

RAS MOHAMMED

PALOUSE

MOROCCO

MAINE WOODS

NEW GUINEA

SAHARA

QUELIN

NEW YORK CITY

CONTENTS

Location photography is character study. Each place, like each person, is unique, with a style and personality of its own. It is character, not famous sights or gorgeous sunsets, that makes a place truly beautiful. For me, the photographer has only one job: to reveal that character and communicate it to the viewer; to have him not only see a place but feel it and "know" it. Otherwise, it's just a pretty picture.

The Most Beautiful Place in the World had to be more than picturesque. I wanted beautiful defined in the widest, most subjective sense possible. It had to come from both the place and the photographer's own experience of it. I wanted a book that would not only please the eye but stir the senses; that would not only show the face of a place but look into its heart; that would reveal both the endless wonders of the world and the equally endless ways of experiencing it. For in the end, "the most beautiful place in the world" is always inside each of our heads.

Jay Maisel
December 28, 1985

EASTERN

GALEN

SIERRA

ROWELL

I love mountains. I guess everyone does. The first time you see a mountain peak, words like wonder, awe, majesty are no longer clichés. If anything, they don't express enough.

In terms of elevation, the Eastern Sierra are relatively ordinary. Their tallest peaks are dwarfed by those of other continents. Yet the mountains possess a unique magic, a grandeur all their own. It's the grandeur of primeval landscape, of strange light and color, of wildlife. It's the grandeur of the earth itself.

John Muir called this area "a gentle wilderness." One can see why. Wildness coexists with the green and familiar. Nestled in the midst of harsh desert peaks, there suddenly appears an ancient, lovely forest of bristlecone pines. Southeast of here, sand dunes lead to Death Valley. Yet nearby, the springtime landscape comes alive with fields of wildflowers. Drive north and you're at Mono Lake. A "solemn, silent, sailless sea," Mark Twain called it. Towers of white tufa rise above the waters and, by twilight, the landscape has an otherworldly look.

The high point of the range is Mount Whitney. It is the highest peak in the original forty-eight states, and has a spectacular sheer vertical drop, thousands of feet into a deep glacial cirque with permanent snowfields. Viewed from the east at dawn, Mount Whitney's face is a deep crimson reflected against the snow.

The entire Eastern Sierra escarpment is nothing less than a vast biological and geological edge, a place where the Great Basin ends with startling suddenness. The contours of the land lie exposed as if on some natural topographical map. A hiker can trek cross-country for days on end, without trails, finding personal landscapes, discovering new vistas, constantly being surprised and exhilarated at each new turn.

I guess those words—surprise, discovery, exhilaration—sum up, for me, the Eastern Sierra experience. As a Californian, it is a place I return to again and again. No matter how often I climb its mountains, explore its hidden lakes and valleys, I am filled with the same sense of excitement as when I first gazed upon its landscape.

CALIFORNIA NEVADA

EASTERN SIERRA

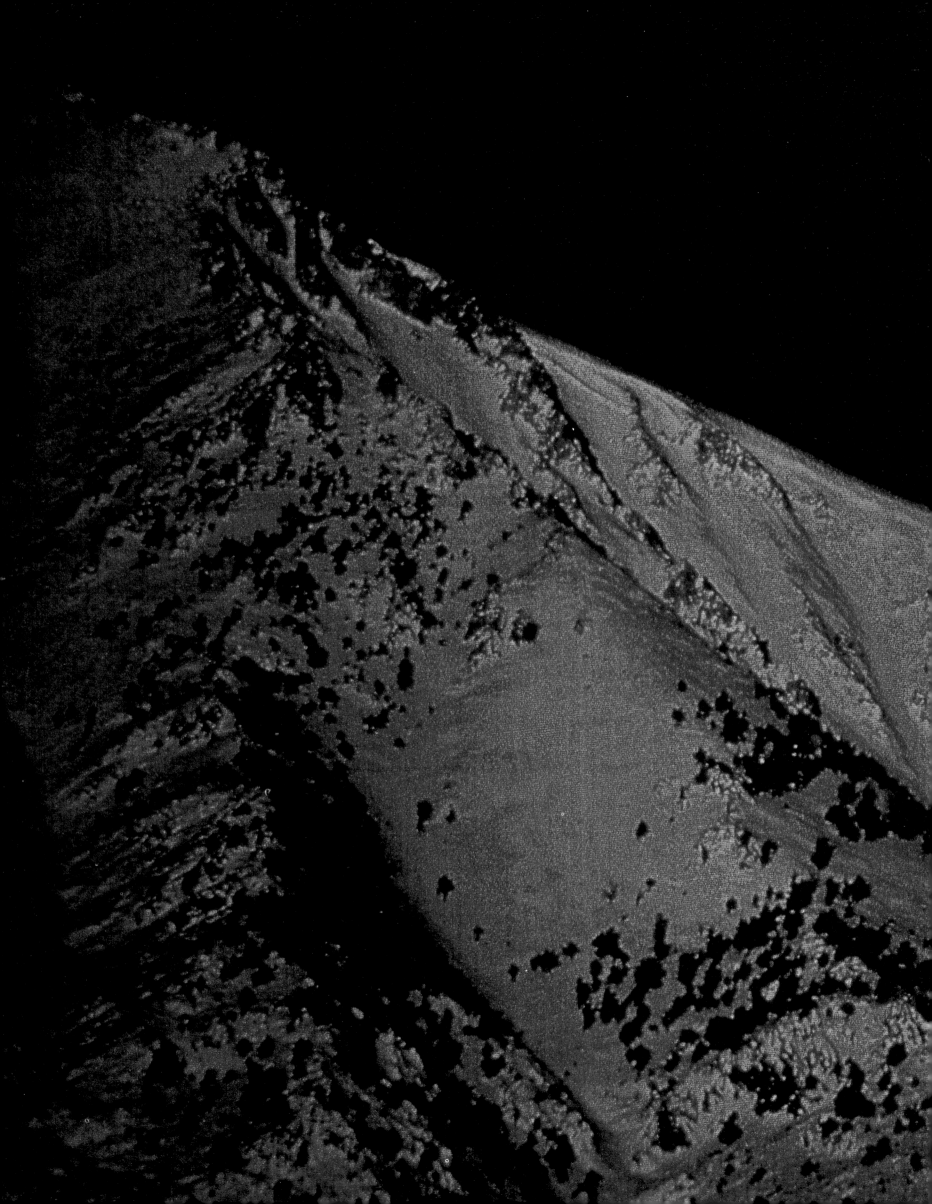

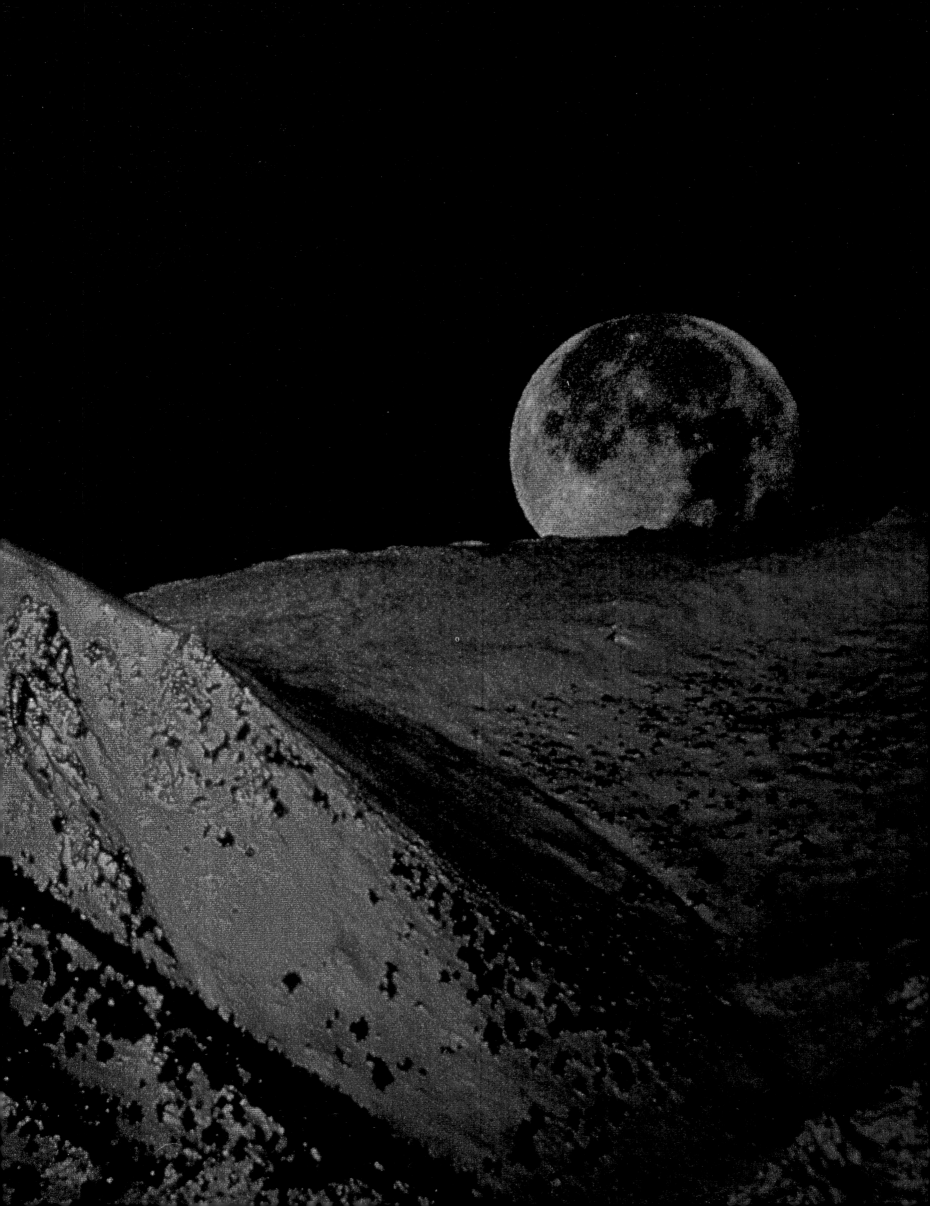

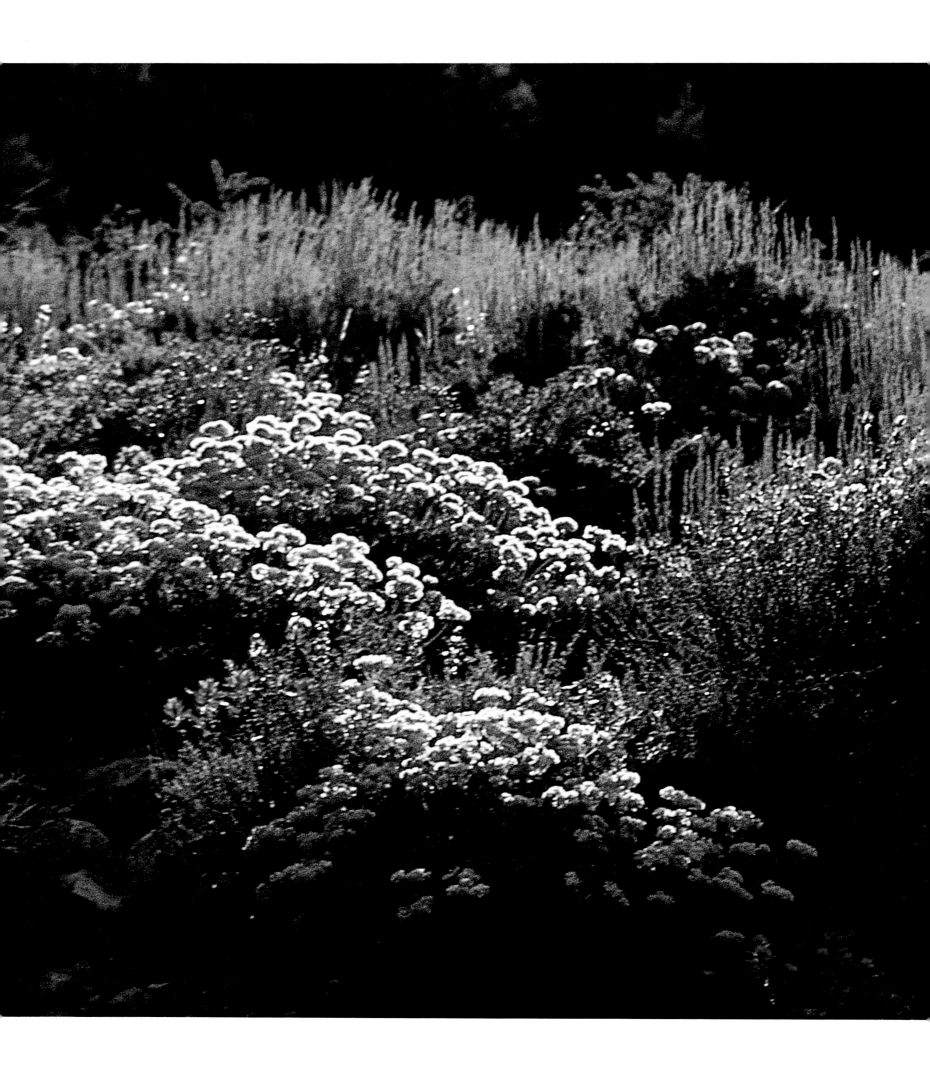

Summer flowers
in a sagebrush meadow
near Grant Lake.

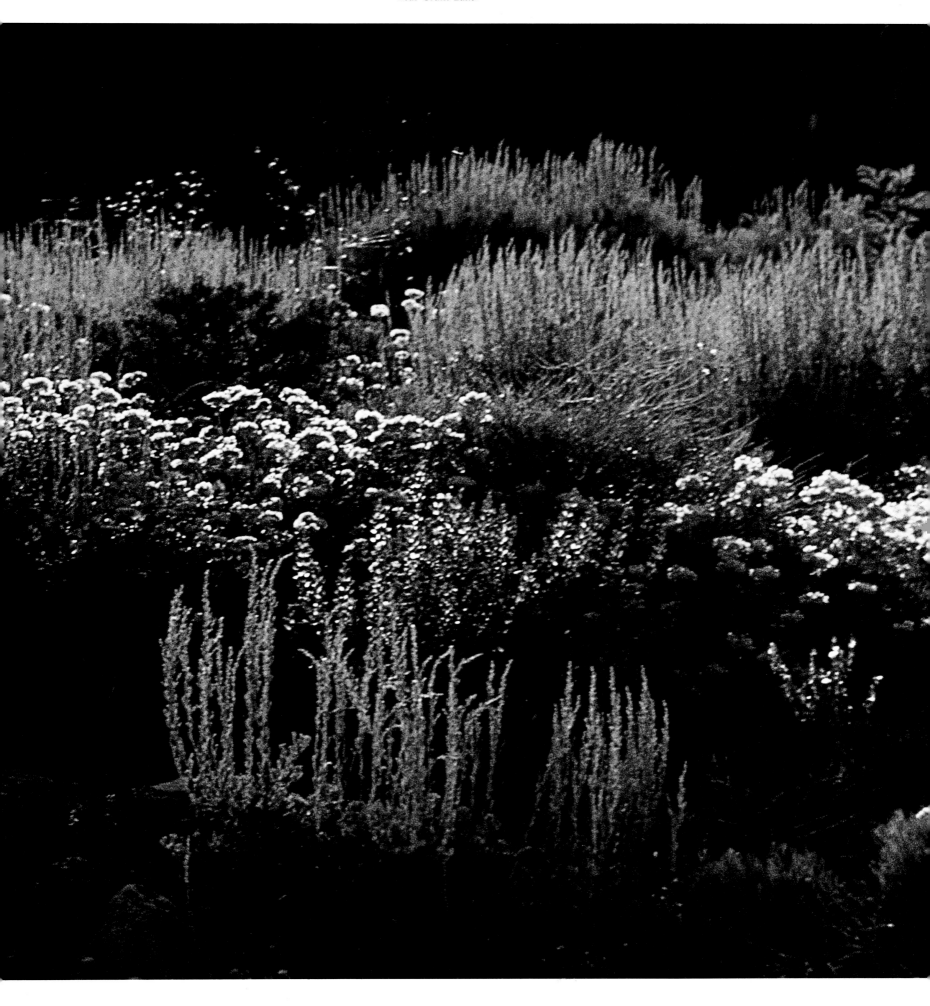

*A climber ascends
Pratt's Crack,
Sierra Nevada range.*

*A climber stands atop a rock
pinnacle near Mt. Whitney, the highest
peak in the original forty-eight states.*

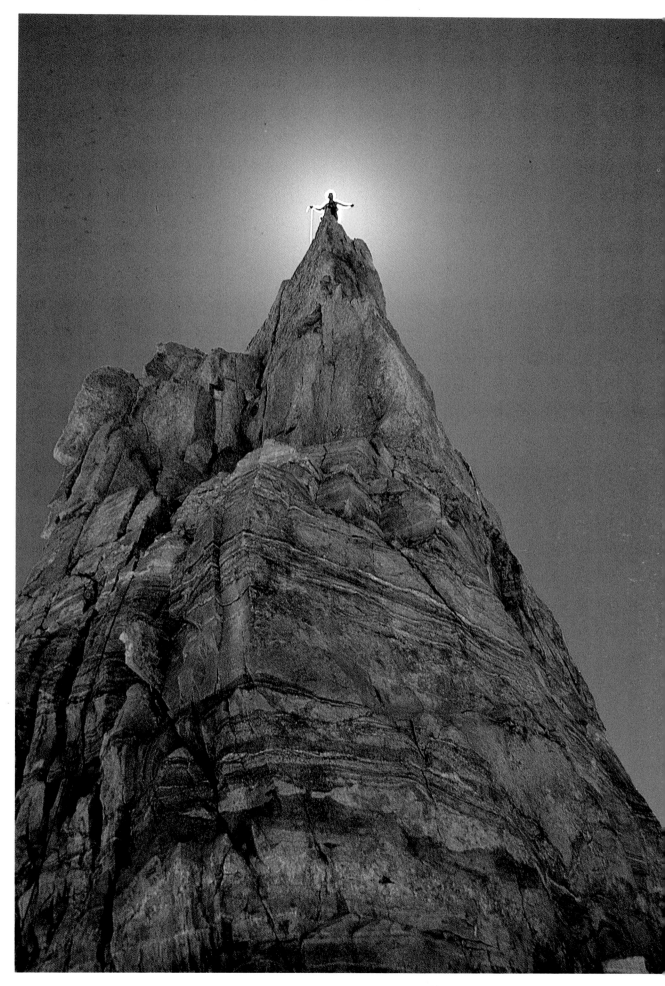

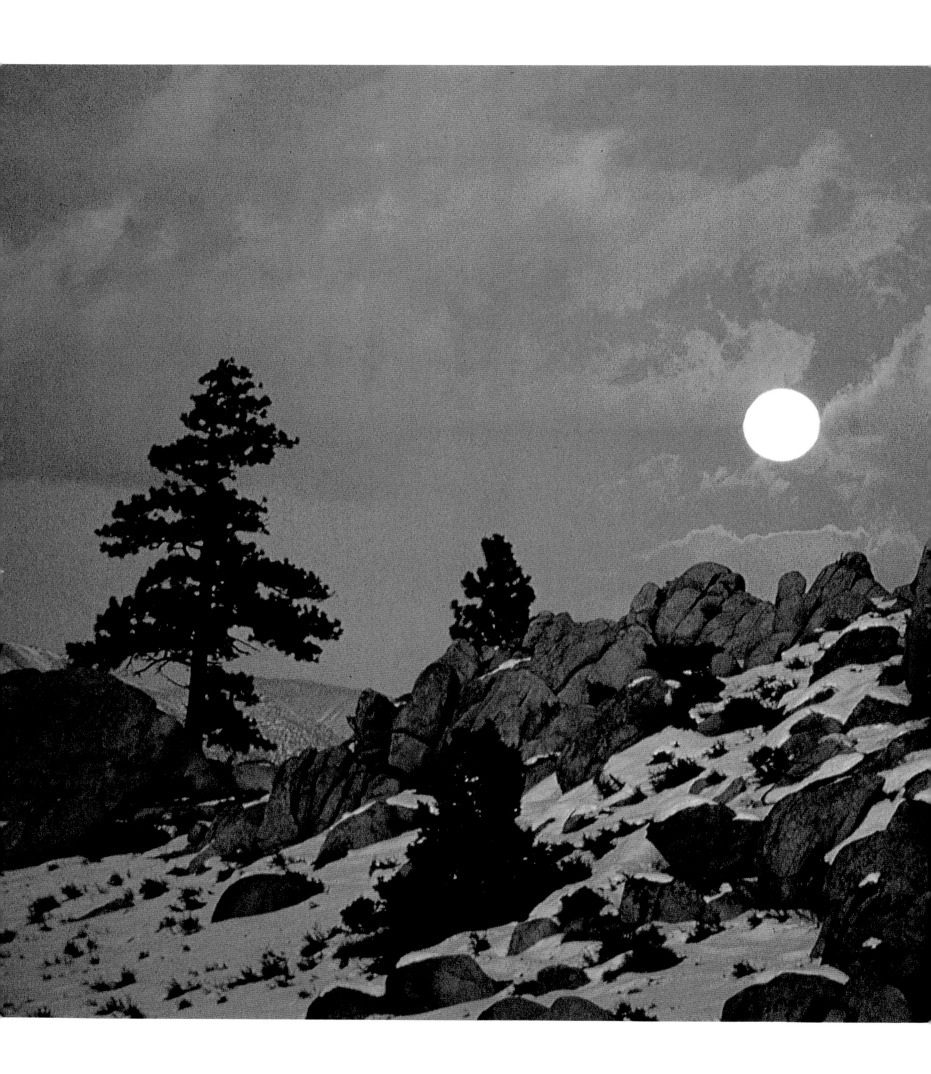

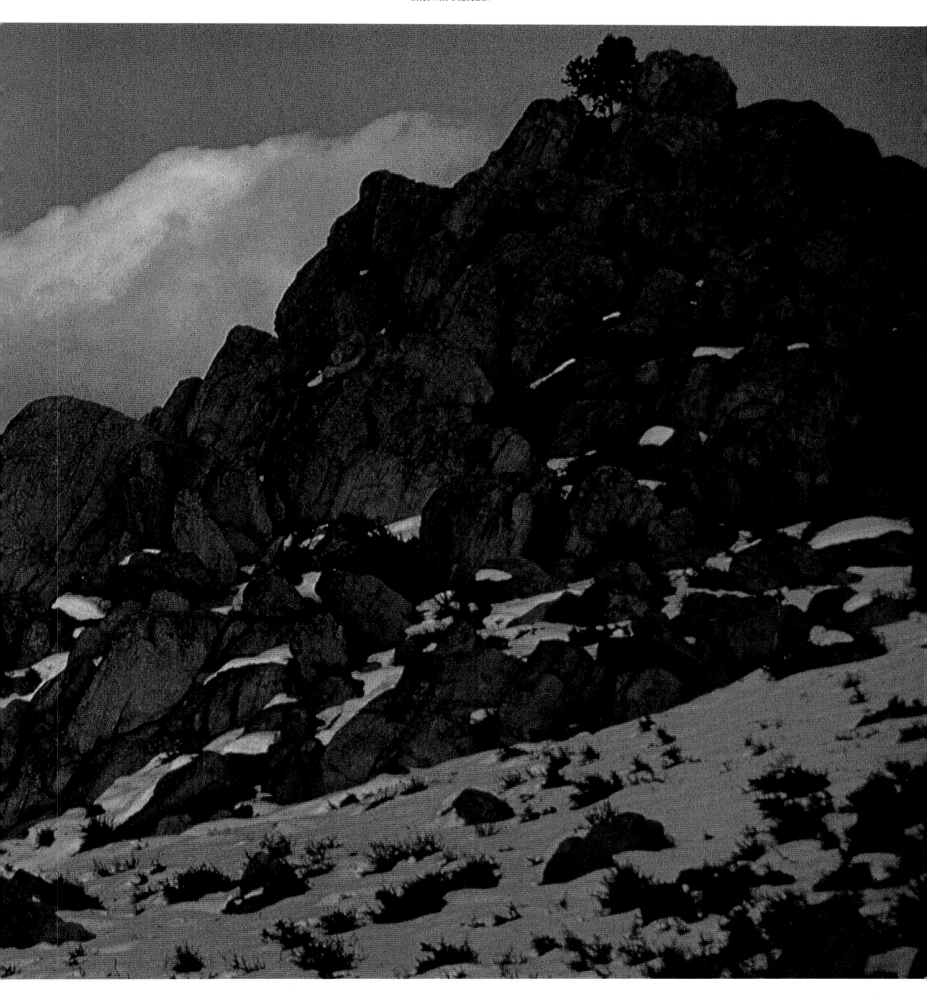

A winter moonrise over the Sherwin Plateau.

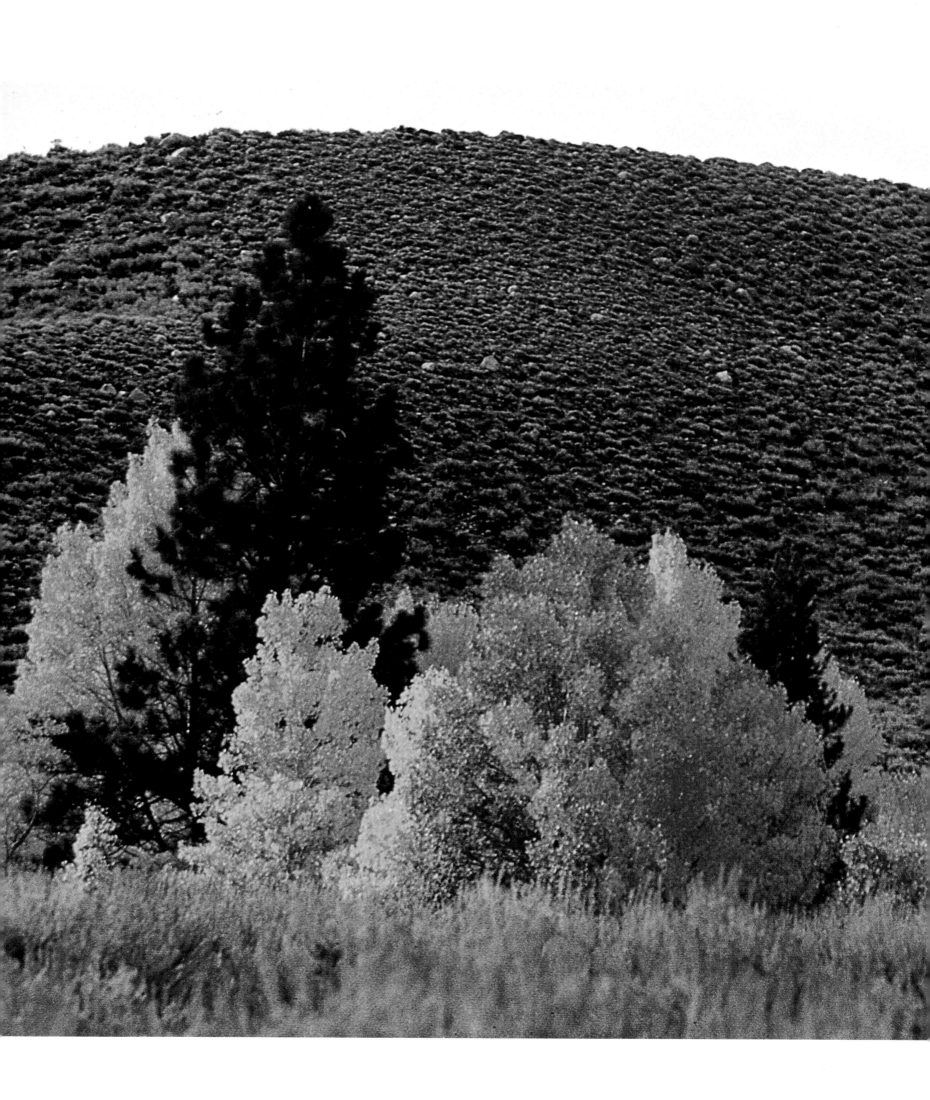

Aspens in the fall,
Lundy Canyon near
Mono Lake.

Next page:
Alpenglow on the east
face of Mt. Whitney.

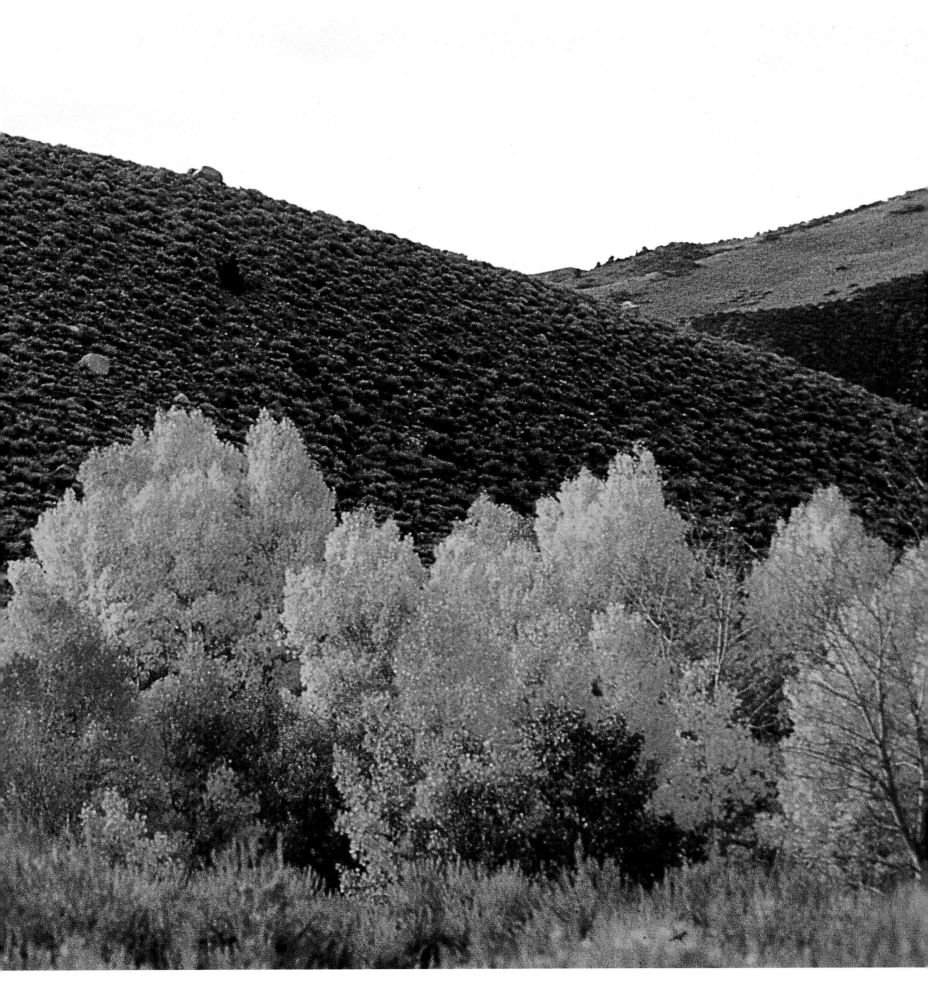

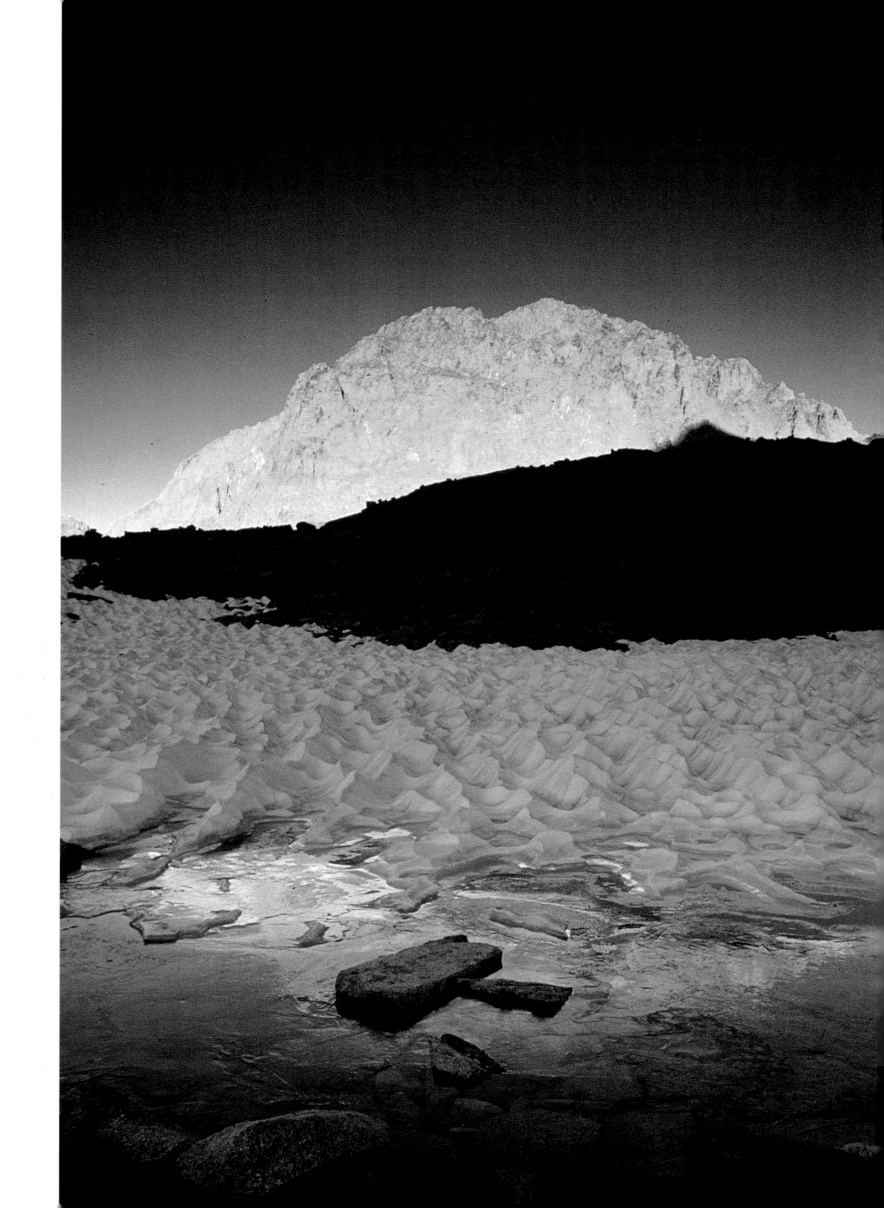

Late summer
snow beneath
Mt. Williamson.

A winter sunrise
on a Bristlecone Pine
in the White Mountains.

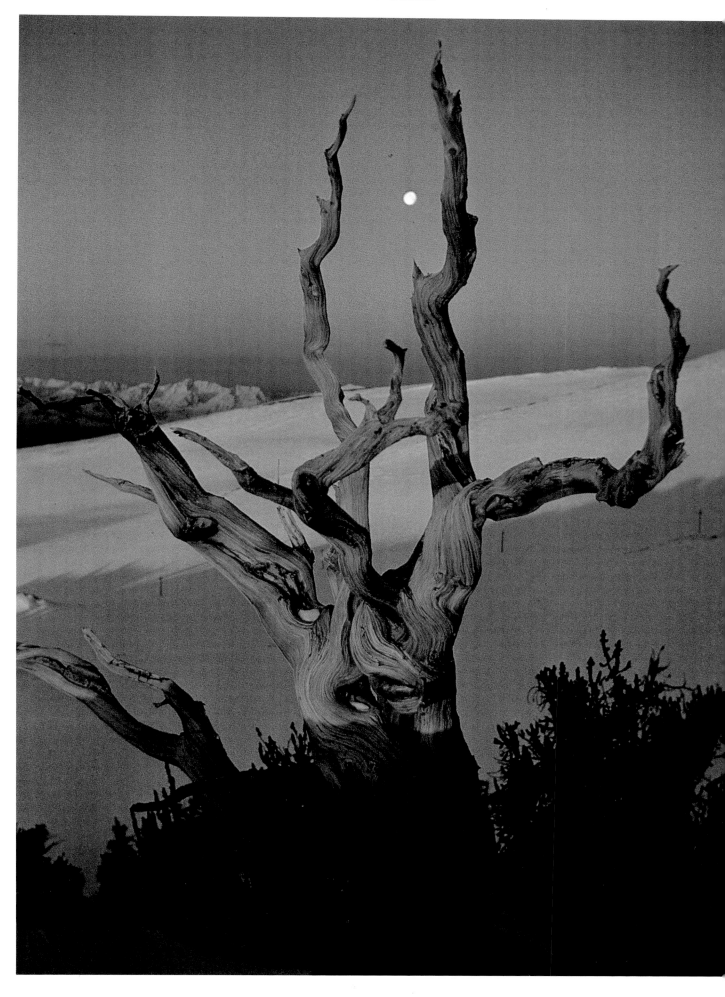

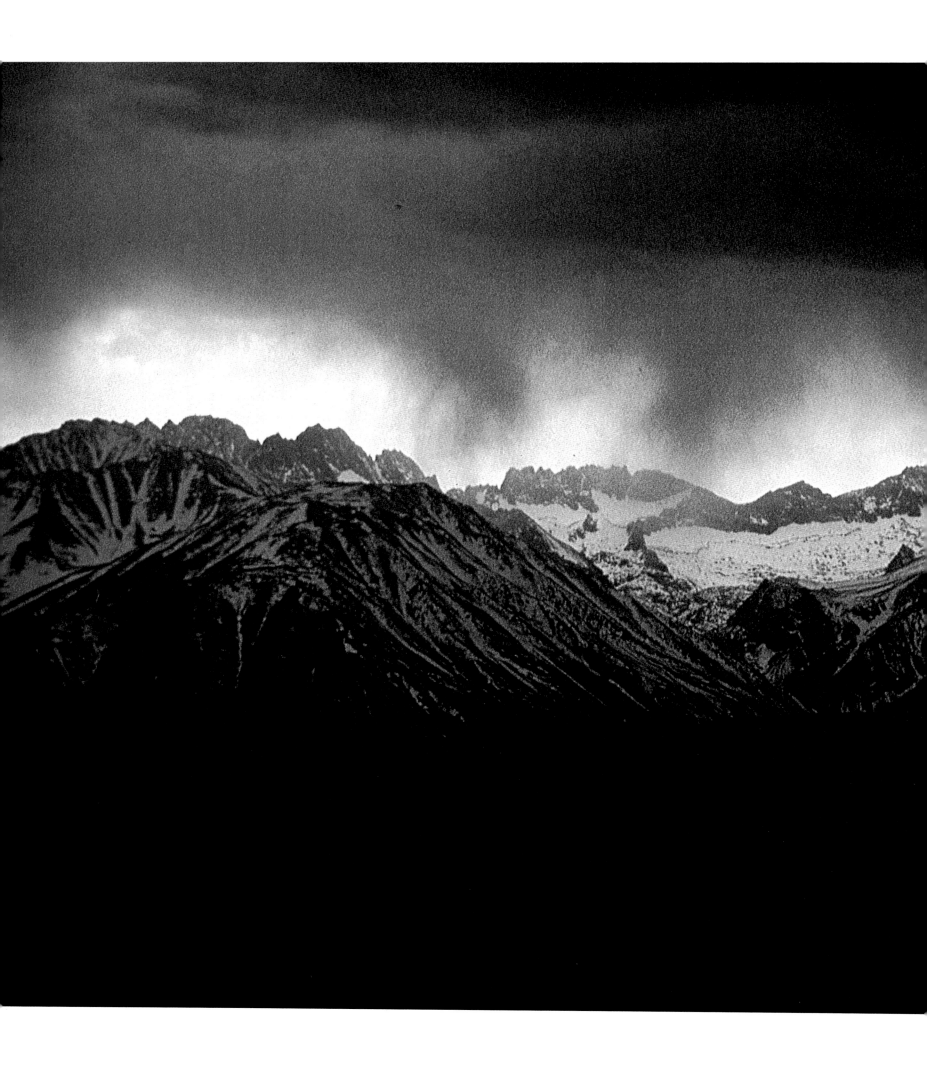

*A storm over
the Palisades
range.*

*Next page:
Sunrise at Tioga Pass,
Yosemite National Park.*

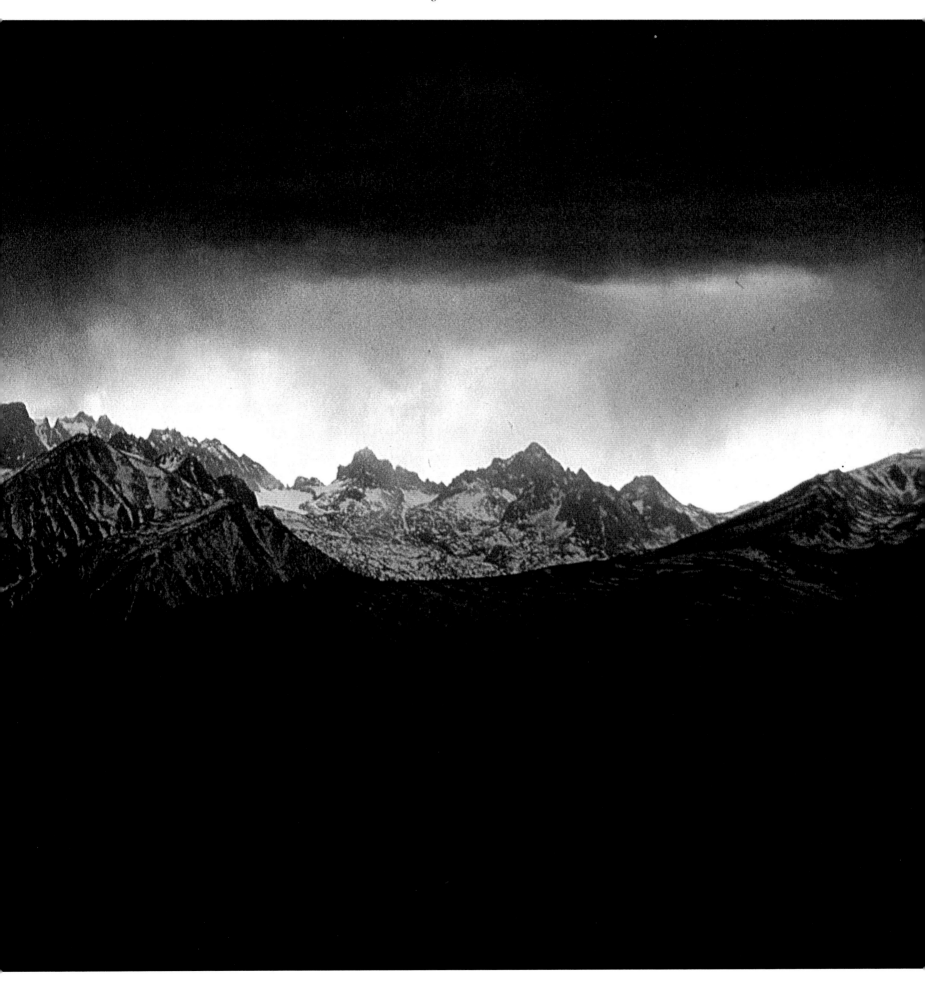

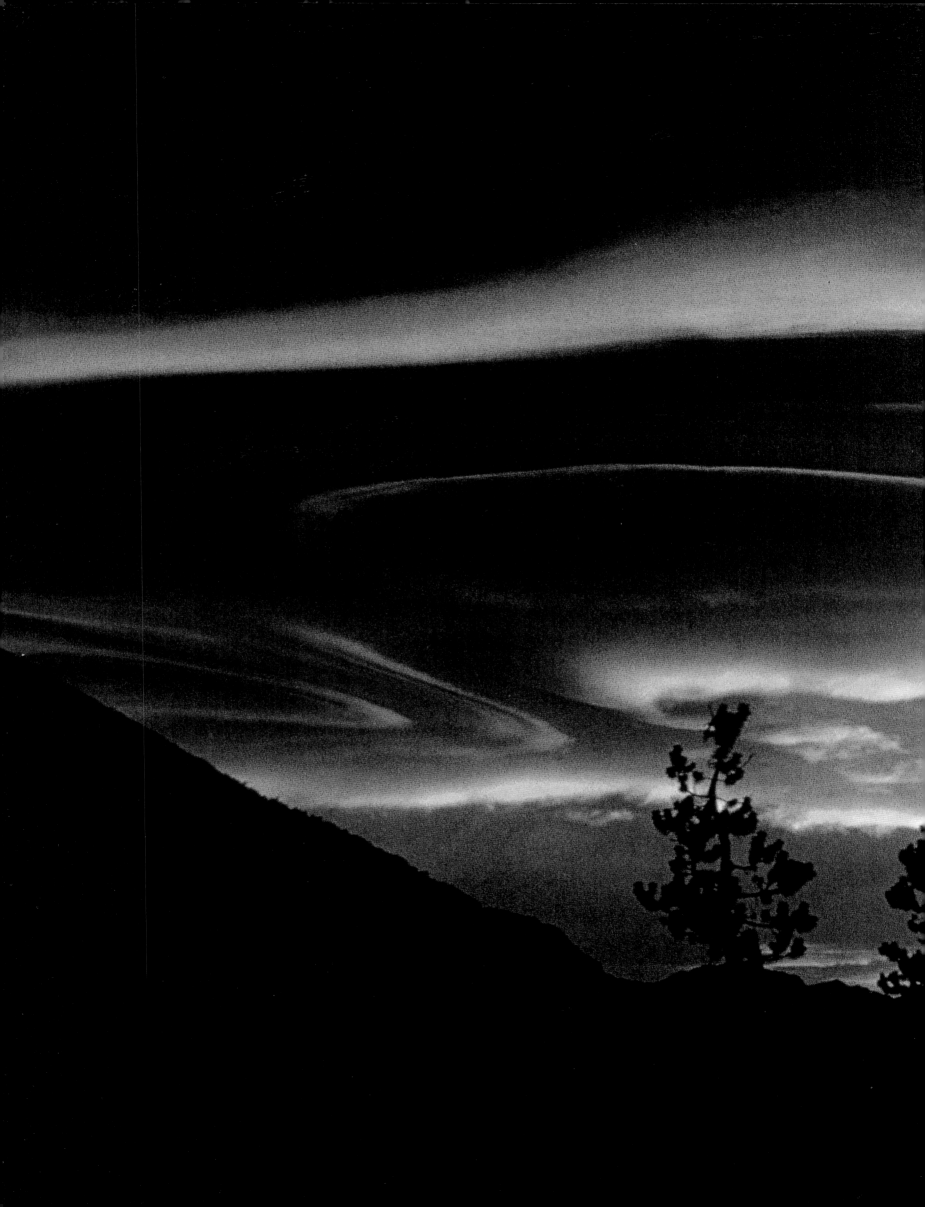

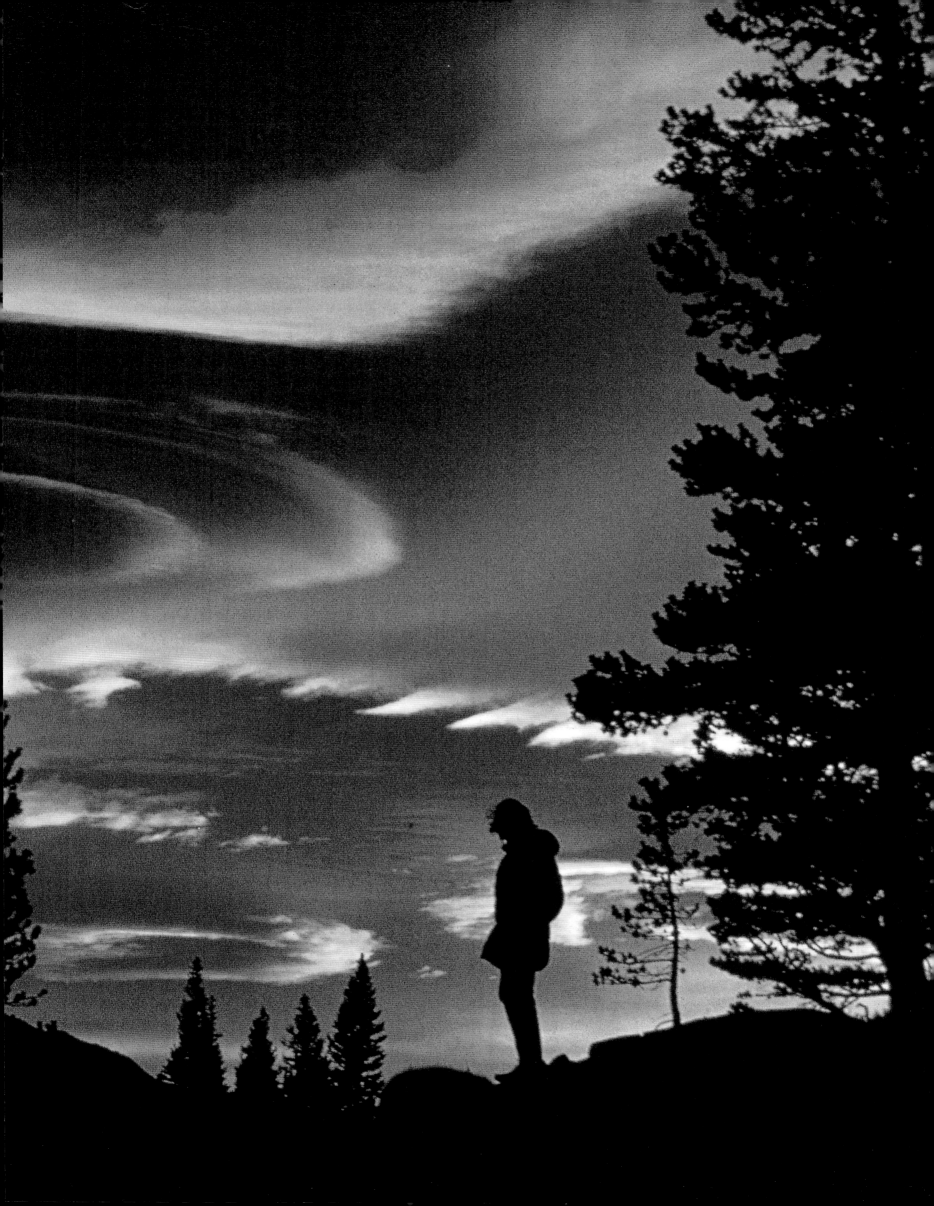

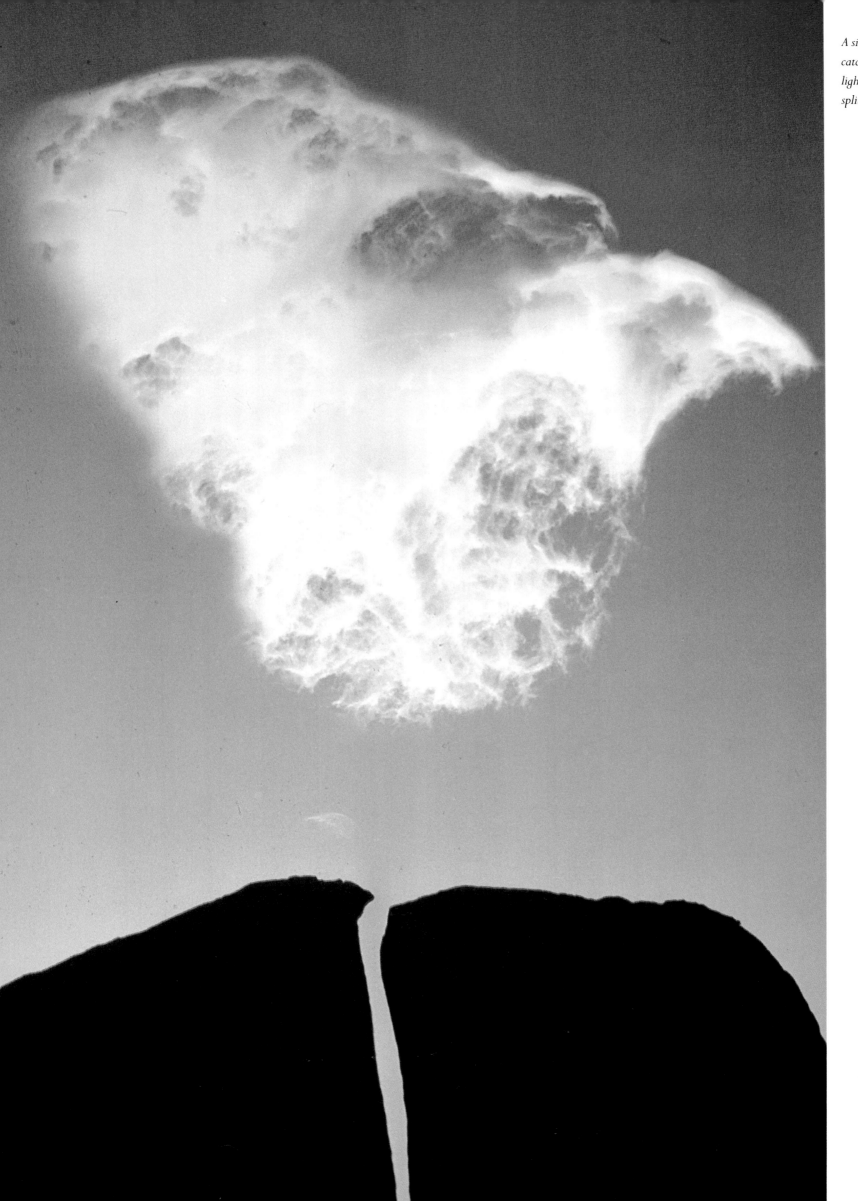

A single cloud catches the last light over a split boulder.

VEN

ERNST

ICE

HAAS

Some places are unique, originals isolated in their own history and appearance. I love these kinds of places and, for this reason, I love Venice. It is incomparable. There must be legions who would join me in my opinion. Anyone who has ever visited Venice feels he has been enriched by a very special experience. For me it is the most romantic and poetic city in the world.

Venice is a grand old dame; slightly decadent, witty, wise, satirical, quite realistic, but tolerant in everything which has to do with the pleasures of the senses. Live and let live is what she preaches. If she gives you the illusion that you have a very intimate relationship with her, you soon find out you are not alone. Venice is as fickle as a cat; a courtesan, she gives herself to anyone who can afford her.

Which city in the world satisfies all your senses? In Venice you have the sensation of being in a living museum. Walking along the canals and narrow streets you experience living theater unsurpassed. There are hundreds of small bridges to walk over. But you can also glide under the same bridges for a totally different perspective, while you listen to the gondolier sing his songs. Venice is art as total environment.

Venice is a challenge and a confrontation. Whatever you see has been seen, whatever you hear has been heard. It's a real test of daring for anyone who wants to find his very own Venice. Everywhere you stand or walk, another painter, poet, writer, or composer has stood before you.

You can study her schools of painting, music, and architecture, her many mixed styles from Byzantine-Gothic to Renaissance. But the style which is purely Venetian is a combination of lightness, mildness, elegance, and tolerance. There are cozy, narrow streets to stroll, museums for inspiration, gondolas for closeness, romantic hotels for intimacy, and of course churches for confession. Incomparable.

Light, water, and stone are the three basic elements of Venice, and every season creates a new display by shifting and mixing the immaterial and the fluid with the material and solid. Whatever you see along a canal will be reflected in the water, and it is reflection which is the greatest transformer in this city. Every view has as its mirror image a never-ending variation of swimming color abstractions. No halfway sensitive human being can be untouched by this magic. It will bring out the artist, the hidden poet, the dreamer, the walker in you.

So many negatives are changed into positives. The crumbling walls, patinas, and bleached colors create a symphony whose title could be The Beauty of Decay. Likewise, it was not the sun that inspired the great painters; no, Venice in the fog, Venice in the rain, created the masterpieces.

Venice invites you to walk, sit, drink, think, taste, but most of all, to see. See for seeing's sake; absorb, discover, be open to surprises, and then, accept. This eternal Lady will force you to love her.

You will gladly succumb.

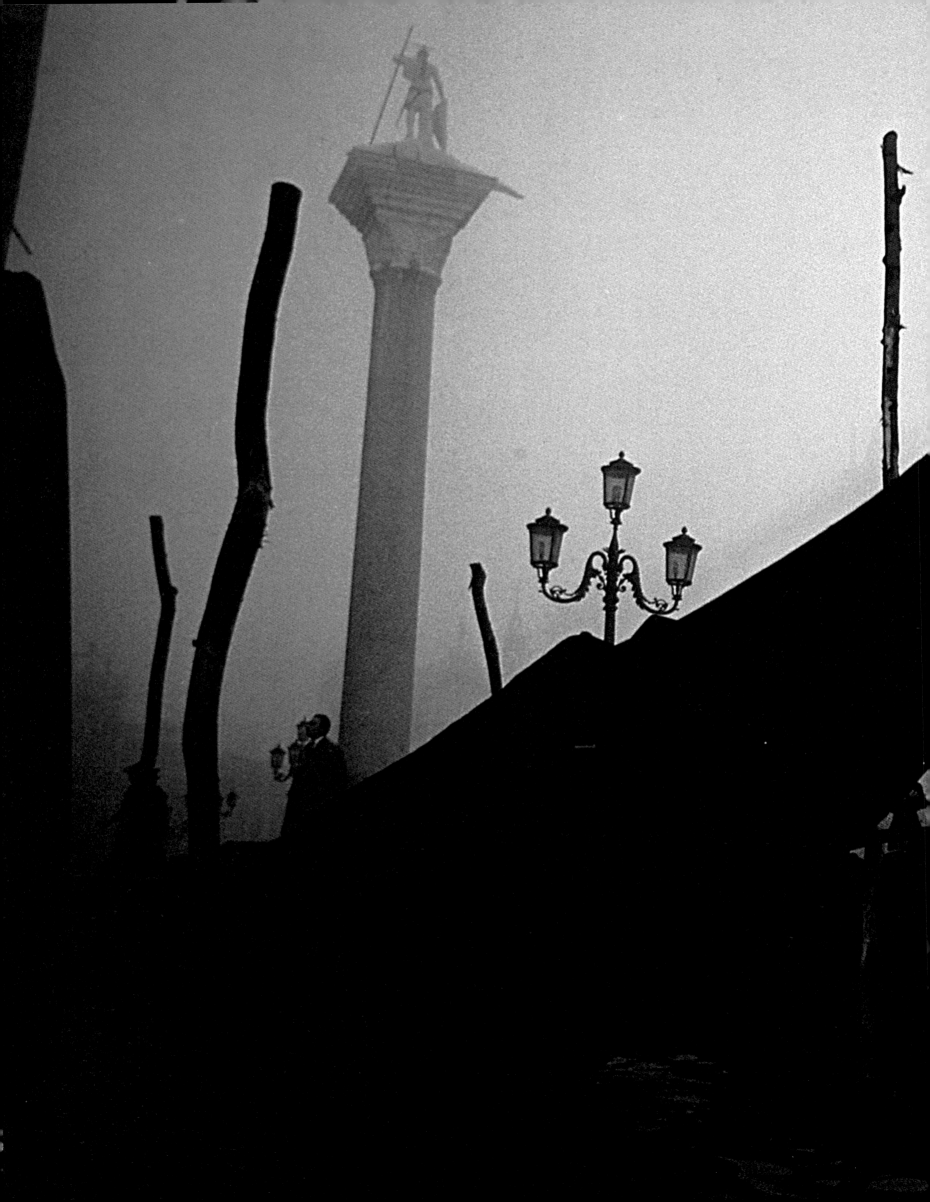

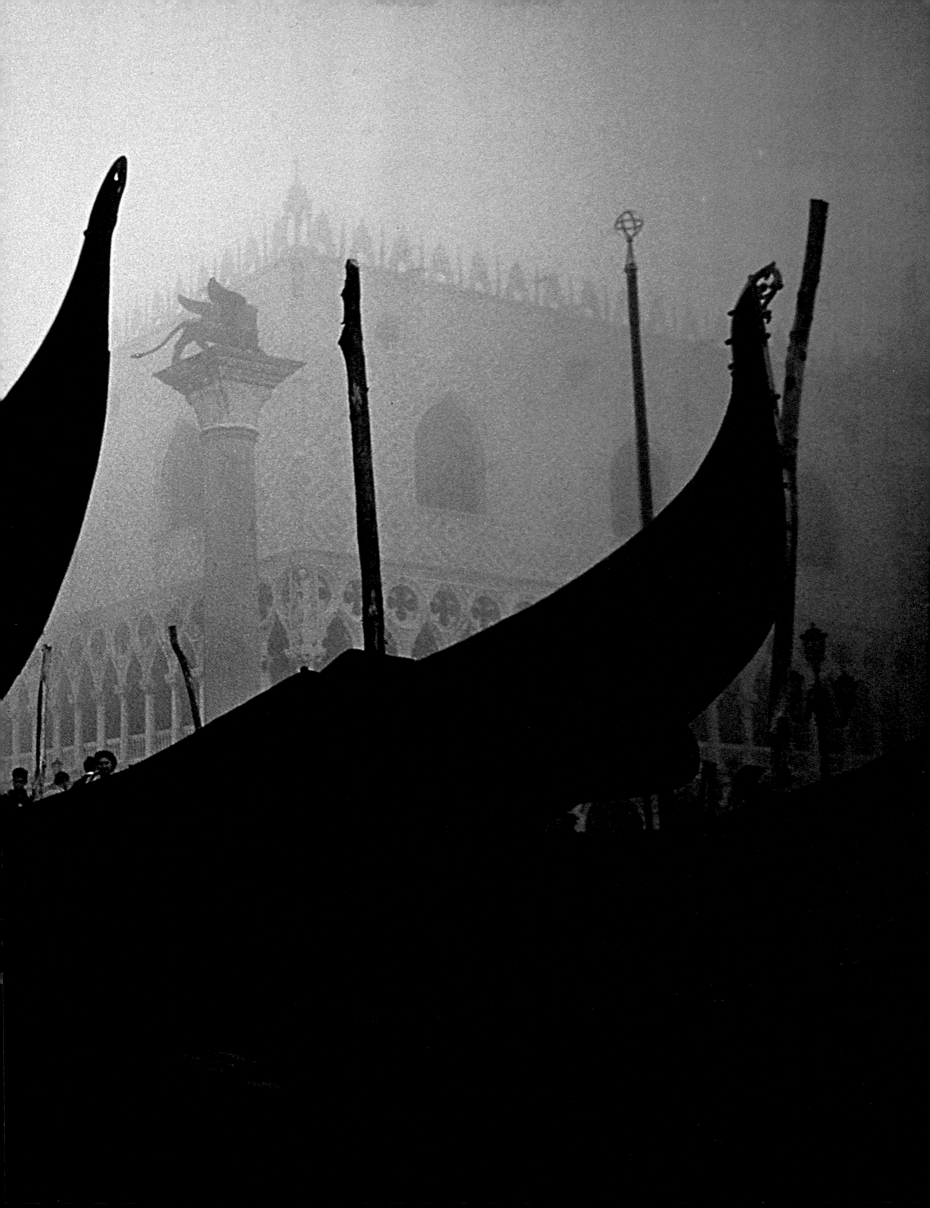

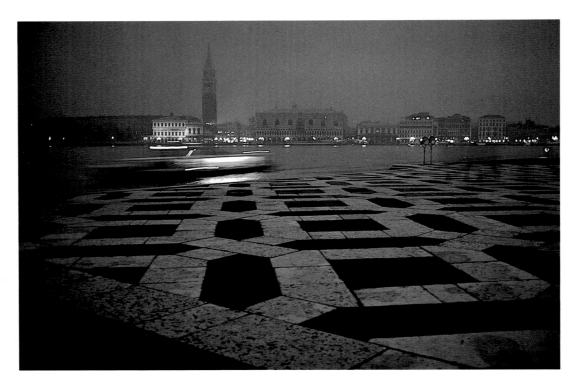

The city of Venice is illuminated on a wintry
New Year's night as seen from San Giorgio.

Right page: Every morning the city of Venice feeds
the pigeons who make the piazza alive.

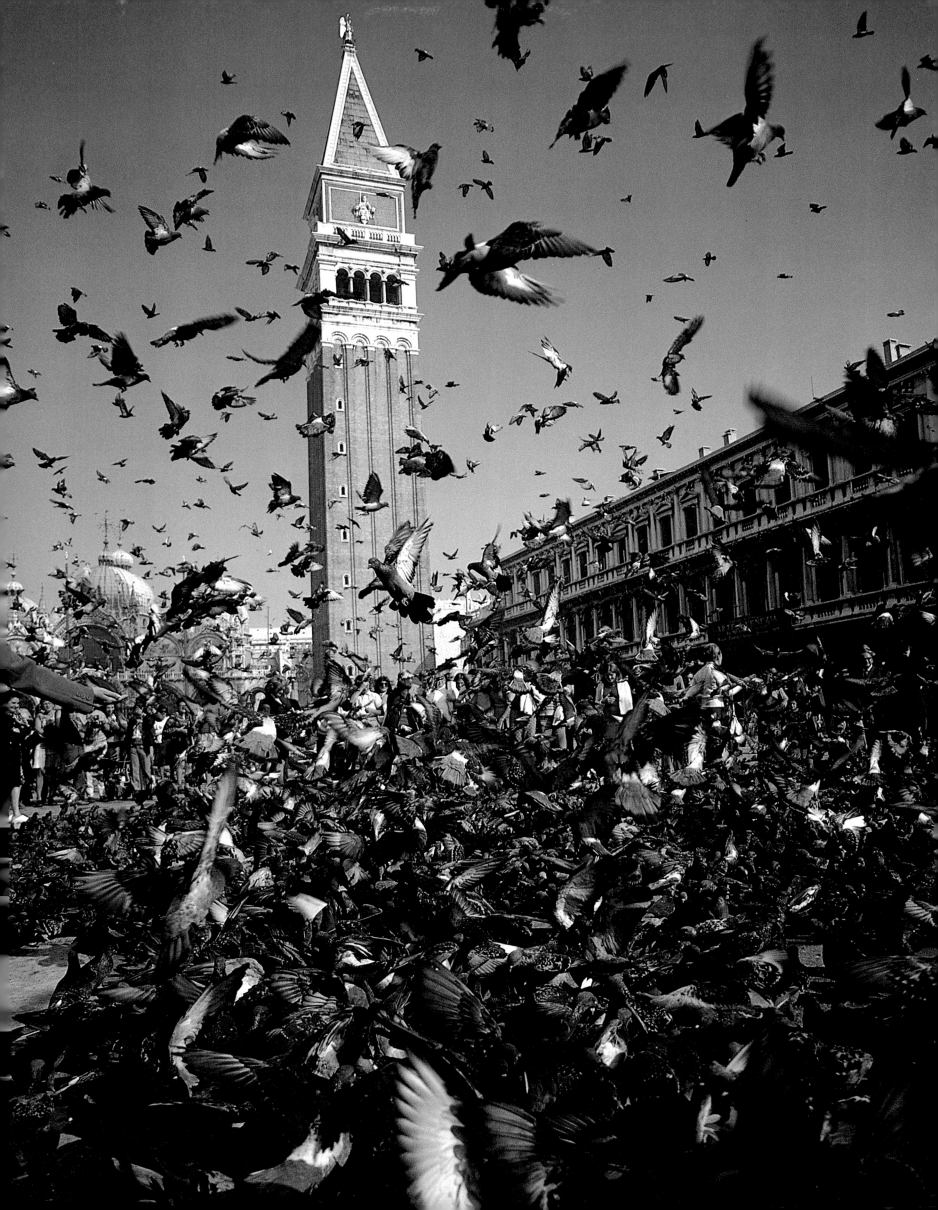

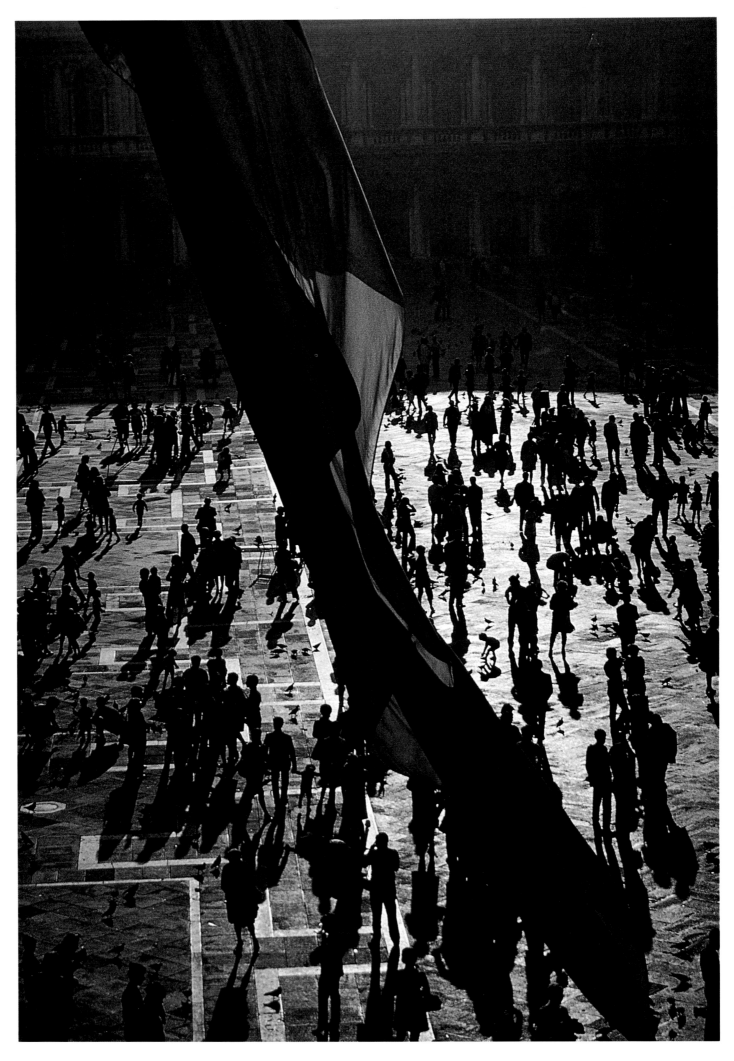

Huge Italian flag hanging down on the Piazza San Marco.
The Piazza San Marco is called the Salon of Europe.

A mosaic seen from a different perspective changes the colors.

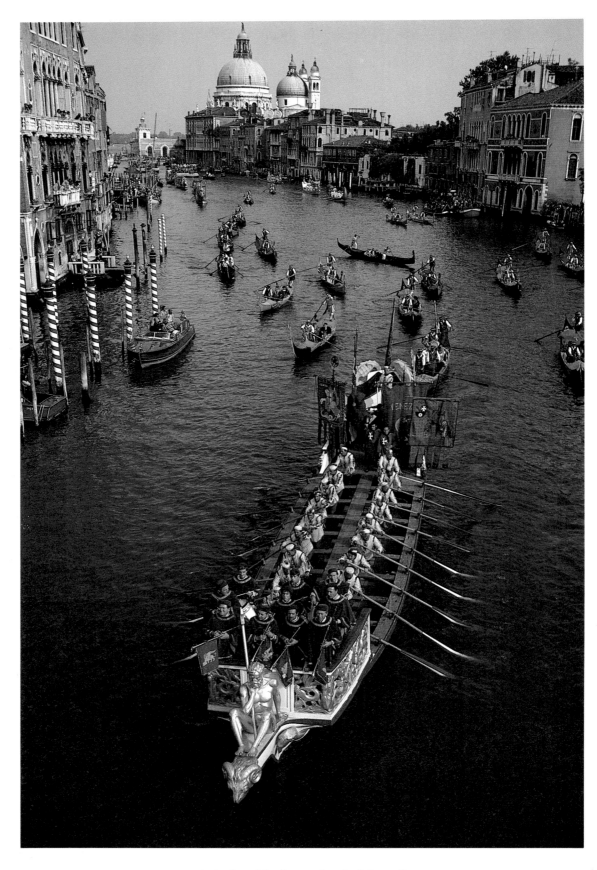

*Hundreds of gondolas decorated in the fashion of ancient
times compose the Historical Regatta in September.*

*Right page: Inlaid stones adding splendor to the Piazza San Marco as
viewed from the Bell Tower during the flood season.*

Next page: Reflection of the Bell Tower in the flooded Piazza San Marco.

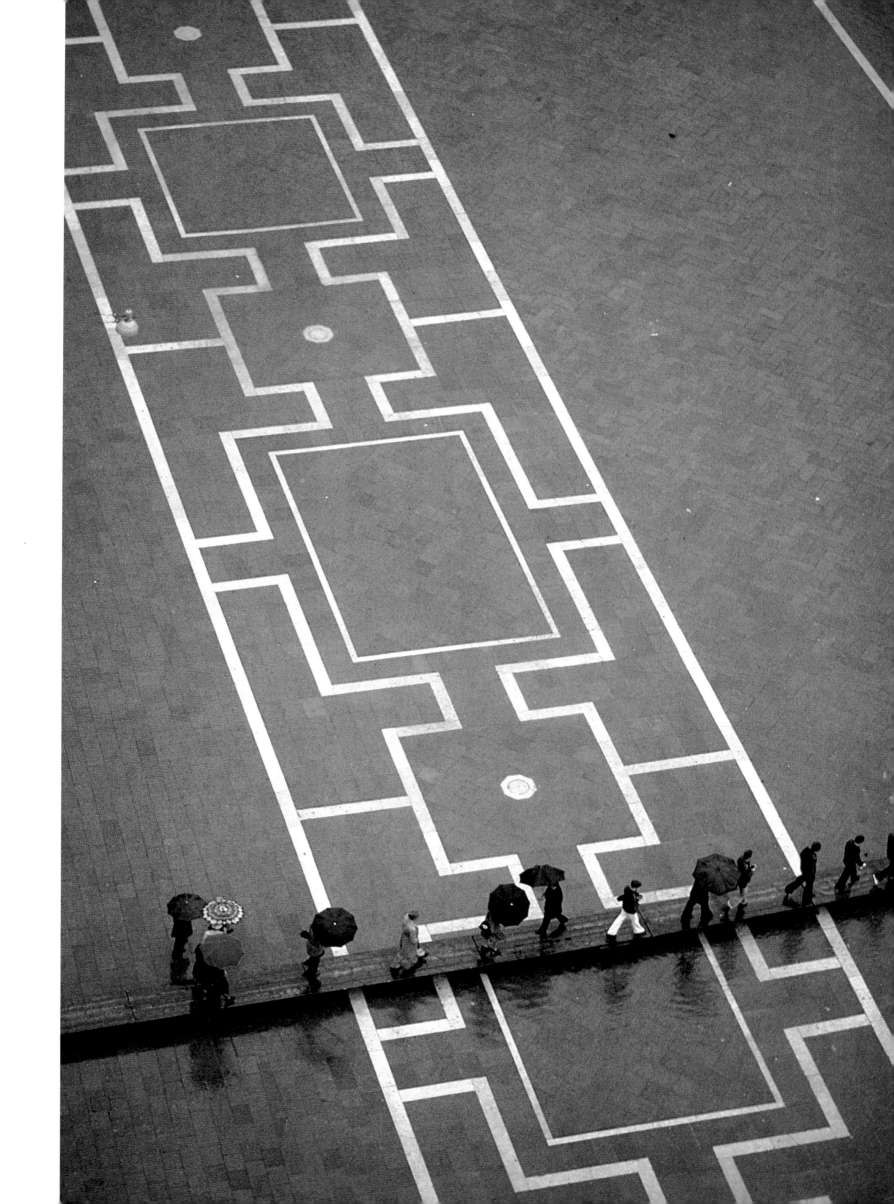

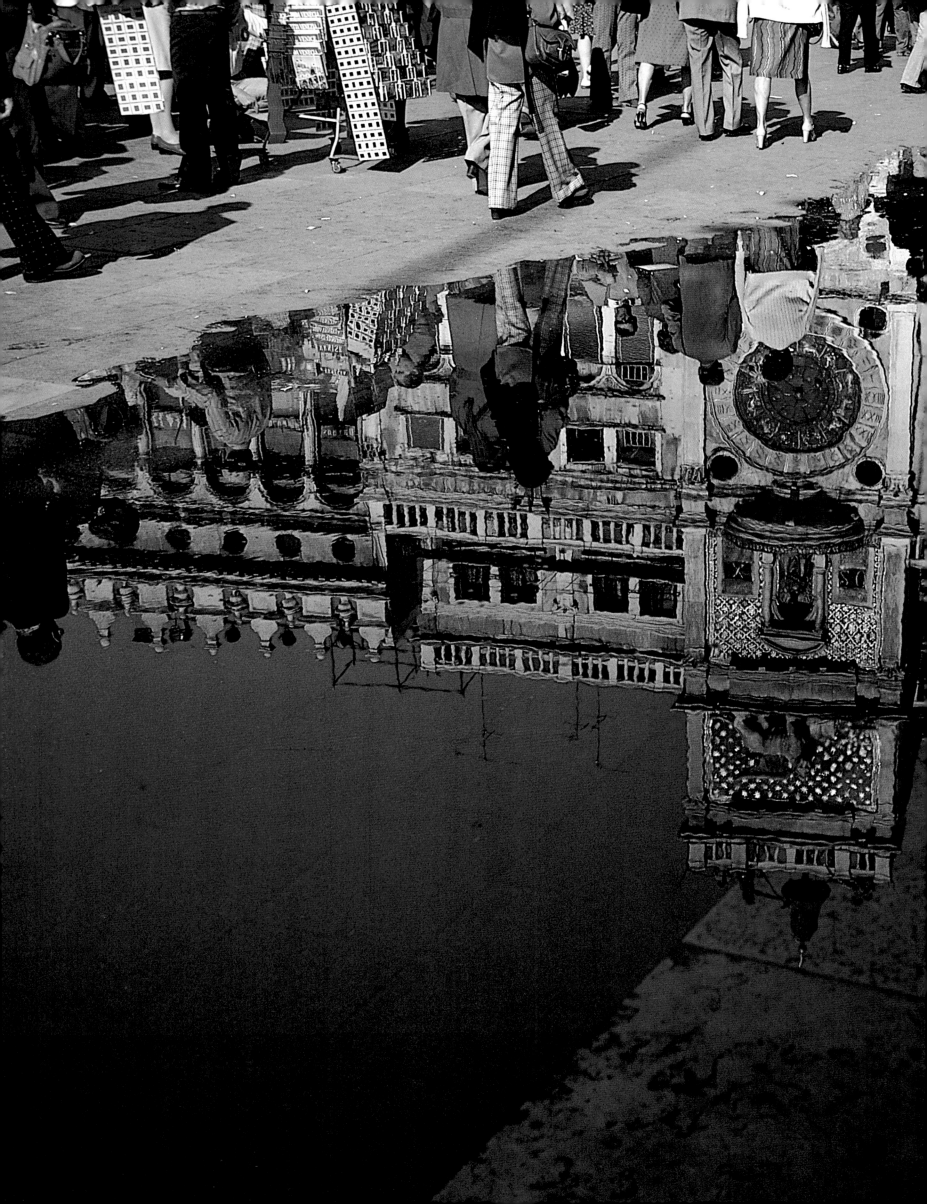

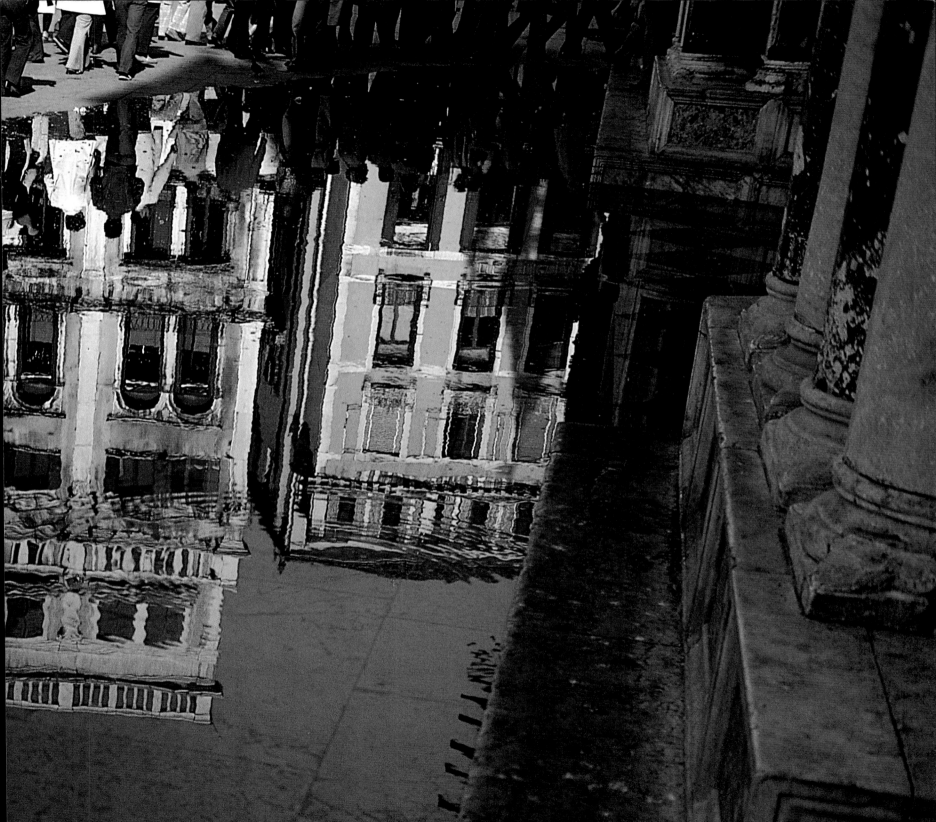

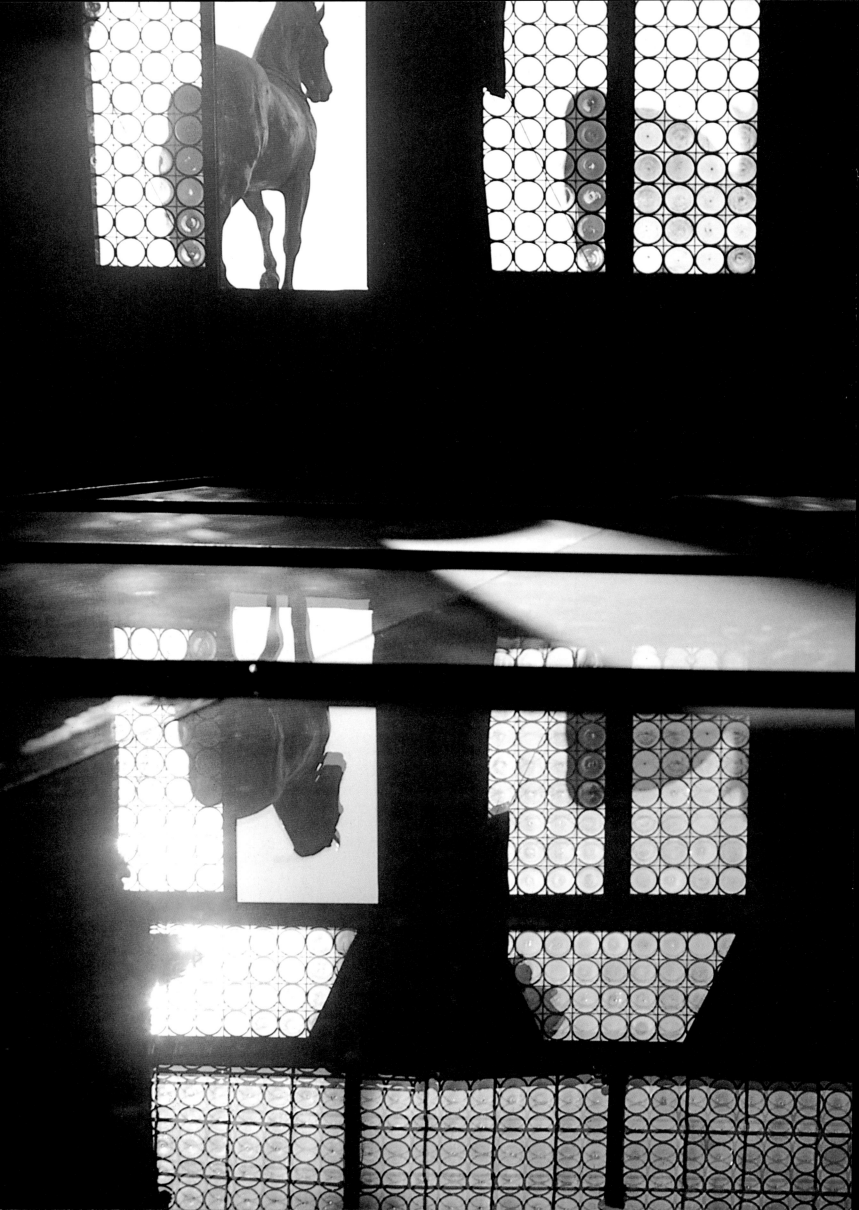

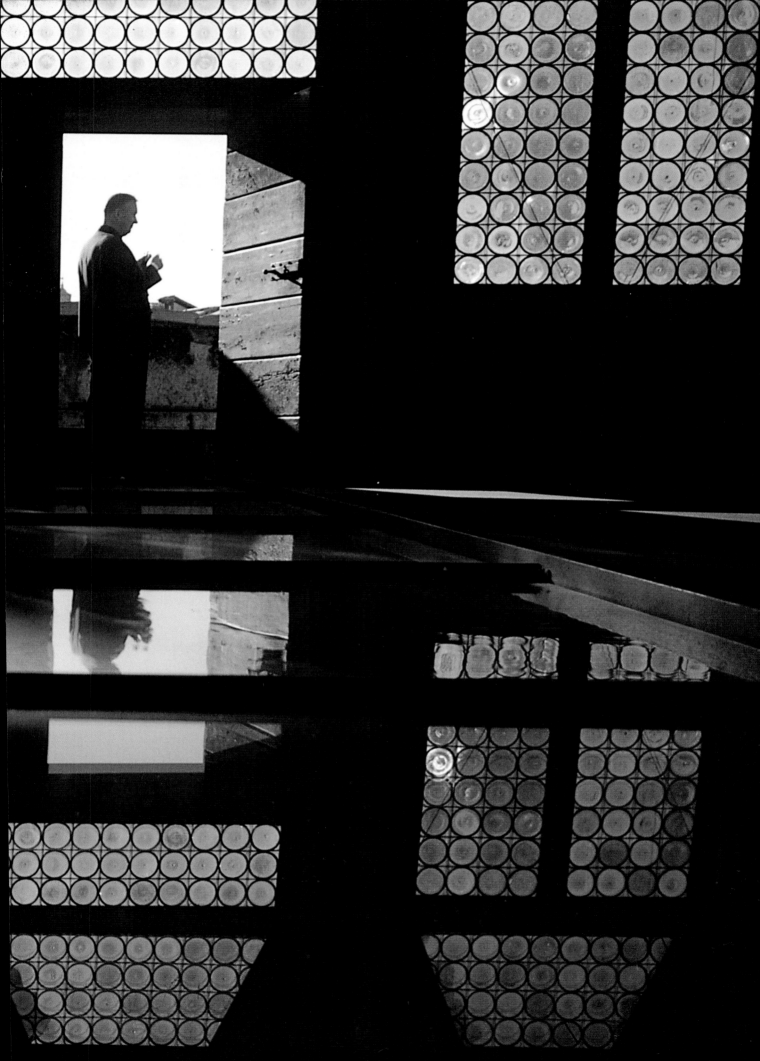

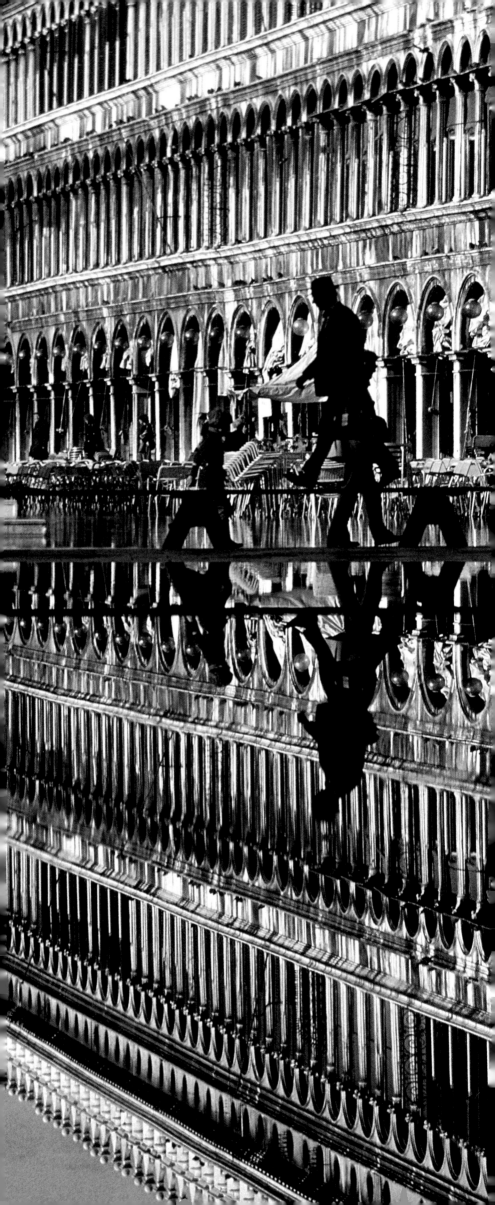

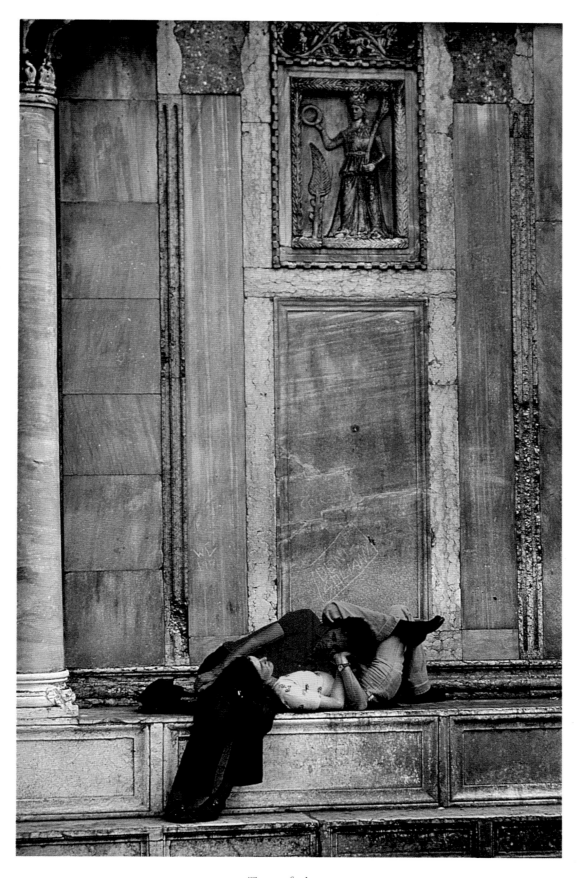

The city for lovers.

Left page: Walkways crisscross the piazzas during the flooding season.

Preceding page: The balcony of the horses at Basilica San Marco.

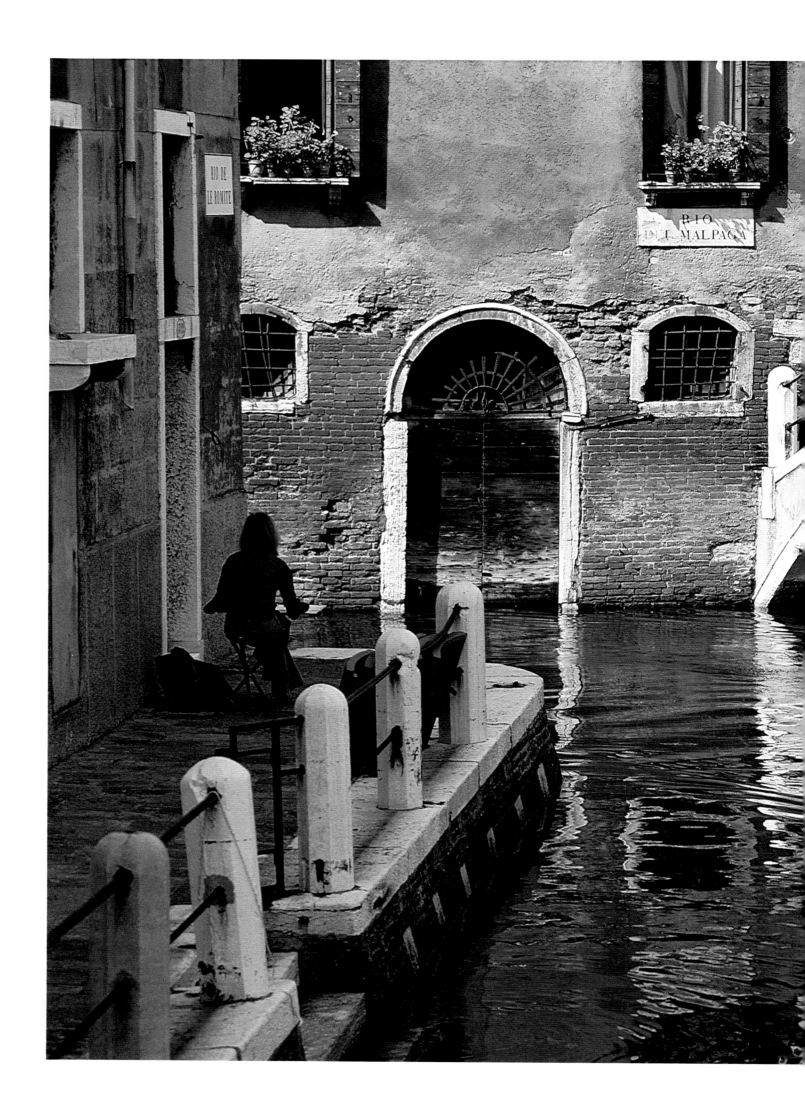

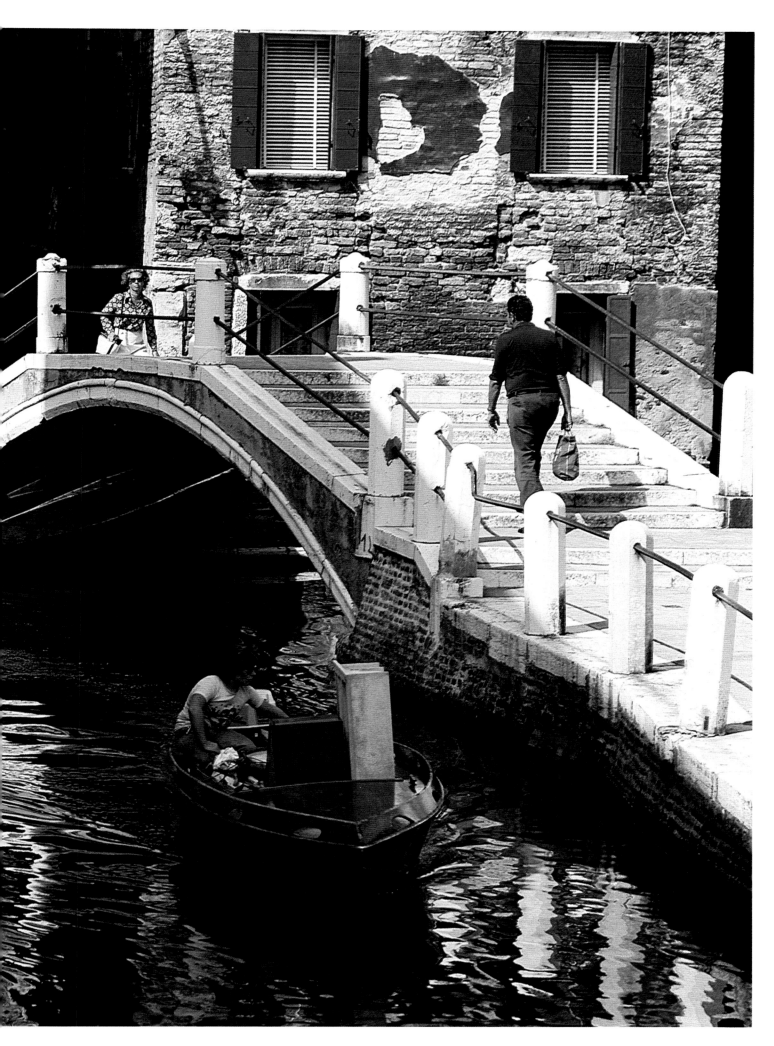

A typical canal scene with gondolas and a painter
on one of the many canals of Venice.

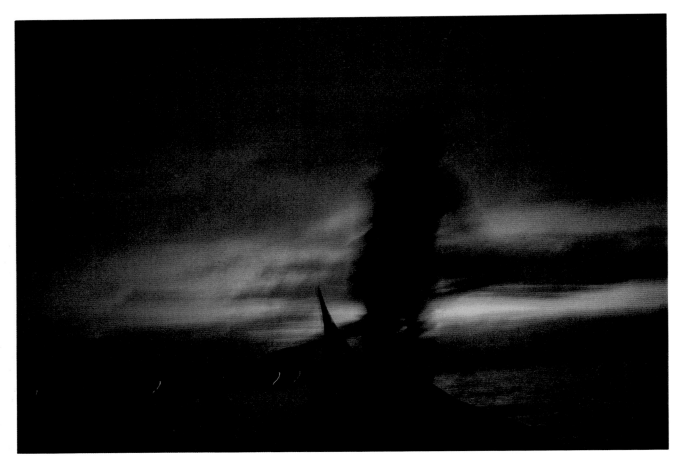

Gondola returning home in the sunset near Piazza San Marco.

Right page: A gondolier's hat awaits its owner.

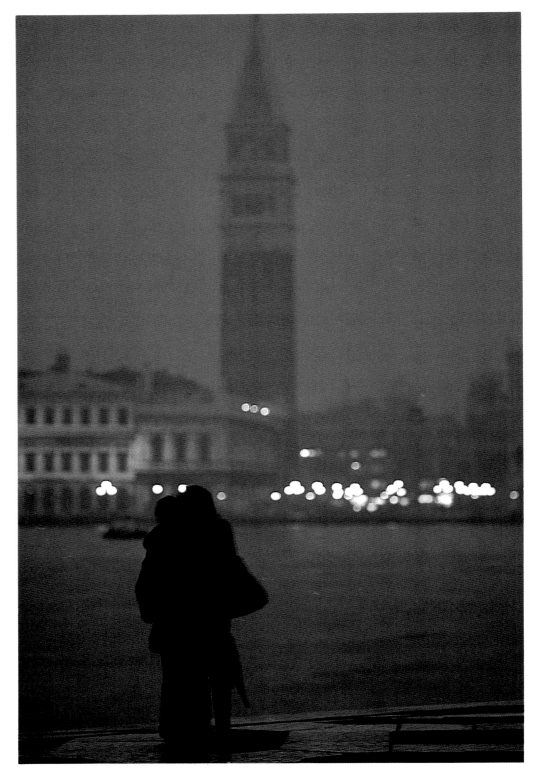

Lovers on a foggy November night.

RAS MO

DAVID D

HAMMED

OUBILET

Anne and I sit, backs to the reef wall, at Ras Mohammed. We are motionless, our exhaled bubbles creeping up the sides of the wall, seeping to the surface sixty feet above. We look into the deep water. It is a blue darker and richer than lapis lazuli. Below our fins, the reef wall of Ras Mohammed drops into blackness. Above, the late morning sun pushes shafts of light into the sea. Orange anthias fish swarm out from the reef. A passing silver jackfish dives into this endless school. The whole reef flinches from the attack. Then the anthias fish swarm out again, darting, feeding, picking up bits of plankton from the sea. It looks like orange clouds against a deep blue sky.

In the open sea, fifteen short-nosed gray reef sharks circle. They do not see us. They circle. Then suddenly the group dissolves and sharks—males chasing females—make fighter-plane passes at each other. A male suddenly bites a female on her flank. It is the mating dance, the courtship of short-nosed gray reef sharks. It is a secret of the sea. It is December in Ras Mohammed.

Ras Mohammed is a jewel that sticks out from the tip of the Sinai peninsula. Like a V' the two northern arms of the Red Sea embrace the Sinai. On the east is the Gulf of Aqaba; on the west, the Gulf of Suez. All the waters from both gulfs pass by the tiny peninsula of Ras Mohammed. The Gulf of Aqaba is deep, in places six thousand feet deep.

At the very end are two sunken coral islands—the North and South Islands.

At low tide they barely break the surface. They are perfect reefs, full of life, covered with soft coral, then veiled with schools of brightly colored fish. The confluence of waters, and the rich marine life of the reefs create in Ras Mohammed a complete underwater universe.

Anne and I have watched great schools of snapper, batfish, barracuda, jackfish and unicorn fish pass as if in review. We have seen hammerhead sharks, manta rays and turtles sleeping on ledges. In midsummer we have been surrounded by a vast school of blue parrot fish who have come together to mate. It is a frenzied time. This temporary school, literally explodes in all directions. At one end of the Ras Mohammed reef, there is a city of anemones filled with yellow clown fish. At the other end of the reef, there is a perfect shipwreck—the *Yolanda*, 220 feet long, sunk in 1979. The sea is now in the inevitable process of converting the *Yolanda* into part of the reef. A school of glassy sweepers has taken up residence in the bow section. In this perpetual steel twilight cave, lion fish with pectoral fins extended, looking much like harmless drifting flowers, hunt the glassy sweepers.

At the end of the harsh, hot Sinai desert lies this peaceful blue curtain of water. Underneath the deceptive cover is a phantasmagorical world; one filled with violence and beauty, fantastic shapes and pure colors, ever-shifting light and shadow.

Ras Mohammed is a memory that seems like a dream.

EGYPT JORDAN

SAUDI
ARABIA

RAS MOHAMMED

RED SEA

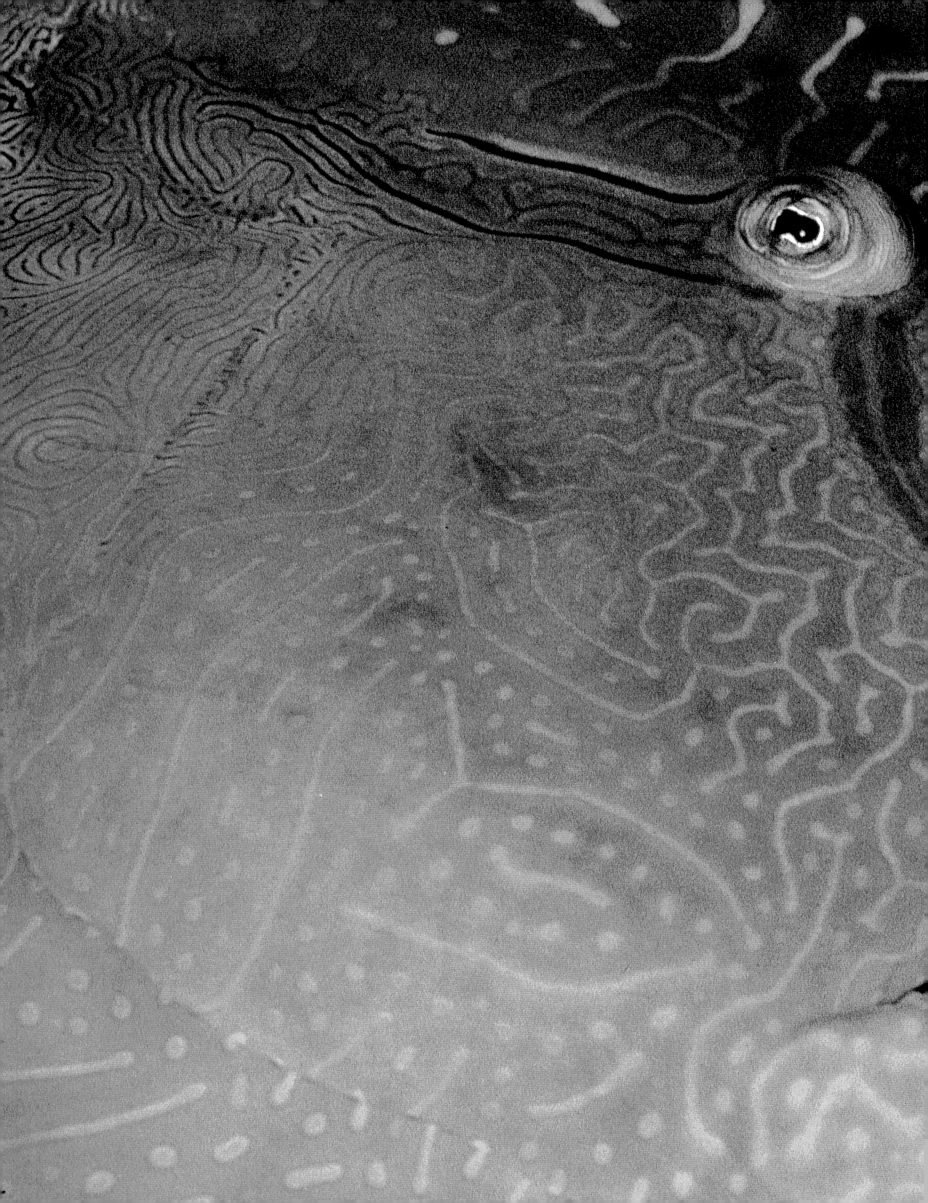

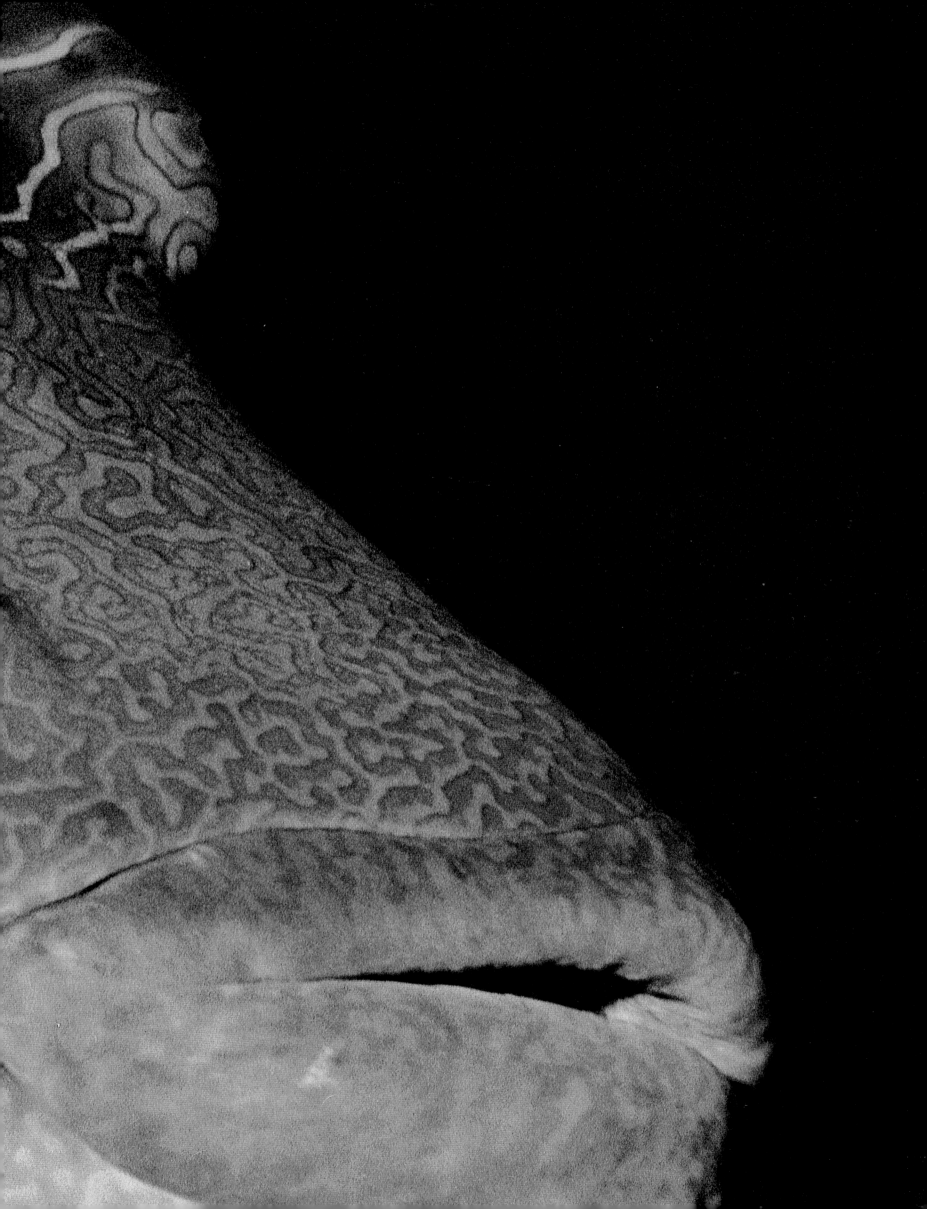

A Fridmanii fish.
This tiny, two-inch-long
plankton eater is found only
in the northern Red Sea.

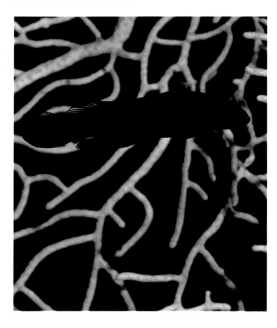

Reflection of a reef. The sky in
this picture is the perfect reflection
of the reef on a flat calm day.

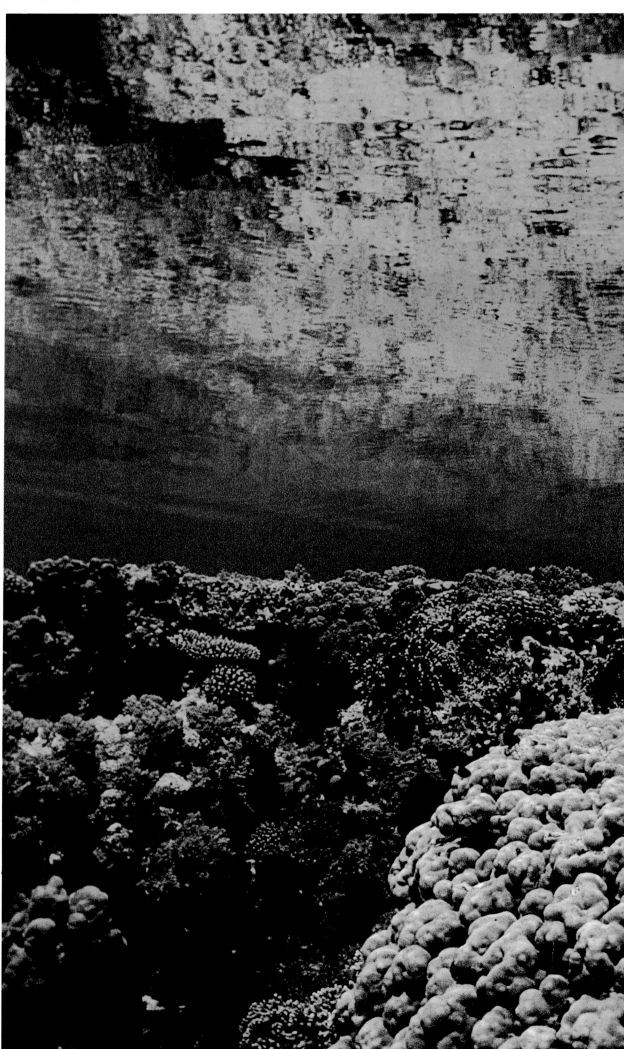

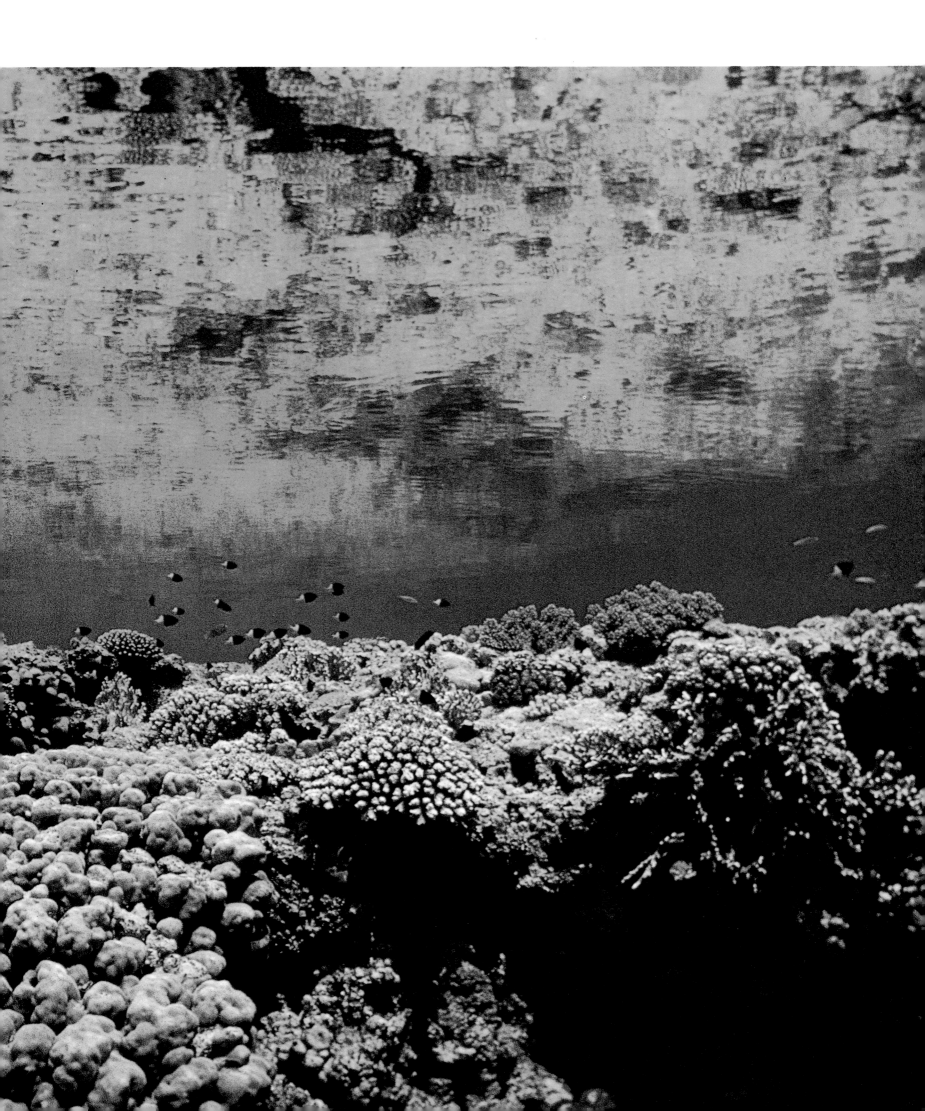

Nickii, a rare sand-dwelling fish,
swims in midwater. This male
has yellow pectoral fins and is
dominant among the fish school.

Diver
and large
gorgonian
coral.

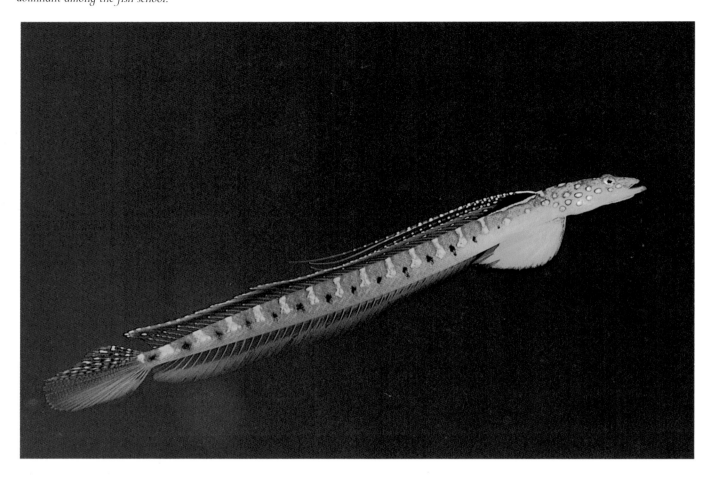

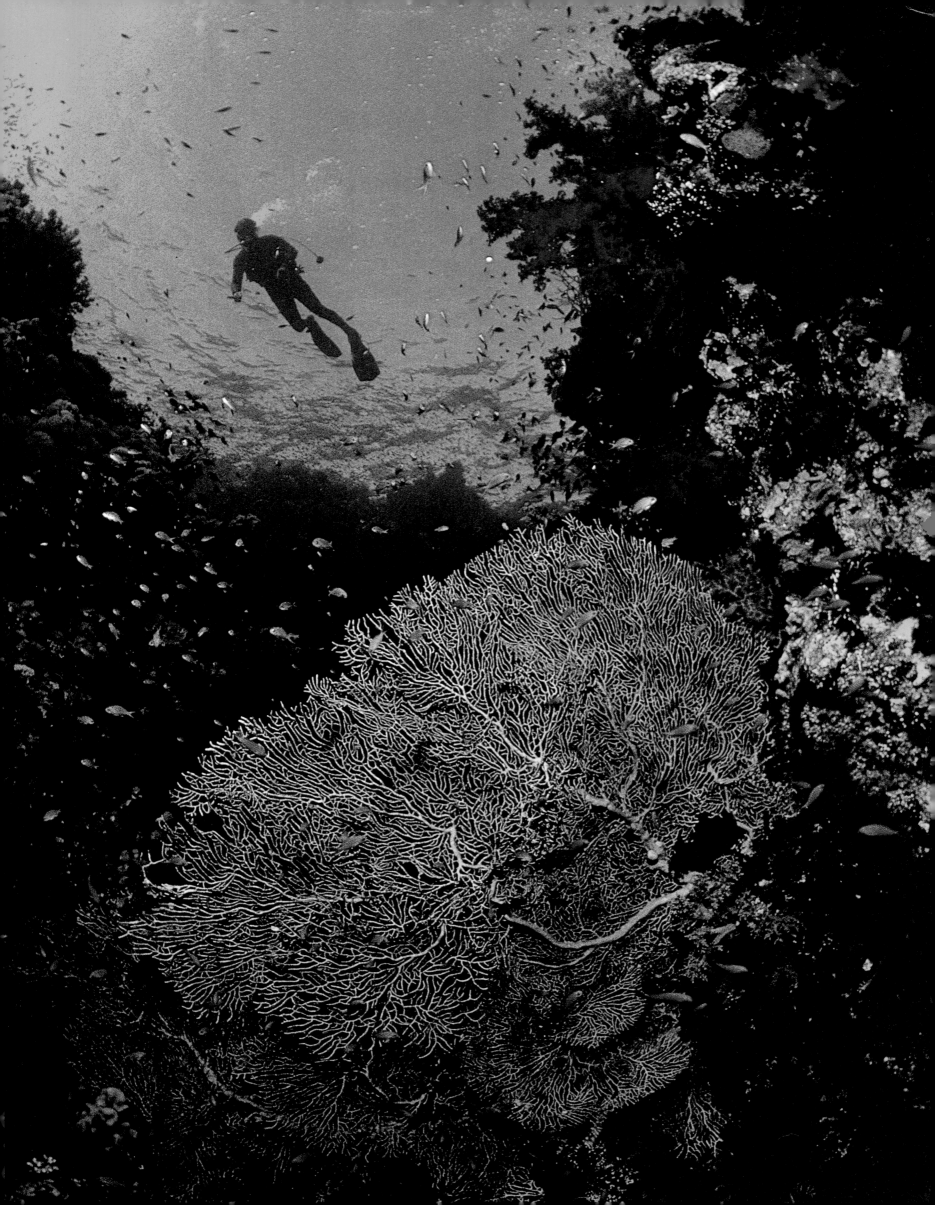

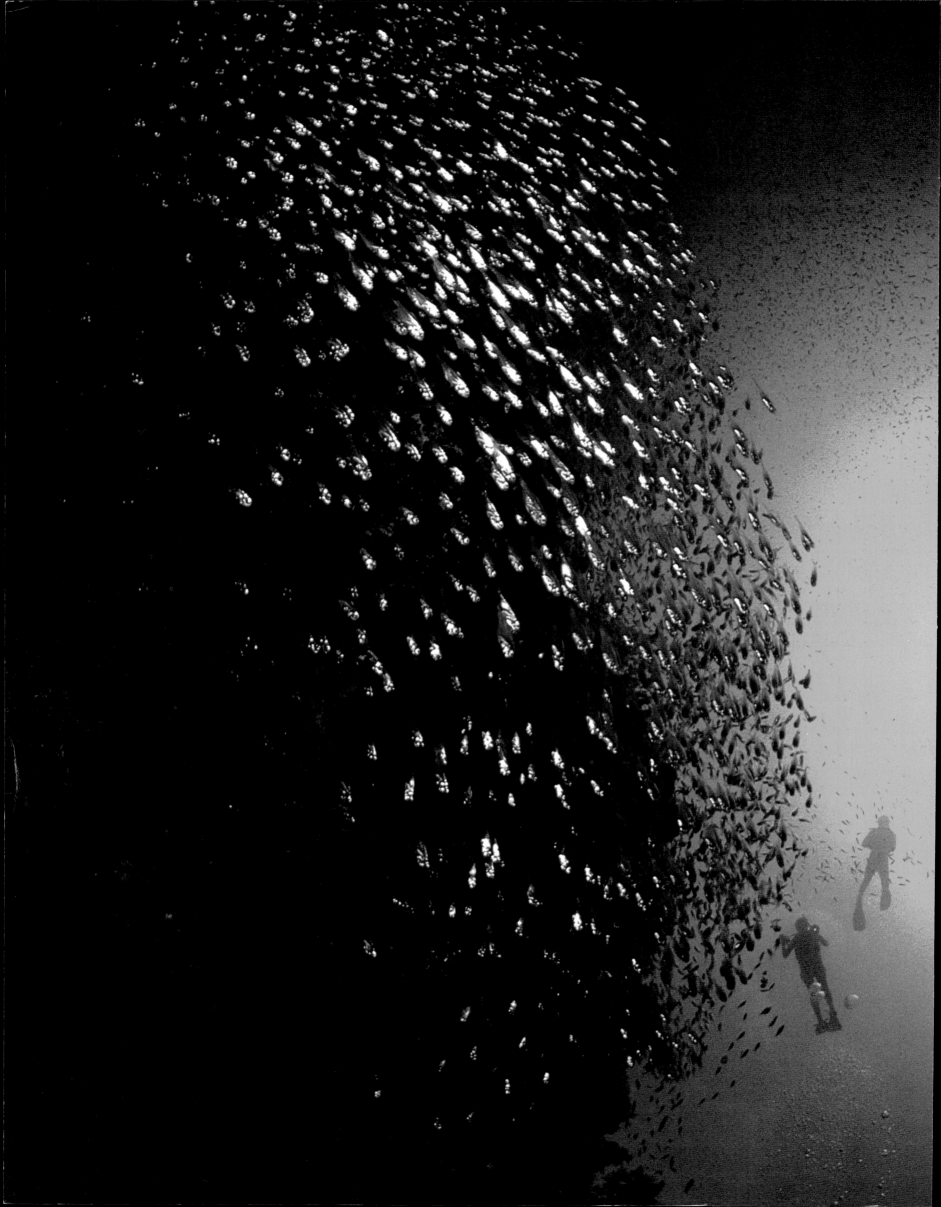

*Divers swim
above a wall of
glassy sweepers.*

*A very red deepwater
gorgonian coral.*

*Next page:
Glassy
sweepers.*

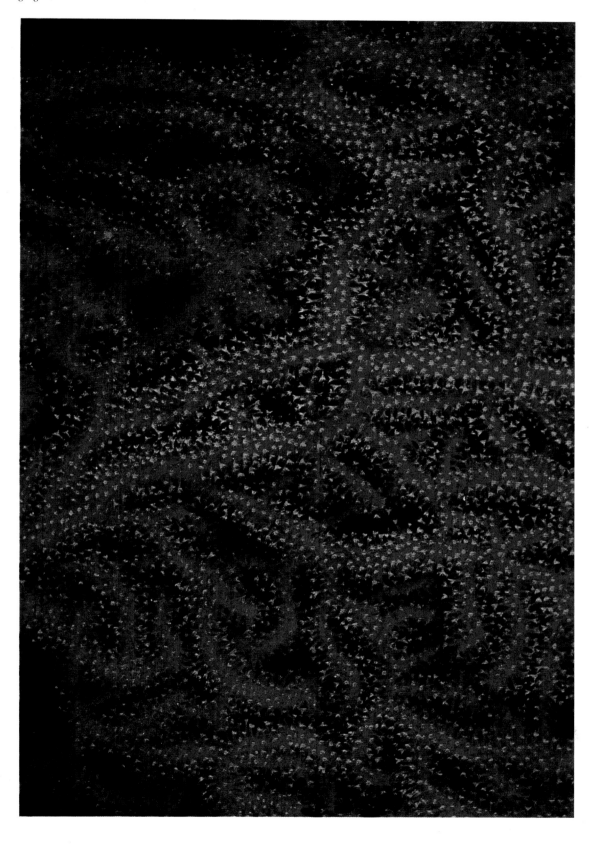

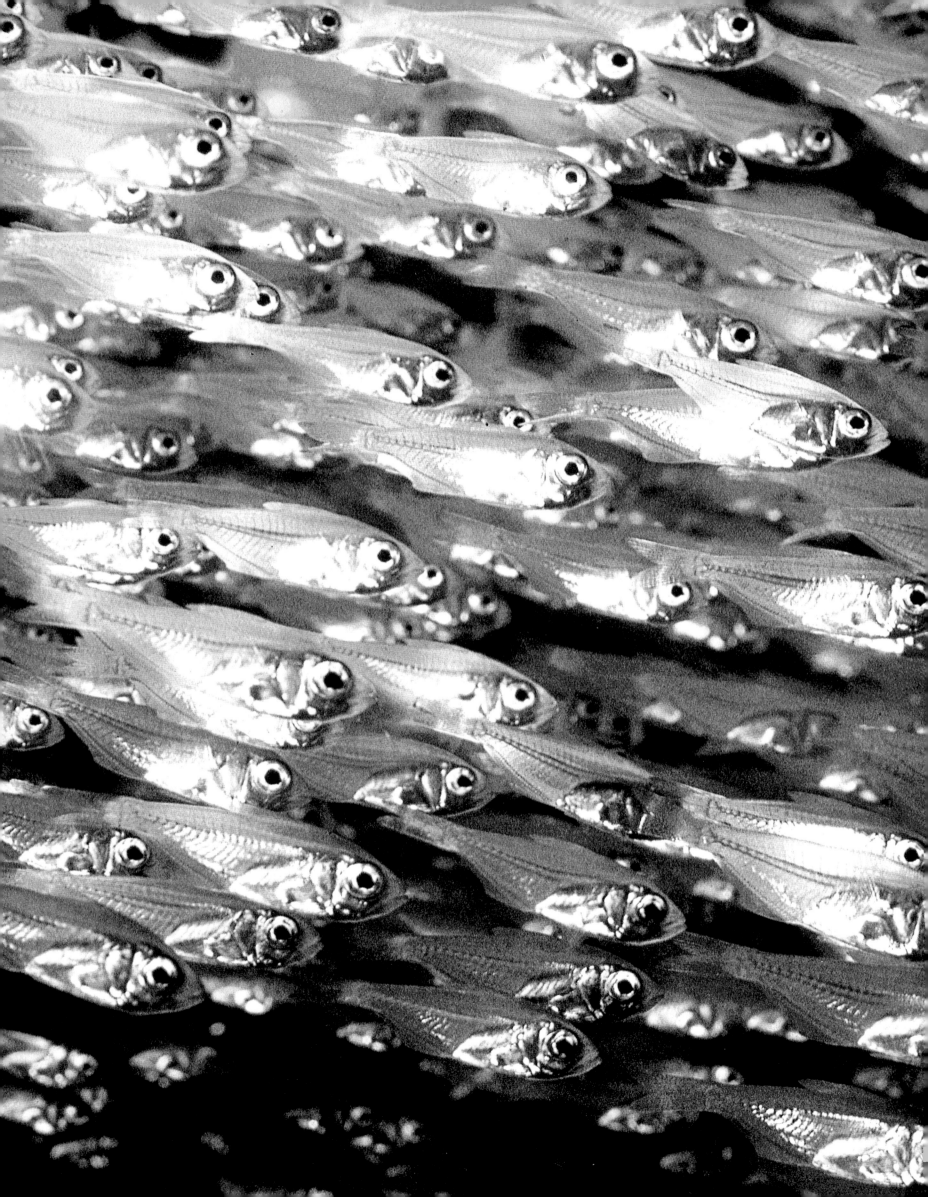

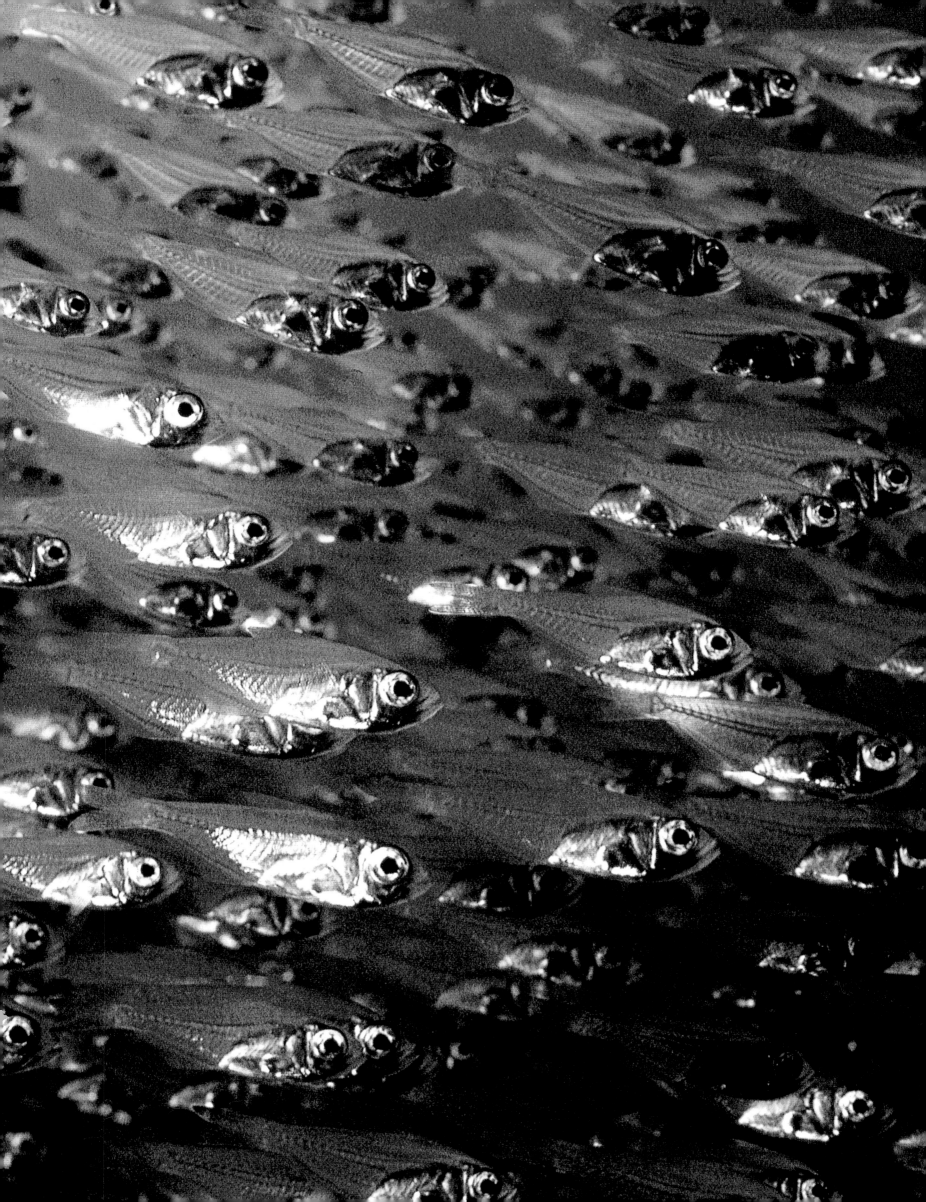

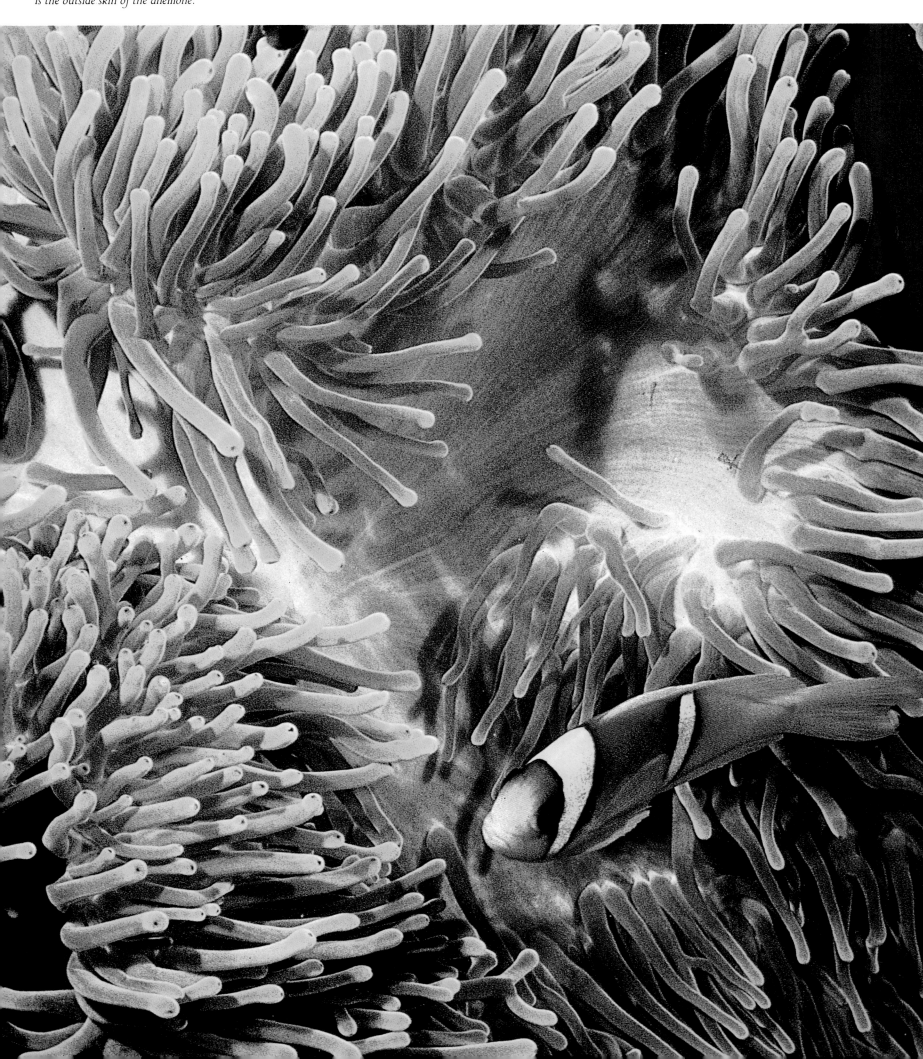

Anemone and clownfish.
The poisonous tentacles of the anemone
protect the clownfish. The red
is the outside skin of the anemone.

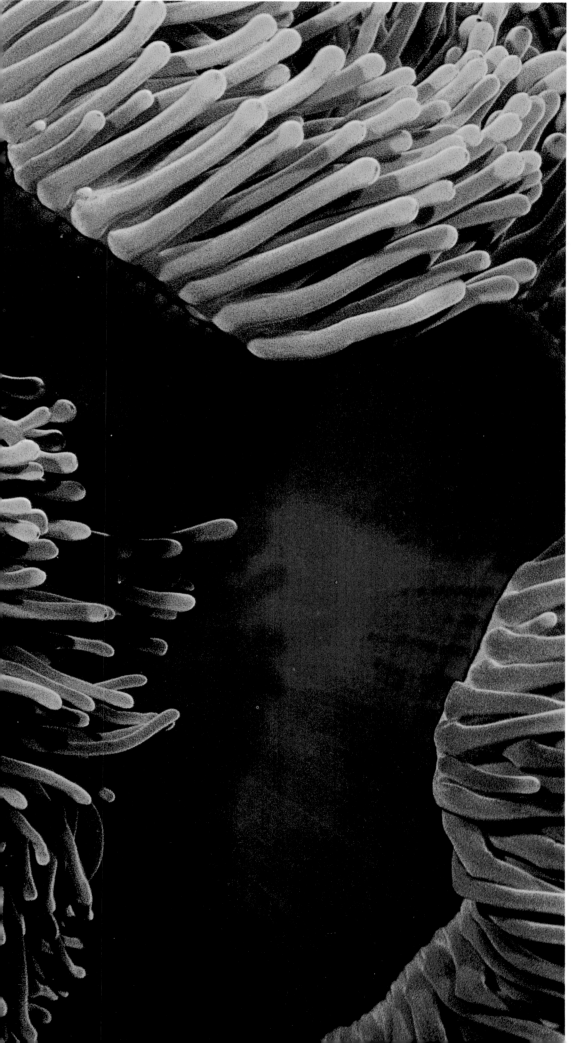

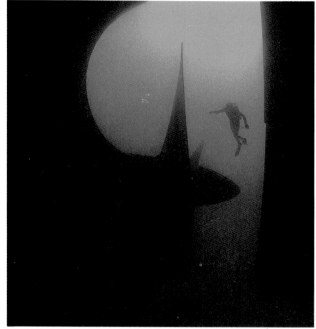

A supertanker over
one thousand feet long.
A diver inspects its
massive single propellor.

Next page:
The undersea
desert.

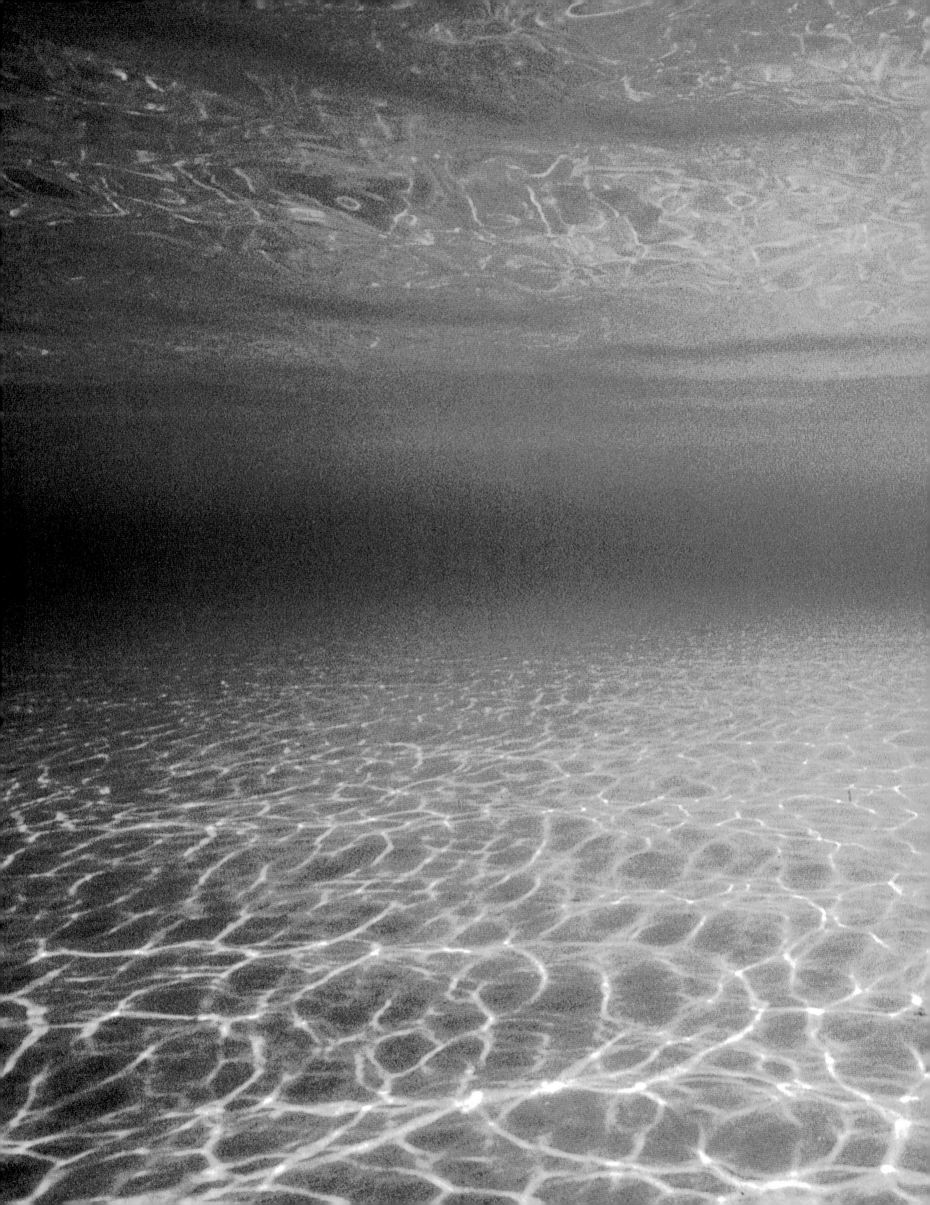

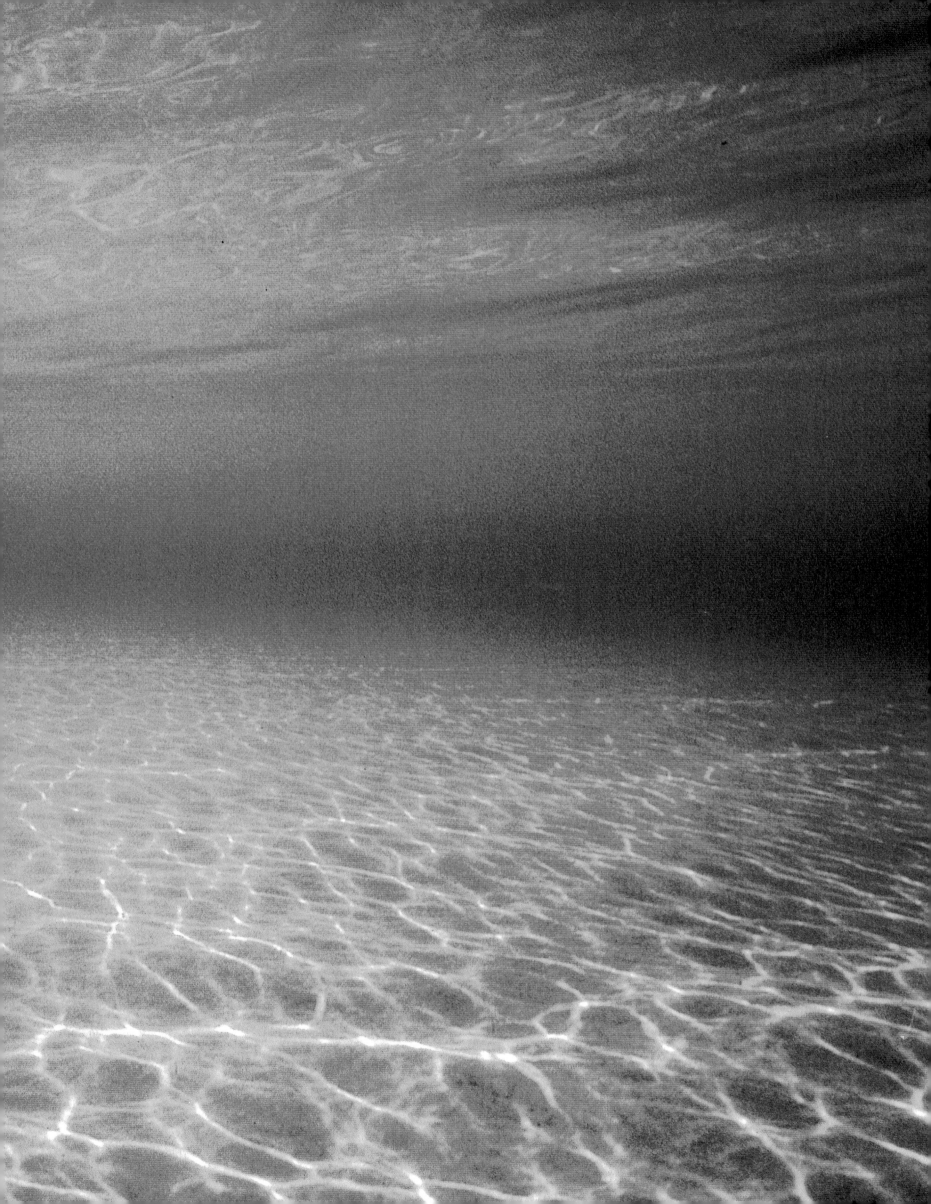

Two yellow-disk
butterfly fish hide
under a coral ledge.

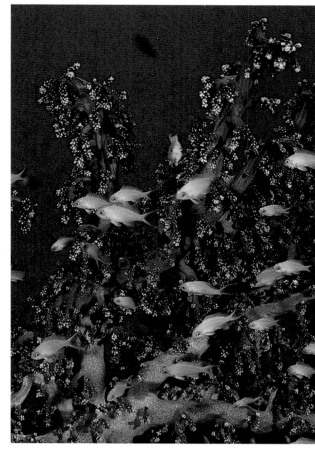

A deepwater gorgonian coral surrounded by anthias fish.

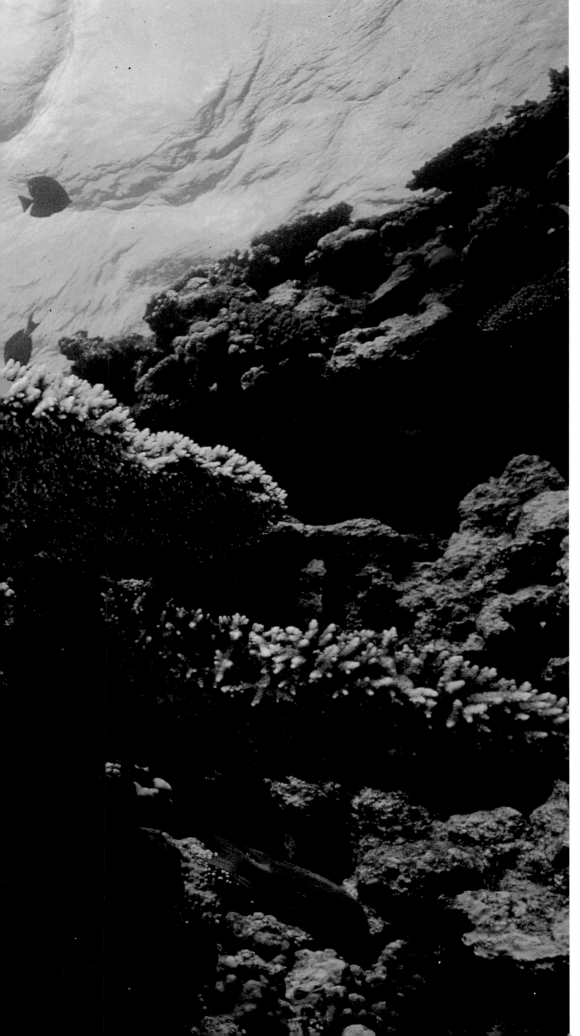

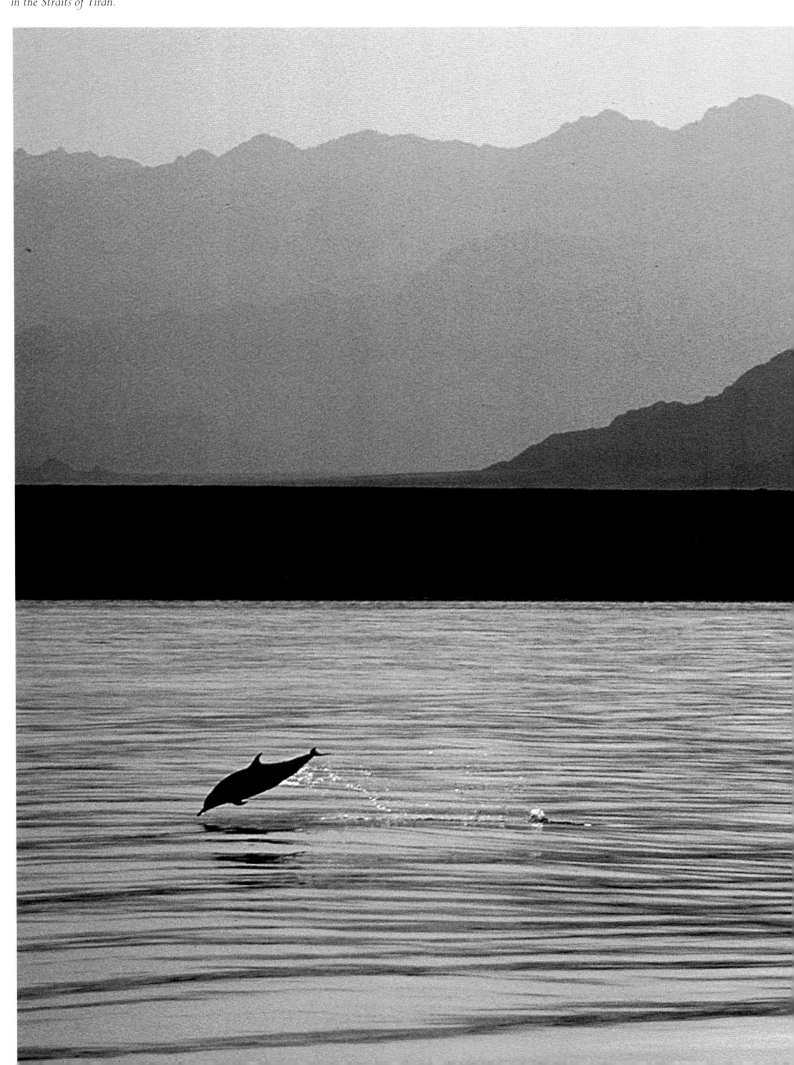

A dolphin leaps at sunset in the Straits of Tiran.

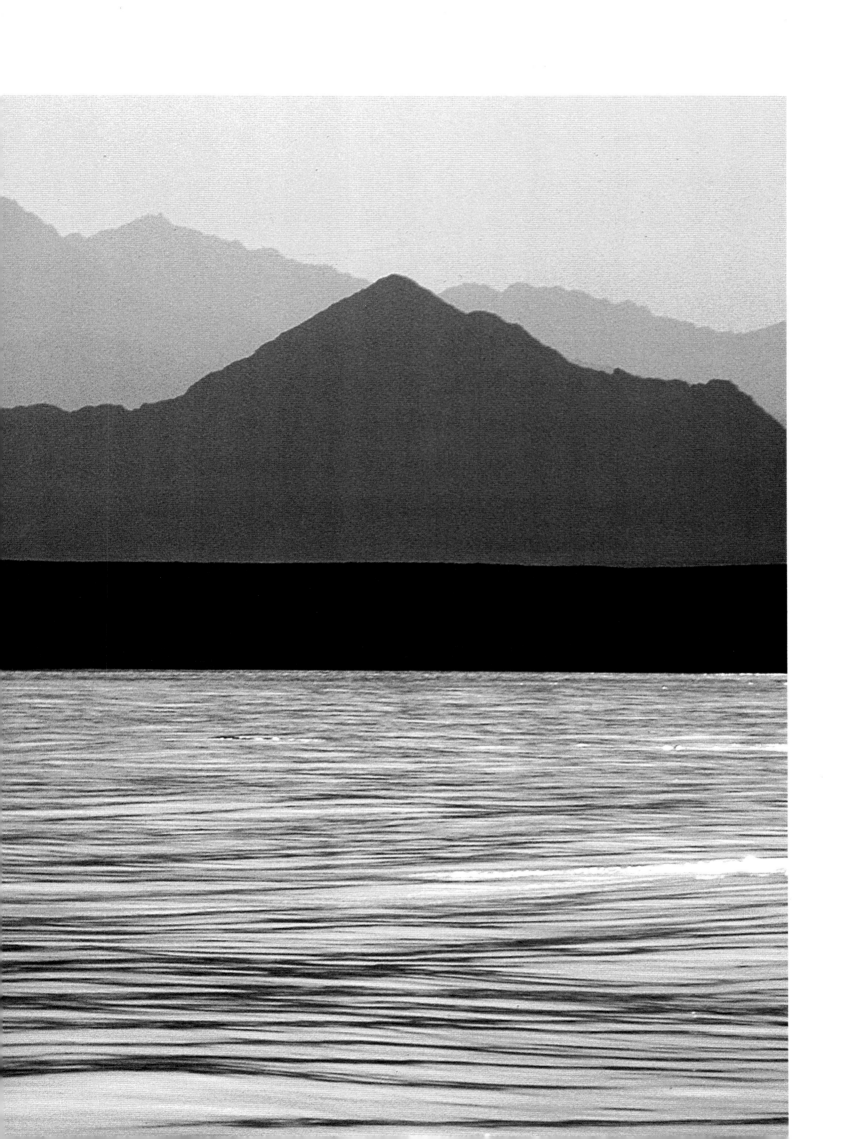

The peninsula of Ras Mohammed thrusts out from the very end of the Sinai Peninsula.
It straddles the Great African Rift which geologically divides Europe from Asia.
The water at the tip of Ras Mohammed is almost five thousand feet deep.

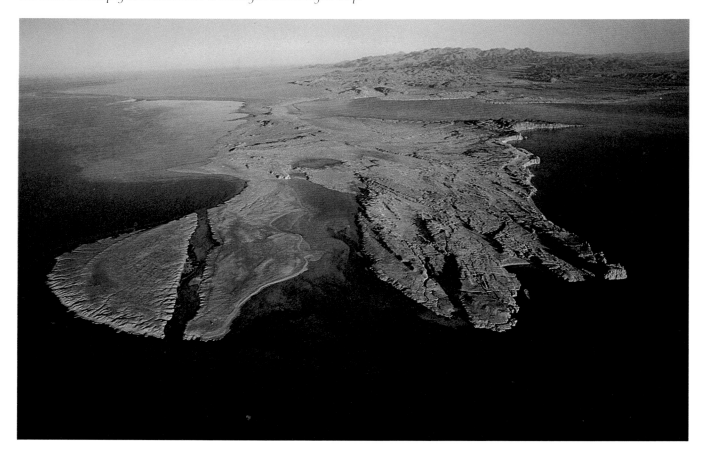

PAL

GEORG

USE

GERSTER

As seen from the air, cities are intriguing and intricate. Mountains are bold and spectacular. But farmlands are works of art.

Thousands of hours flying above the world's rural areas has convinced me that the farmer, sculpting the earth with his plough and harrow, painting the land with the variegated colors of his crops, is an unintentional artist. By simply doing his job, he provides the viewer with a spectacular open air museum.

Palouse is the Louvre of farmlands. Four thousand square miles of rolling hills, straddling the border between southeastern Washington and Idaho, it has the perfect combination of topography, weather, crops and farming methods to produce a stunning collection of what I call land-art.

A comforting reality about farmlands is that the best conservation methods also produce the best visual results; ploughing and planting on contour, strip cropping, crop rotation, channelling run-off with terraces, all transform farmlands into graphic, abstract natural works of art. Palouse, because it is beleaguered by torrential rains and sudden thaws, must practice the most careful and up-to-date methods of conservation. The Palouse farmers' husbanding and stewardship of the land both saves the soil and produces these spectacular scenes.

Once the reverse actually occurred—the land-art helped conservation. A soil conservation agent named David Hein had one of my Palouse photographs hanging on the wall of his office. One day a stubborn local farmer came to his office. For years, he had resisted newfangled conservation methods on his 2,000-acre Palouse farm. The loss of topsoil was running up to 156 tons per year. Suddenly, amazingly, the moment he saw my photograph, he did a 180-degree turn.

"If you can make my farm look as fantastic as that," he told David, "go ahead."

Subsequently soil losses on the remodeled farm dropped to innocuous levels. Later, David and I took a flight over "my farm;" resplendent now in its newly acquired zebra beauty of contoured stripes of fallow and wheat. David told me, "You saved the country millions of tons of the best agricultural soil."

It was a wonderful feeling. At times I have mixed emotions about chasing beauty from above while below farmers are in the grip of a prolonged drought and severe economic conditions. Being aloft does not mean being aloof. I'm thrilled that my visions of this beautiful land can inspire those who are responsible for it.

BRITISH COLUMBIA

WASHINGTON

PALOUSE

IDAHO

OREGON

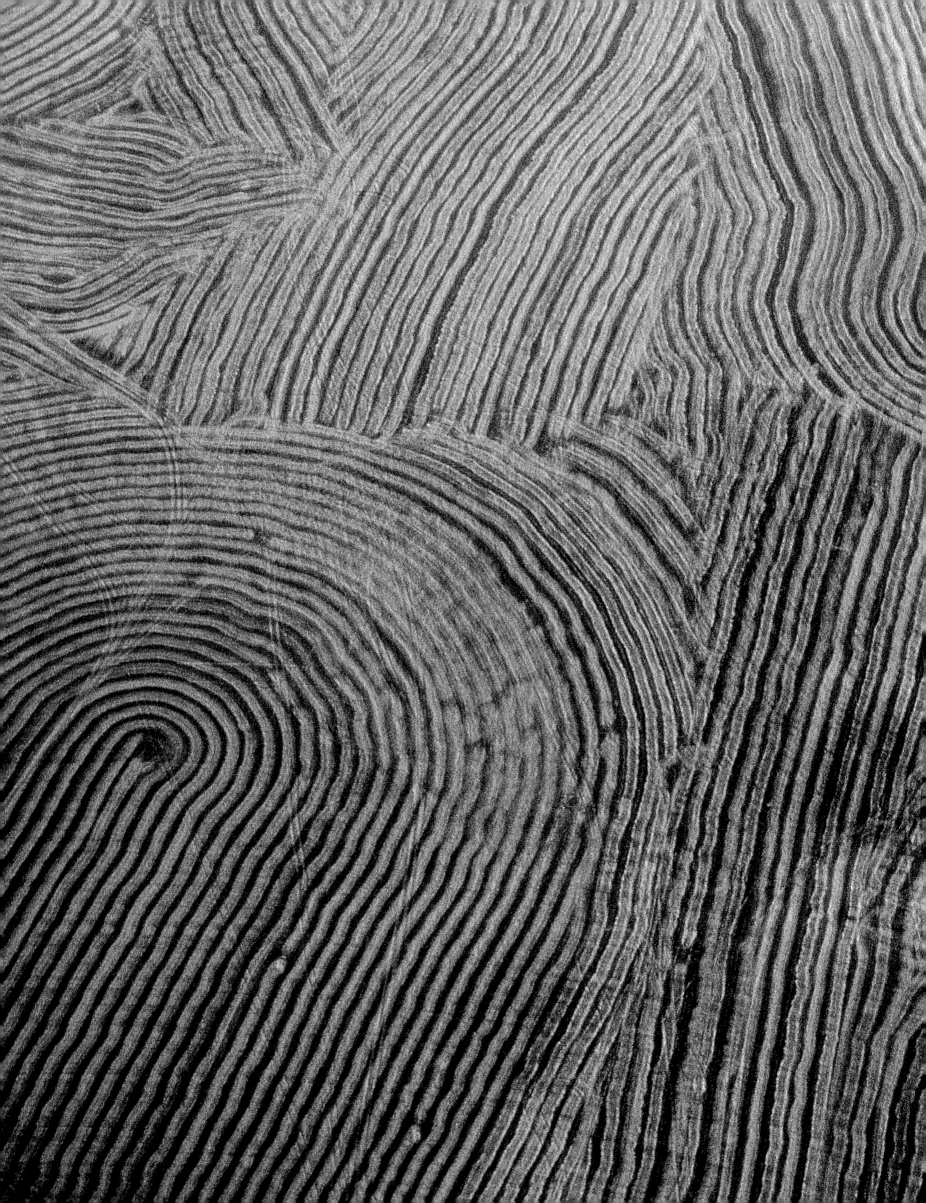

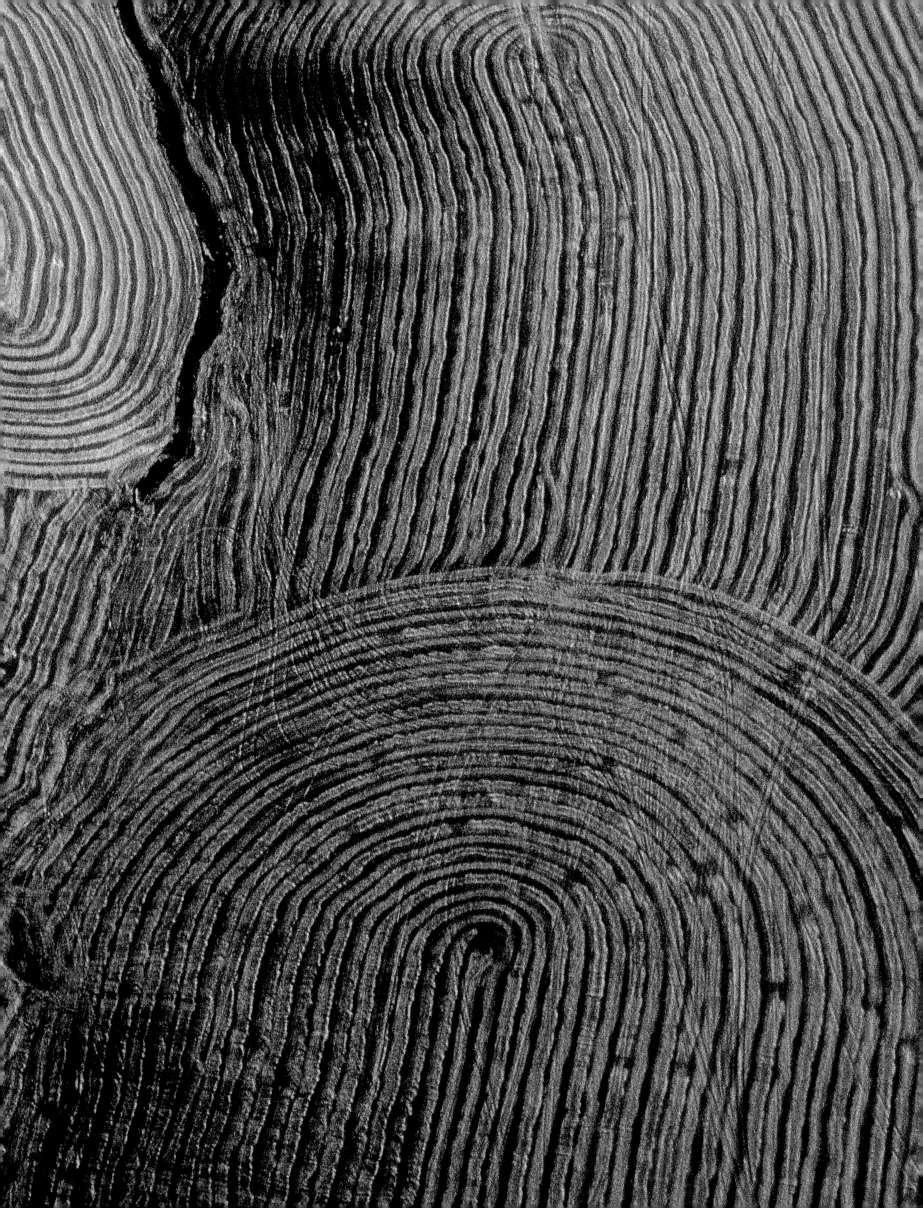

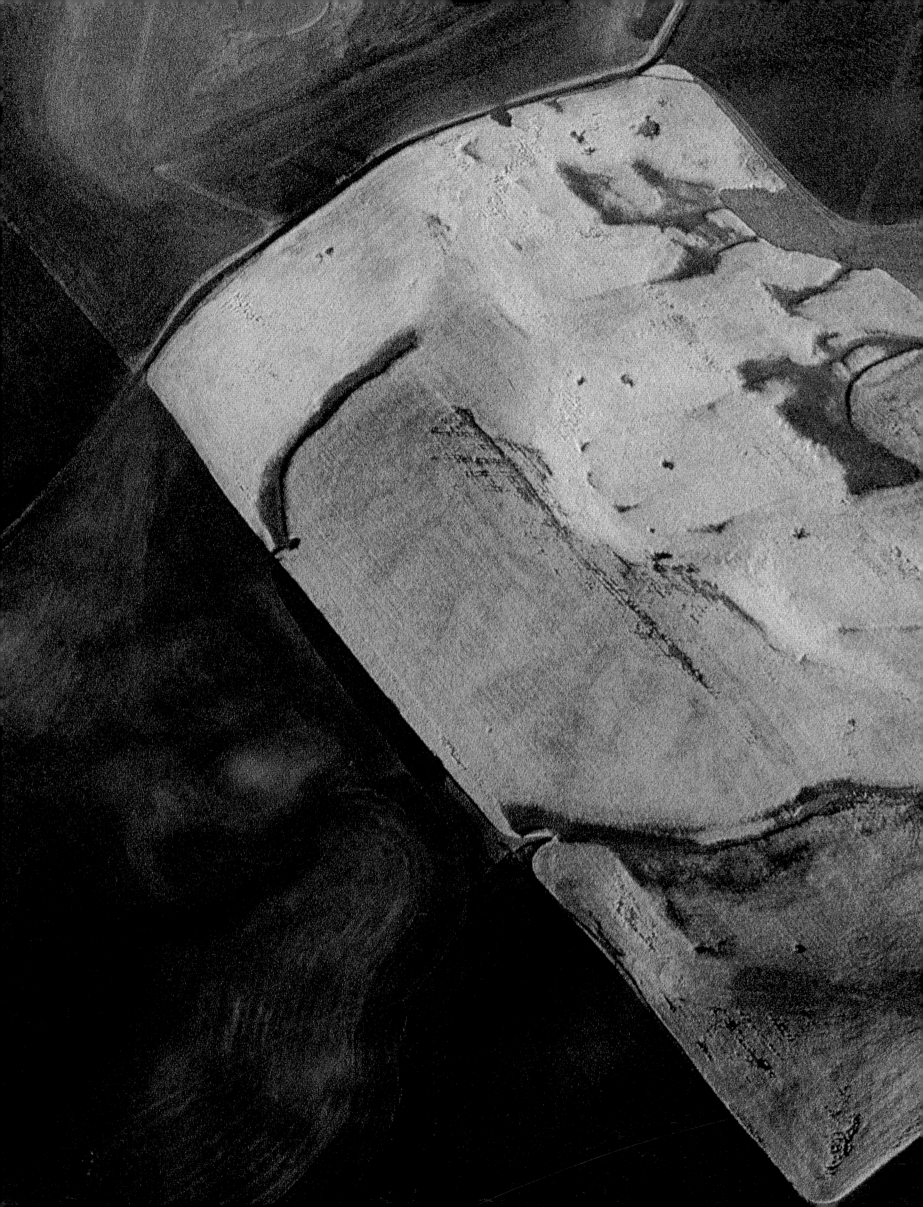

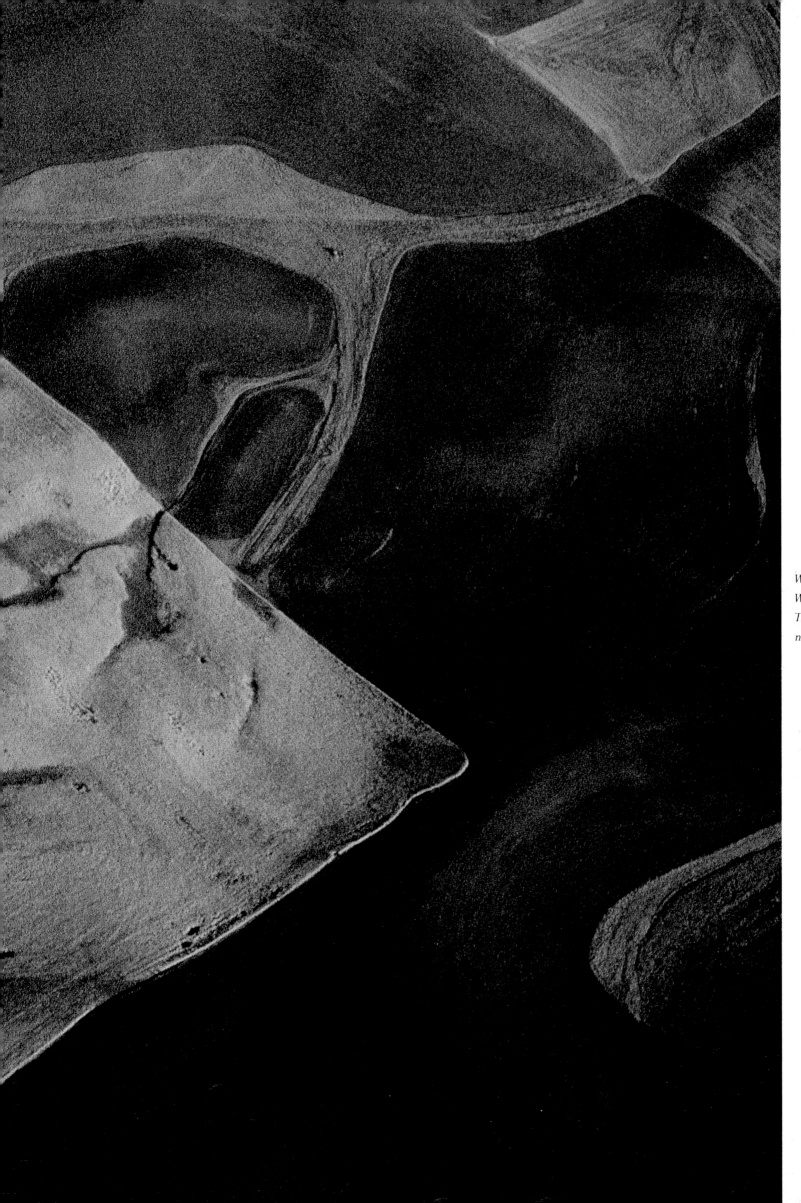

Whitman County,
Washington.
The yellow is rape
near harvest-time.

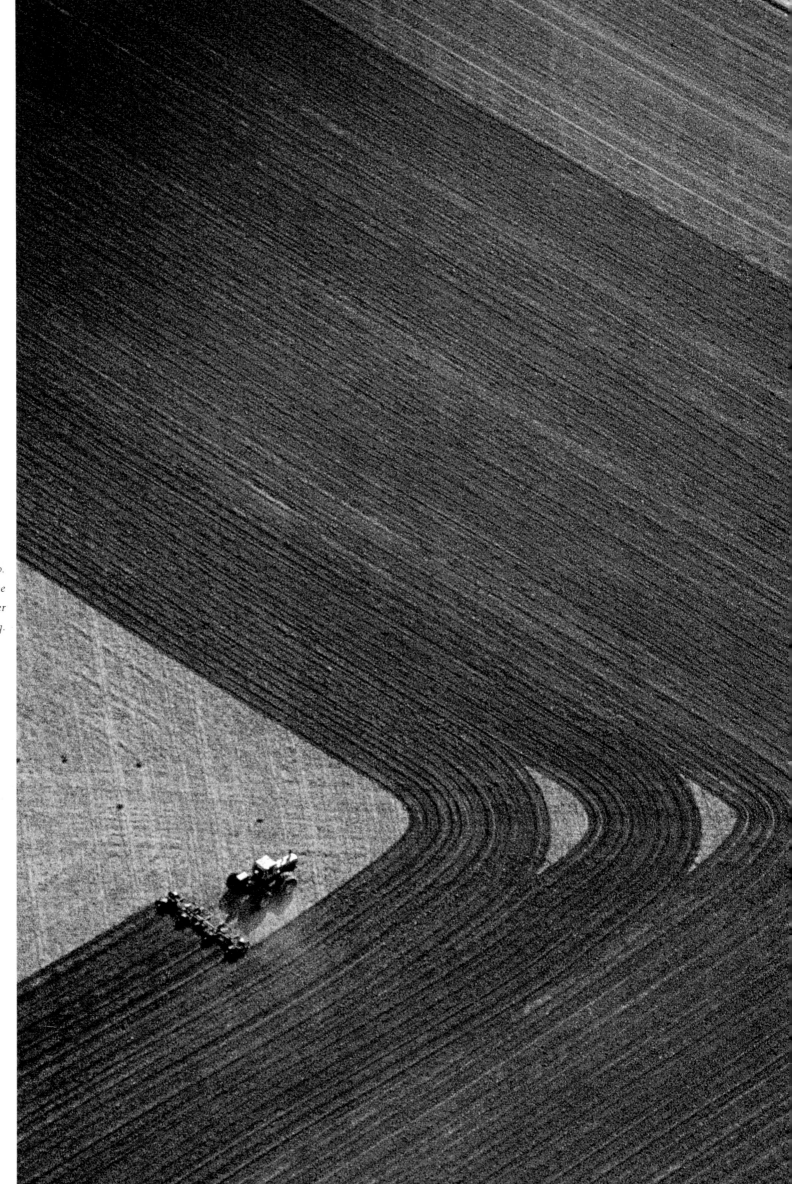

Idaho.
Preparing the
soil for winter
sowing.

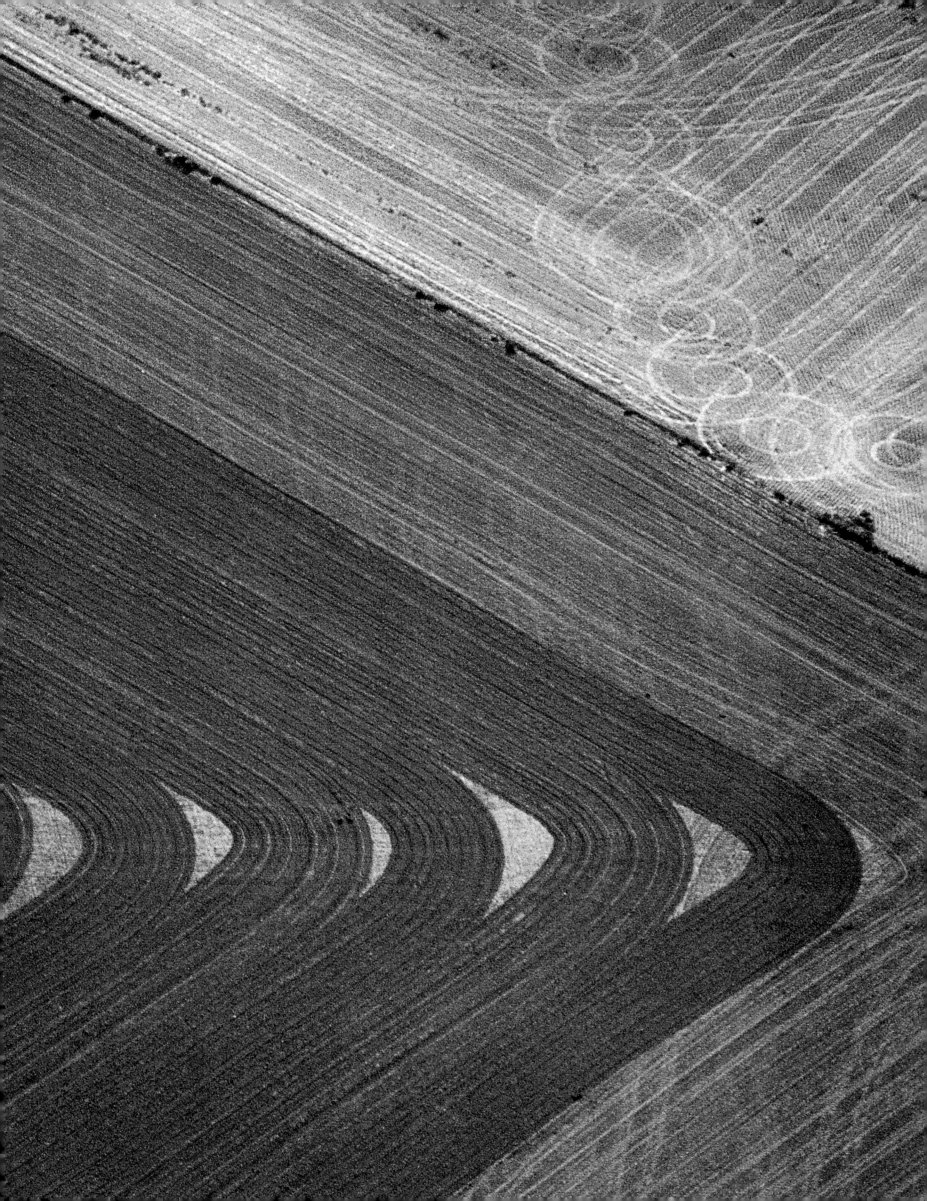

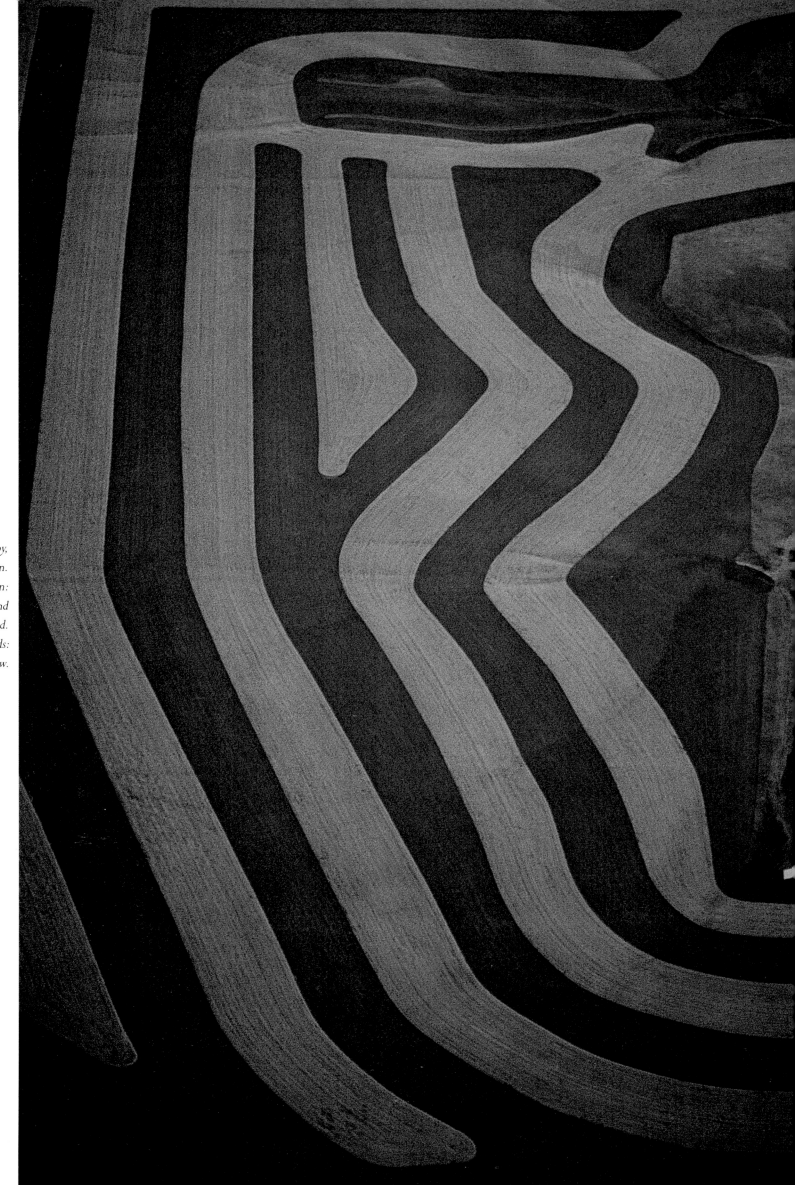

Near Pomeroy,
Washington.
Crop rotation:
fallow land and
wheat just harvested.
The rotation reads:
wheat-peas-fallow.

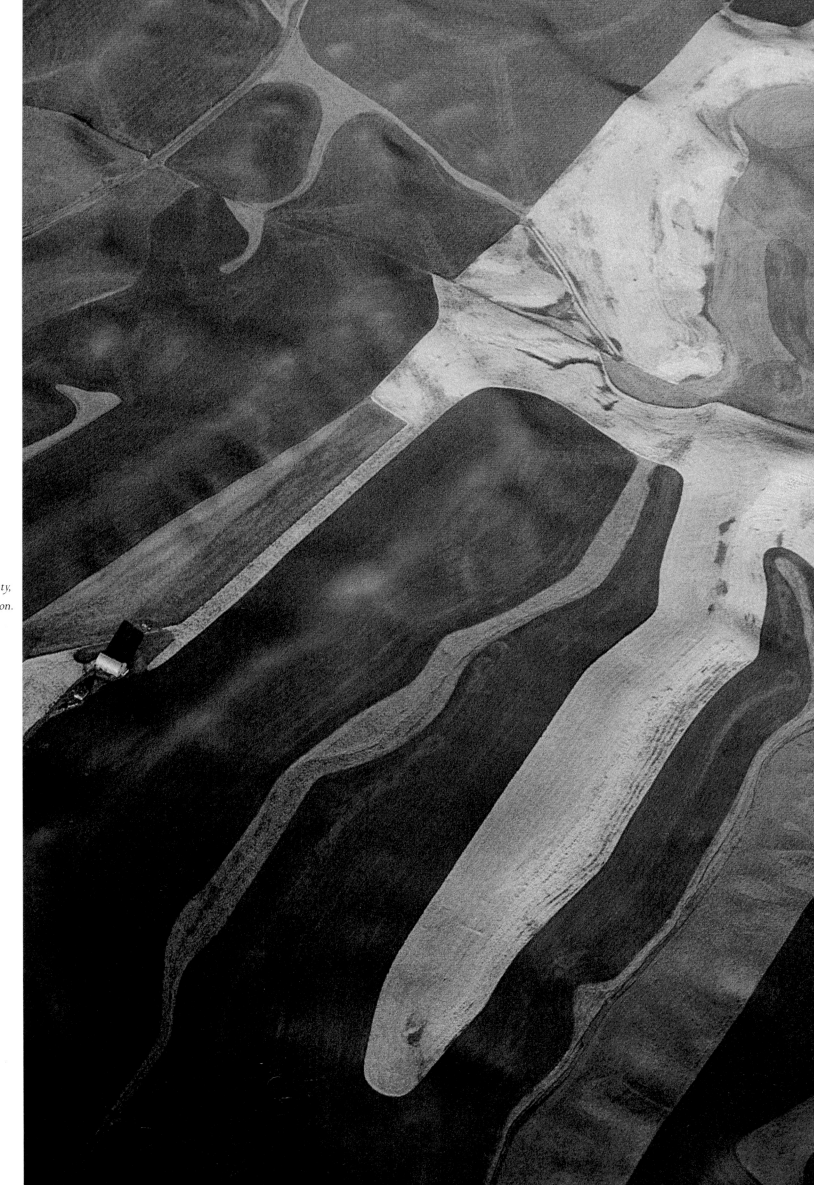

Whitman County,
Washington.

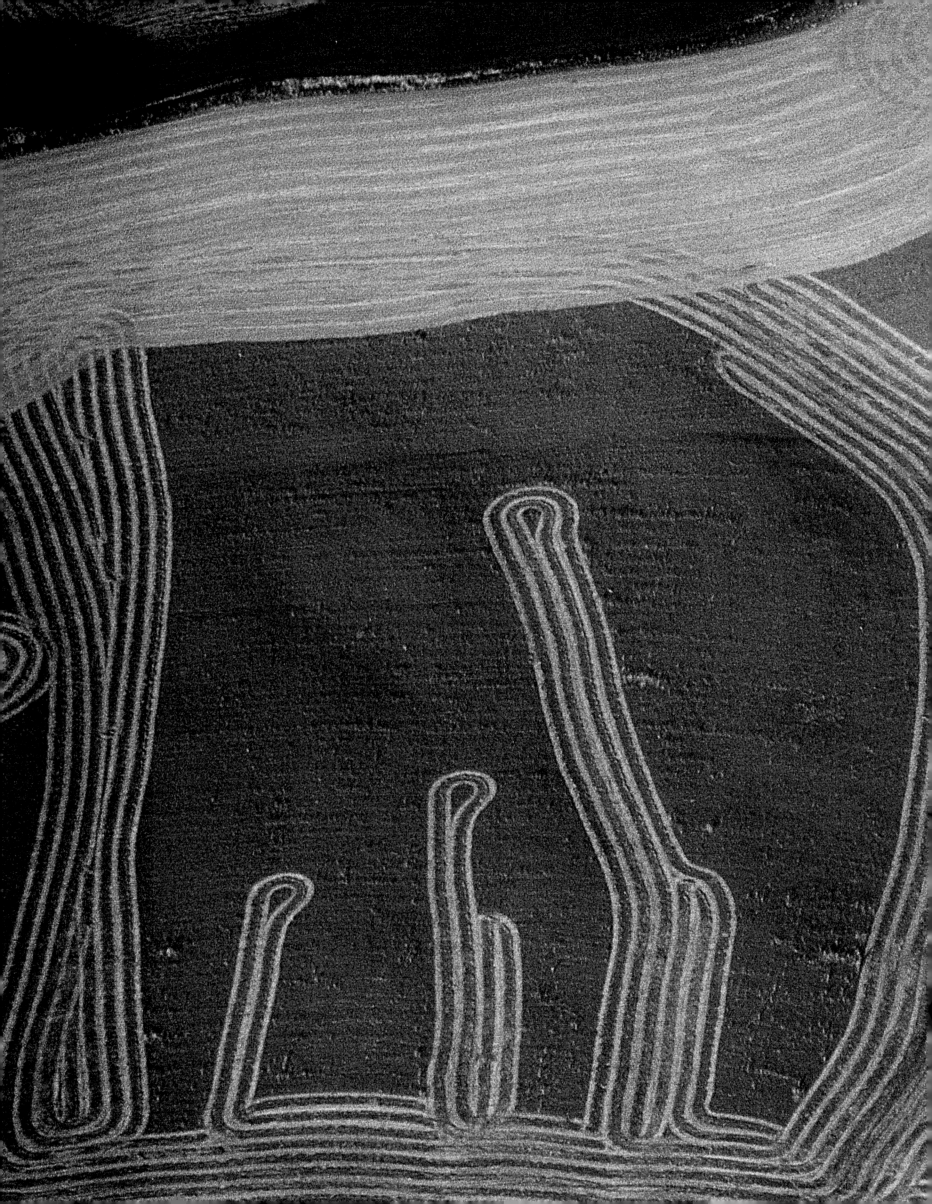

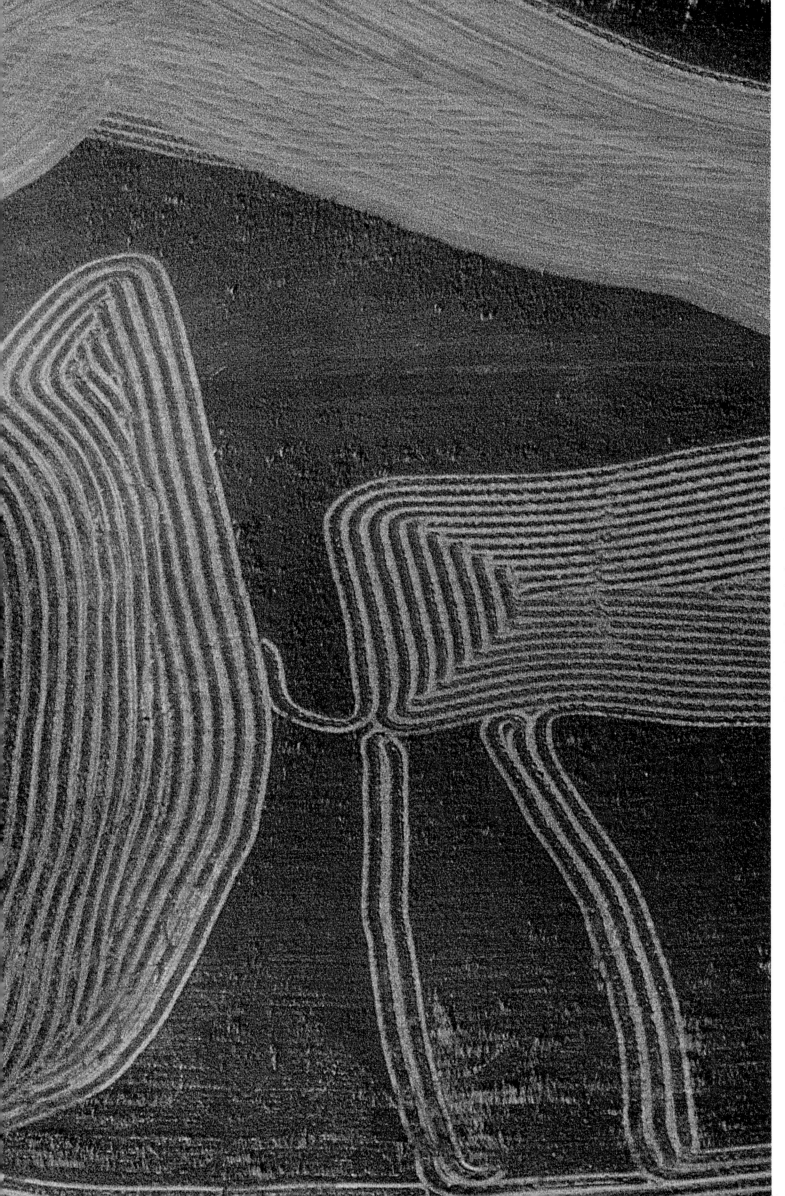

Lentil field in the Palouse Hills, Washington. The lentil is ready to be harvested. A harvesting combine already has started work on the upper part of the slope.

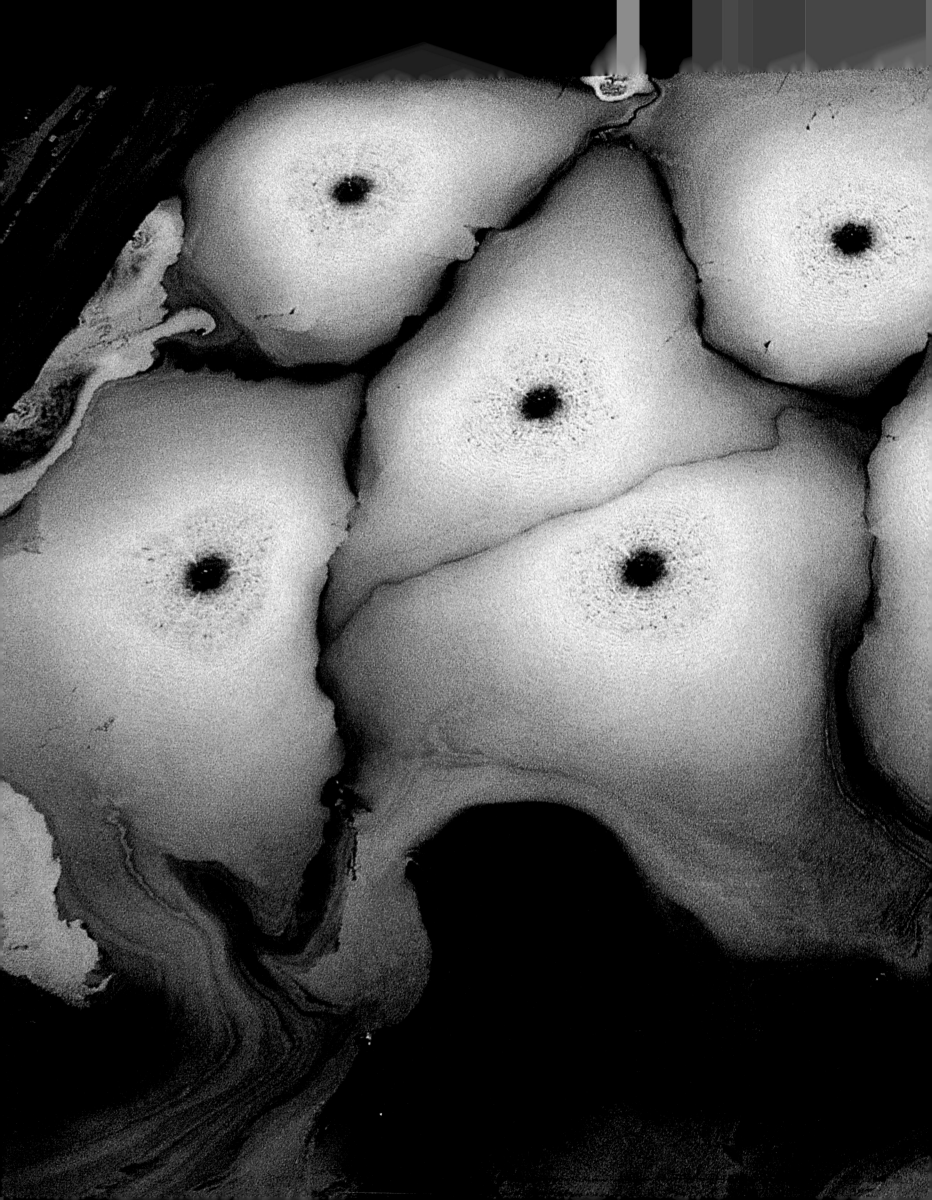

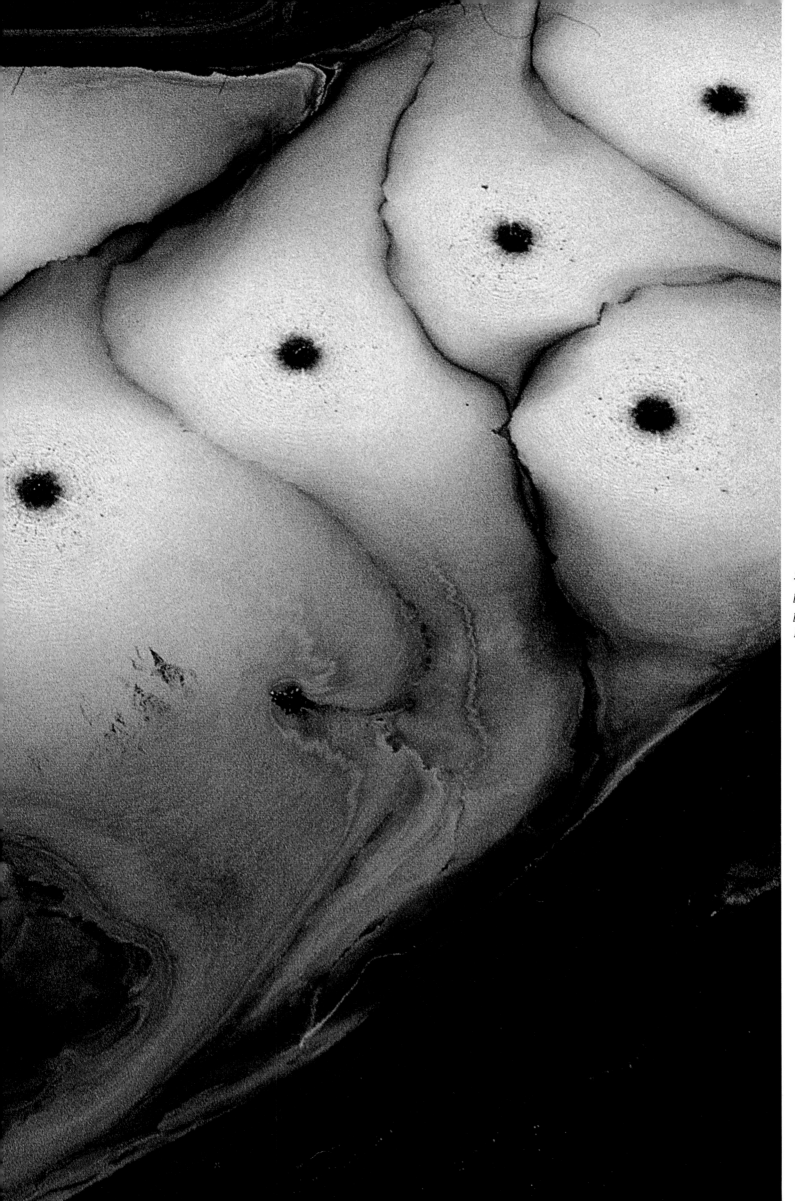

Sewage treatment plan of the pulpmill near Lewiston, Idaho.

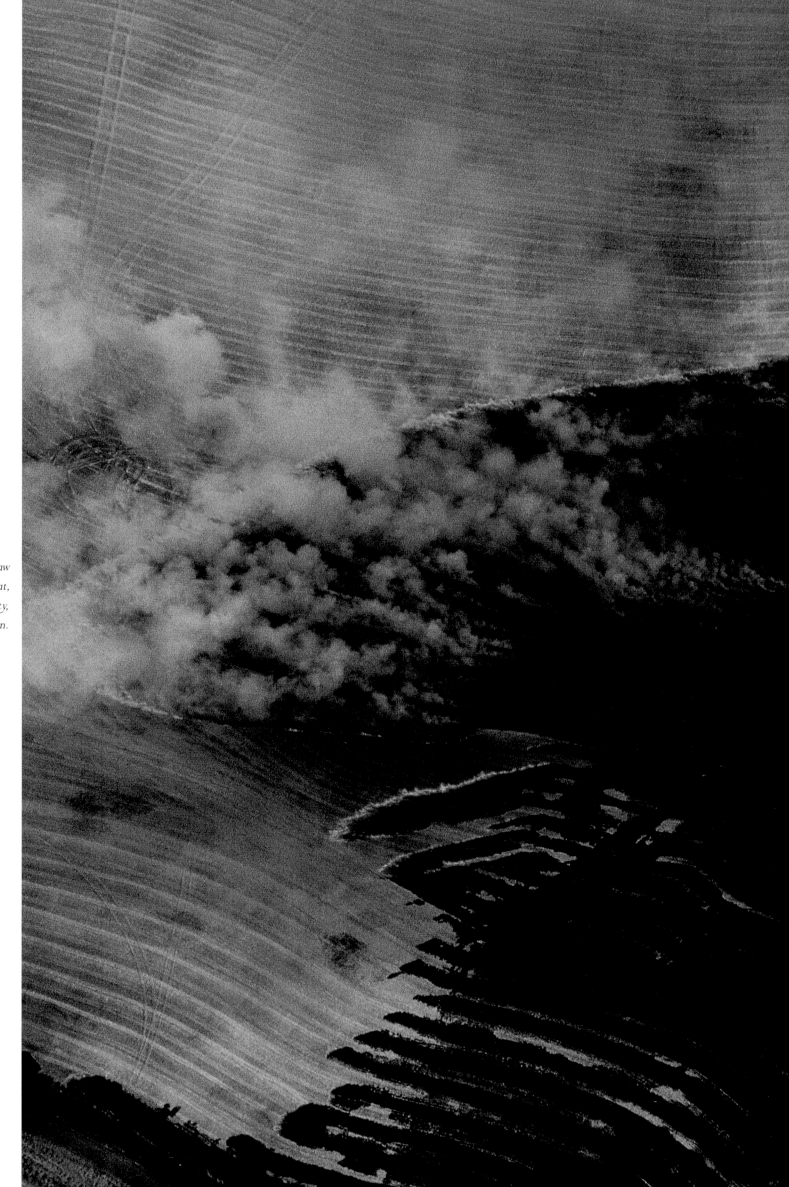

Burning the straw of harvested wheat, Whitman County, Washington.

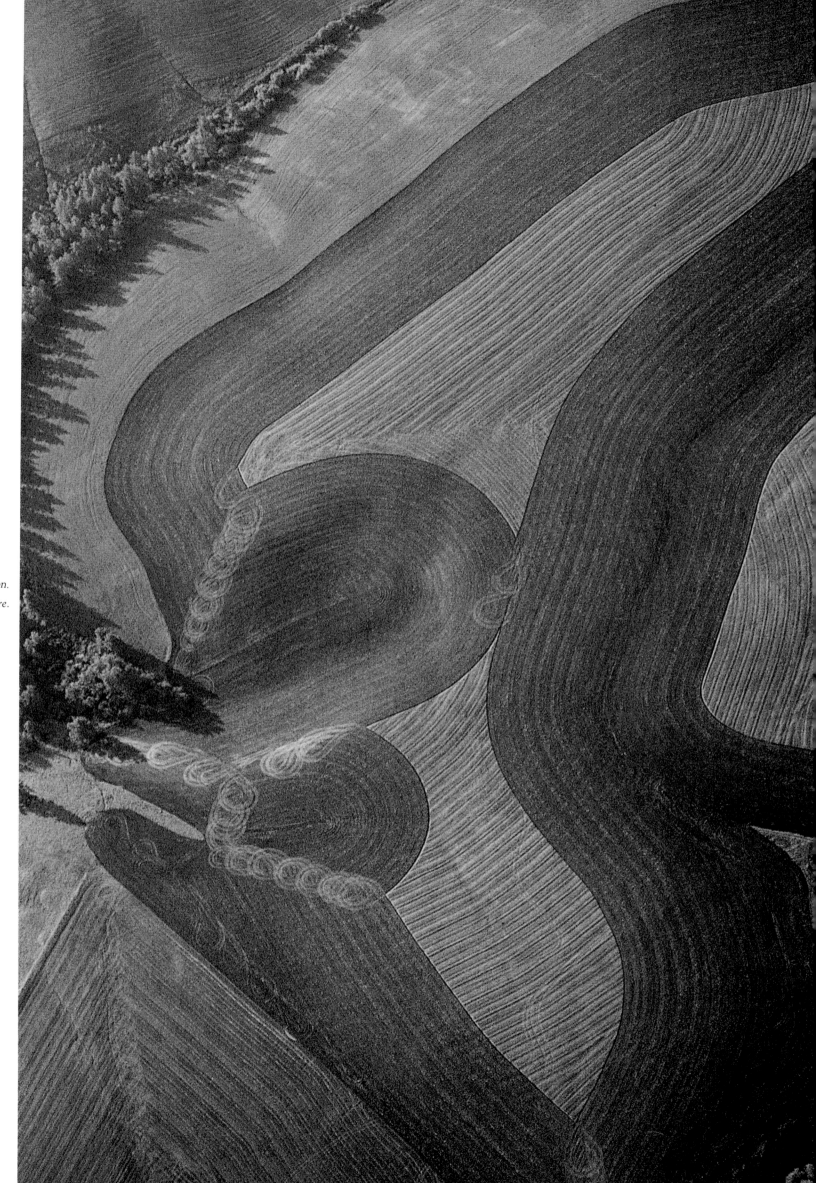

Washington.
A spring picture.

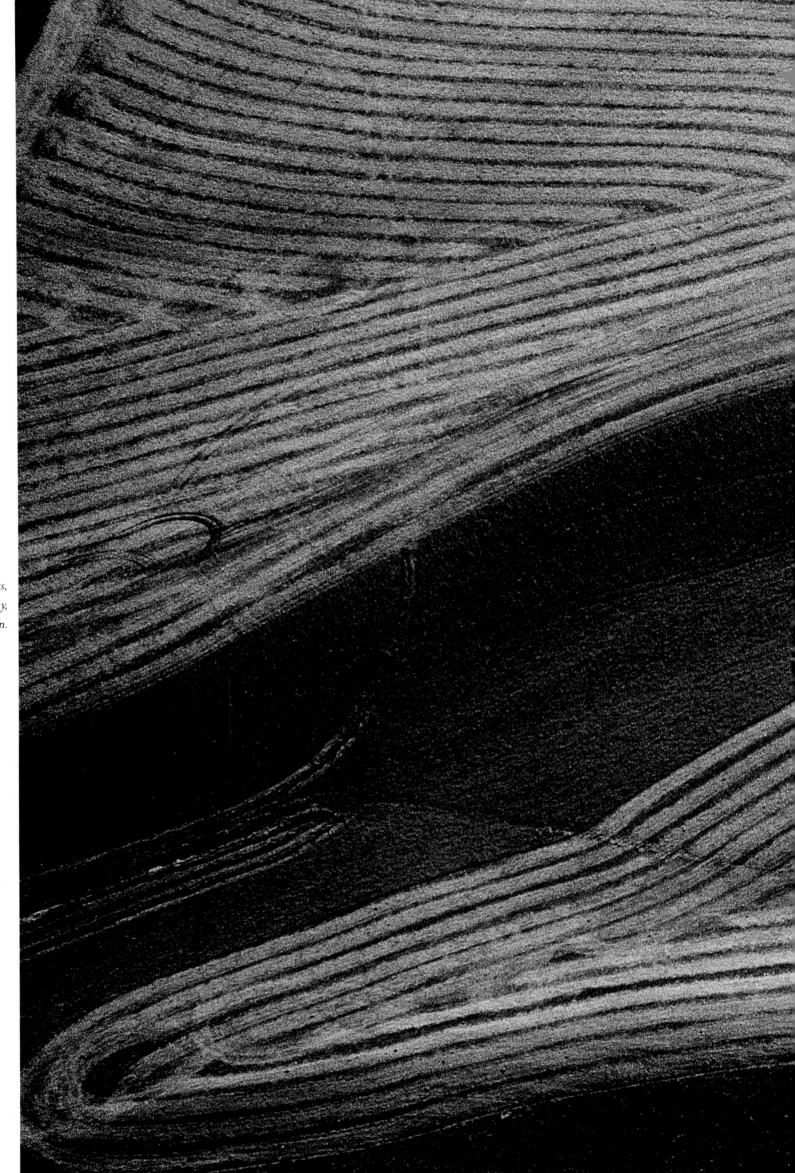

Harvesting dry peas,
Whitman County,
Washington.

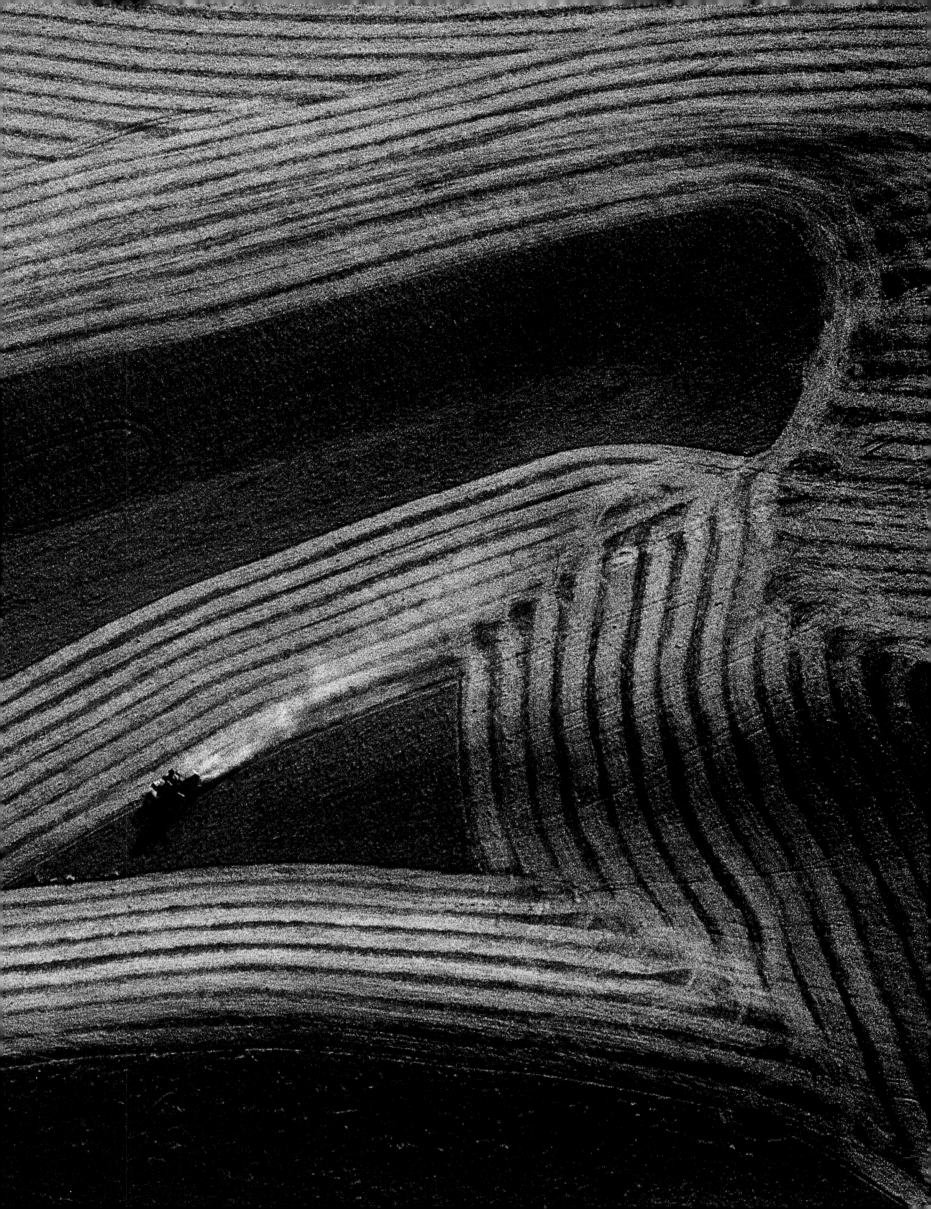

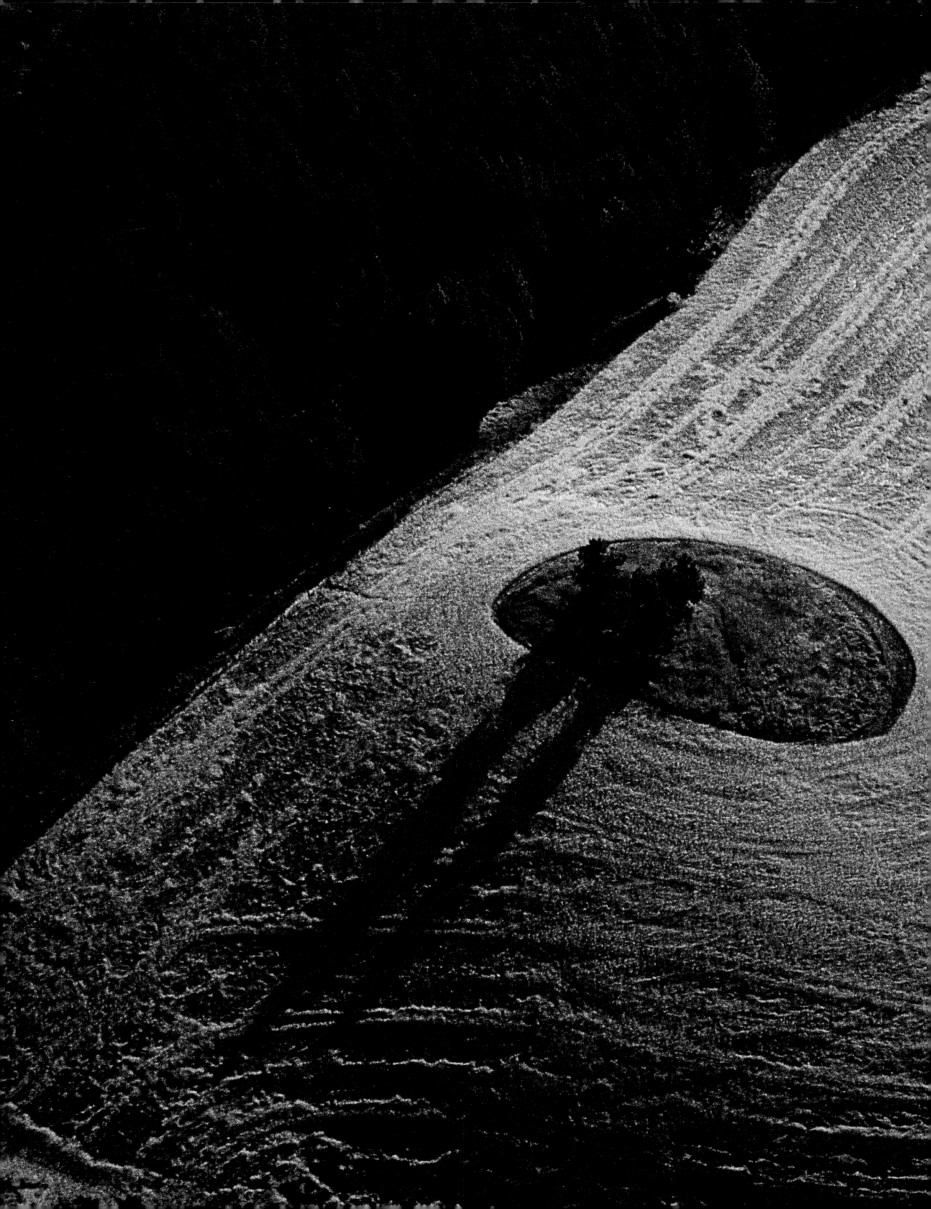

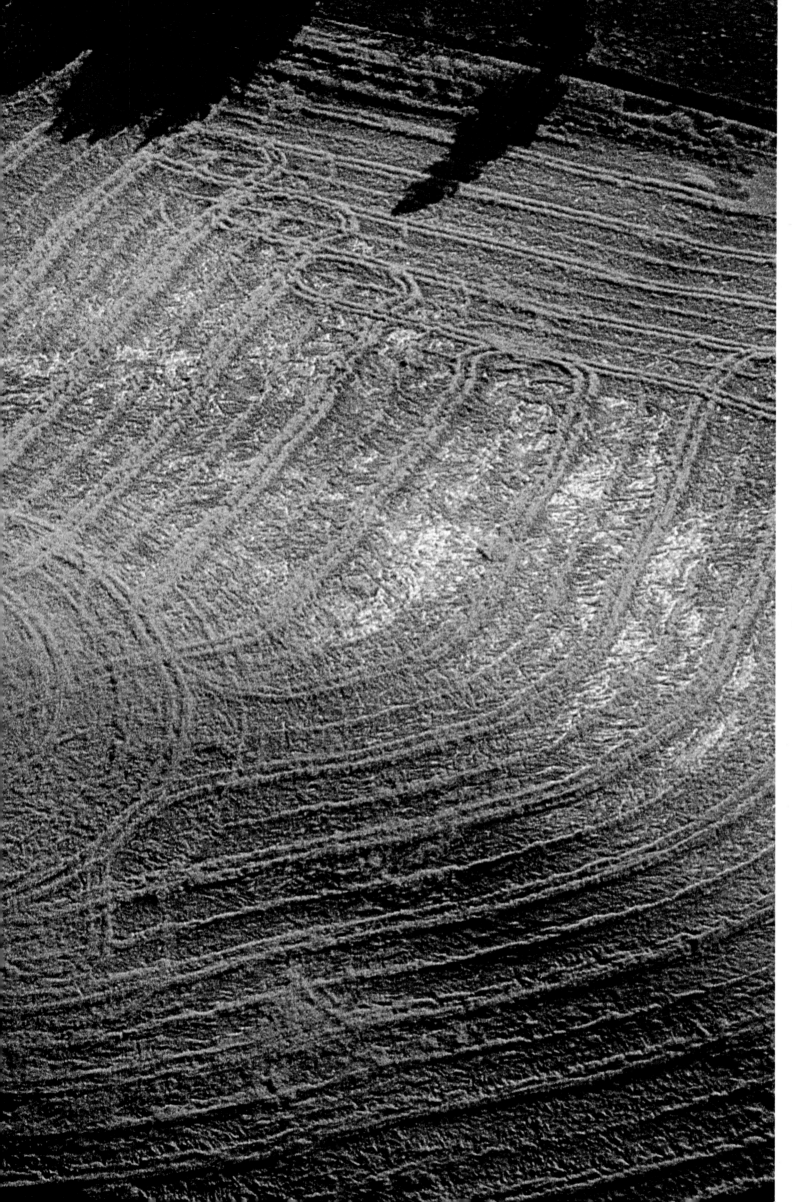

*Idaho, near
Lewiston. After the
wheat harvest.*

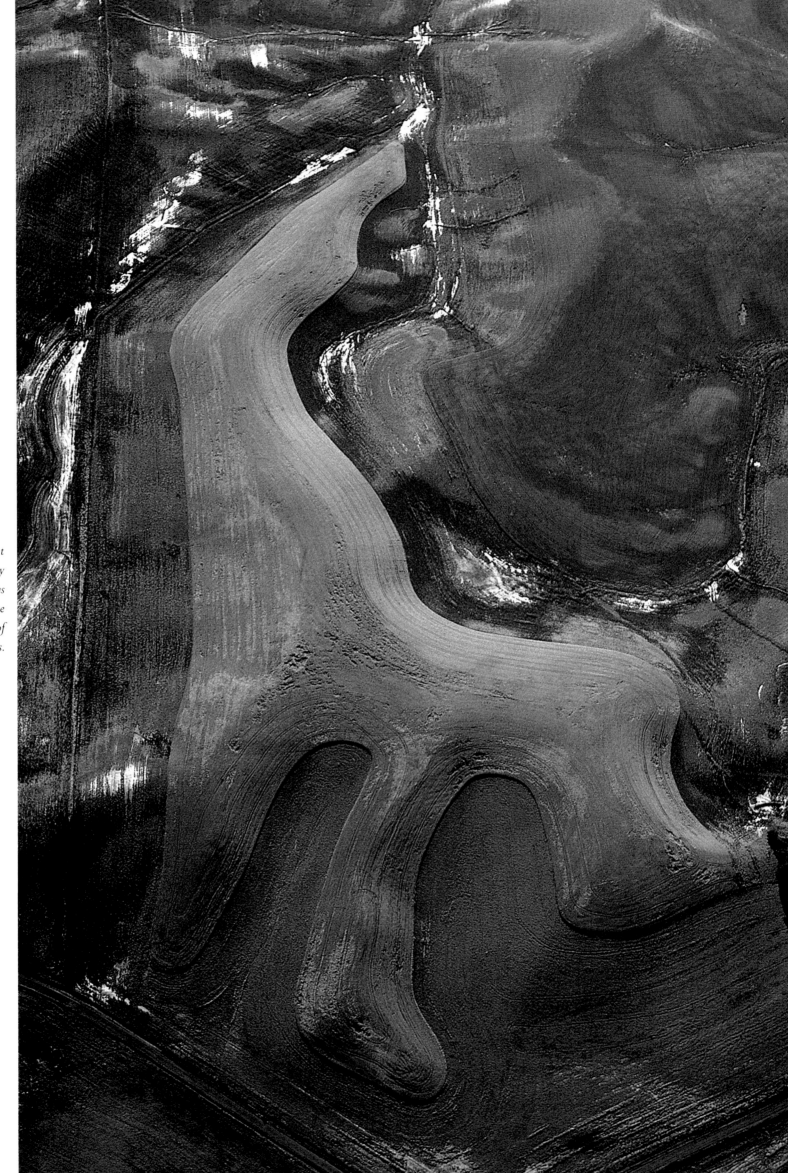

Unharvested wheat field surrounded by grass. White areas are ash, from the latest eruption of Mount St. Helens.

MOR

HARRY G

CCO

RUYAERT

Morocco isn't so much a place as an obsession. I fell in love with it twenty years ago, and it still holds me in its grasp.

Morocco defies definition. It is forever contradicting itself. In the towns one sees the new nation: growing, evolving, finding a place in a new world.

In the countryside and the small villages, it is another place. Nothing happens here that hasn't happened before. Today and yesterday have the same meaning. This became dazzlingly clear to me in a tiny village, near a tiny crossroads. There, years ago, I took a photograph that I especially liked. It was of a man with a fez on his head, walking in a particular direction. I believed that I had captured a specific time and a specific place. Years later, I happened to be standing in the same village on the same spot at the same time of day. Suddenly, I saw the same man with the same fez, walking in the same direction with the same

expression on his face: the light, the shapes, the colors were all exactly the same. I almost screamed, "My picture!" It wasn't. It was Morocco laughing at me.

Morocco constantly teases and frustrates. The faces beg to be photographed. But the people who own those faces refuse. To them a camera image is a theft of themselves. I persist. I'm sure many give in because they think me mad. Sometimes I play a game with the women, a flirtation. They hide and, in their hiding, they show themselves. Sometimes, it is an absolute refusal and I make the refusal the photograph. I am shameless. How can I tell them that what for them is a violation is for me an act of love?

In the end, Morocco can be admired, adored, hinted at, but never possessed. It is forever elusive: shifting shadows, floating robed figures against a landscape that is at once endless and timeless.

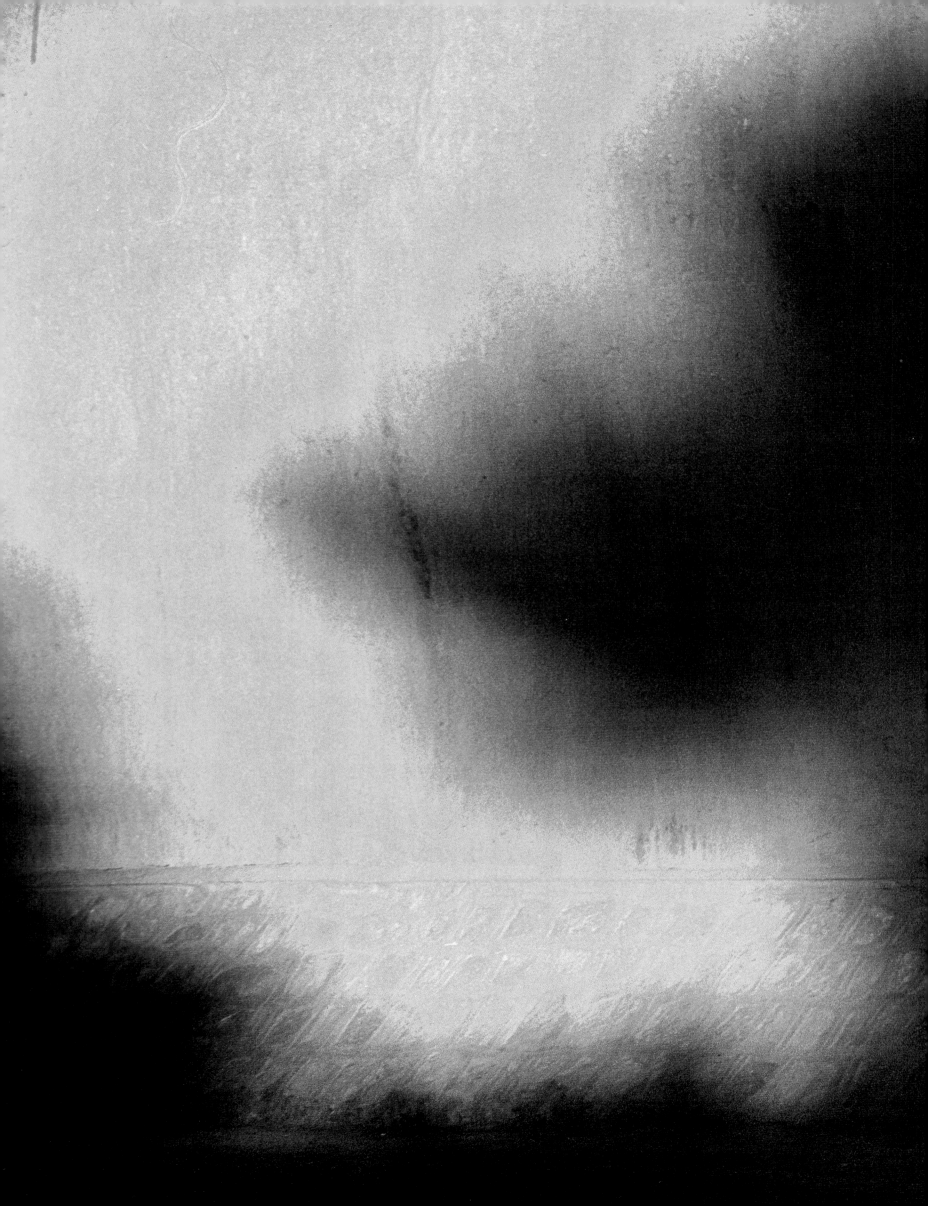

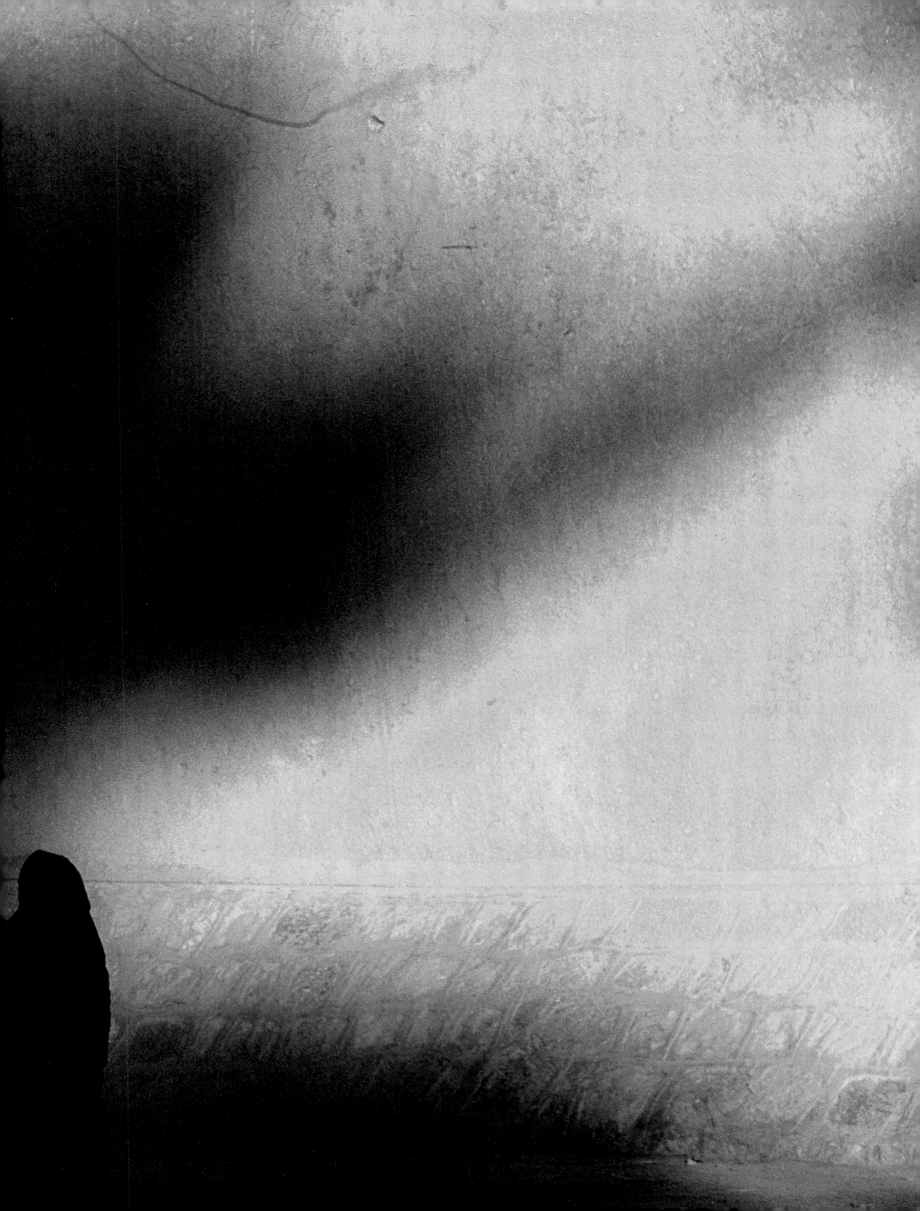

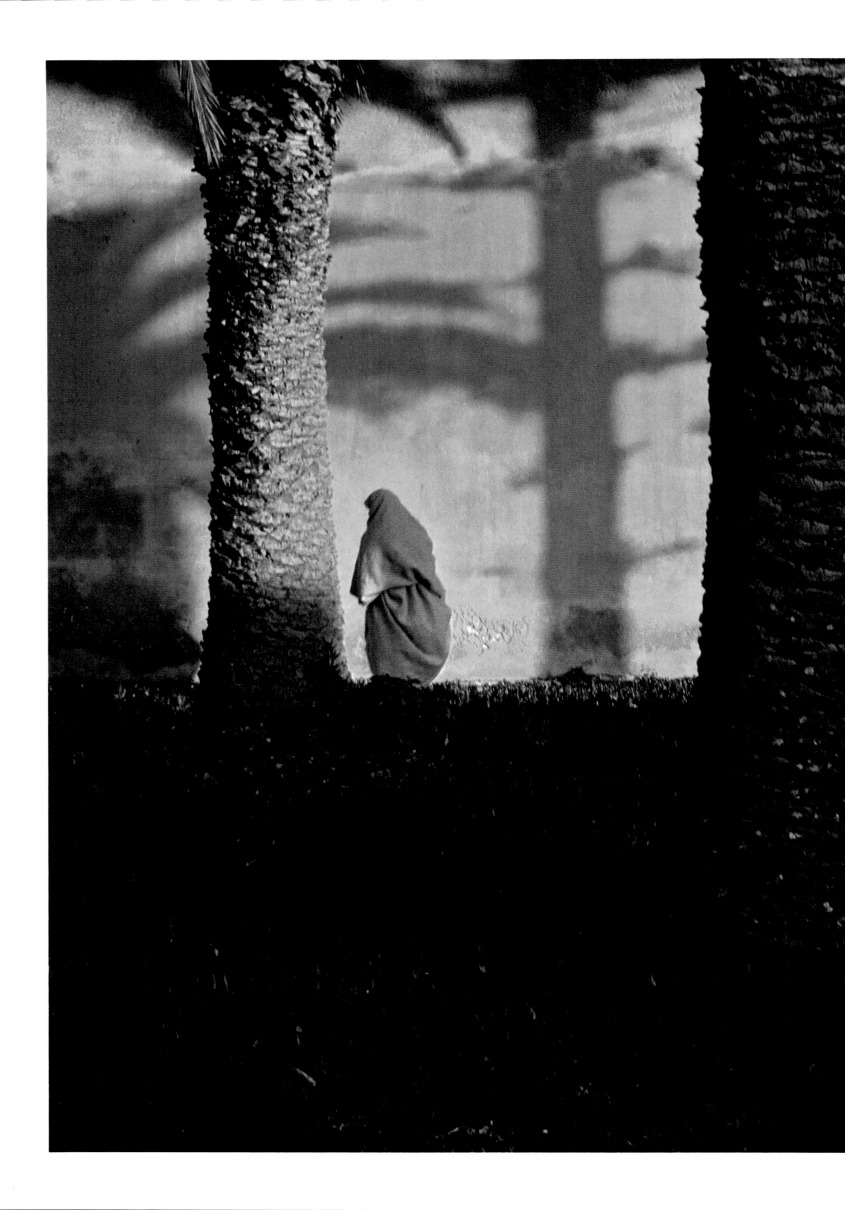

Essaouera: Shadows of palm trees in city walls.

Marrakech: Jemma El Fna Square.

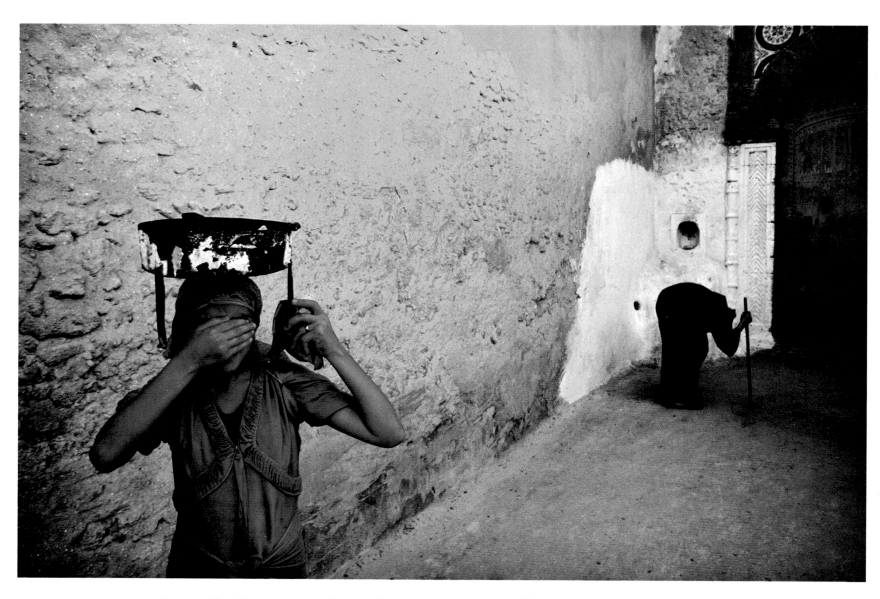

Essaouera: The old woman on the right was walking so slowly that it took her fifteen minutes to advance a couple of yards.

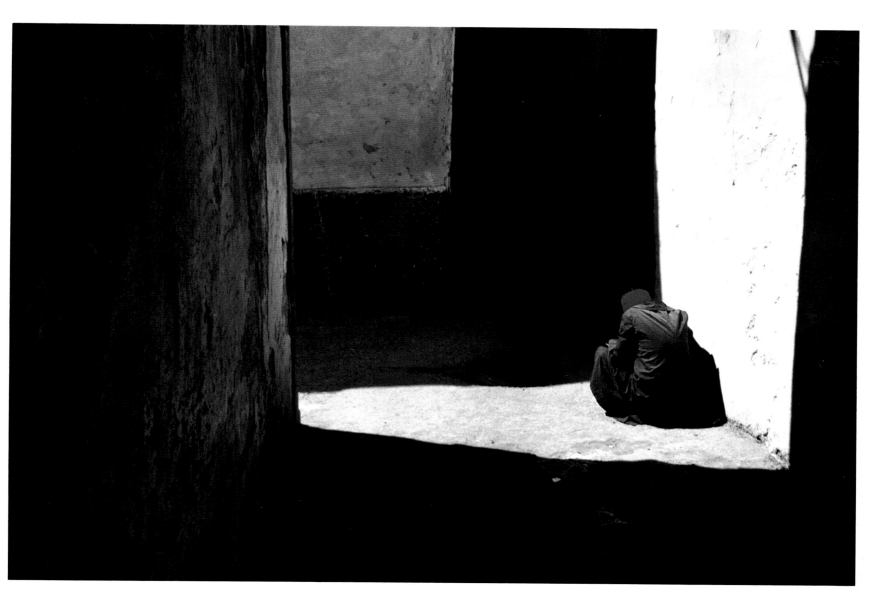

Essaouera: Man with red fez sitting in the sun.

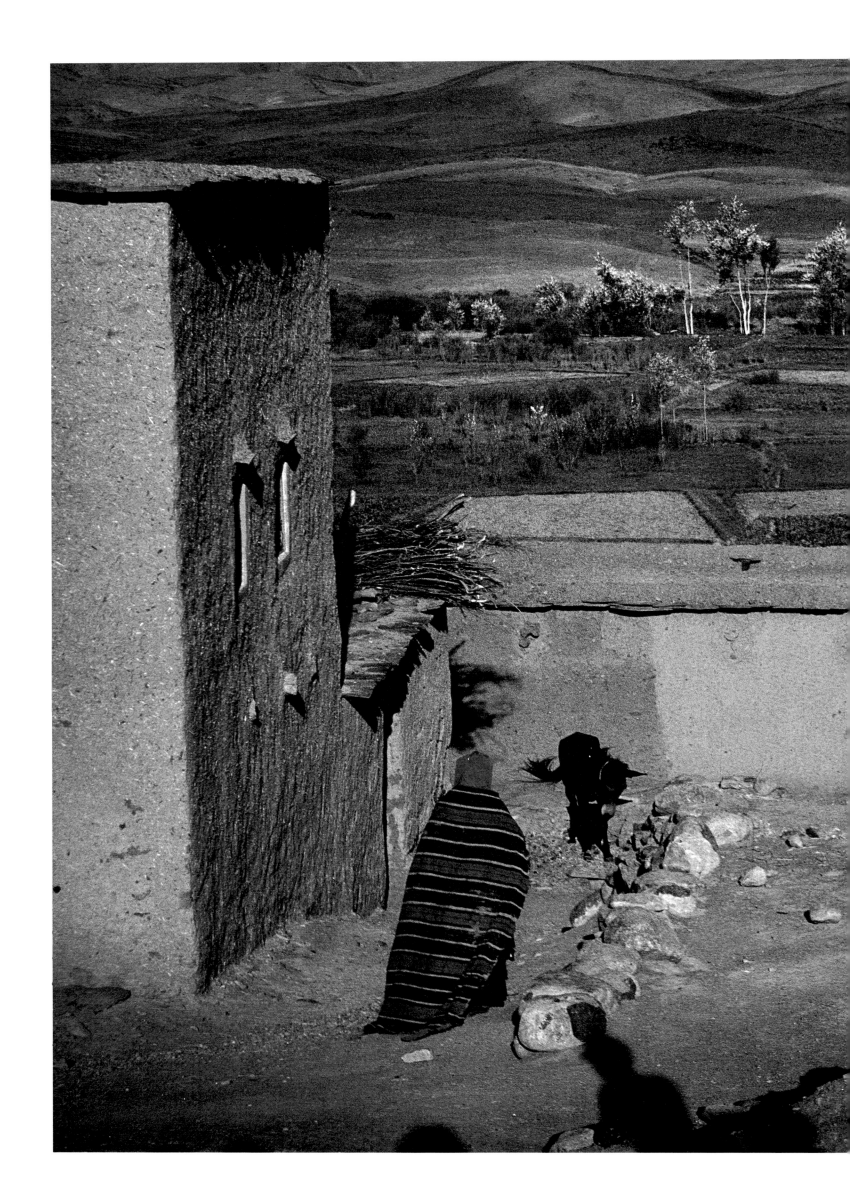

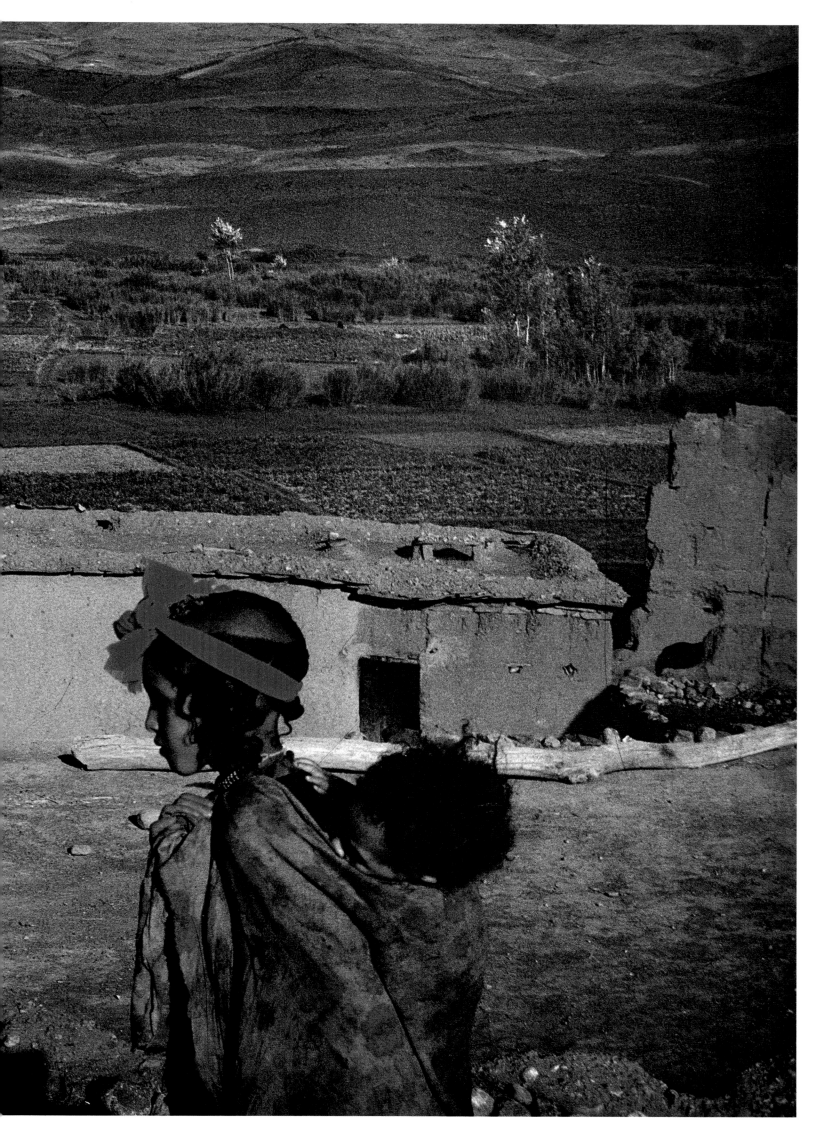

Atlas Mountains: Berber girl.

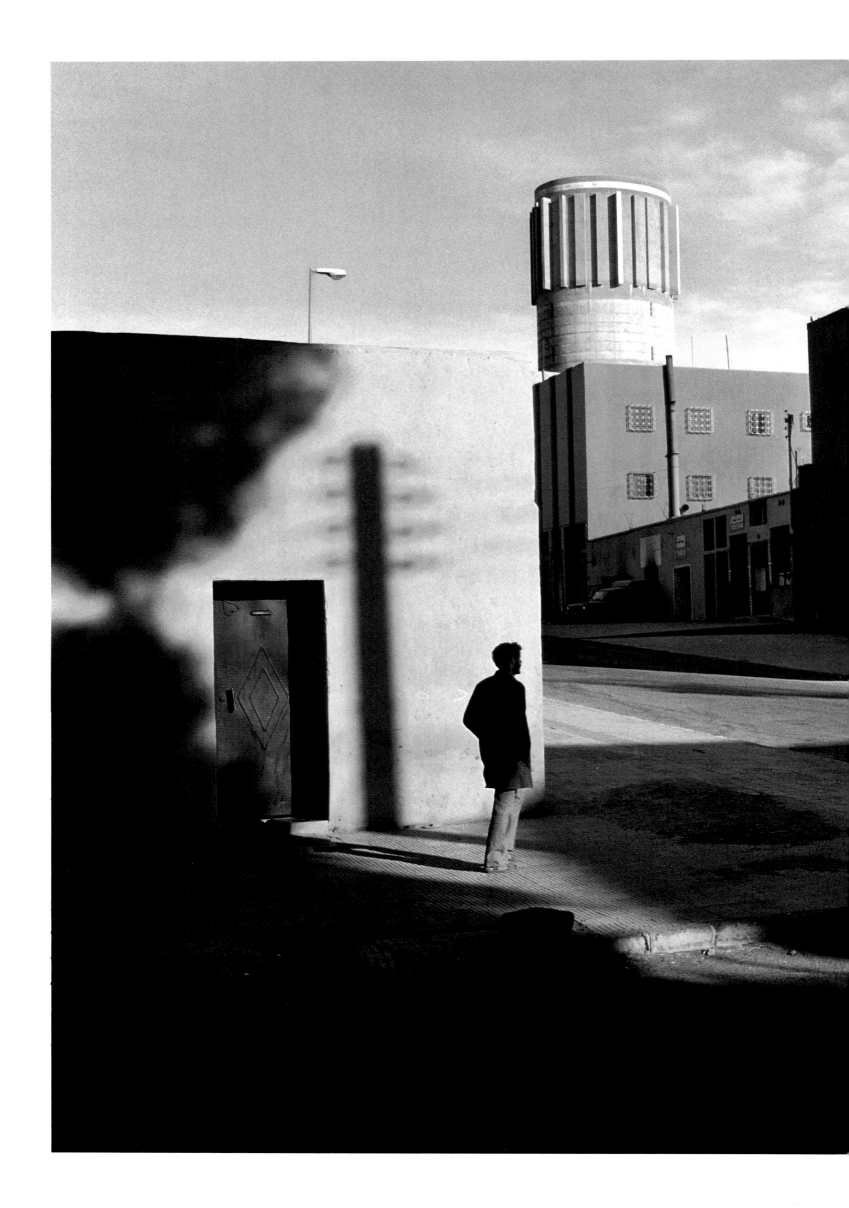

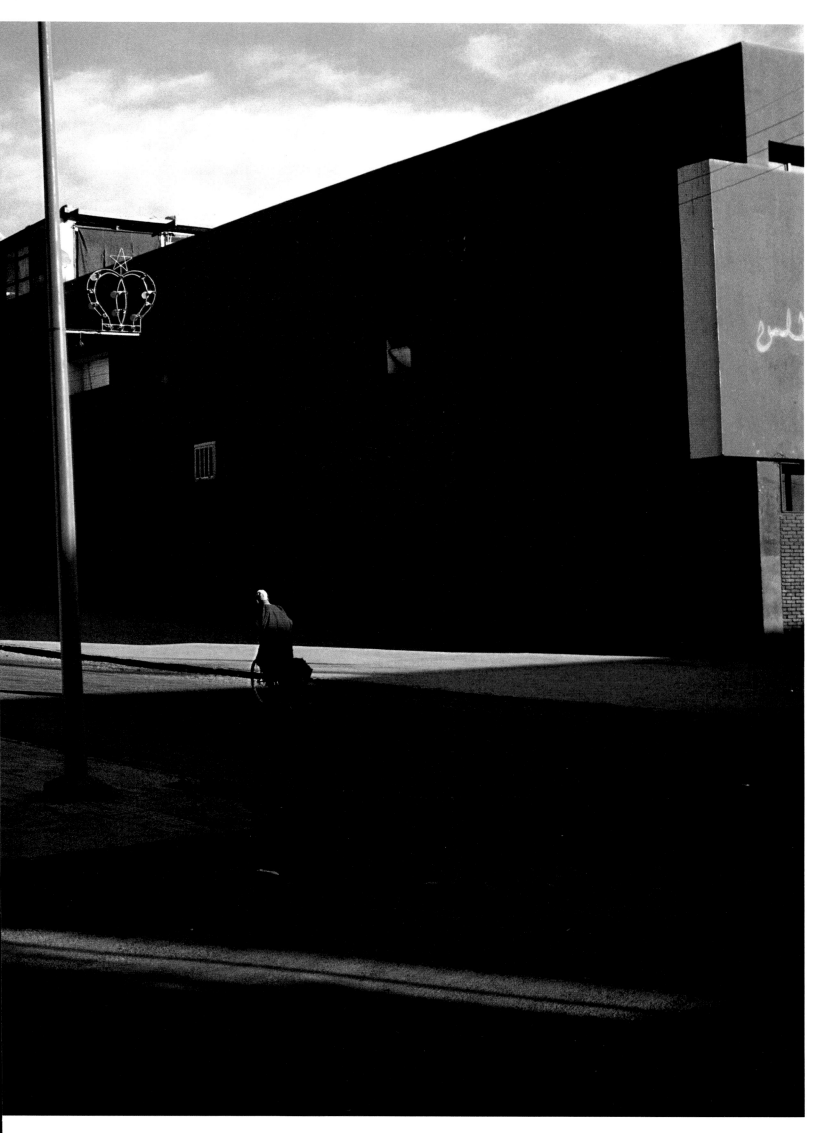

Ouarzazate: This was once a small desert village; it is now an administrative town.

Chechaouen: Mountain village in the north.

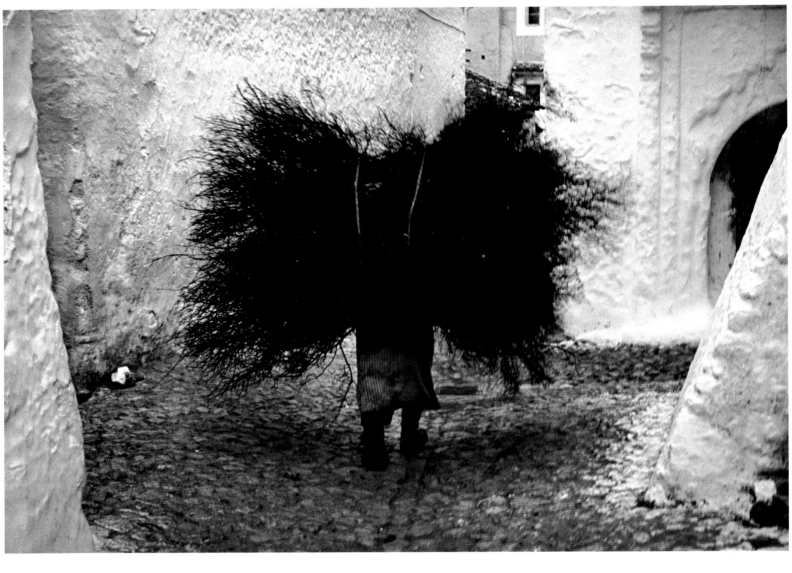

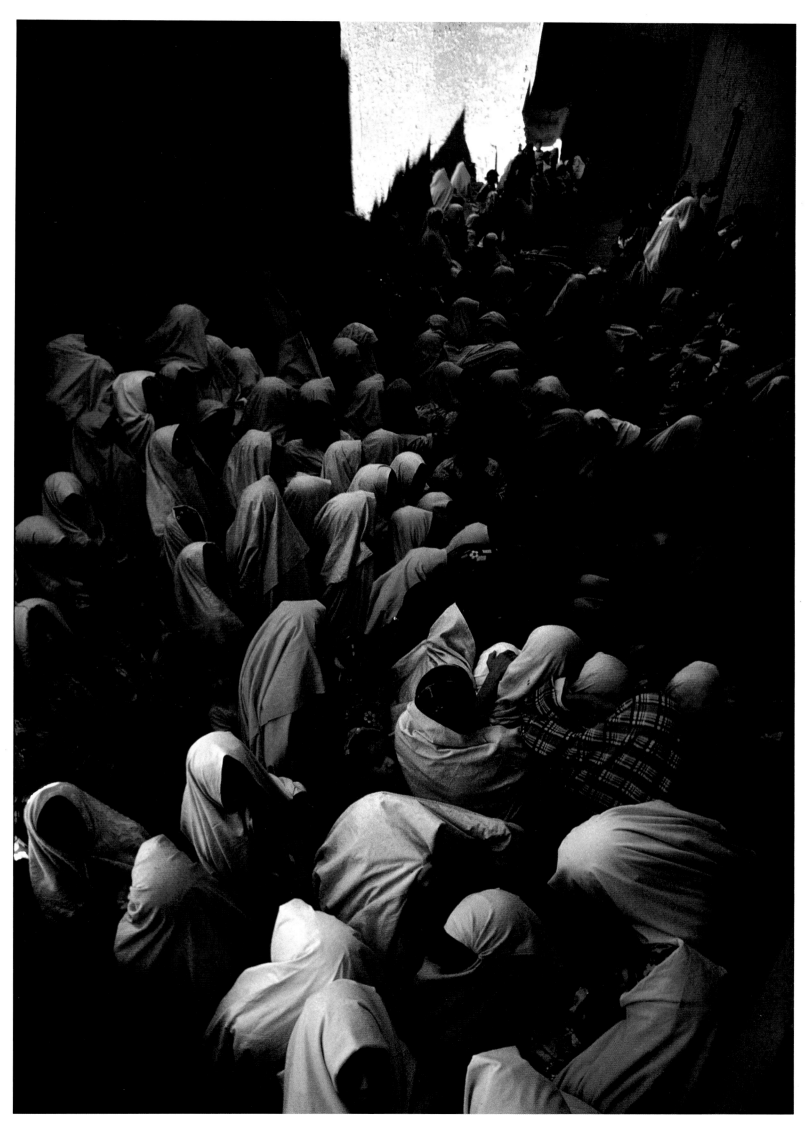

Tinerhir: Women coming for weekly celebration and praying on the tomb of a Marabou, an Islamic saint.

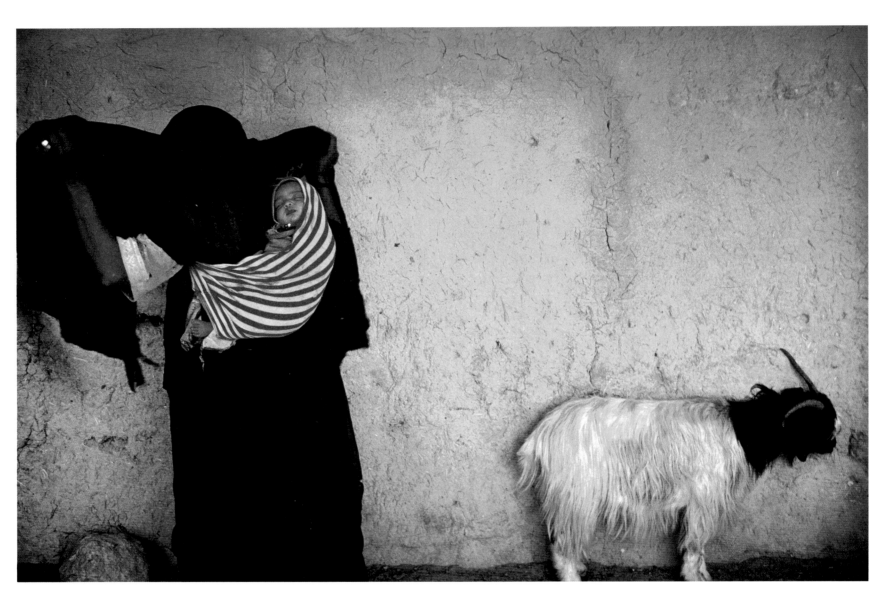

Erfoud: Woman with a baby on her back. She was trying to avoid being photographed. When she turned her back on me, the baby appeared.

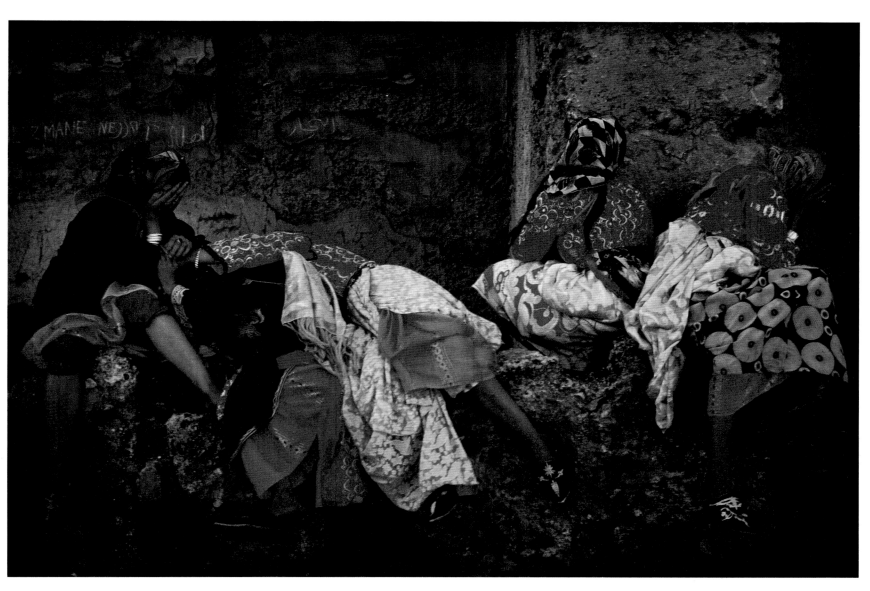

Marrakech: Young girls during the festival of Marrakech.

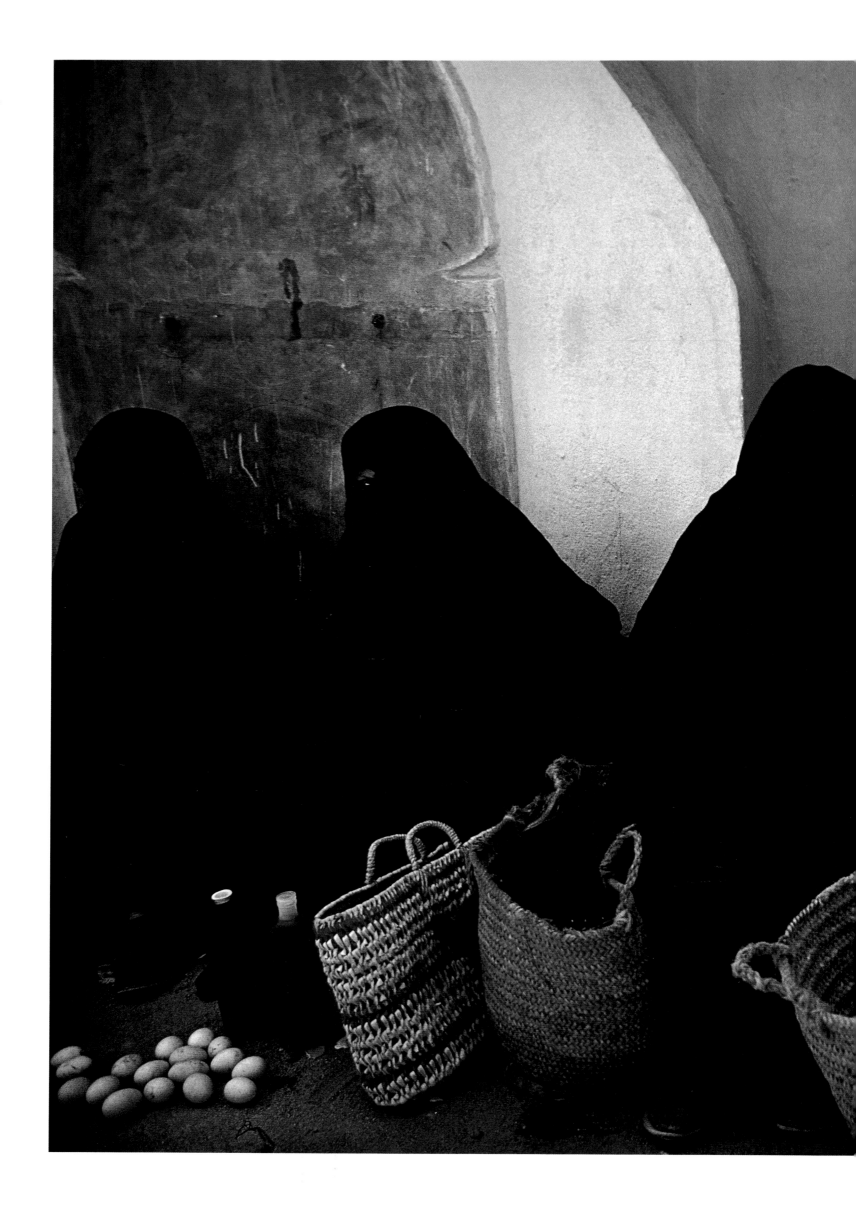

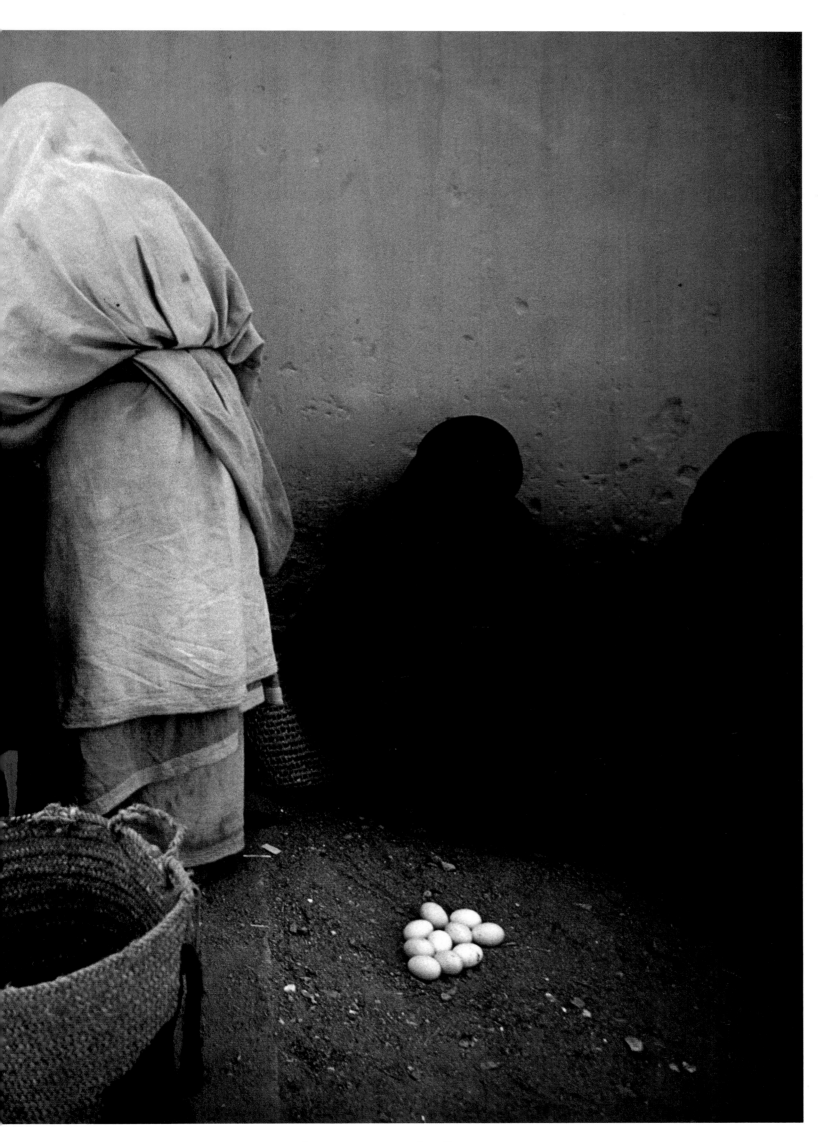

Tafraoute: Women in a market selling eggs.

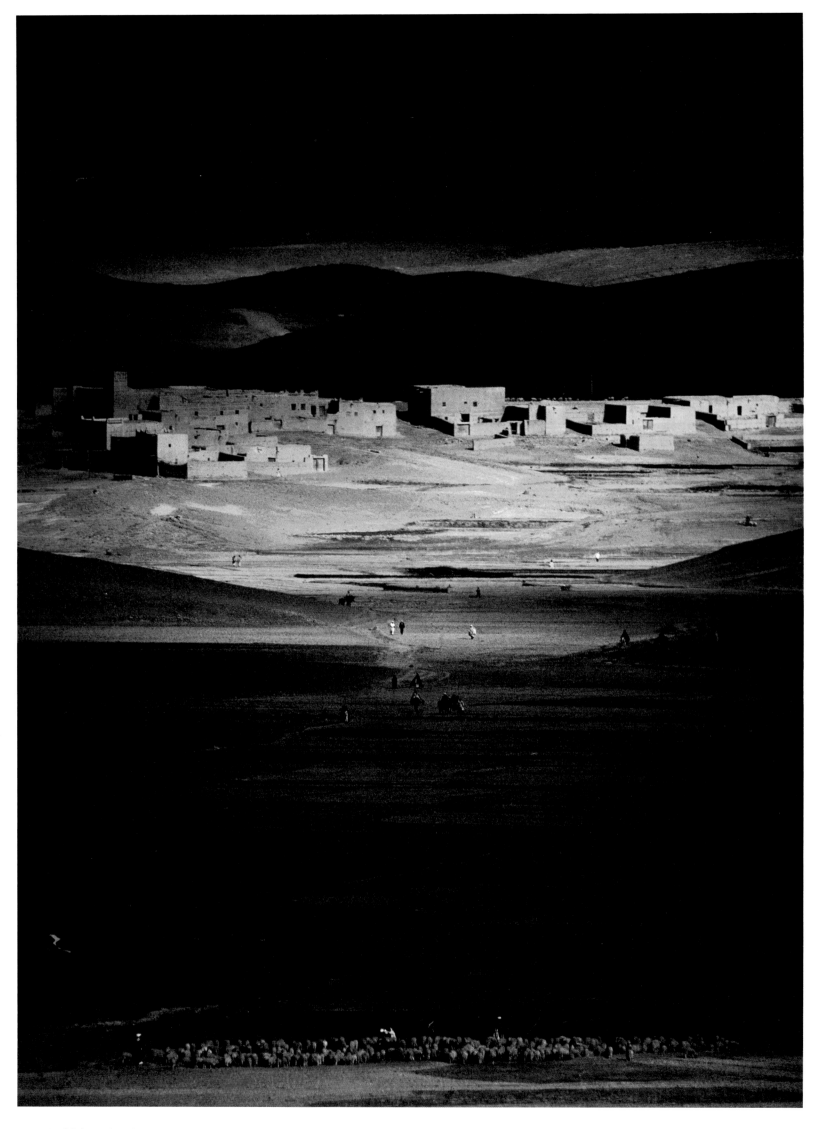

Imilchil: In the Atlas mountains every year in October, there is a big meeting where men come to find a bride. The festival is called "the engagement festival."

MAINE

FARRELL

WOODS

GREHAN

There's no one thing that makes the Maine woods a special place; no famous site or landmark, no largest this or greatest that. There's simply this wonderful forest situated a few hundred miles from anywhere, overflowing with life.

But there are things that will always stay in my memory. Cadillac Mountain, the first place in the United States where you see dawn. There is nothing quite like being at its peak, waiting for the sun to rise out of the chilly Maine mist and realizing you're about to be the first person in this country to see the beginning of another day.

And the moose, which is an extraordinary animal. Apart from its tremendous size, it has a presence which is at once comical and very noble. The first time you come upon a moose in one of those immense clearings, it seems as strange as seeing a rhino or hippo. But after you've been to the woods again and again, the moose becomes almost like an old friend.

And spring. Or rather the week right before spring, which epitomizes what the great photographer Cartier-Bresson called "the decisive moment." All the tree branches are at that final stage of budding when you feel them about to explode

with new leaves. The flowers are already in full bloom, so the woods' floor looks like an enormous palette. It's a fleeting moment, one where you can actually feel the constant renewal of life in the woods.

Autumn in Maine is truly the autumn of our dreams. The woods, endlessly vast, saturated with color: autumn in its purest form.

But as I said before, it's not one thing that draws me back to Maine every year; it's everything. I once did a piece on Thoreau for *National Geographic*. As part of my research, I read his journal, which covered every day of his life for forty years. Recently I found something that summarizes my feelings about these woods.

September 14, 1852: Be not preoccupied with looking. Go not to the object, let it come to you. When I have found myself looking down and confining myself to the flowers, I have thought it might be well to get into the habit of observing the clouds as a corrective. But no, that study would be just as bad. What I need is not to look at all but a true sauntering of the eye.

I find that delightful. It captures the essence of the Maine woods: a place where the eye can saunter and always be fulfilled.

MAINE WOODS

MAINE

NEW HAMPSHIRE

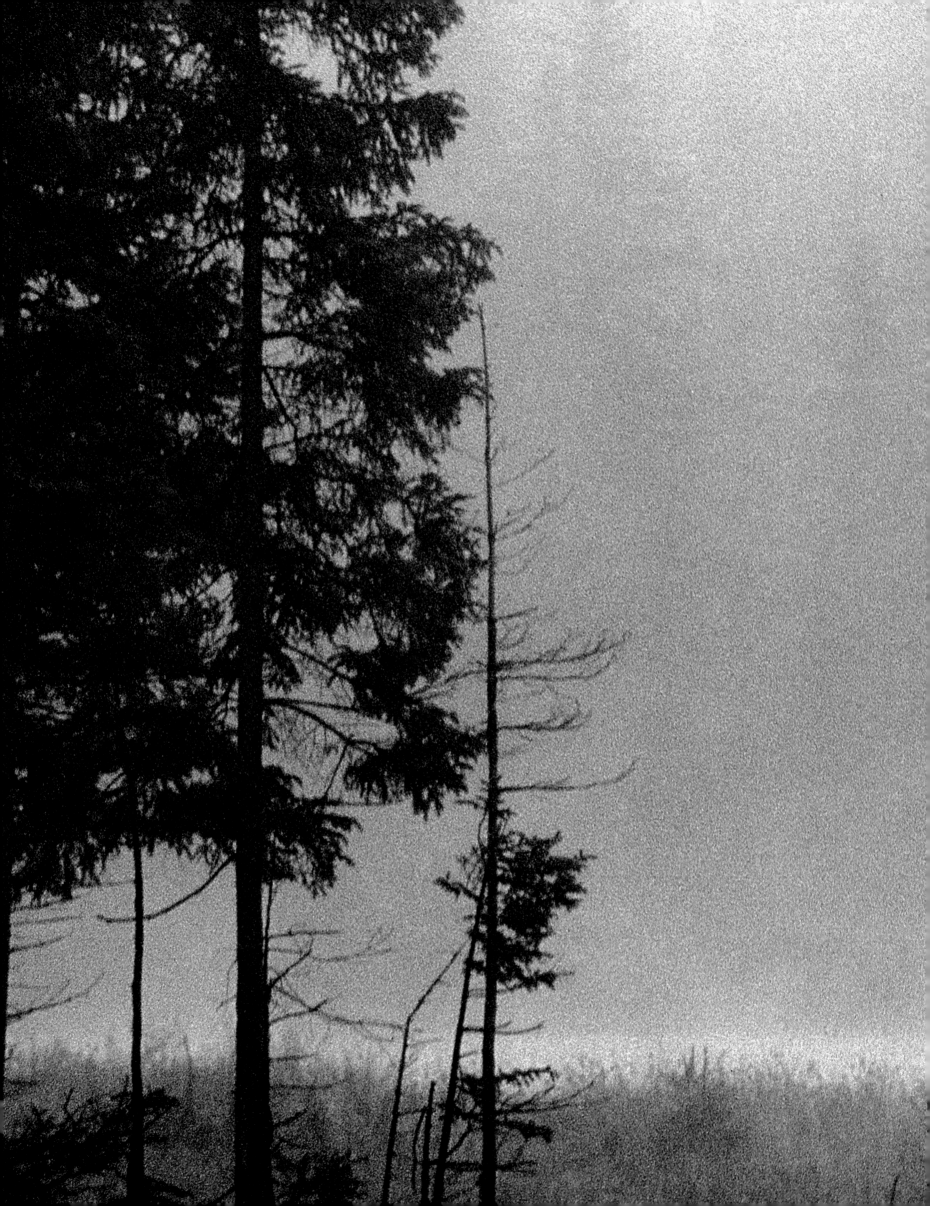

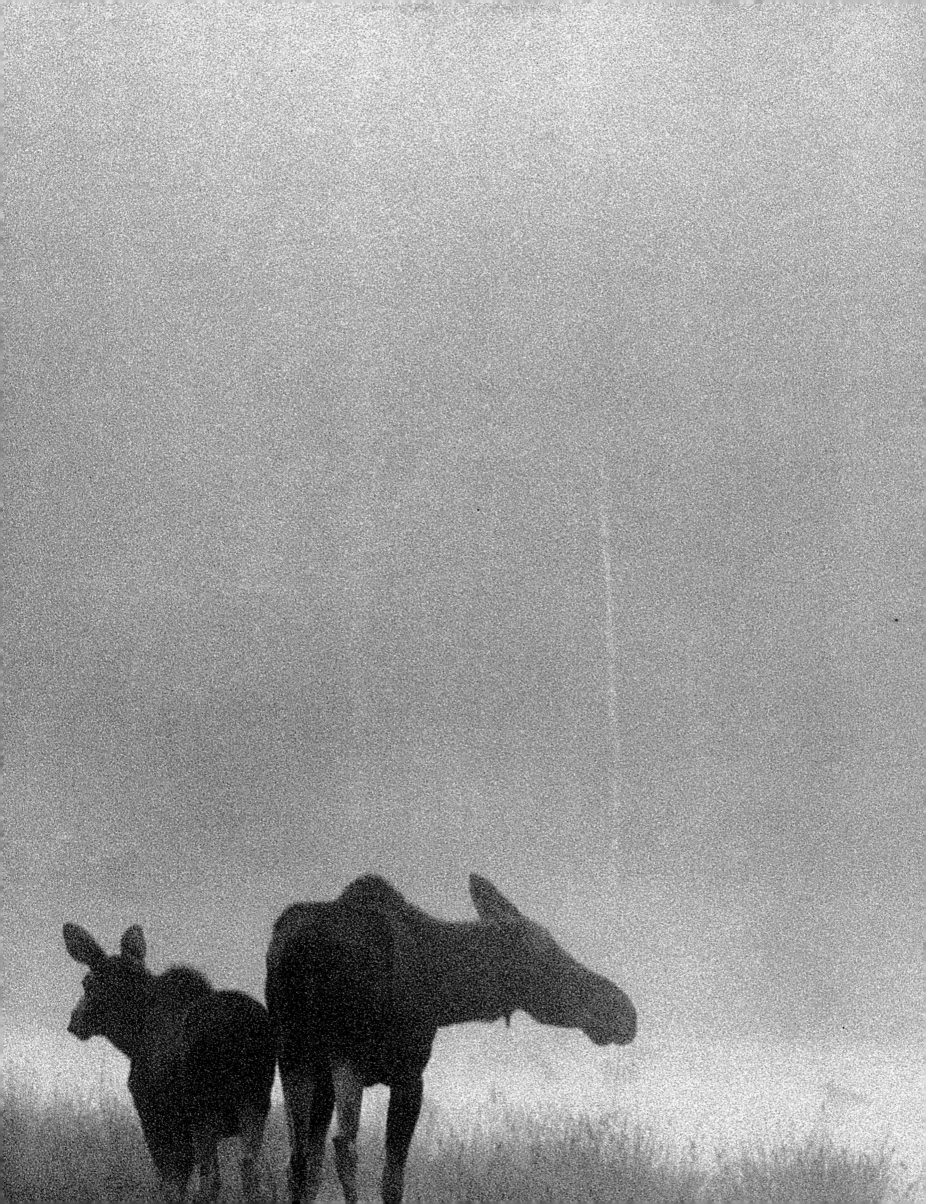

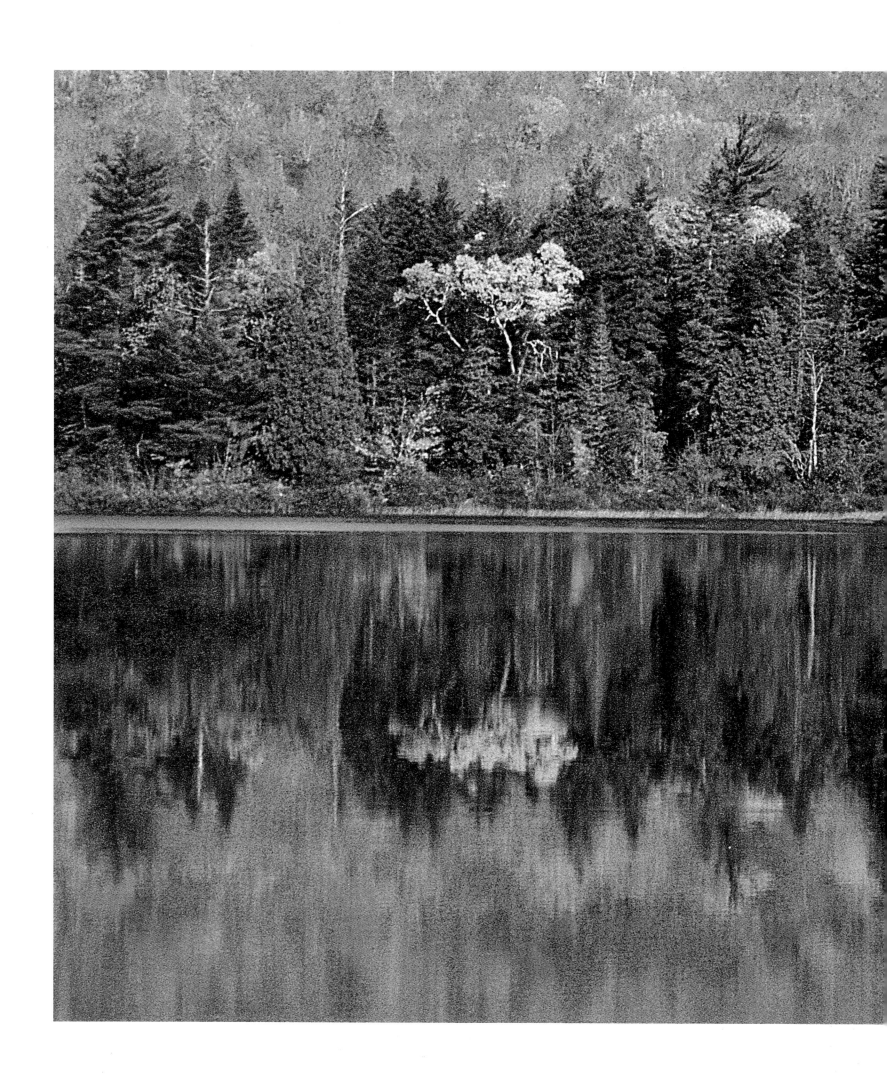

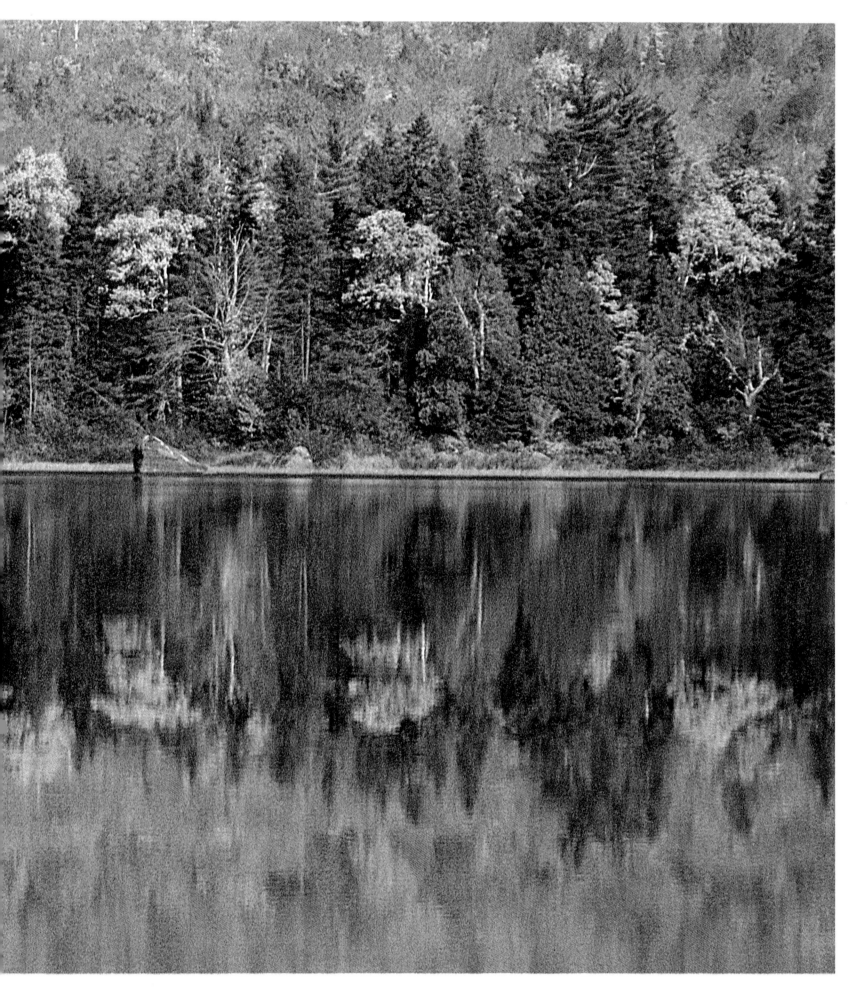

Woods reflected on pond.

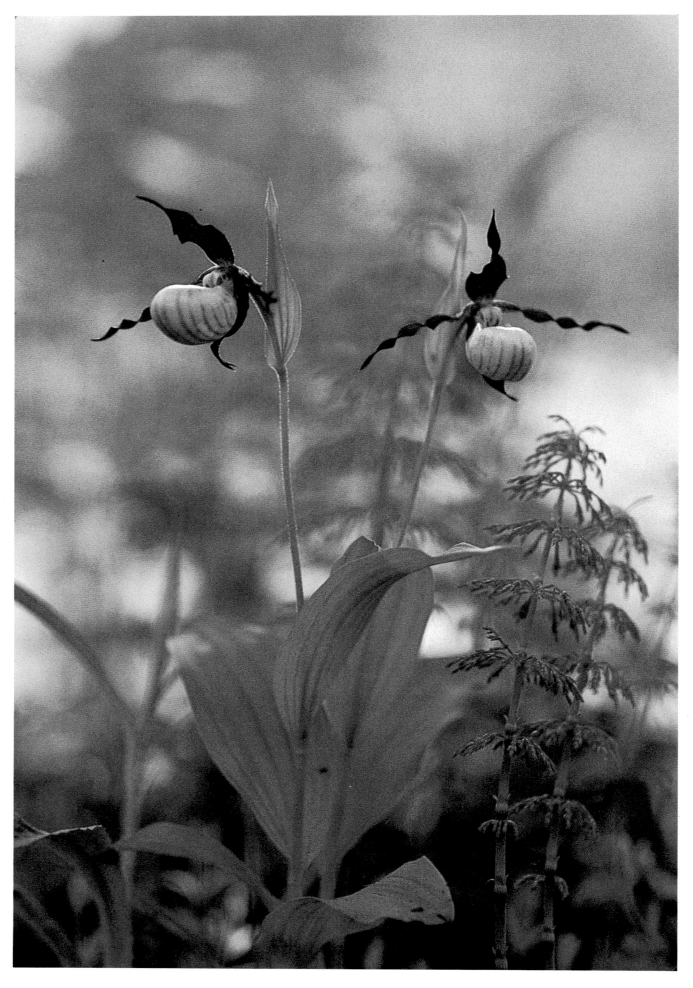

Yellow Lady's Slipper, Acadia National Park.

Right page: Spring seeds on pond.

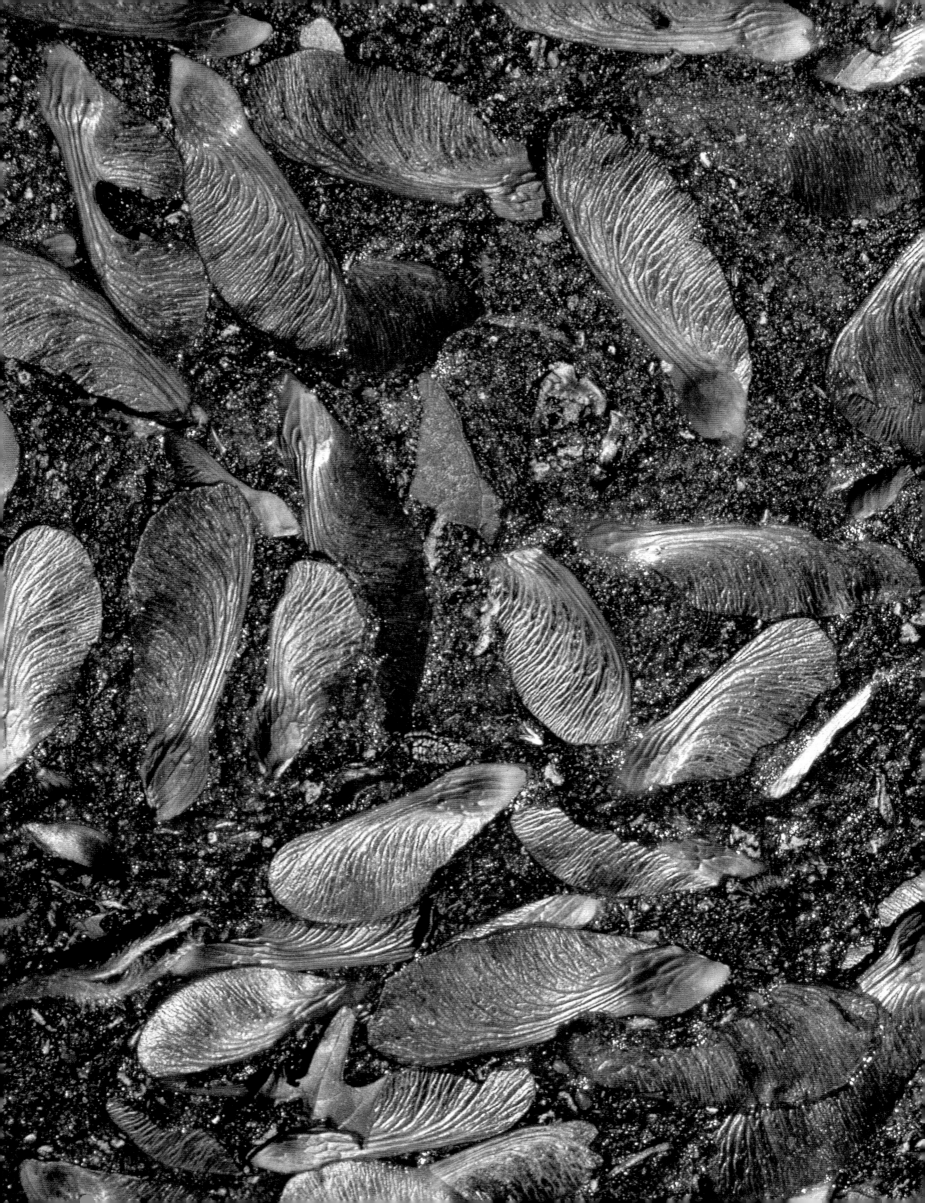

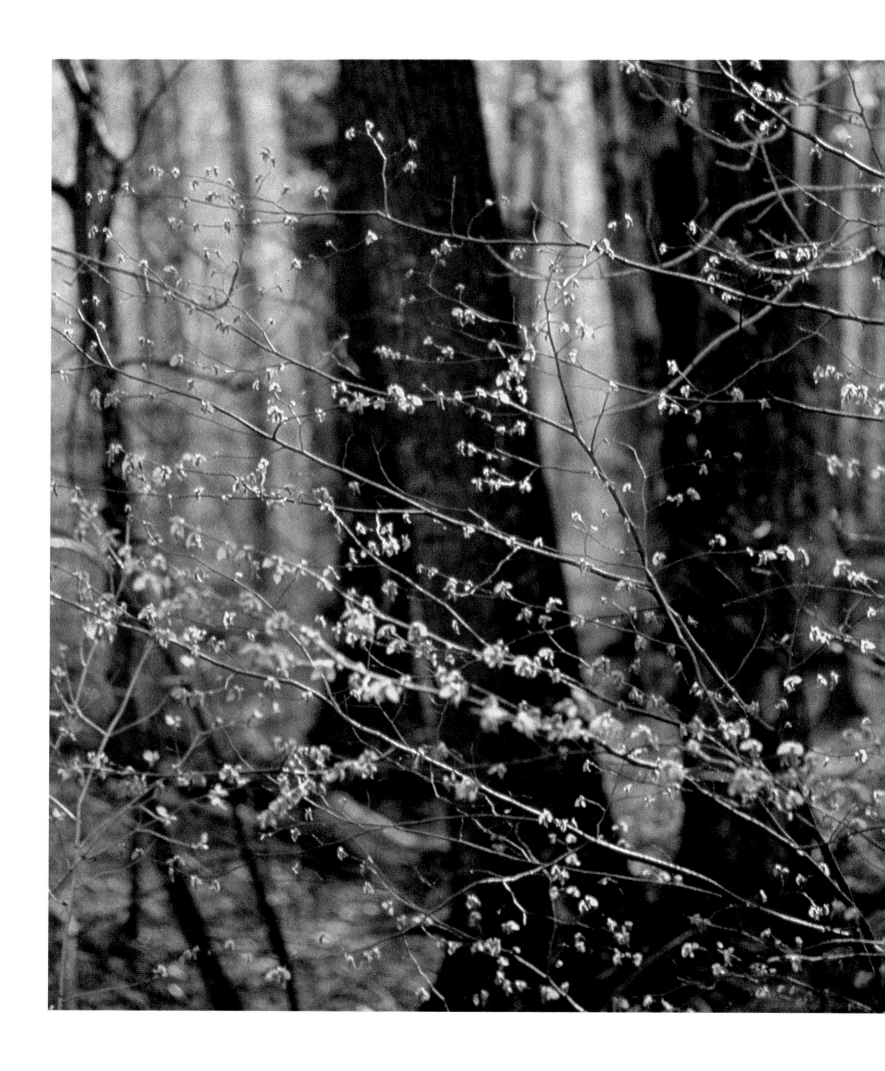

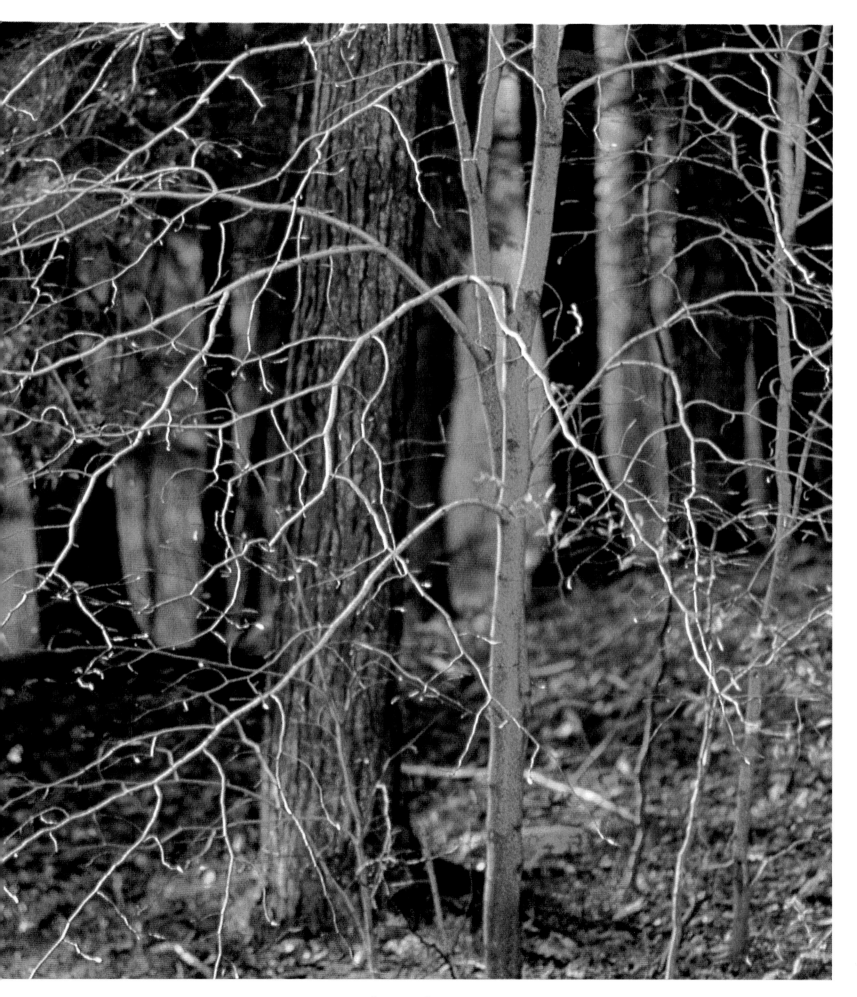

Spring woods.

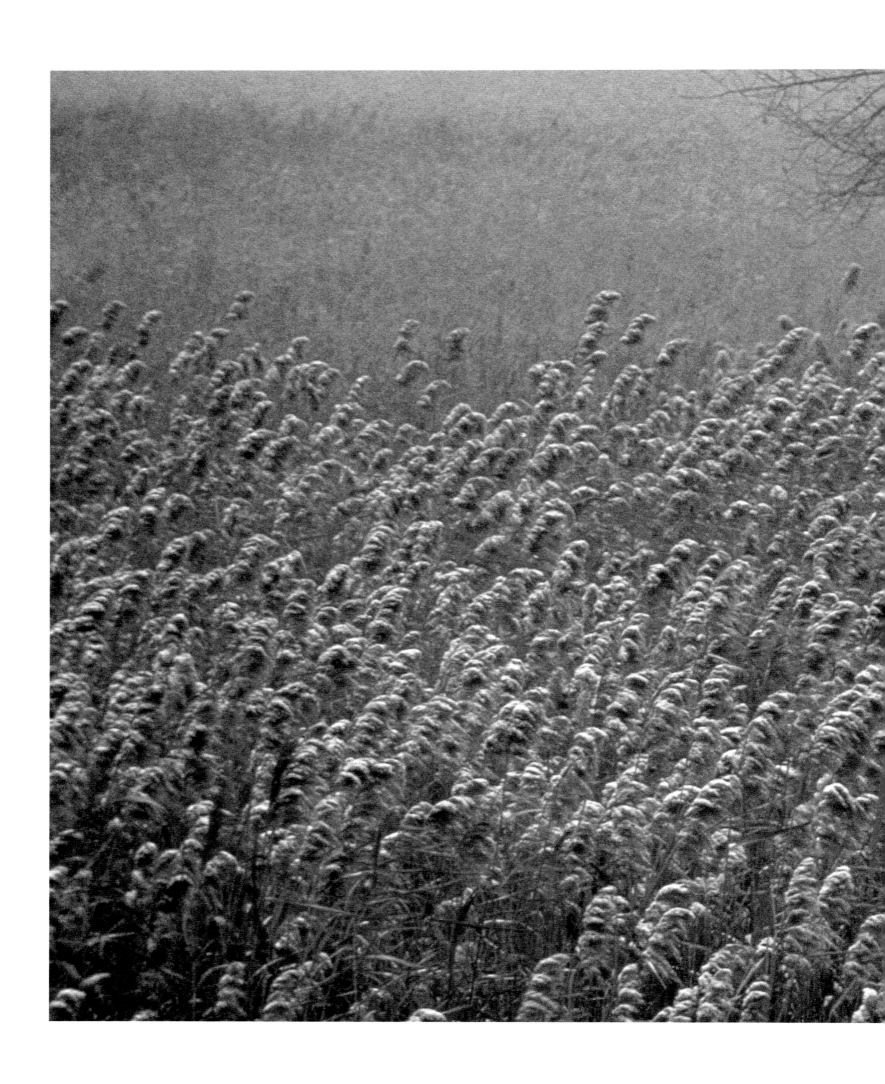

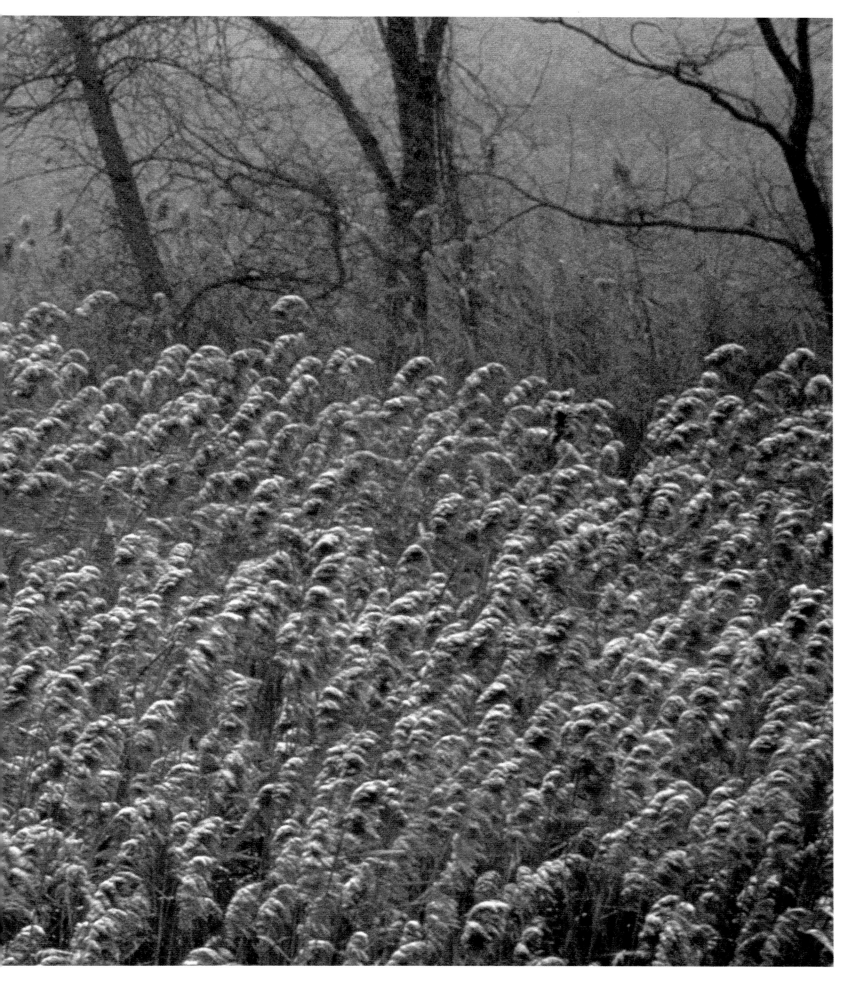

Wildflowers.

Next page: Allagash waterway wilderness.

143

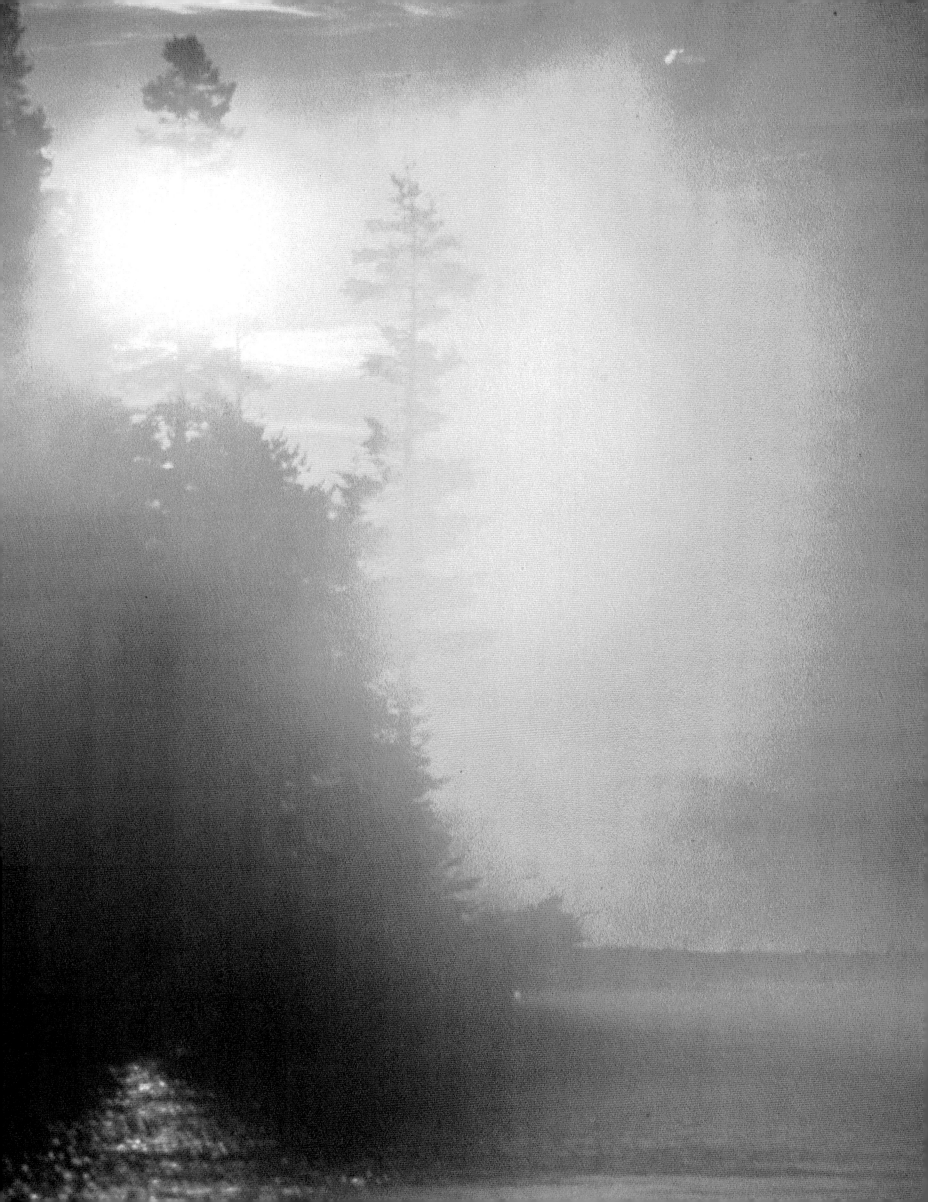

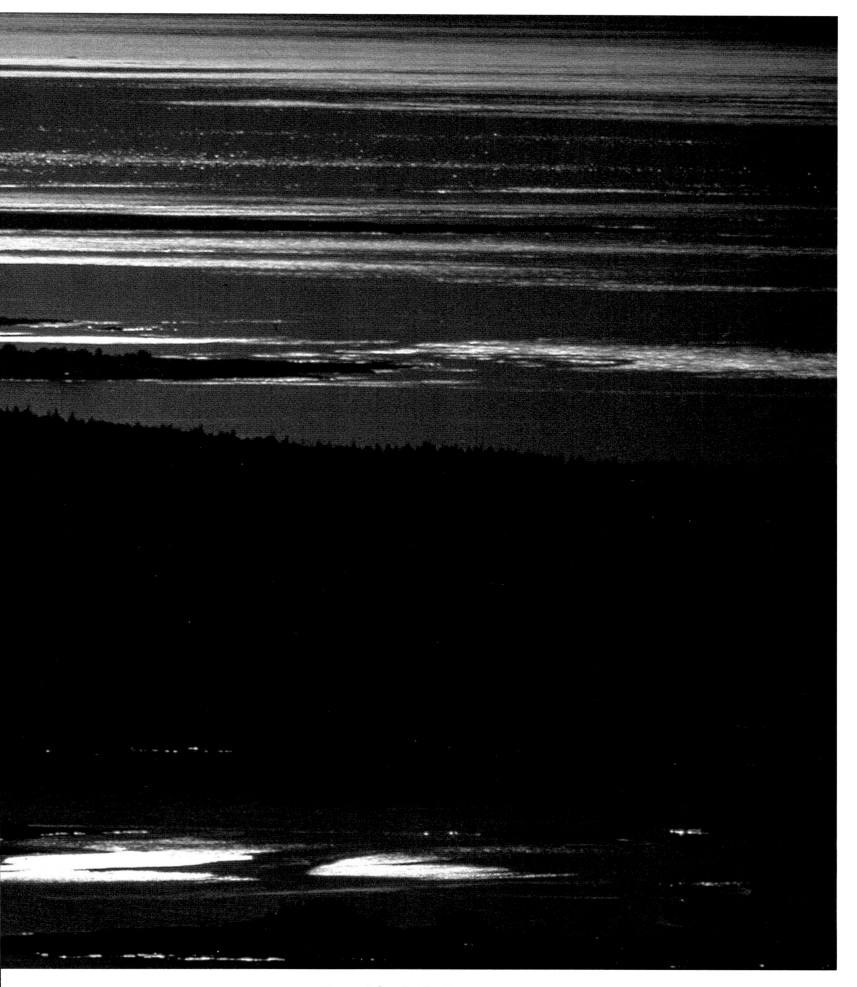

View north from Cadillac Mountain.

Next page: Brook falls.

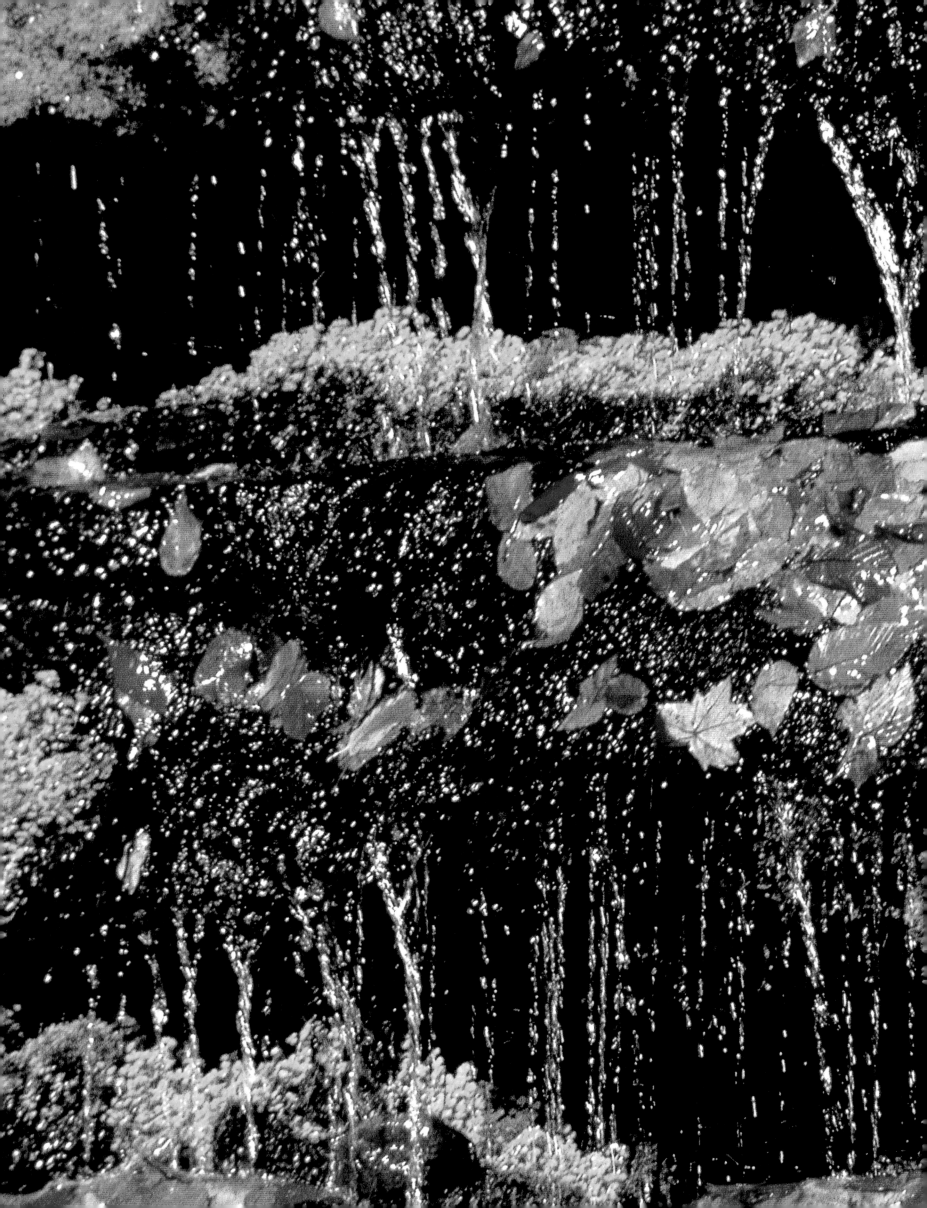

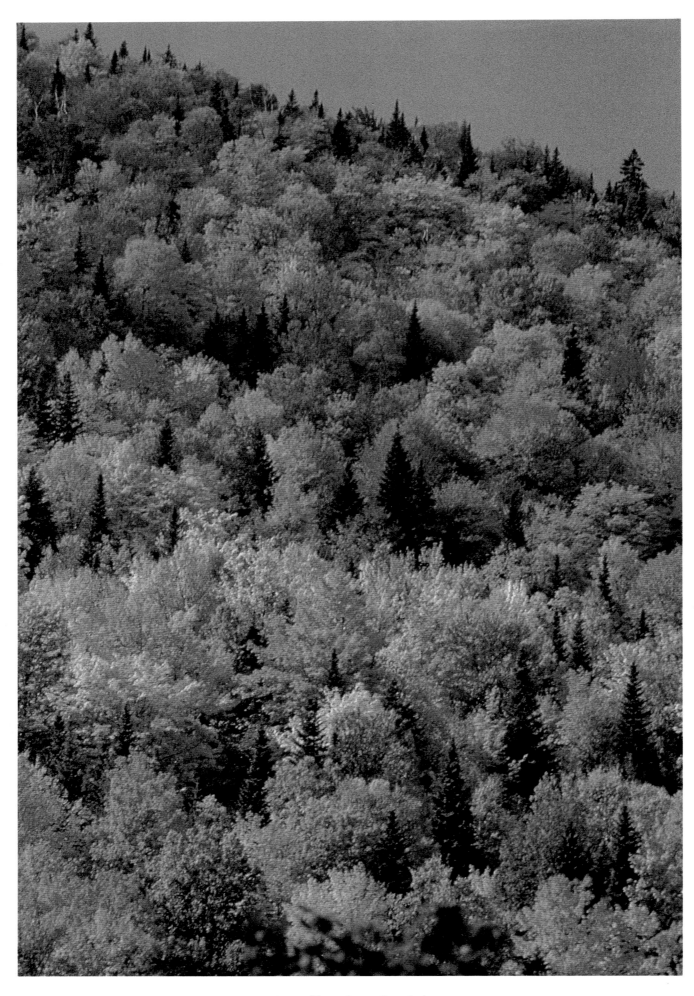

Autum foliage, Baxter State Park.

Right page: Merrybells.

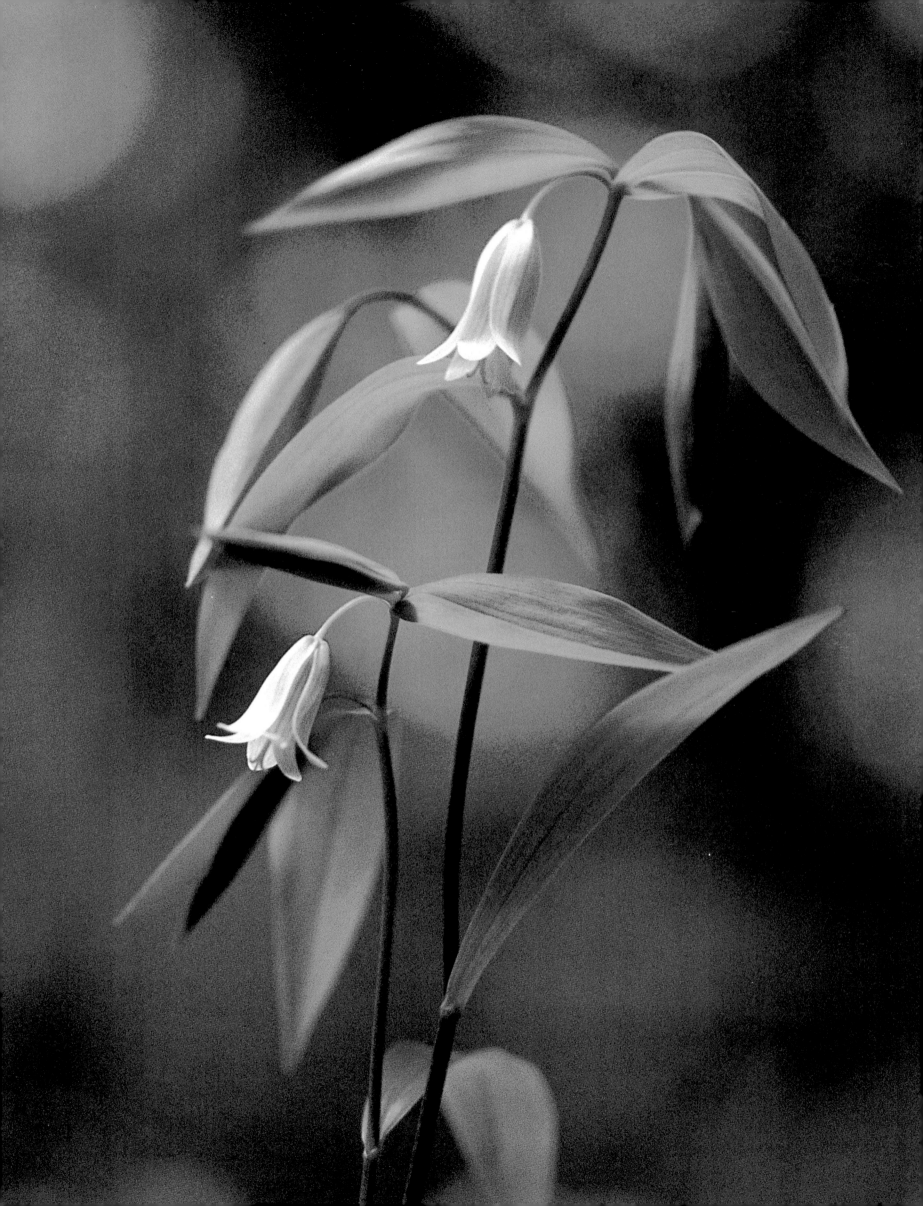

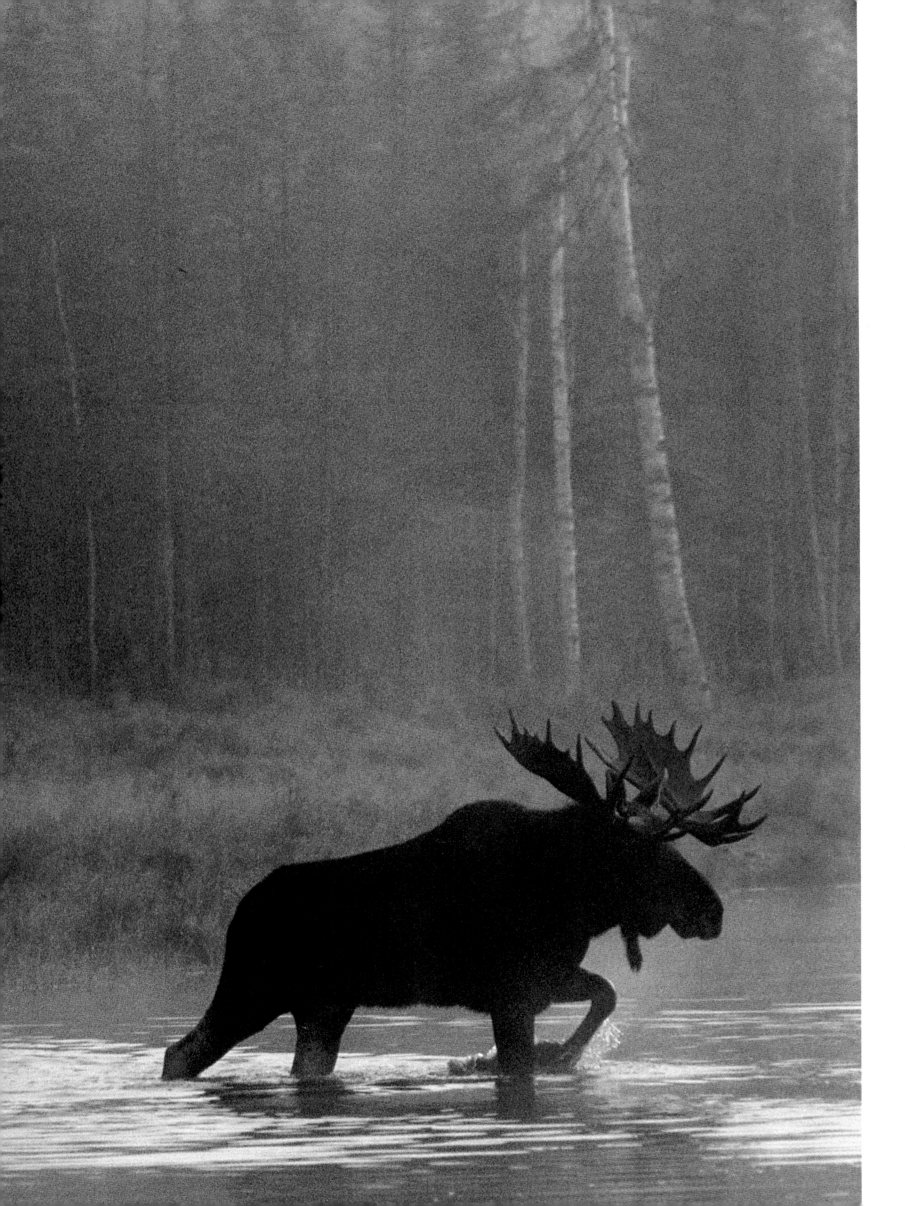

NEW G

BURT

UINEA

GLINN

Choosing the most beautiful place in the world was, for me, quite difficult. If I had been forced to choose on physical beauty alone, I couldn't have made a choice. How could you choose between the sun rising over Mount Fuji and your first sight of the Grand Canal in Venice; between the ambers and ochres of autumn in Rome, and the glistening dew on a green rice field in Bali.

I was able to settle on New Guinea because, for me, its beauty is not just turf-deep. It is the people and the life that make it shine.

New Guinea is a fascinating, unique culture on the edge of disappearance. Unlike the people at the Kyoto festival in Japan, these people are not costumed. They are wearing the very fabric of their lives. Of all the marvelous places I have visited, I could probably go back to most of them and recapture some of their magic. New Guinea, the way I saw it, will never be there again.

These pictures were taken essentially in two distinct areas in New Guinea. In the highlands, the temperature is moderate, everything is green, life is easy and

the natives spend all of their creative efforts decorating and adorning themselves. All of the decorations have religious overtones, but they are totally self-centered. Mudmen build their masks and daub themselves to represent the spirits of the dead to frighten their opponents; these efforts are not god-directed, but self-directed. In the lowlands, on the other hand, the temperature is hot and humid, the land is difficult, almost impossible to cultivate. Life is anything but paradisal, so the efforts of the people are directed to appeasing and appealing to the gods for protection and for making life easier. Here, instead of decorating themselves, people have built soaring spirit houses and carved magical figures, all in the service of the gods.

 To be able to photograph these incredible people just before the arrival of cloth caps imprinted with the word Yamaha (caps which are taking the place of the feathered headdress) was an exhalting experience. In that way, at that time, this place meant beauty: a haunting, unmatchable beauty.

NEW GUINEA

AUSTRALIA

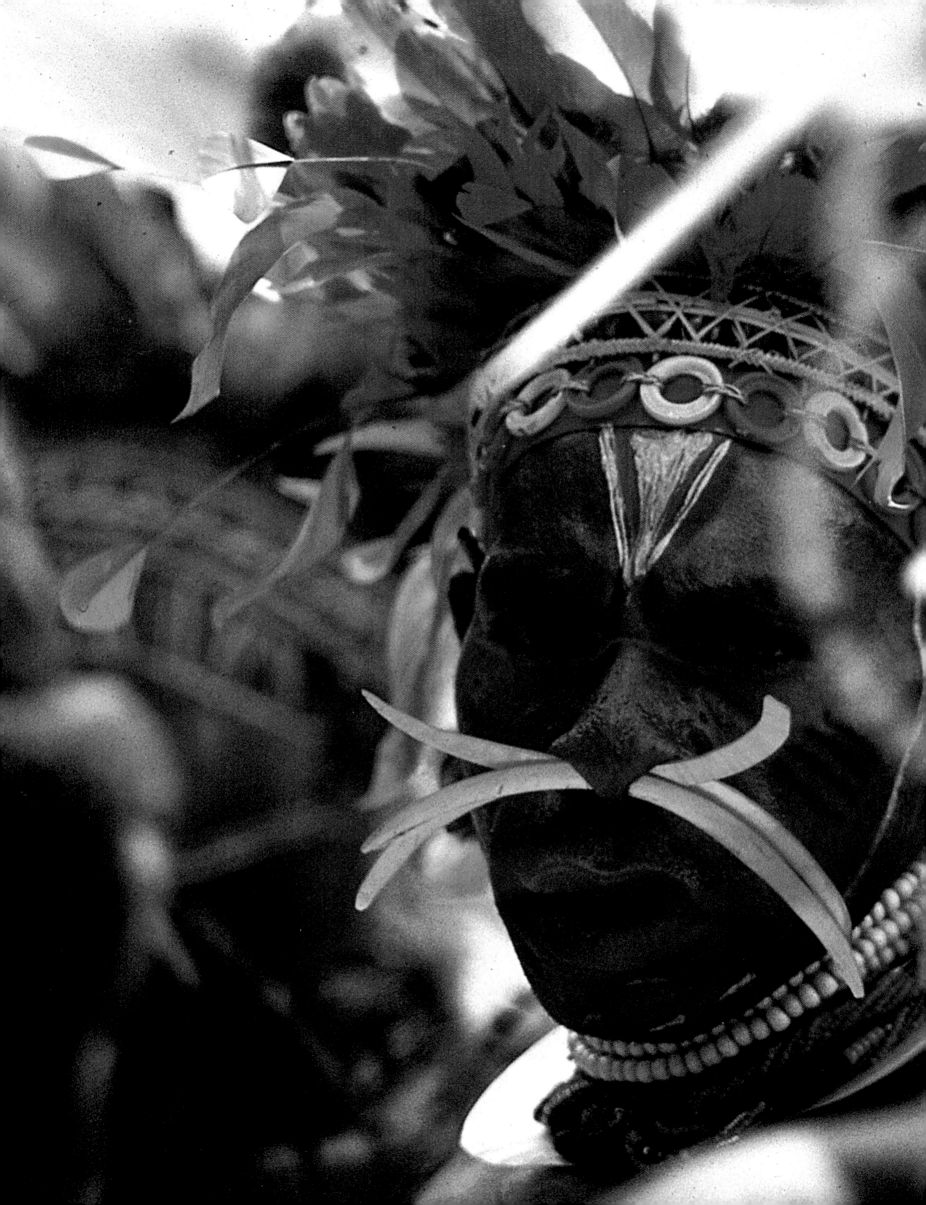

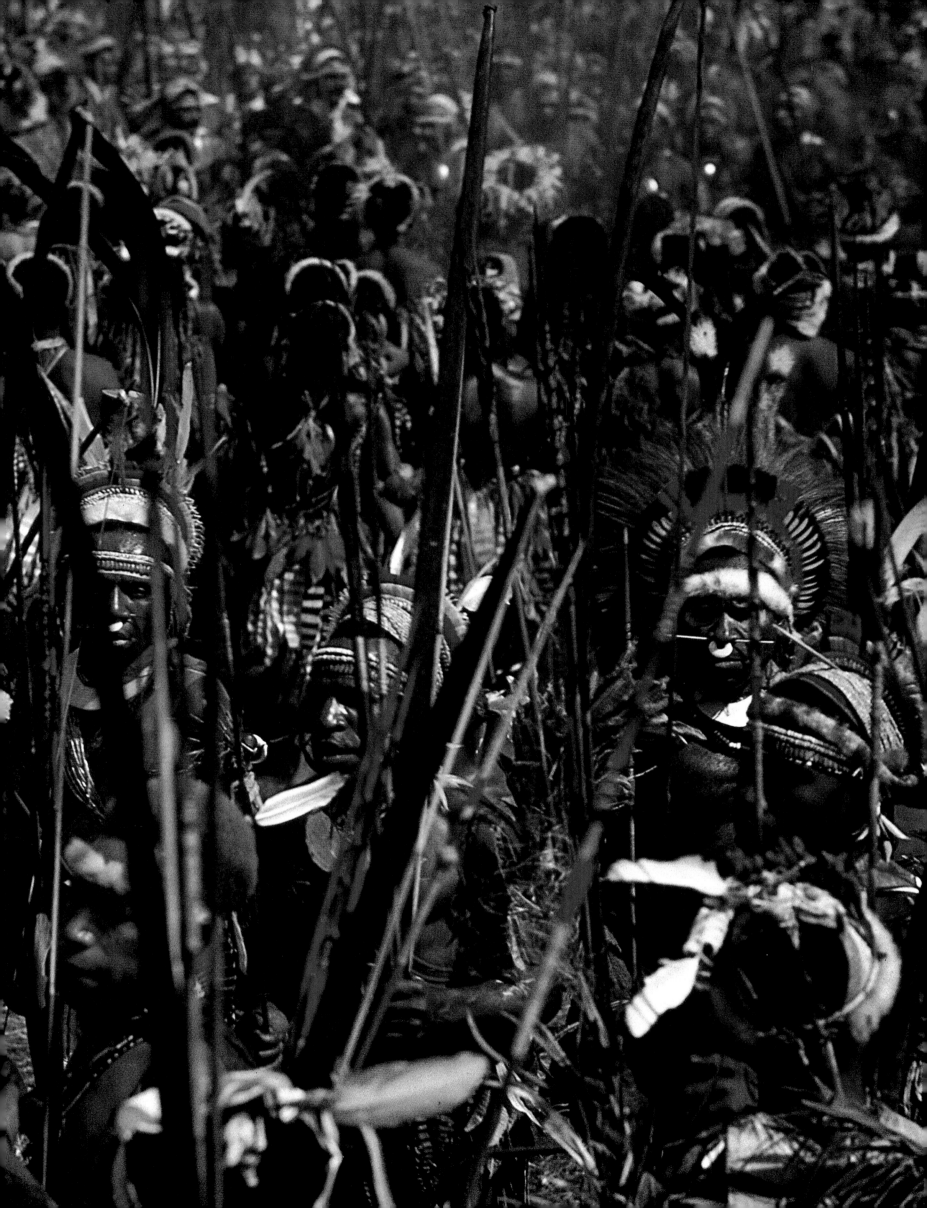

Three men inside a spirit house near Maprik blowing homemade
flutes into hollowed-out, carved idol resonators.

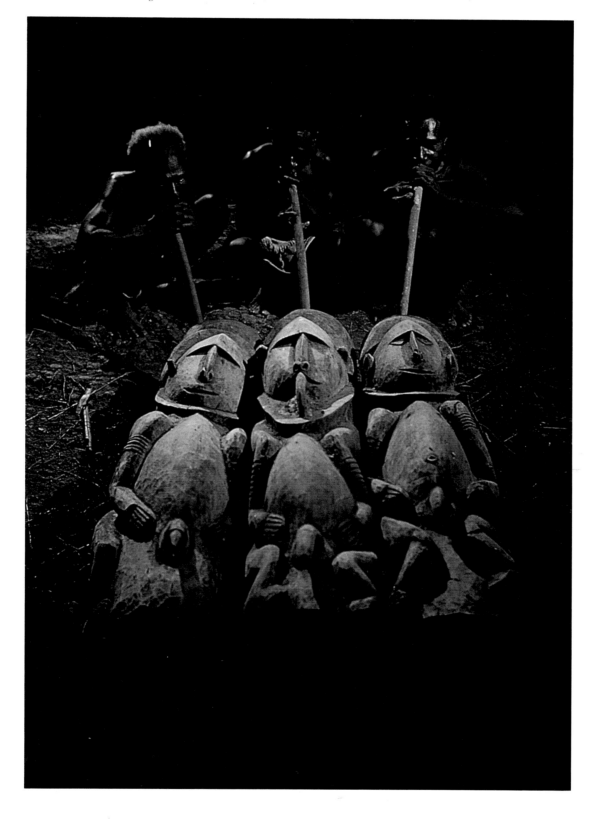

Left page: Gathering of highland tribesmen at the annual Goroka fair.

Man leaning against the pillar of a Tamberan, the center of Sepik men's
ceremonial life. The post is carved into an ancestor figure. The crocodile face
represents the Wagan, a water spirit.

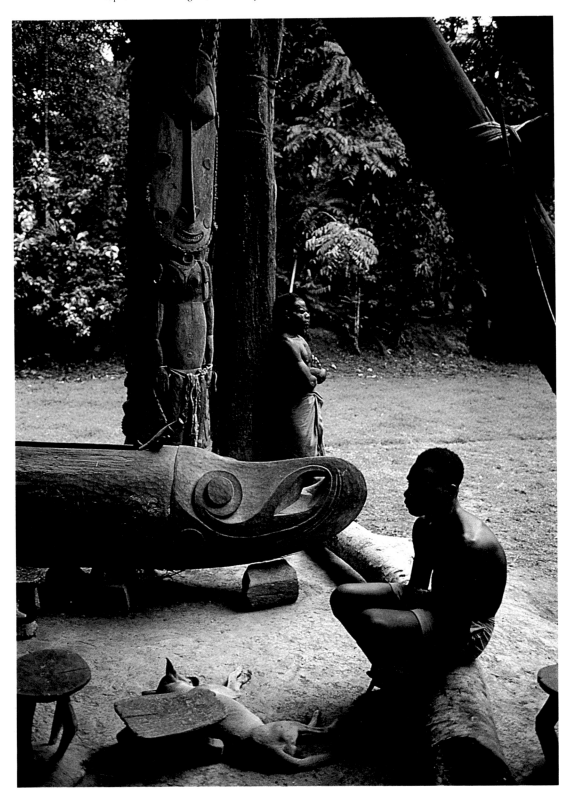

Right page: Men putting up lintel on spirit house underneath the painted bark facade.
The lintel is carved and painted inside the unadorned spirit house in a period
of days. Men who carve and paint stay inside the house without food and drink,
totally naked from the beginning until the project is completed.

Next page: These are highland warriors, spear-carrying natives of Mount Hagen.
They are wearing fiber aprons, gold-lipped shells and brass plates in their noses and
on their foreheads' and plumage of Greater Bird of Paradise feathers.

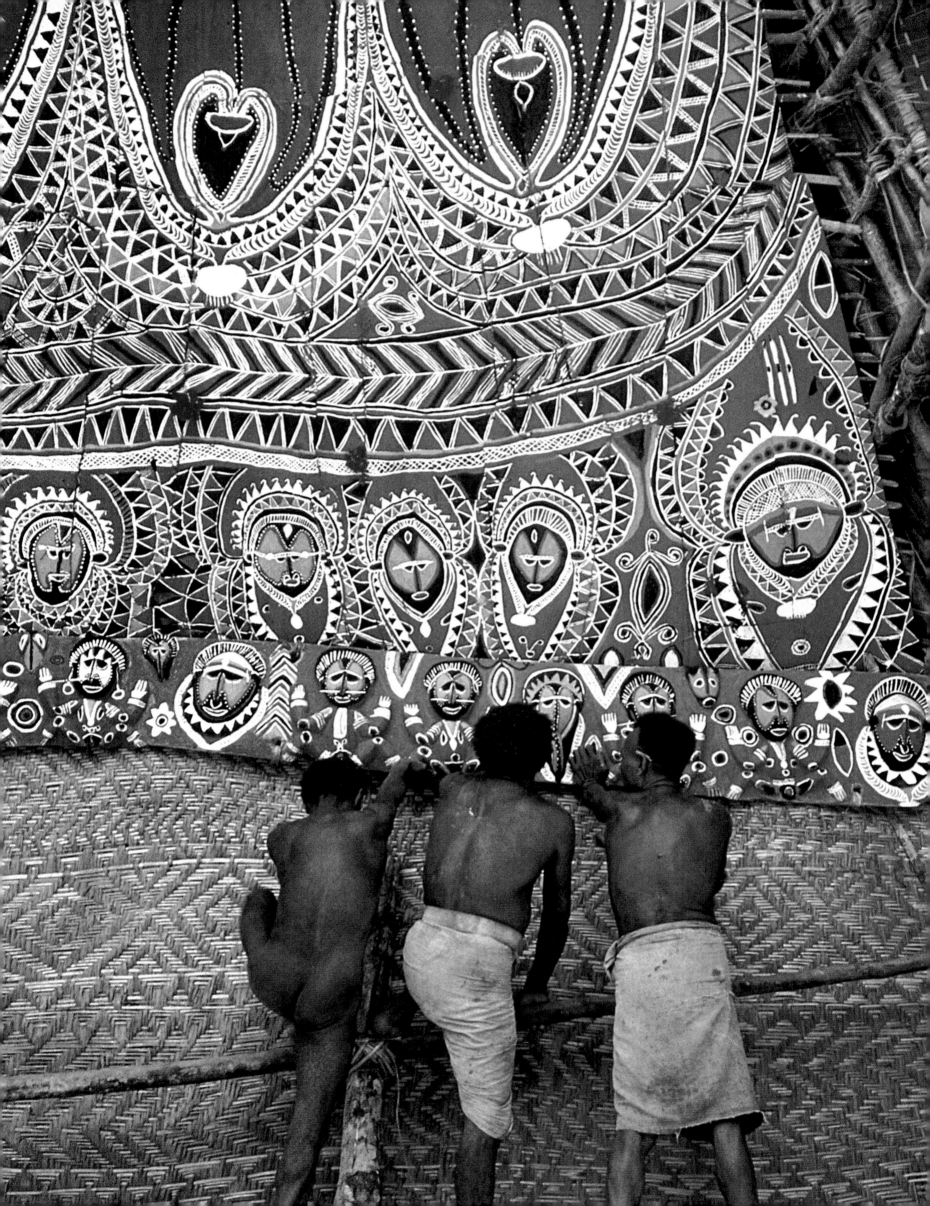

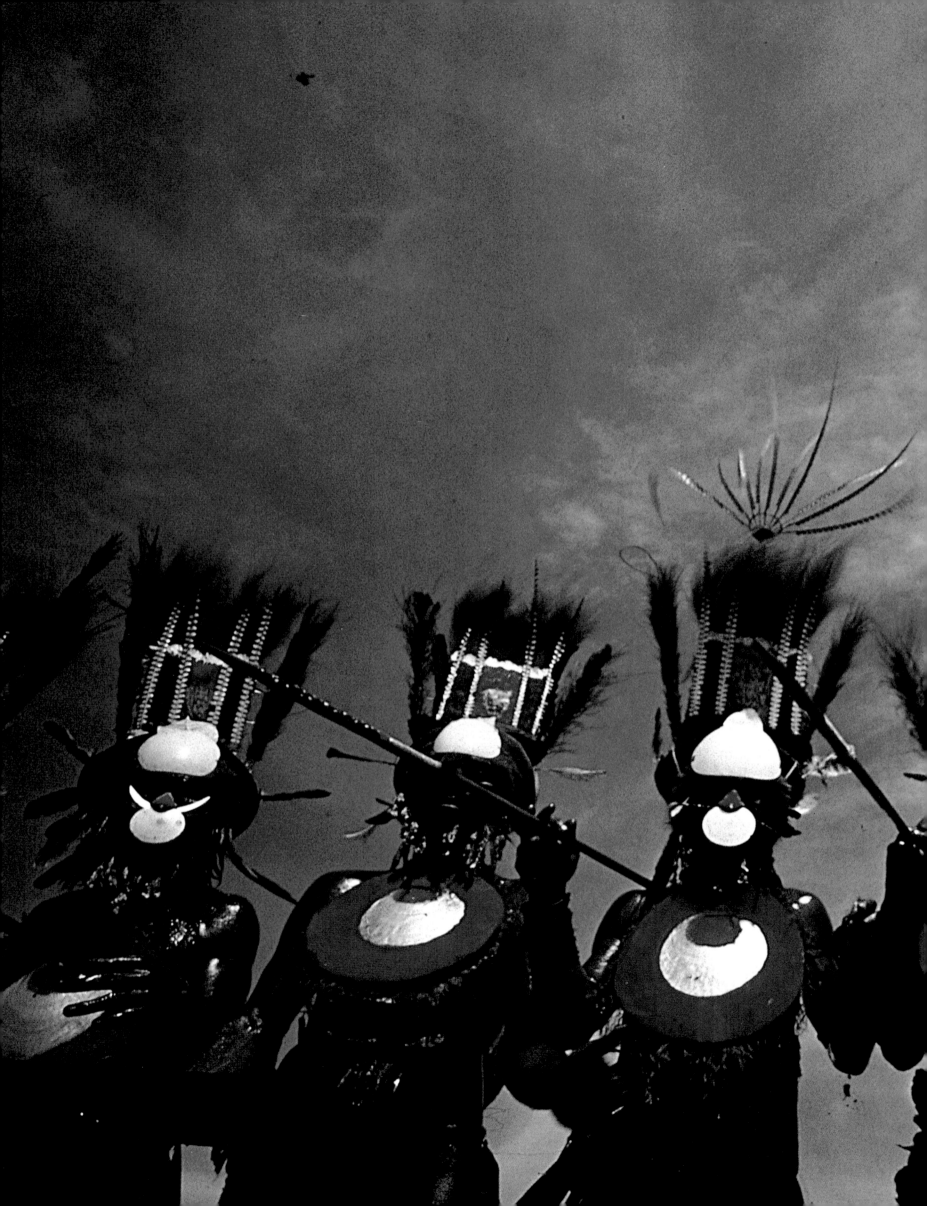

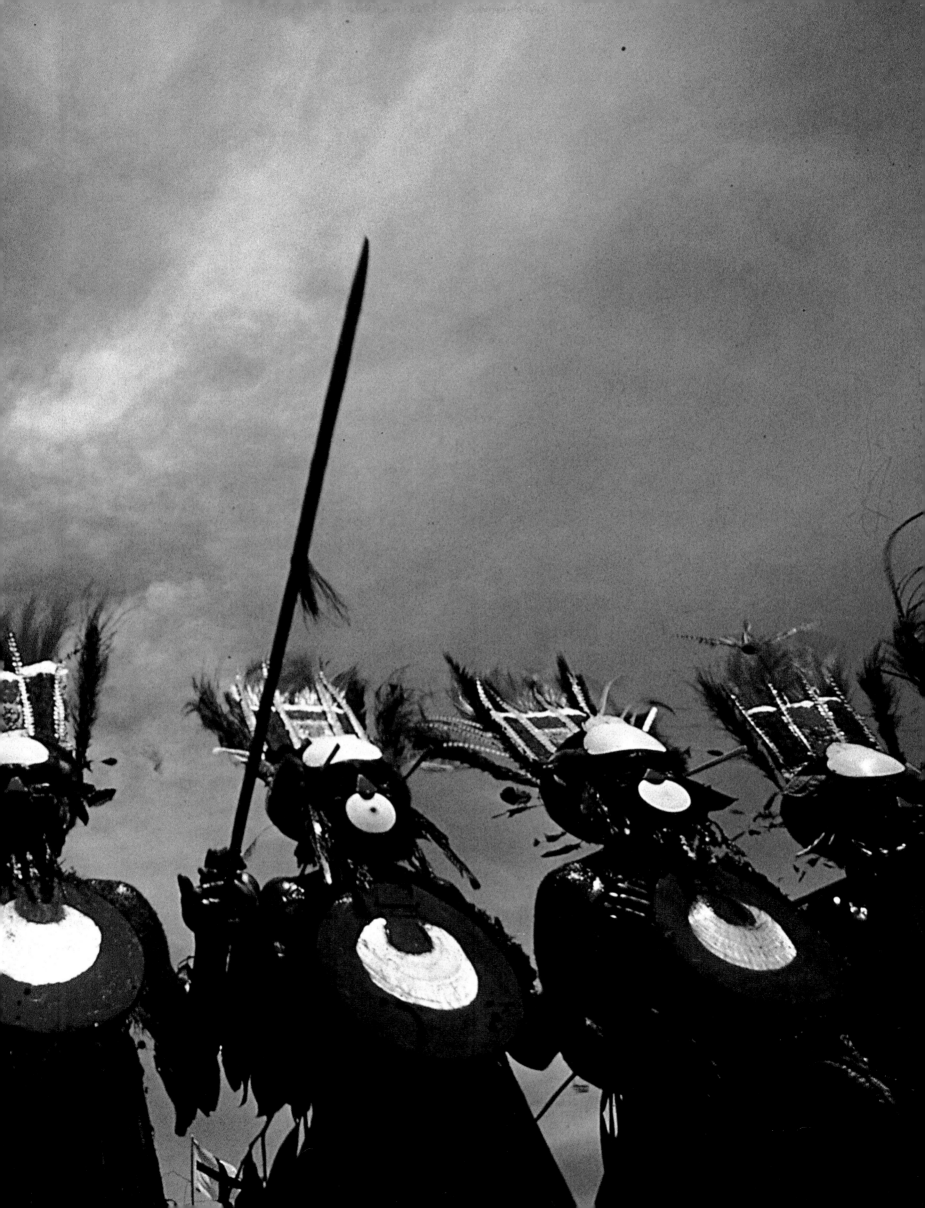

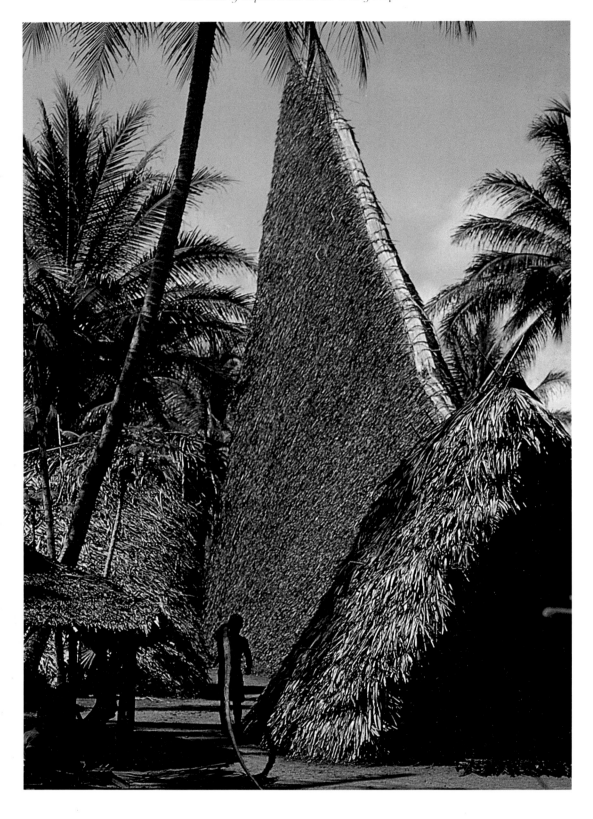

Right page: A highland dignitary.

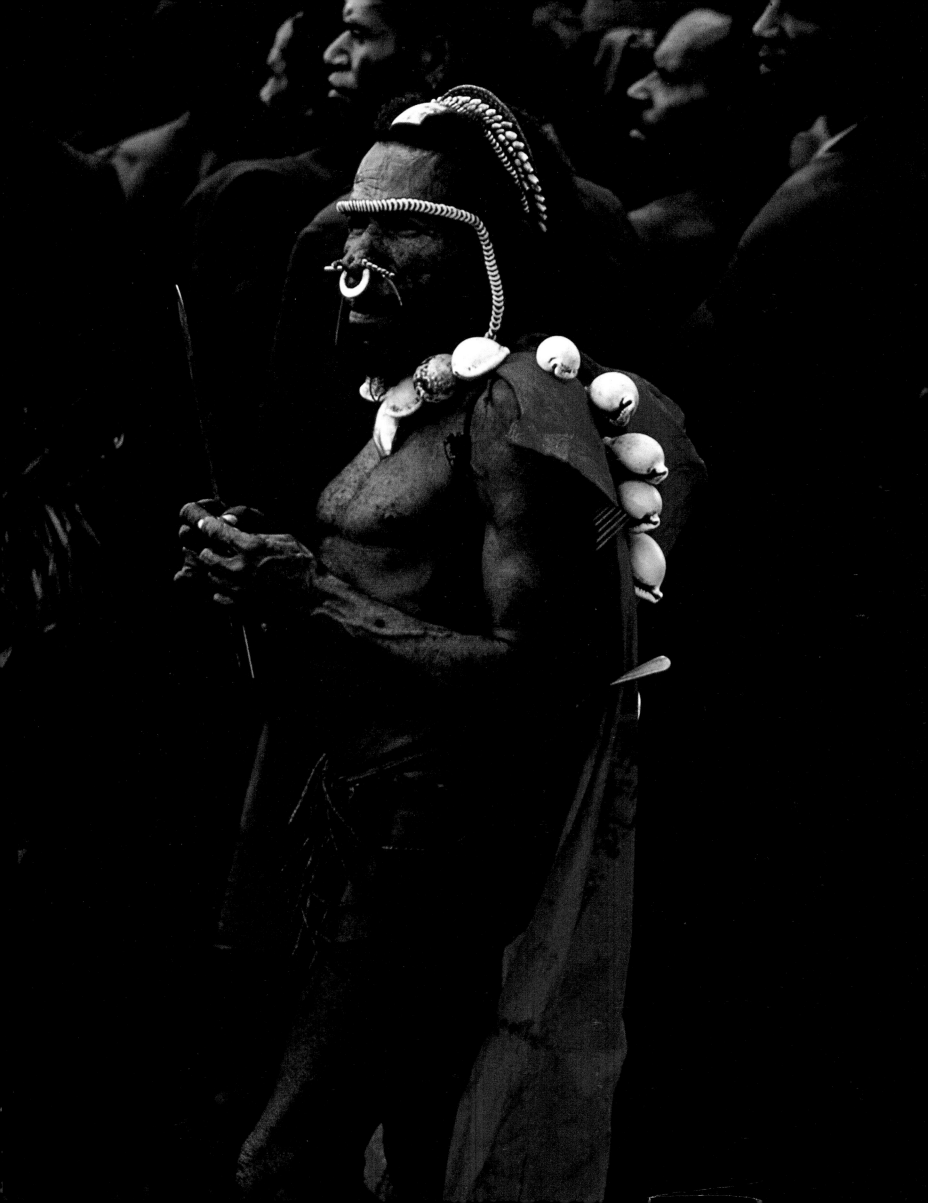

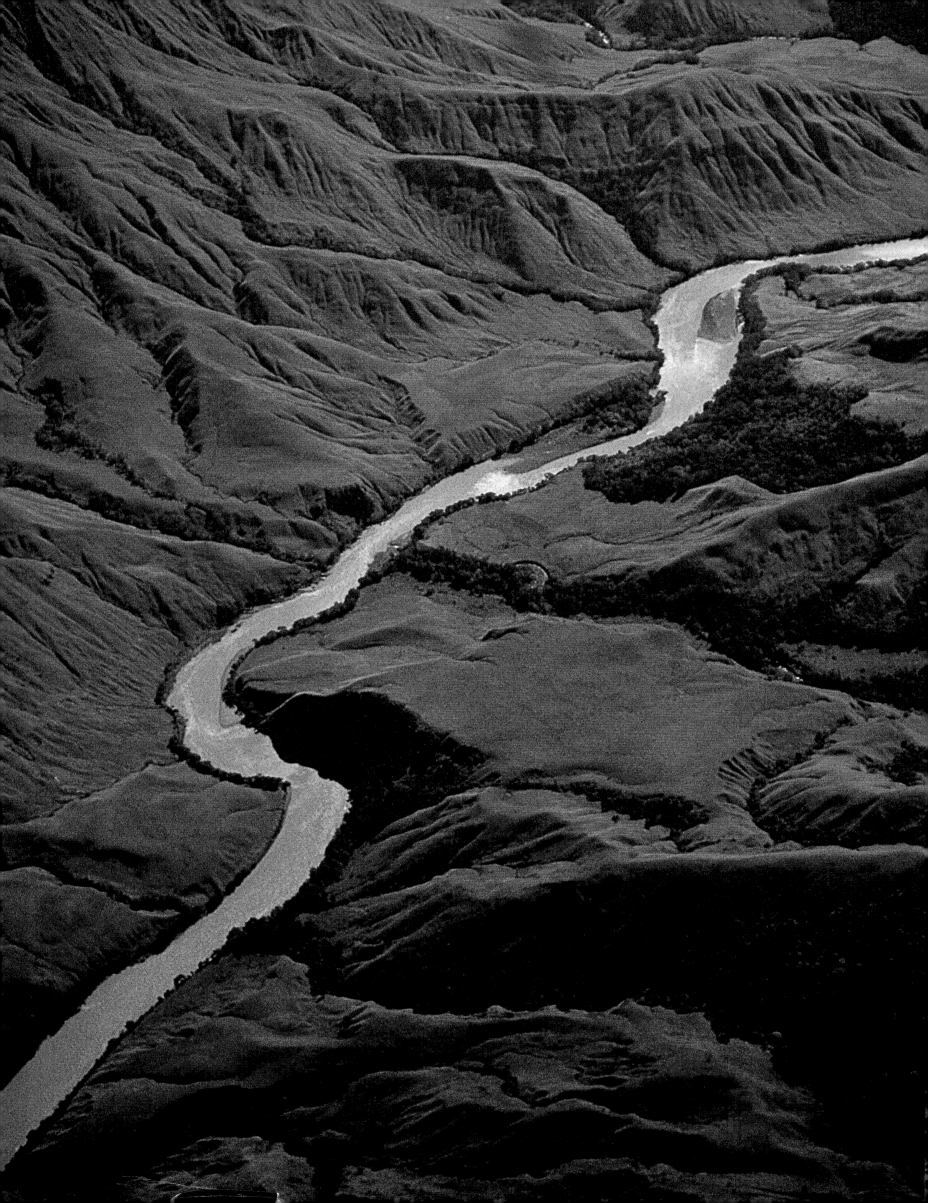

Gathering of spectators at Mount Hagen sing-sing. This is a very rare and unpredictable occurence coming every six or seven years. At a sing-sing, the host tribe displays its wealth of feathers and shells and kills an enormous quantity of pigs.

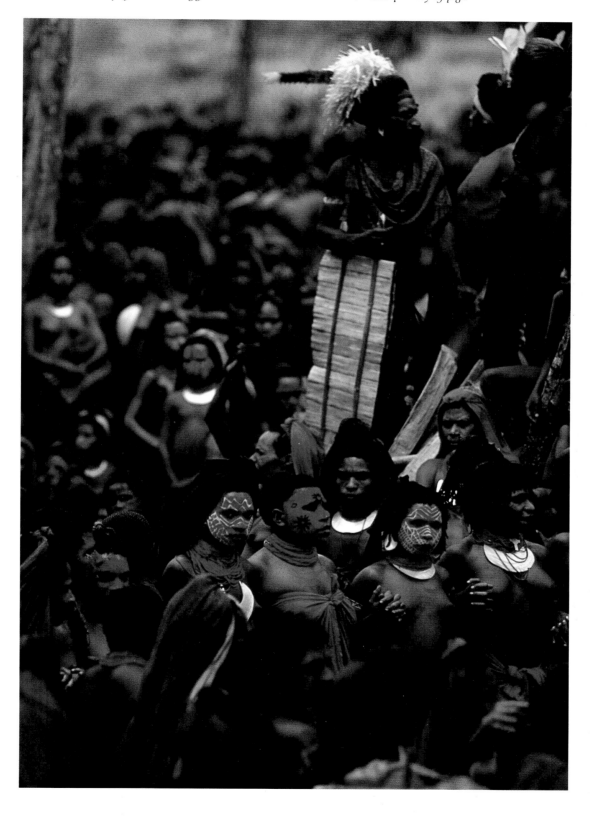

Left page: The river flows through the foothills down to the sea.

Next page: Mountain people in their daily garb walking across the ridge in an area near Mount Hagen.

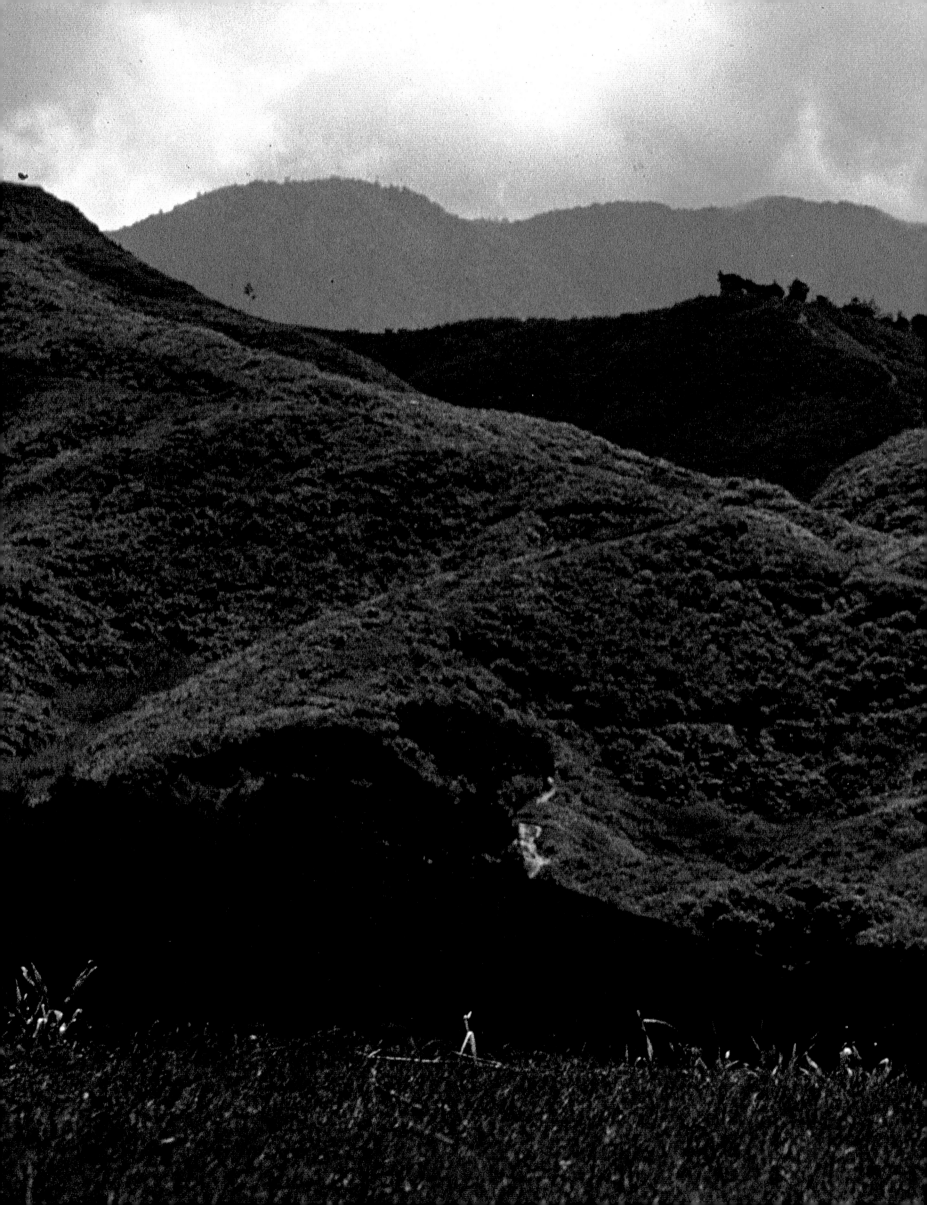

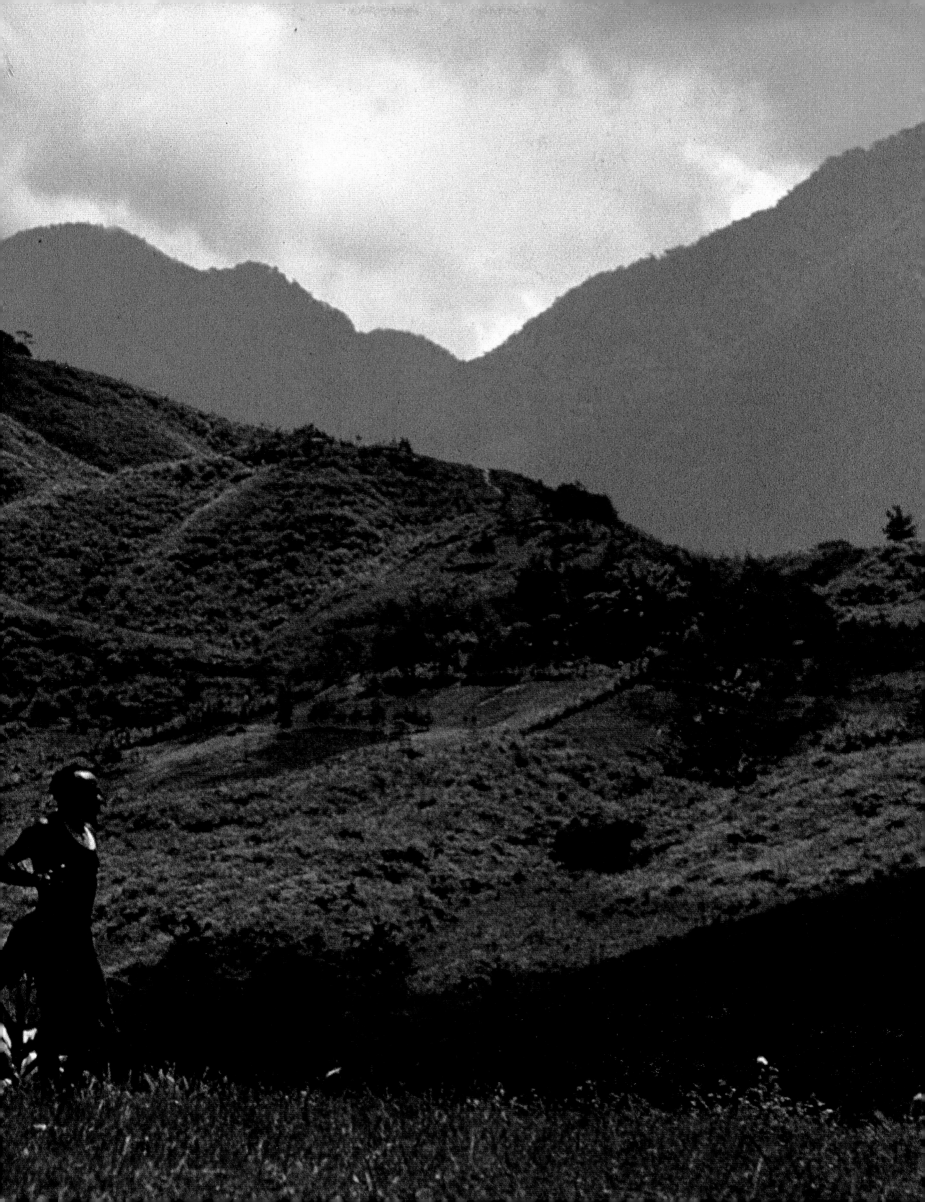

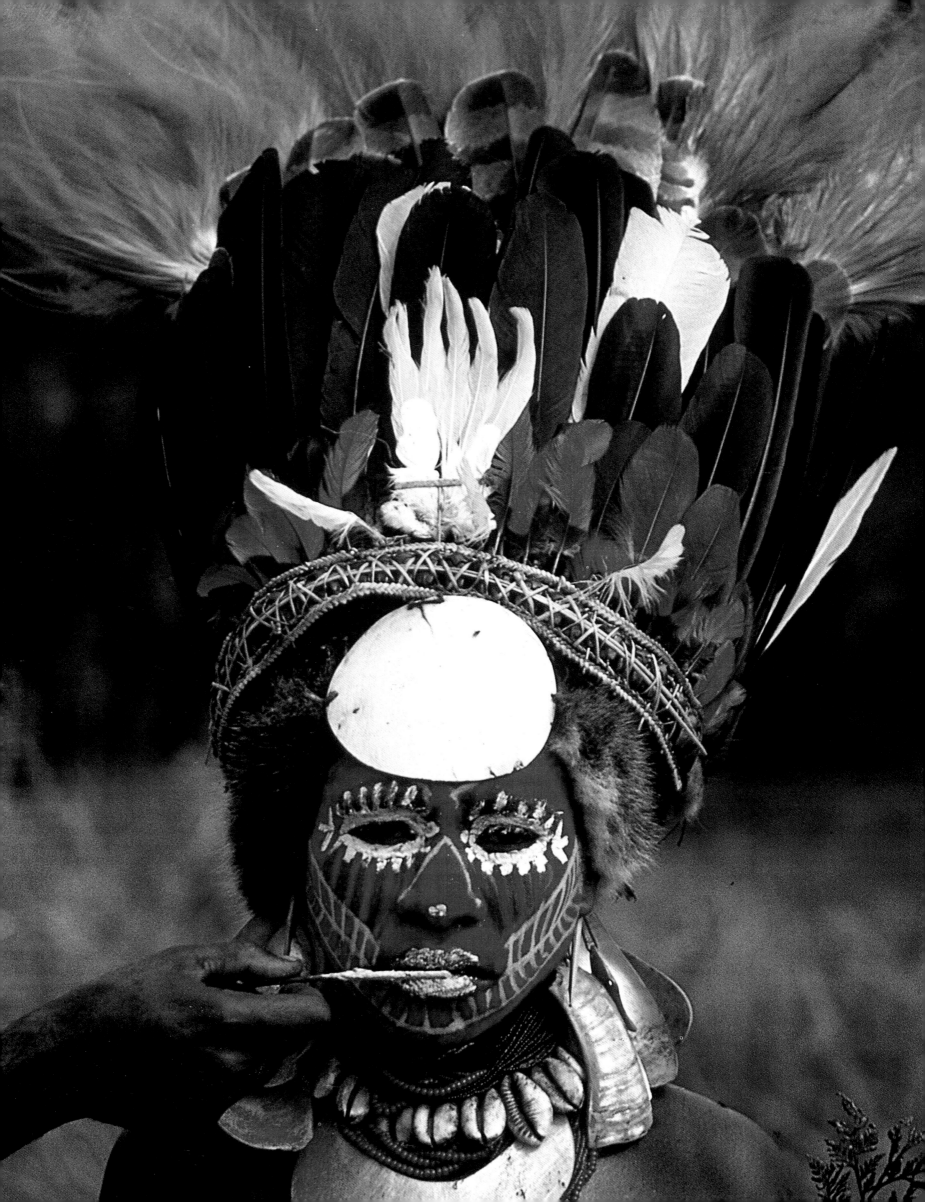

Left page and below: Front and back view of woman. She is painting herself for the Mount Hagen sing-sing. Her headdress consists of eagle plumage and Greater Bird of Paradise feathers. The shell necklace is a sign of great wealth but the plastic arm bracelets are the beginning of the end—the encroachment of the 20th century.

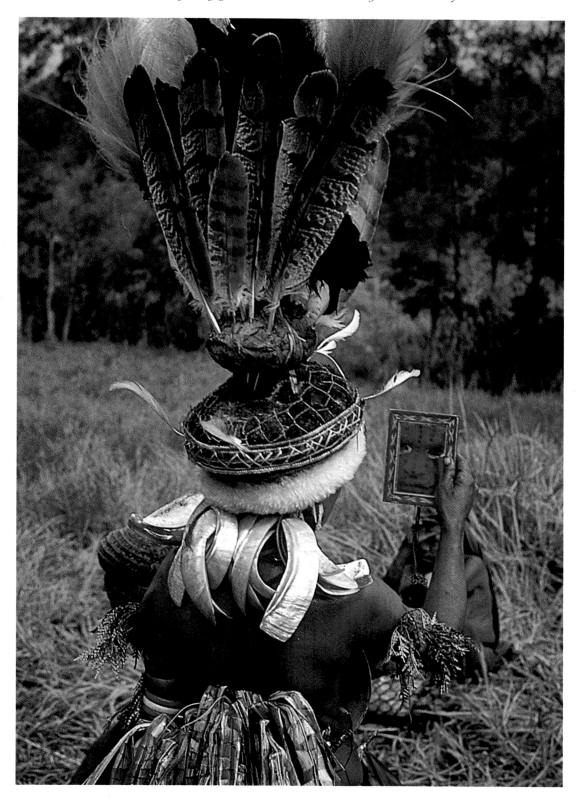

Next page: Mudmen from a village near Goroka in the highlands. They are made up to represent spirits and ghosts and perform a kind of danse macabre *before ceremonies. This one preceded a village pig killing.*

173

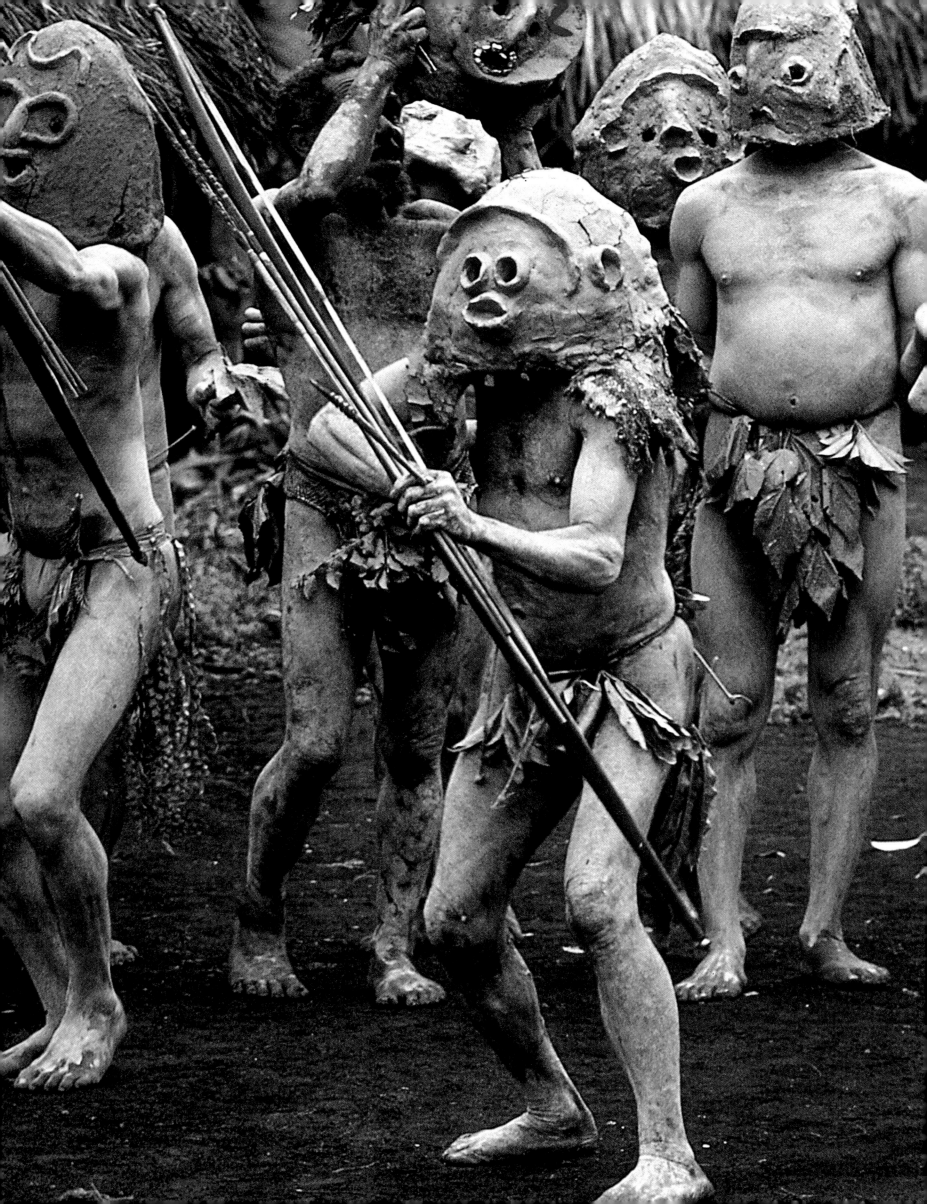

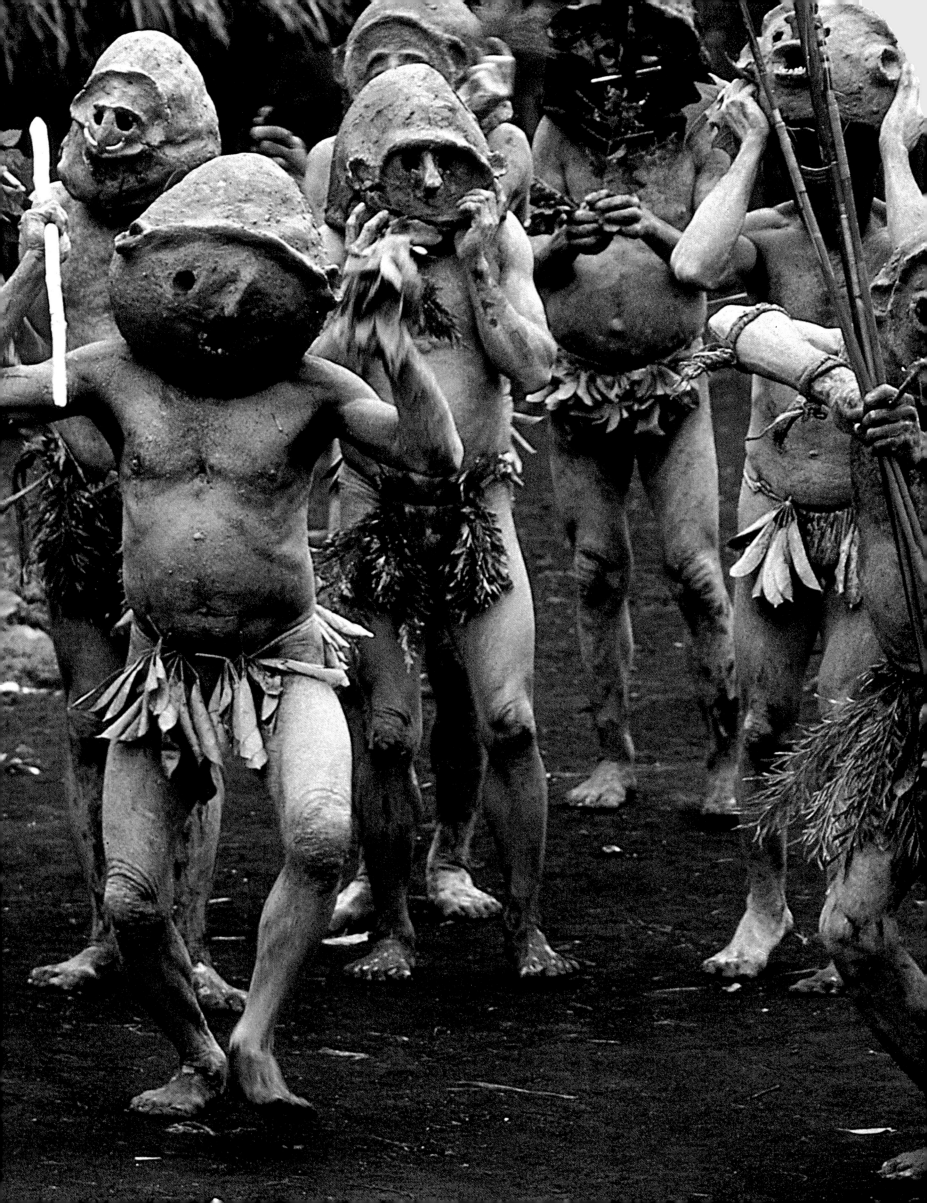

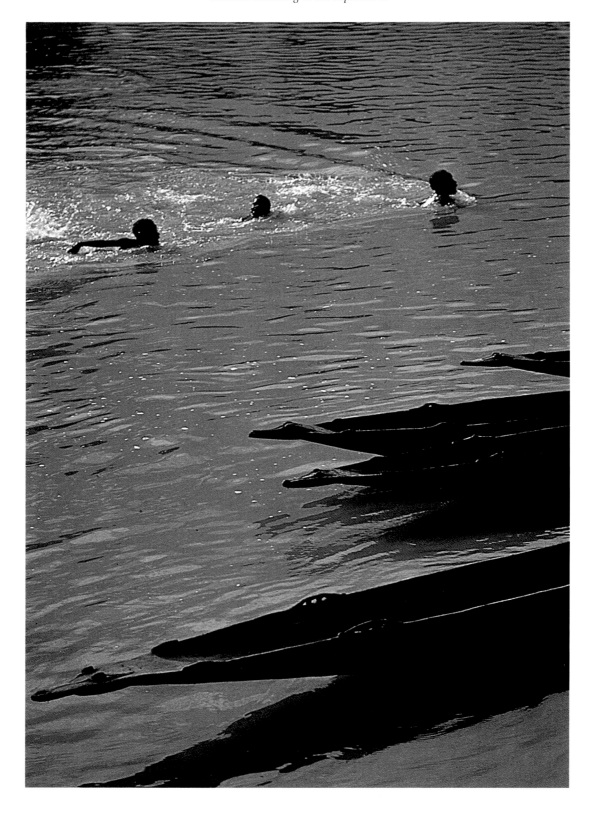

SAH

KAZUYOSH

ARA

I NOMACHI

From time to time I hear the desert calling me.

The voice haunts me deep in the night, when I sit exhausted, lost in a maze of thoughts, and putting away my pen, take an absent look at the twinkling lights of distant buildings. Once captivated by the desert, you find yourself aching for it when you are returned to the routines of urban life. You become aware of the vacuum within yourself. It sounds like wind blowing over the horizon, or sand running down a slope. It is the desert syndrome, incurable unless you stand on that blank horizon.

My first contact with the Sahara came thirteen years ago. I was without any particular purpose, but an obscure urge drove me south across the Algerian Sahara. When I cleared the Atlas range, the horizon suddenly unfolded before me. To be honest, the sight of the infinite blue of the overhanging sky frightened me. The straight line of the asphalt highway looked as if it fell into an abyss. It was just a week's trip, but I was simply overwhelmed by the sheer expanse of the Sahara.

The more I knew of the desert, the deeper was my attachment to the life of the Taureg, one of the nomadic tribes of the area, known by the veils they wear. Until the French came and settled there, they had long controlled the camel routes. They had lived a life as free as the wind. Closed to the outside world, they kept tradition and lifestyle intact as they wandered.

The Taureg men I met had piercing eyes. Their faces struck me as a creation that had been polished with sand and wind and the horizon's edge. Each of them wore a meter-long sword as he rode a camel across the desert—the figure of a lone fighter who was born out of sand only to return to sand.

The days of those Taureg now seem to be numbered. The serious drought during the past few years has left their precious wells, many of them as deep as a hundred meters, dried up, one after another, turning them into graveyards for the animals they herd. The once-proud Taureg will soon be gone, leaving nothing but the infinitely dry and blackish-blue skies.

I have been a witness to various dramas. A friend of mine, desert-possessed, took a lone trip across the Sahara on camelback. He died embraced by the desert. For another man I knew, traveling to the Sahara had become life itself. He would come home totally spent from the desert journey. Then he would work hard just to make enough money for another trip to the Sahara. He just could not help placing himself on that desert horizon. He would bring home stories about the sweat and dust he saw in the Sahara. When he resumed his life in the city, he would try to write more, only to realize that, once he left the Sahara, he had nothing worth writing about. Heaving a sigh, he would only listen to the voice of the desert rising from the blank page.

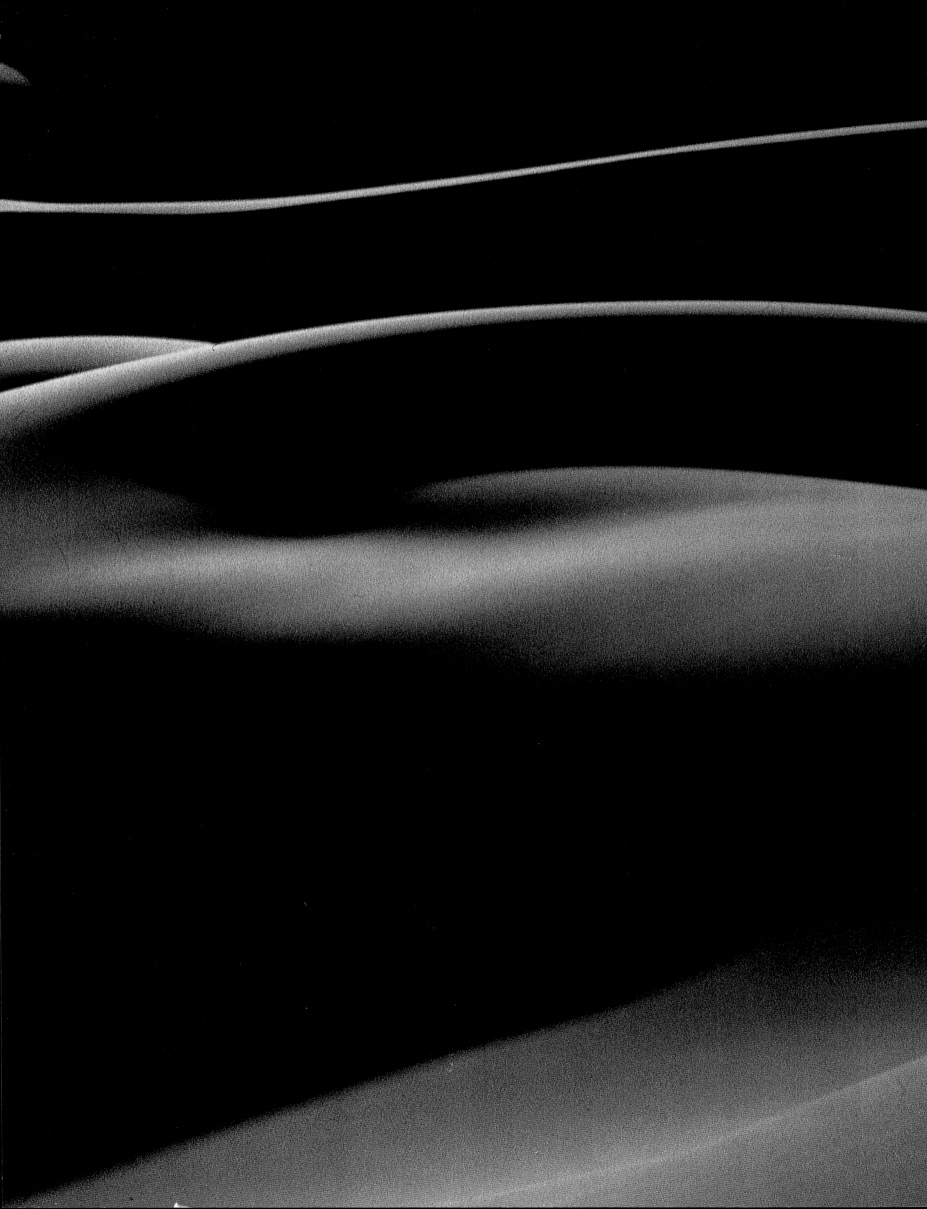

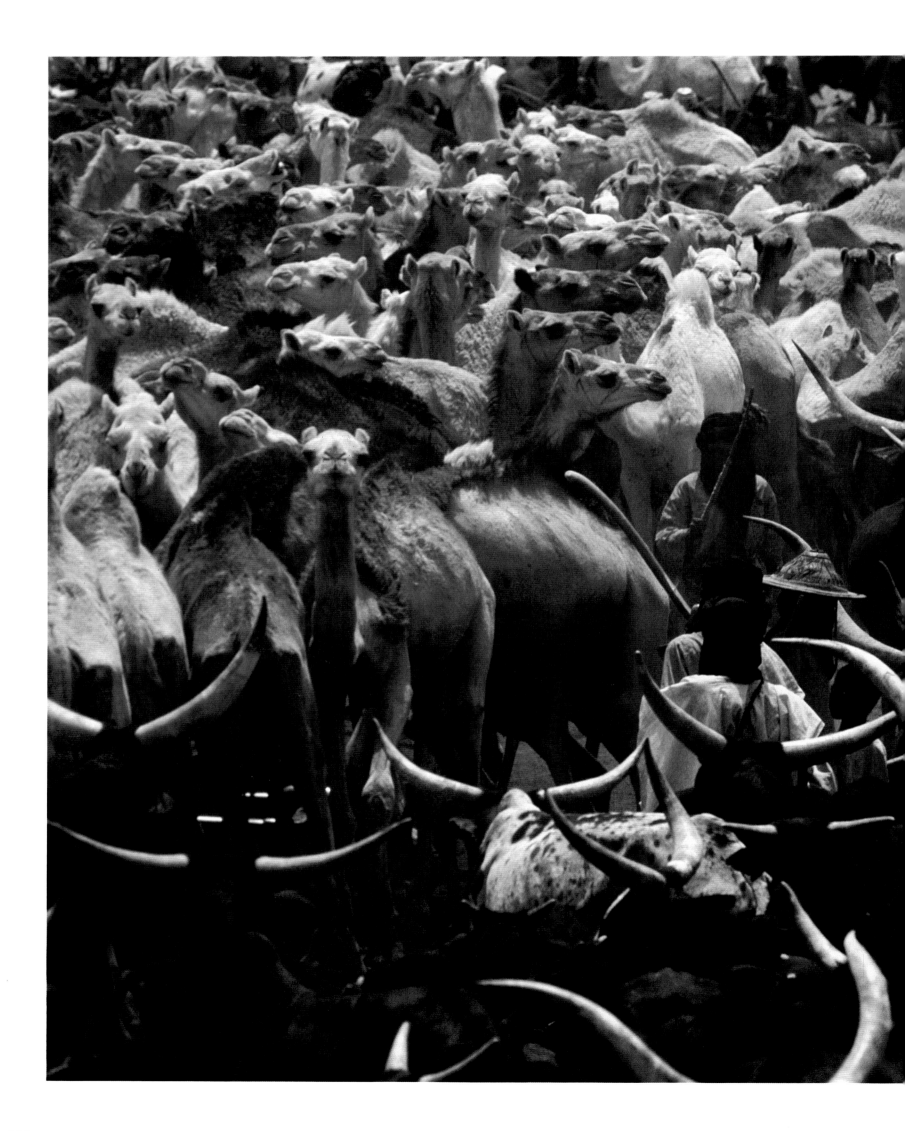

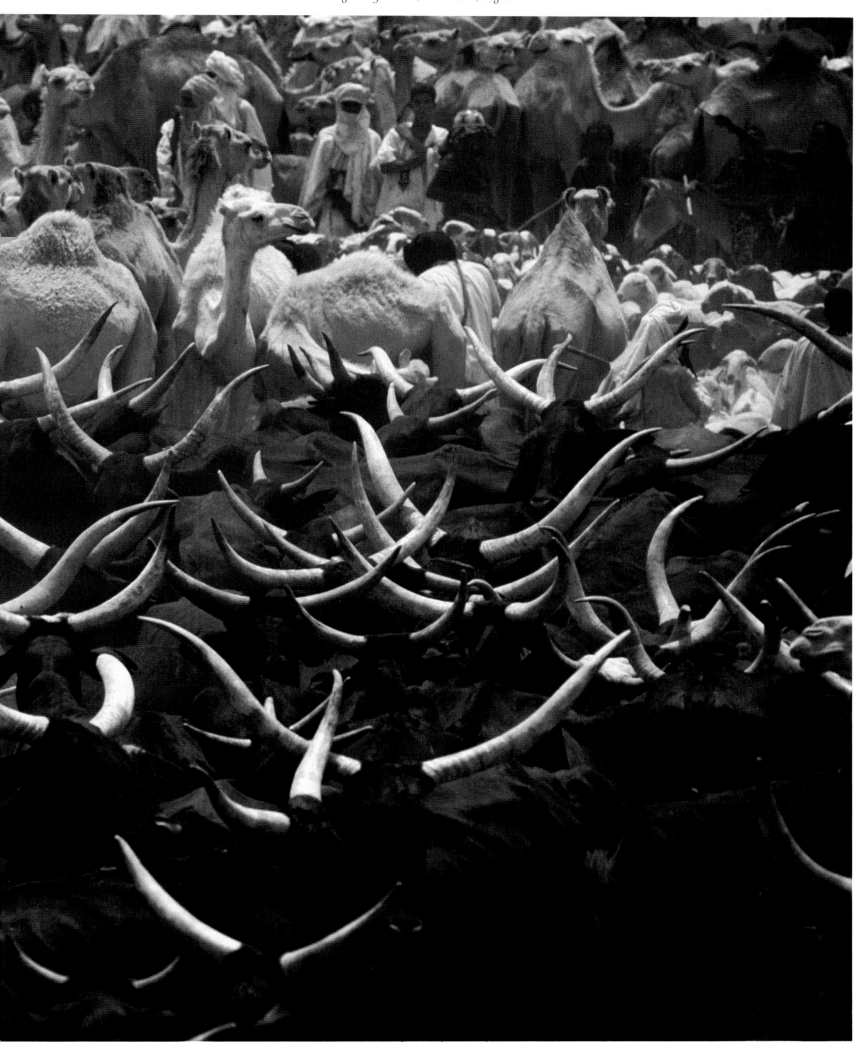

Cattle gather for water, near Tahoa, Niger.

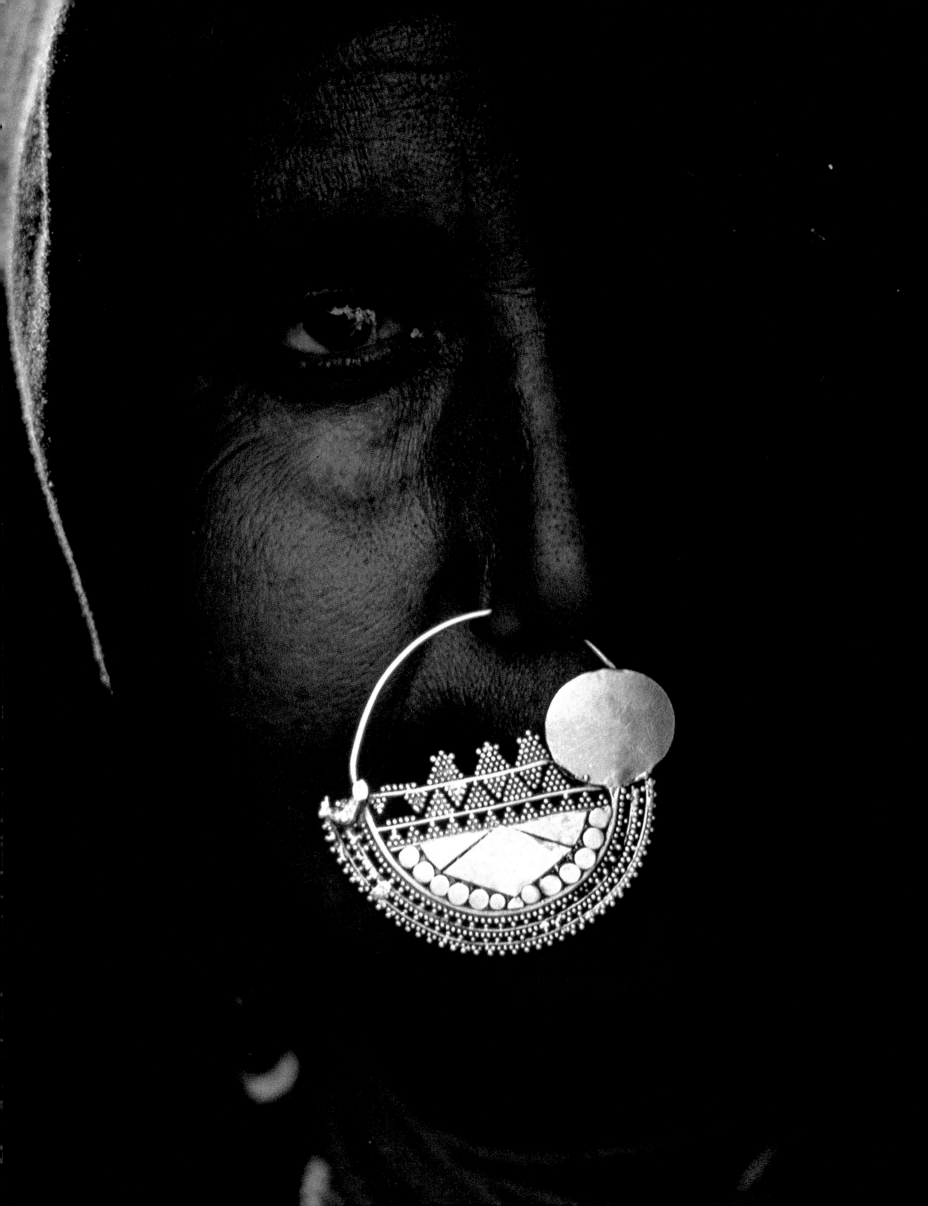

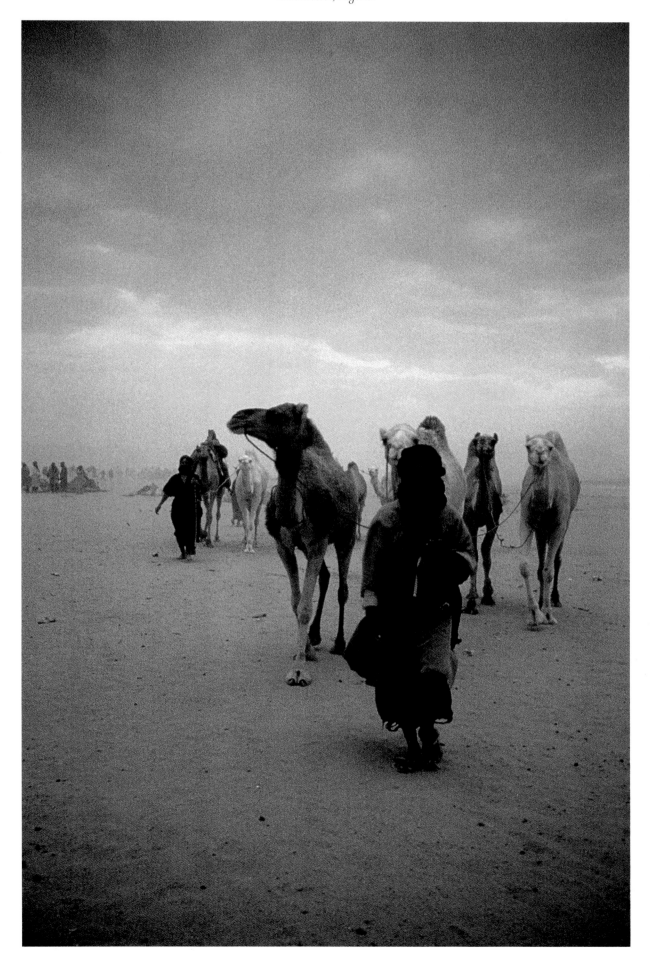

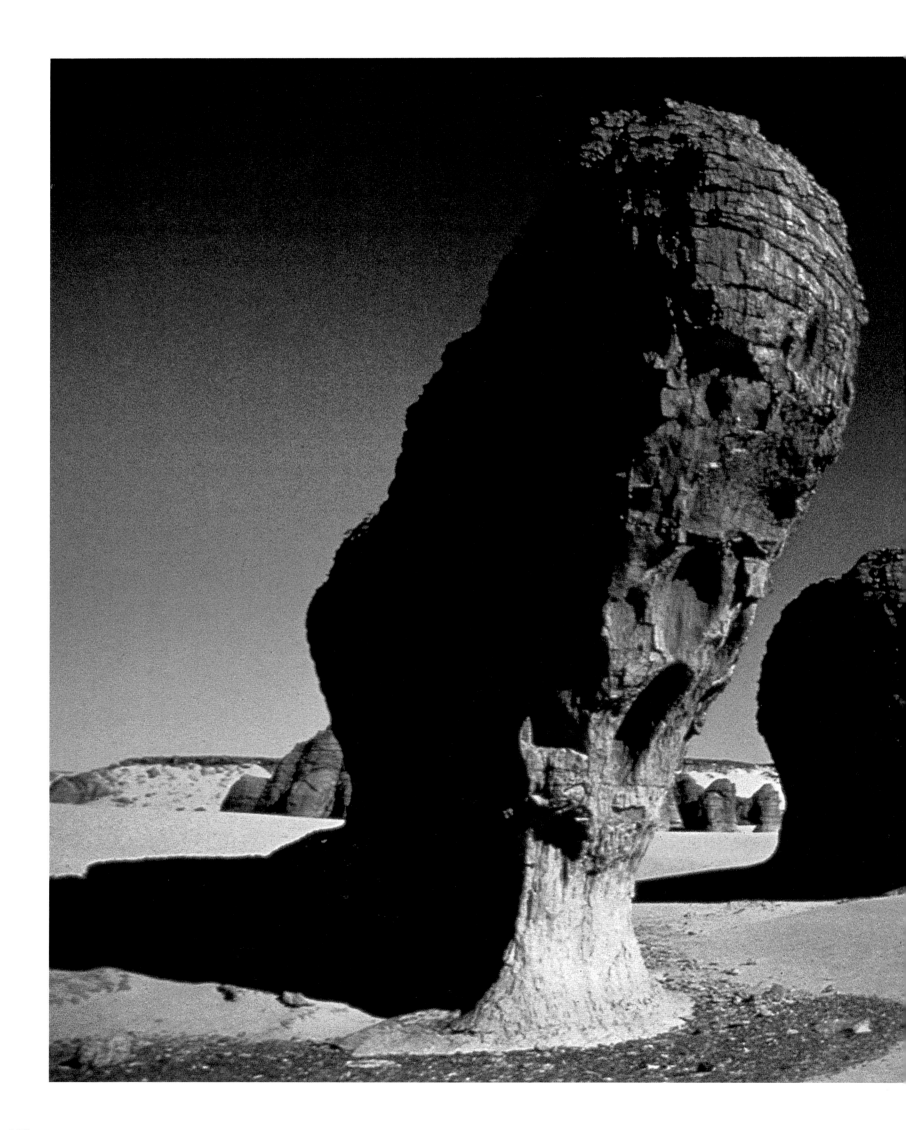

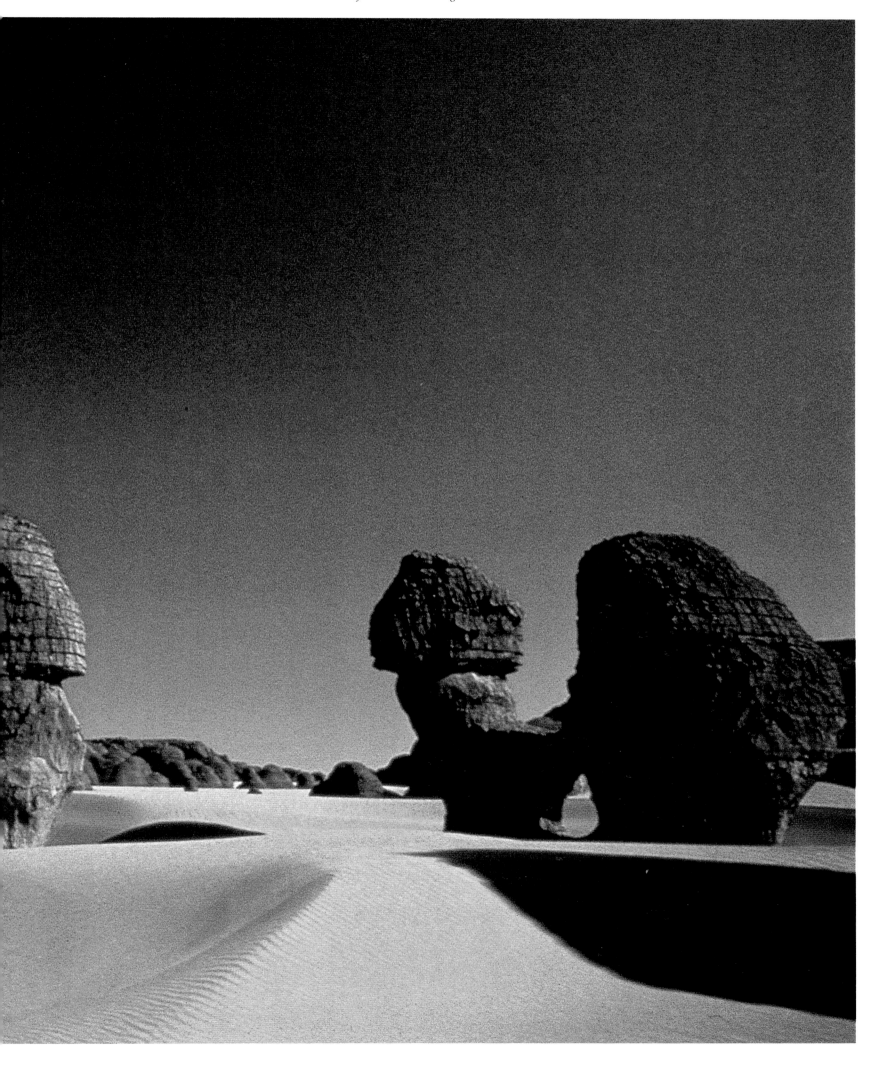

Sandrocks, eroded by sand, Southern Algeria near In-Guezzam.

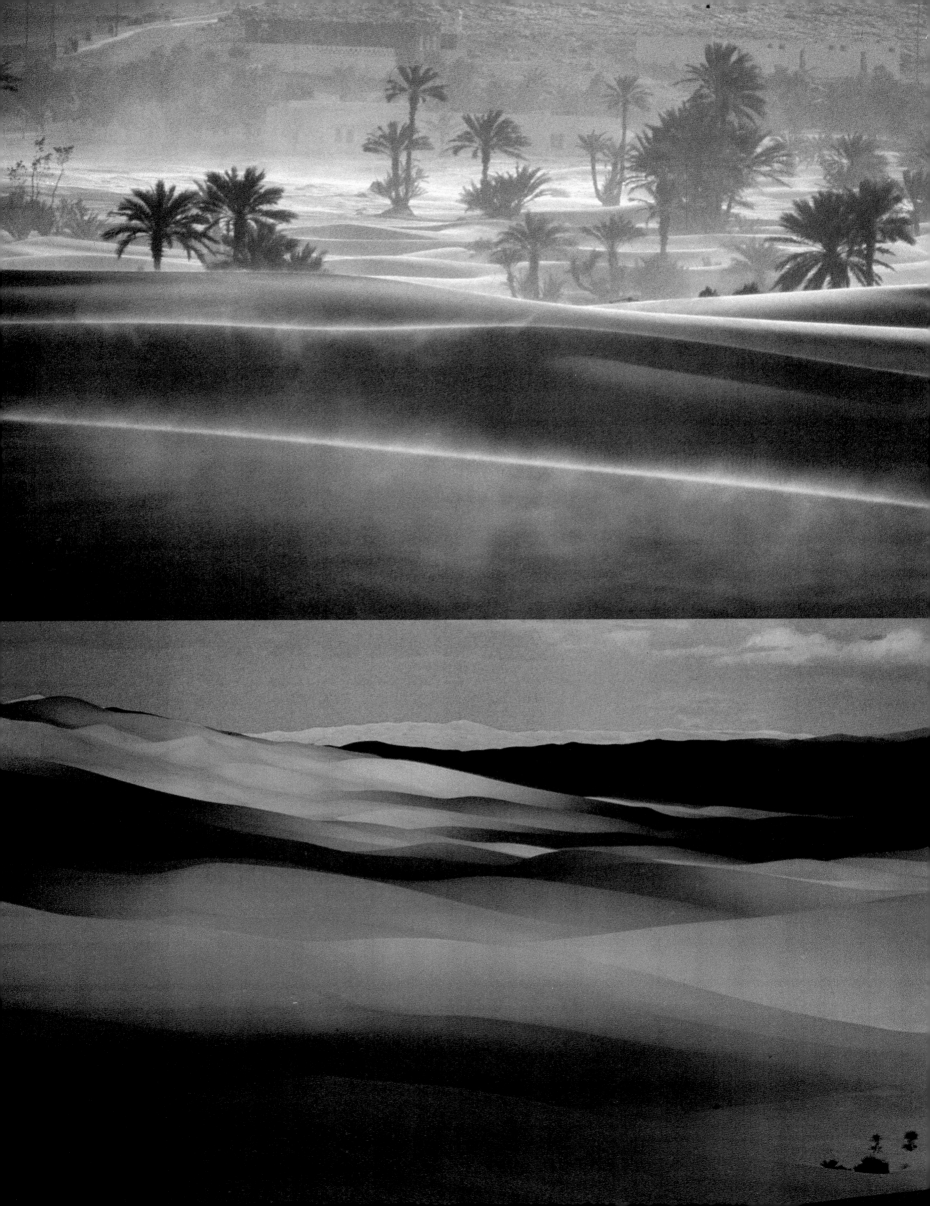

Taureg girl, Northern Niger.

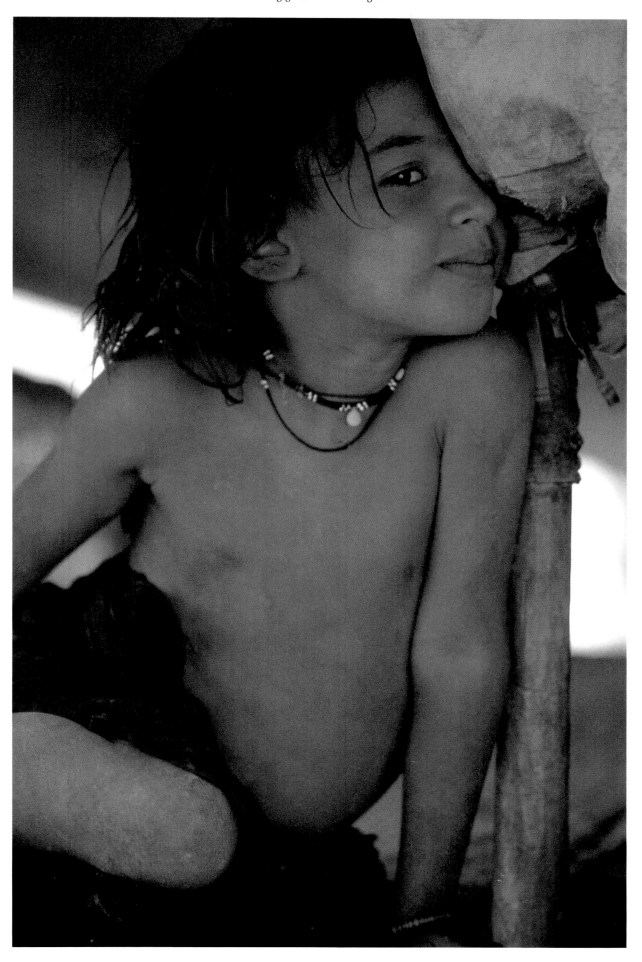

Left page, top: Oasis under sandstorm, Kerzaz, Algeria.
Left page, bottom: Grand Erg Occidental, Algeria.

Next page: Young Taureg, Tamanrasset, Algeria.

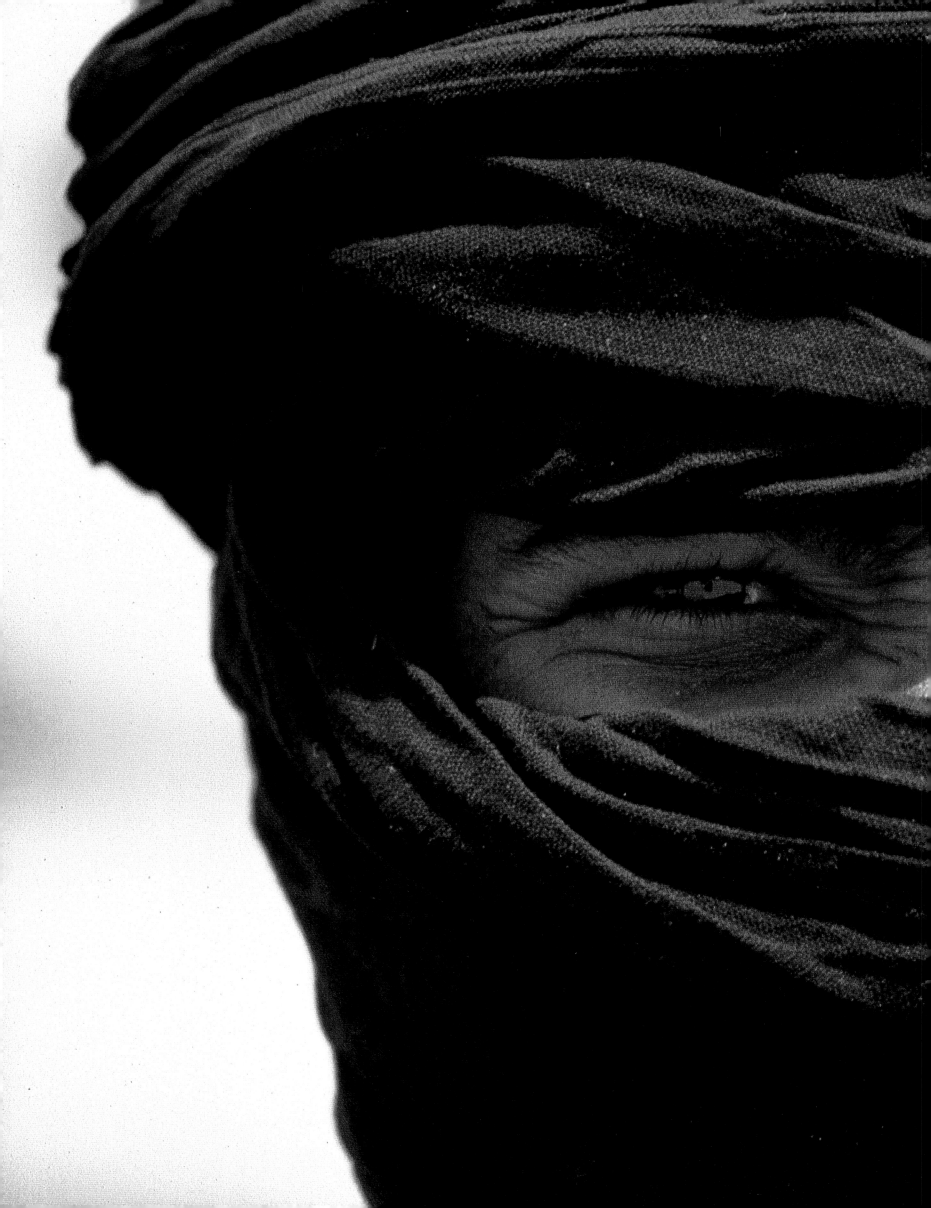

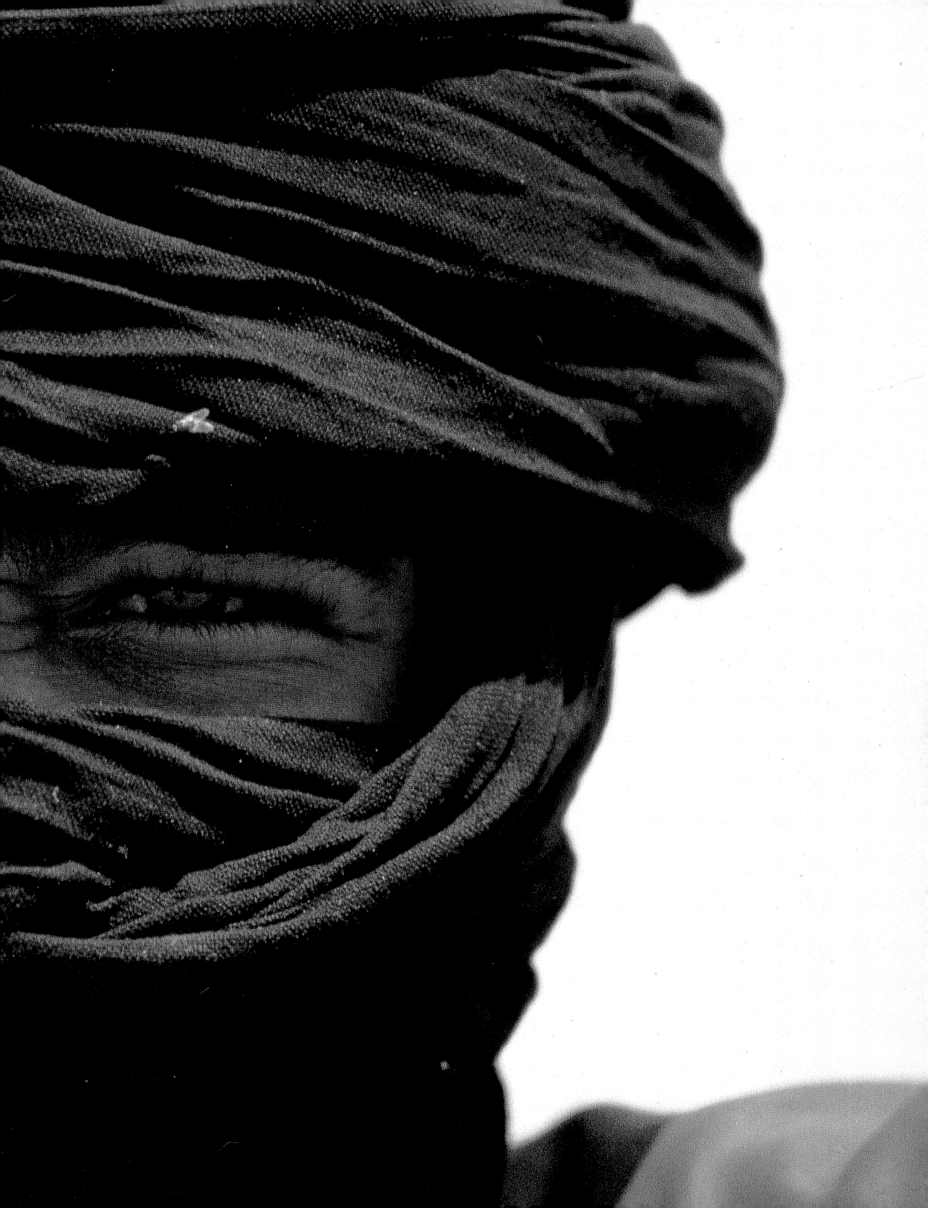

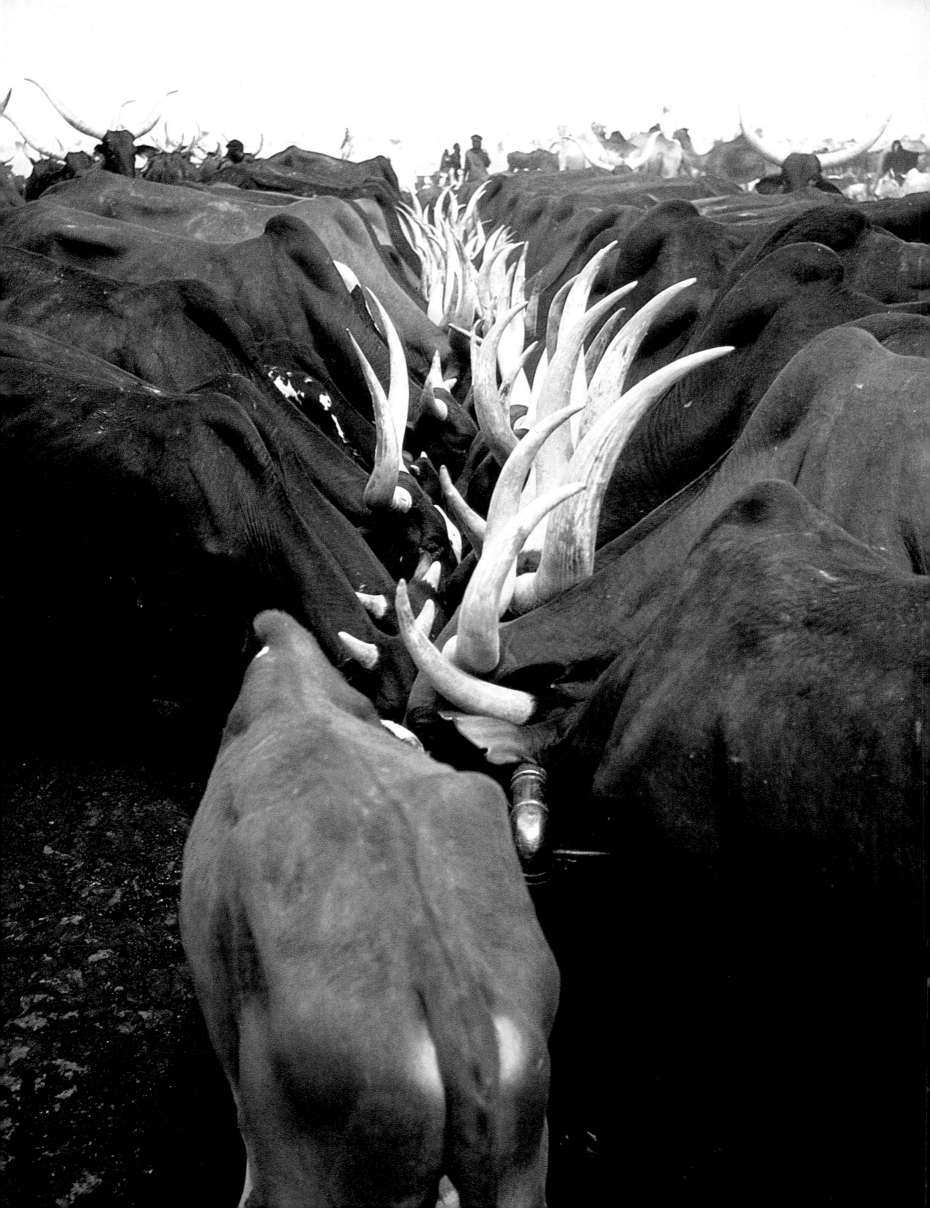

Leader of a camel caravan rests in the shadow of a camel.

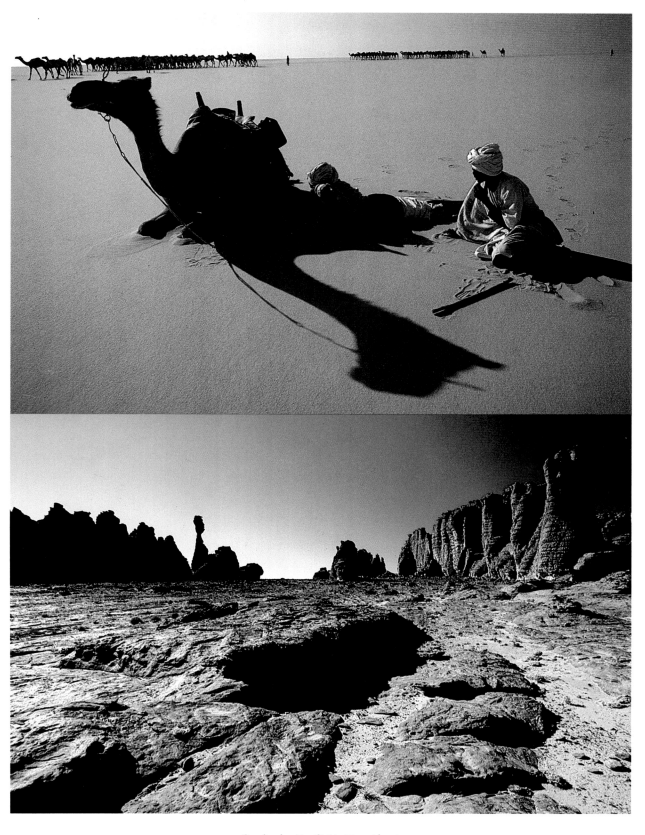

Sandrocks, Tassili-N-Ajjer, Algeria.

Left page: Cattle drinking water, Northern Niger.

Next page: Caravan consisting of 264 camels.

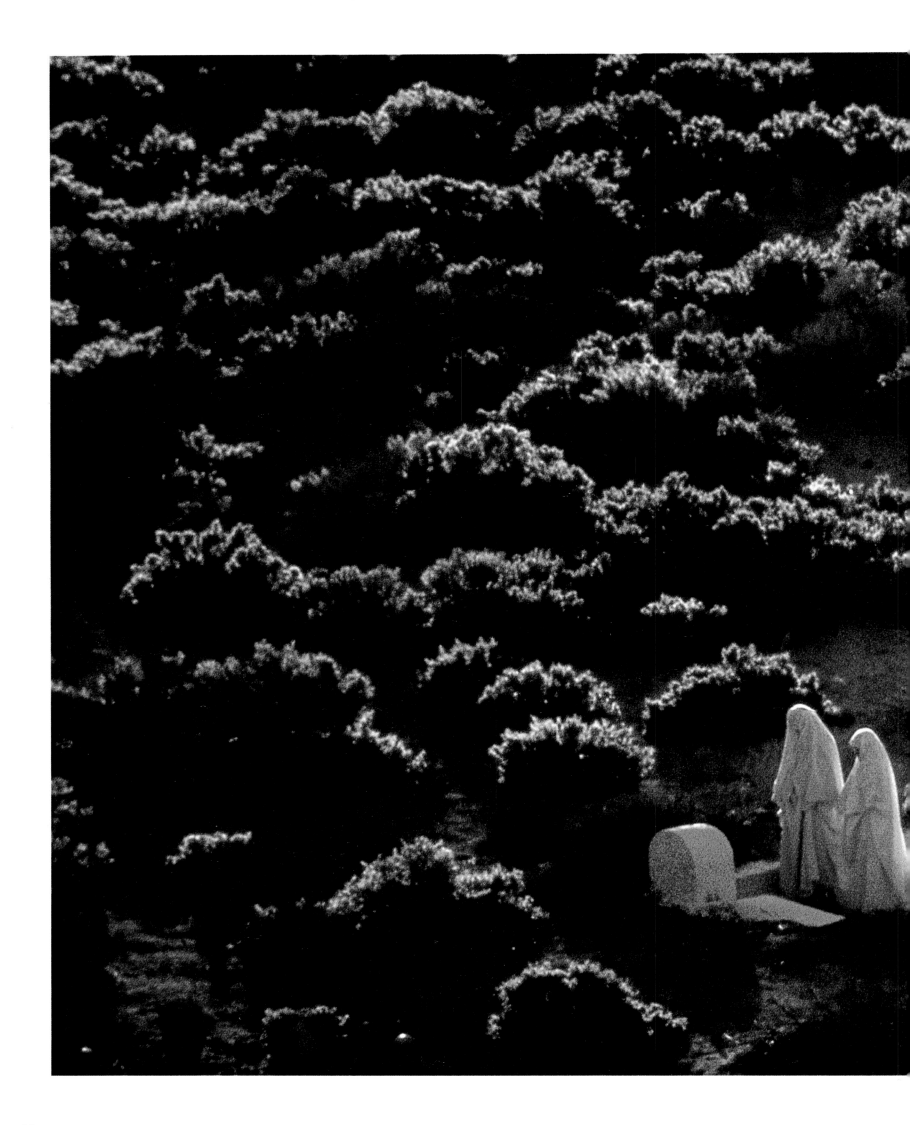

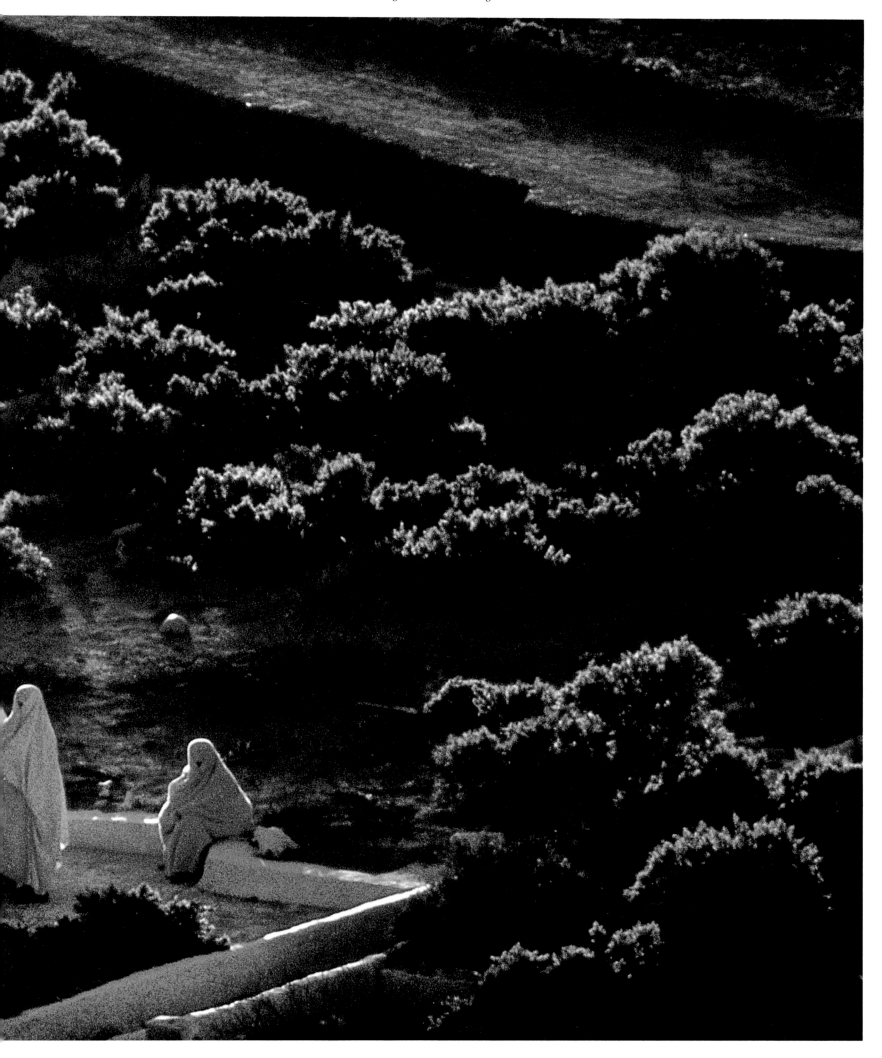

Women visit a grave, Ghardaia, Algeria.

A boy walks through shadowed sand dune, Kerzaz, Algeria.

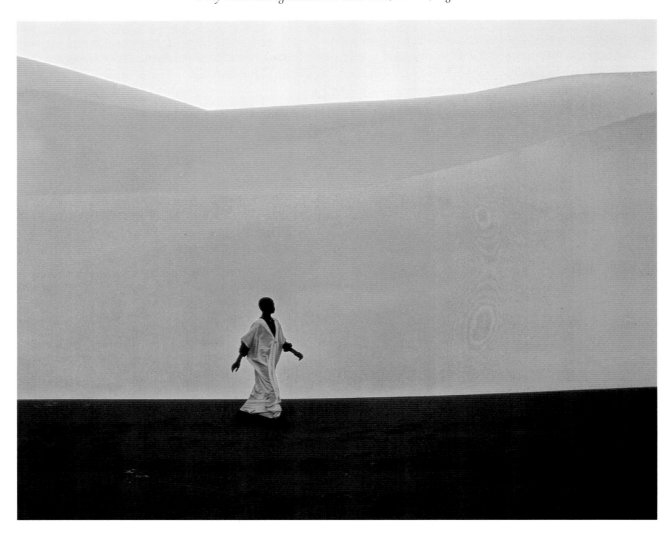

QUE

HIROJI

LIN

KUBOTA

I think I dreamed of Quelin before I saw it. It's possible. Quelin is a landscape that looks more like fantasy than reality. More likely, my dream came from something literal. Before I left for China, I was shown those famous paintings of the mysterious mountains of Quelin. Even though these works were hundreds of years old, and as far as I know, the artists couldn't fly, the mountains were painted from above. They captured my imagination and I knew then that I had to shoot Quelin from the air.

This was in 1979. China's door was opening very slowly, very cautiously. Chartering an airplane for photography was unheard of, especially for a foreigner. I persisted. I pushed. I cajoled. Finally, after receiving authorization from the Joint Chiefs, the Ministry of Foreign Affairs and the Central Committee, I became the first person to depict Quelin from the air.

Or maybe not. For when I went aloft, I was amazed by more than the spectacular landscape; those artists hundreds of years ago had gotten it exactly right! They seem to have painted Quelin's mountains from the seat of an airplane. Perhaps they *could* fly. Or perhaps Quelin does appear in our dreams.

Anyway once I had my plane I kept shooting. I went aloft again and again. They weren't the most ideal conditions, even for an experienced aerial photographer, (which I wasn't): a vintage biplane, an open door, shooting while held by parachute restraints, a large format camera, slow shutter speeds, always waiting for the plane's vibration to abate. But an opportunity like this comes along once in a lifetime. I didn't complain.

But it isn't just that opportunity and the mountains that make Quelin the most beautiful place for me; it's the people and their life. They give it a completeness. They make the fantasy of Quelin real. Mountain areas are often spectacular, but barren. Yet Quelin is lived-in, almost homey. Generation after generation has worked this land, through dynasties and revolutions, surrounded and inspired by these other-worldly mountains.

During the Cultural Revolution Madame Mao actually banned the scenery of Quelin. Nobody could visit it; it wasn't political enough. Perhaps she was right. Quelin doesn't inspire revolutions. What it says to us all is, "This too shall pass."

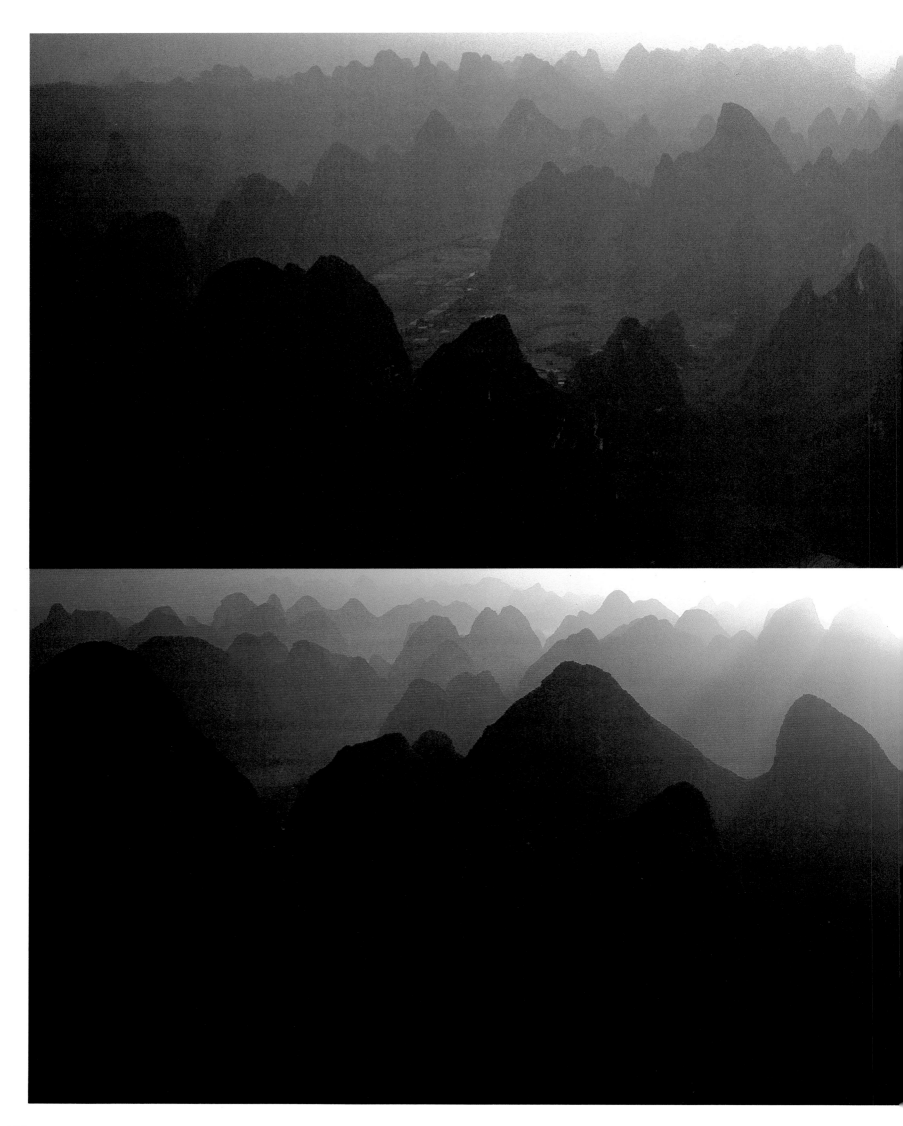

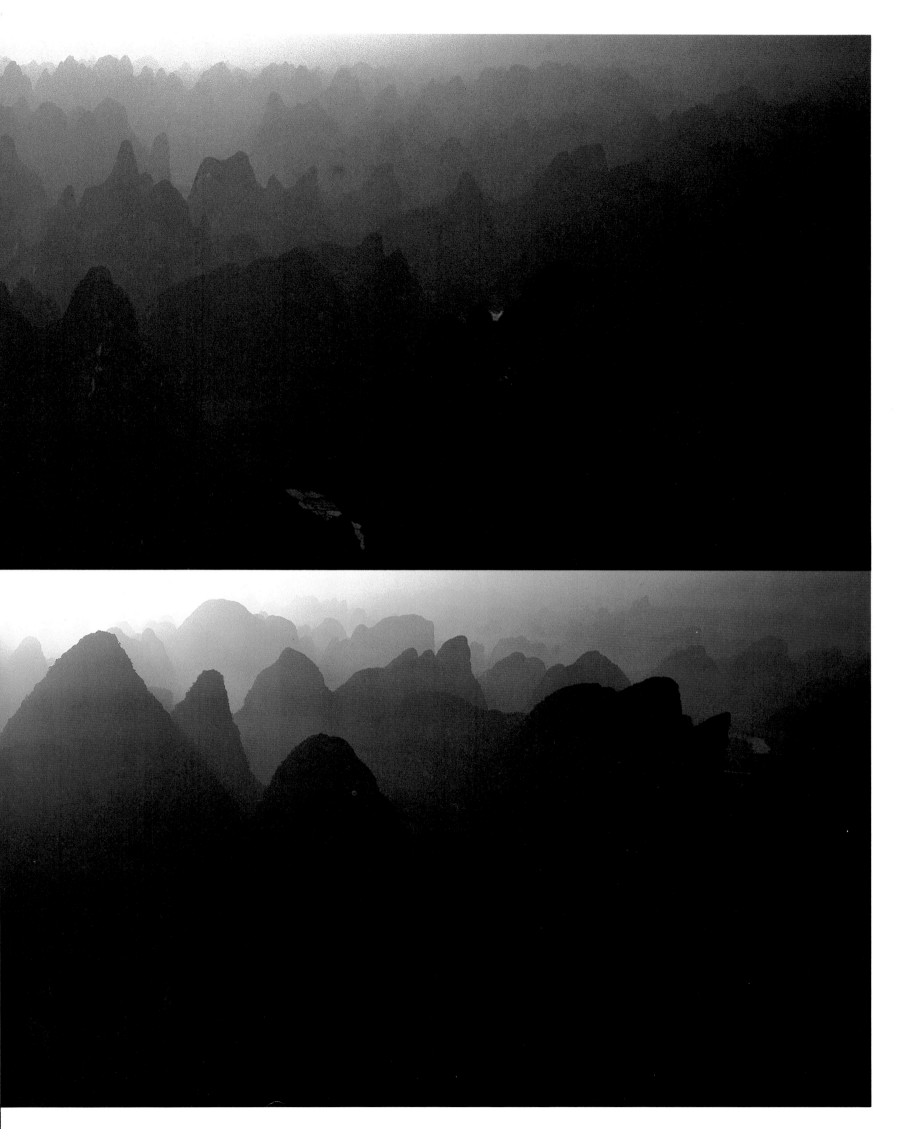

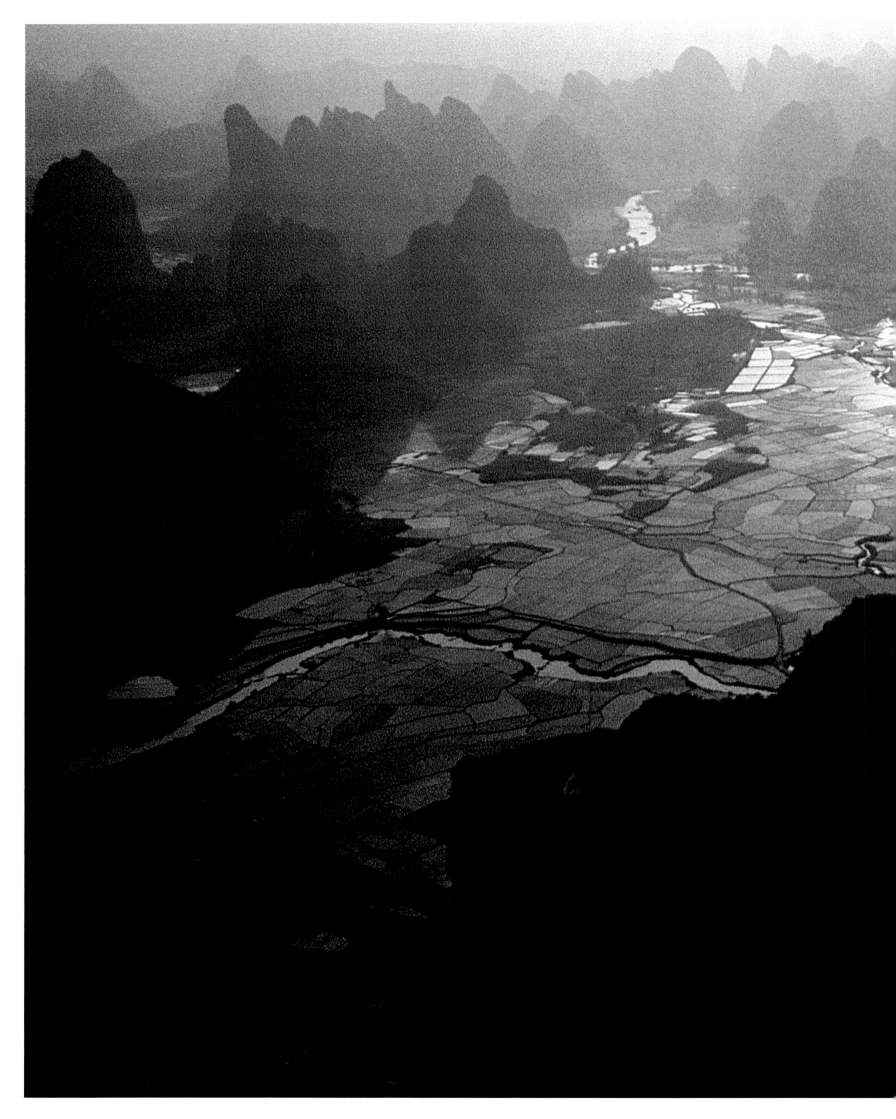

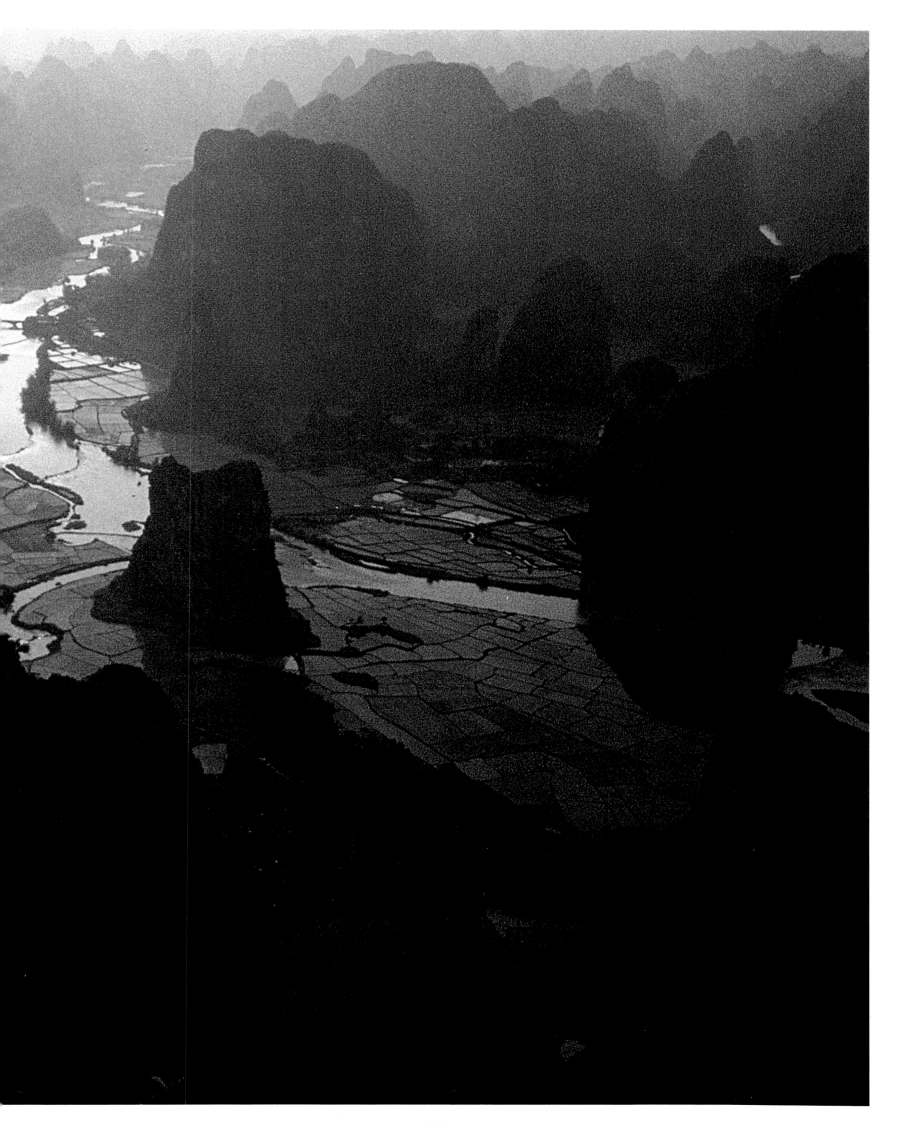

Gaotian: just before sunset.

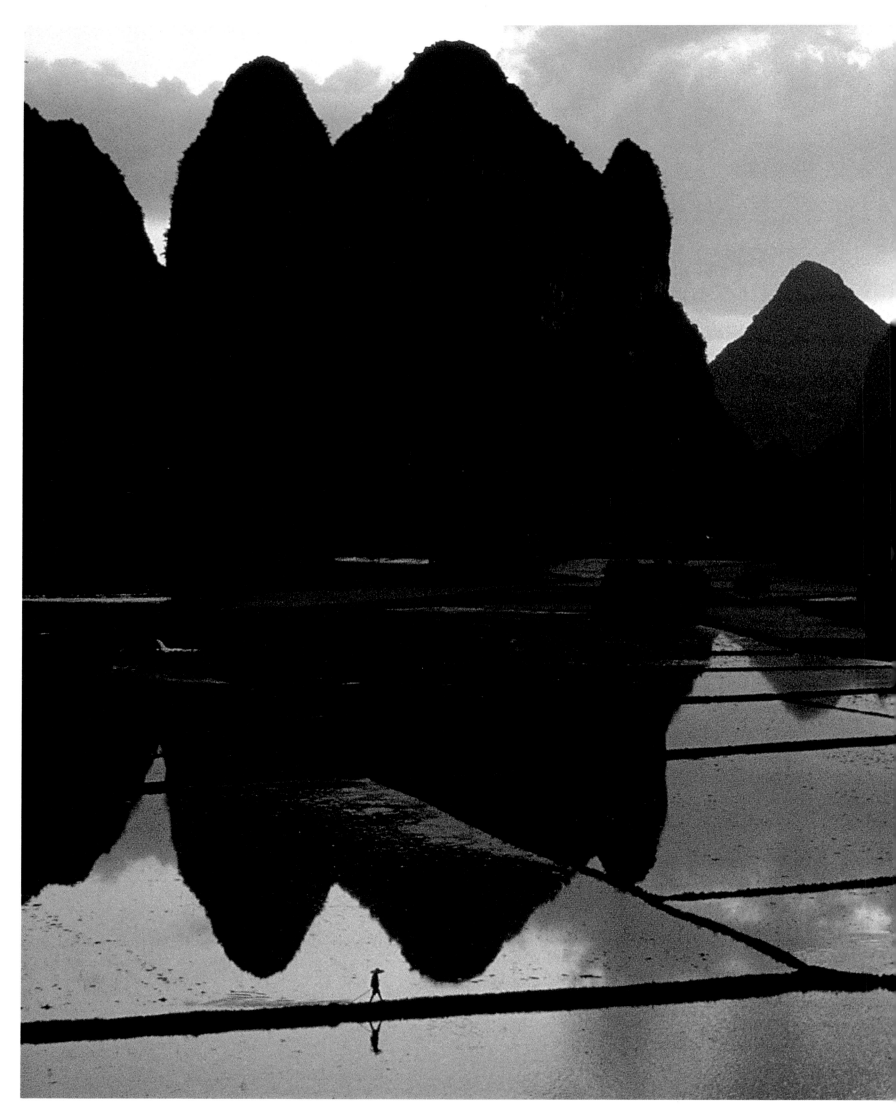

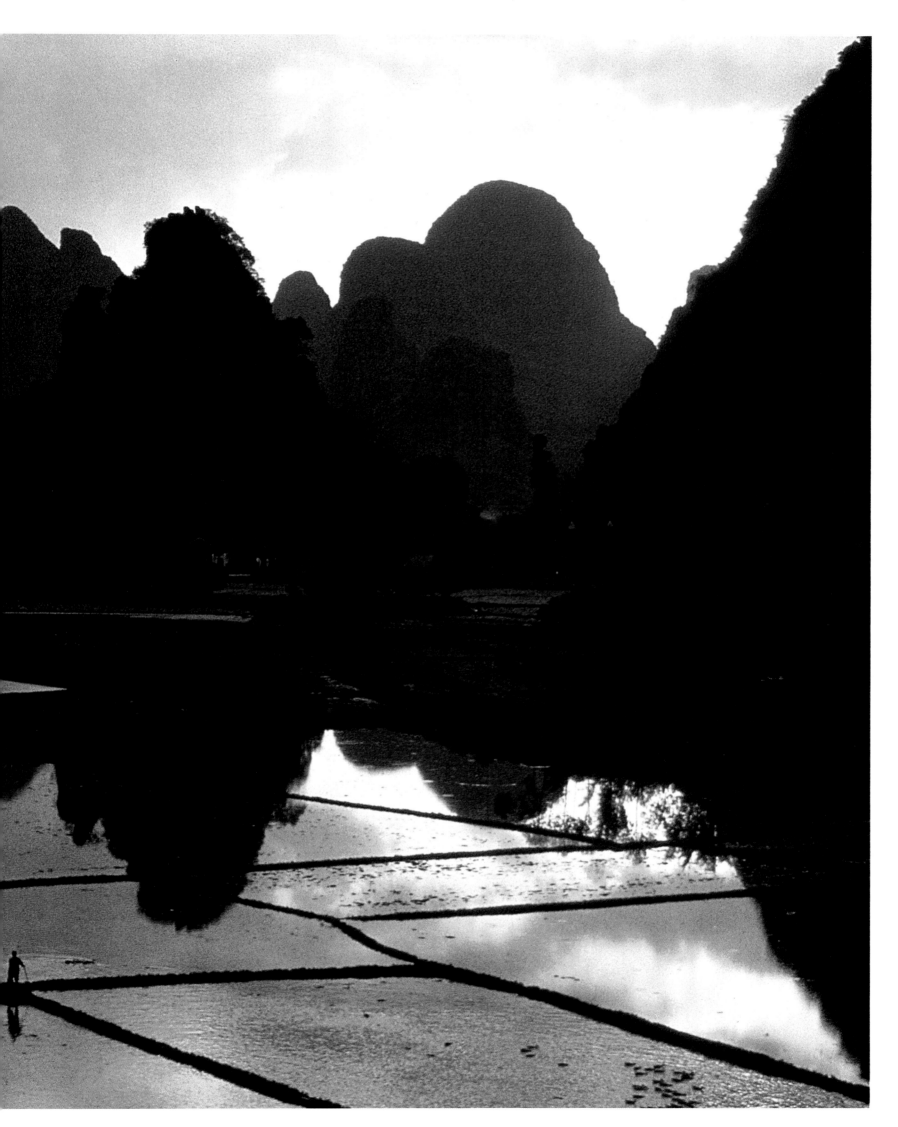

Gaotian: rice paddies prepared for transplanting.

211

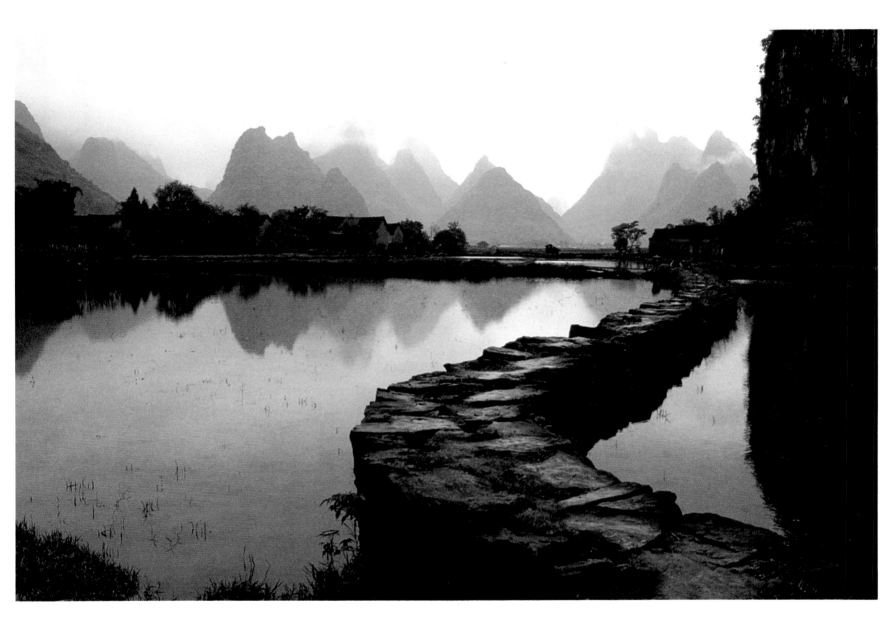

Village of Zhongman. Stone pathway between rice paddies serves as a divider and footpath for villagers.

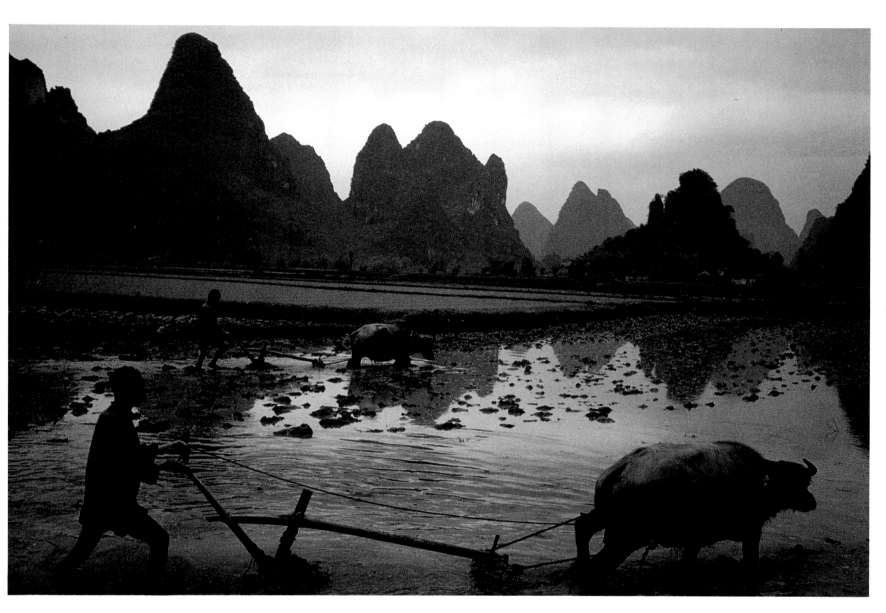

People ploughing with water buffalo, Gaotian. The farm implements are very primitive. The methods of farming have probably not changed much in hundreds of years.

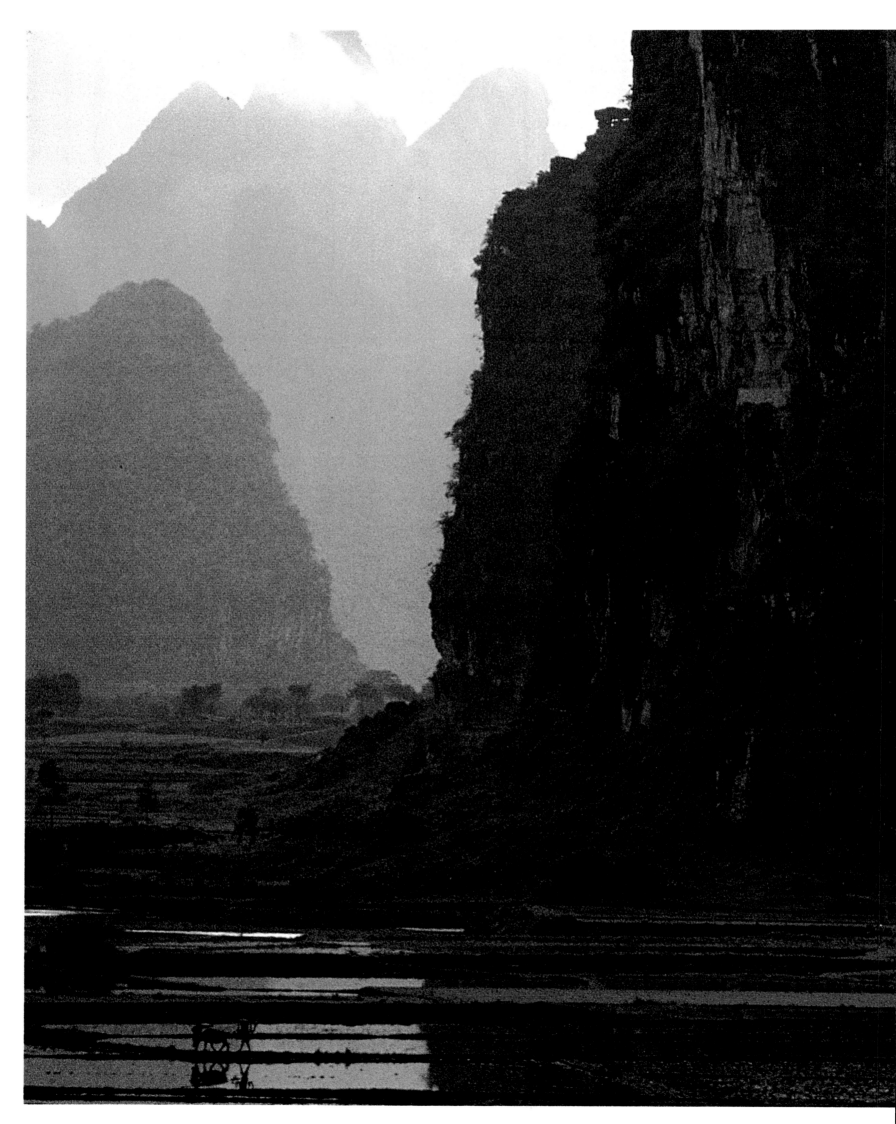

This is Gaotian again. This gives you an idea of what one of those peaks looks like from below.

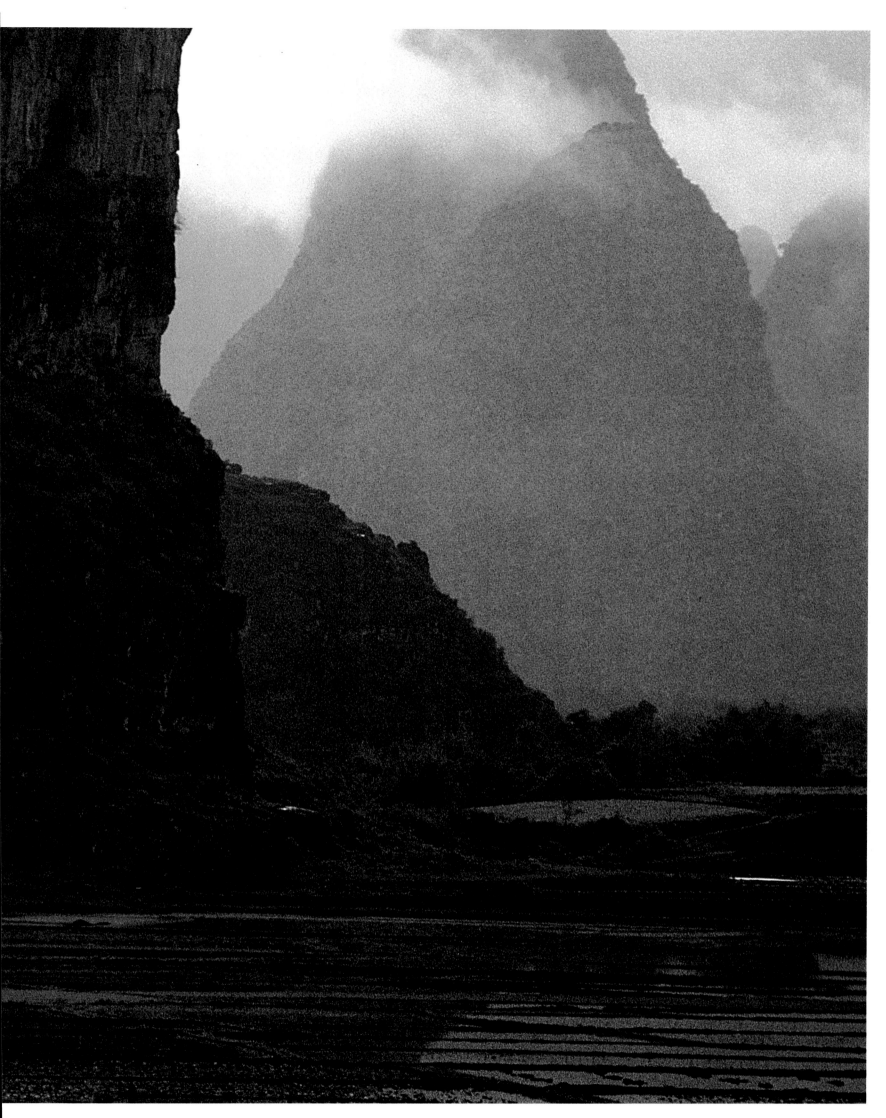

Next page: Early morning in a small area just south of Yangshuo. This is one of the most beautiful areas of all Quelin.

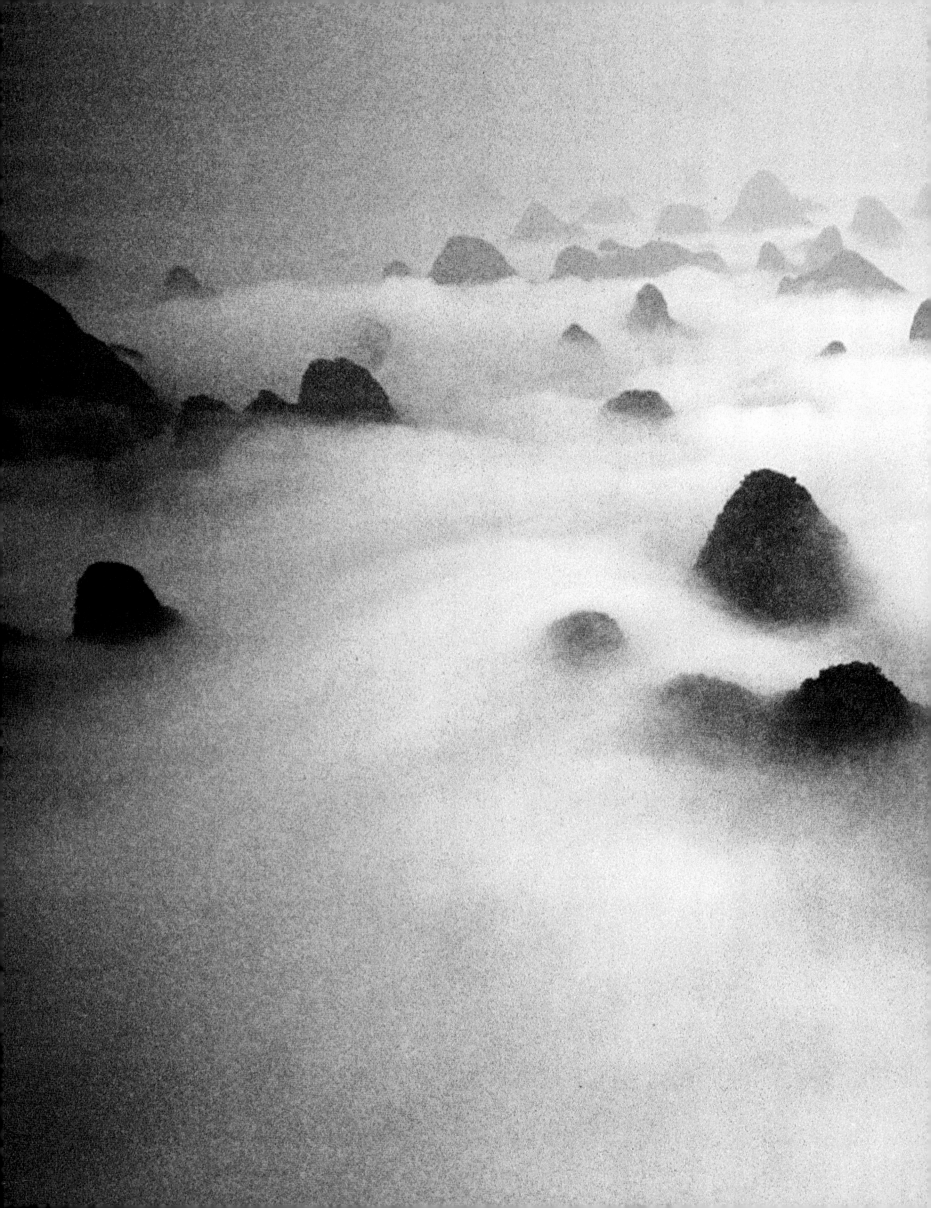

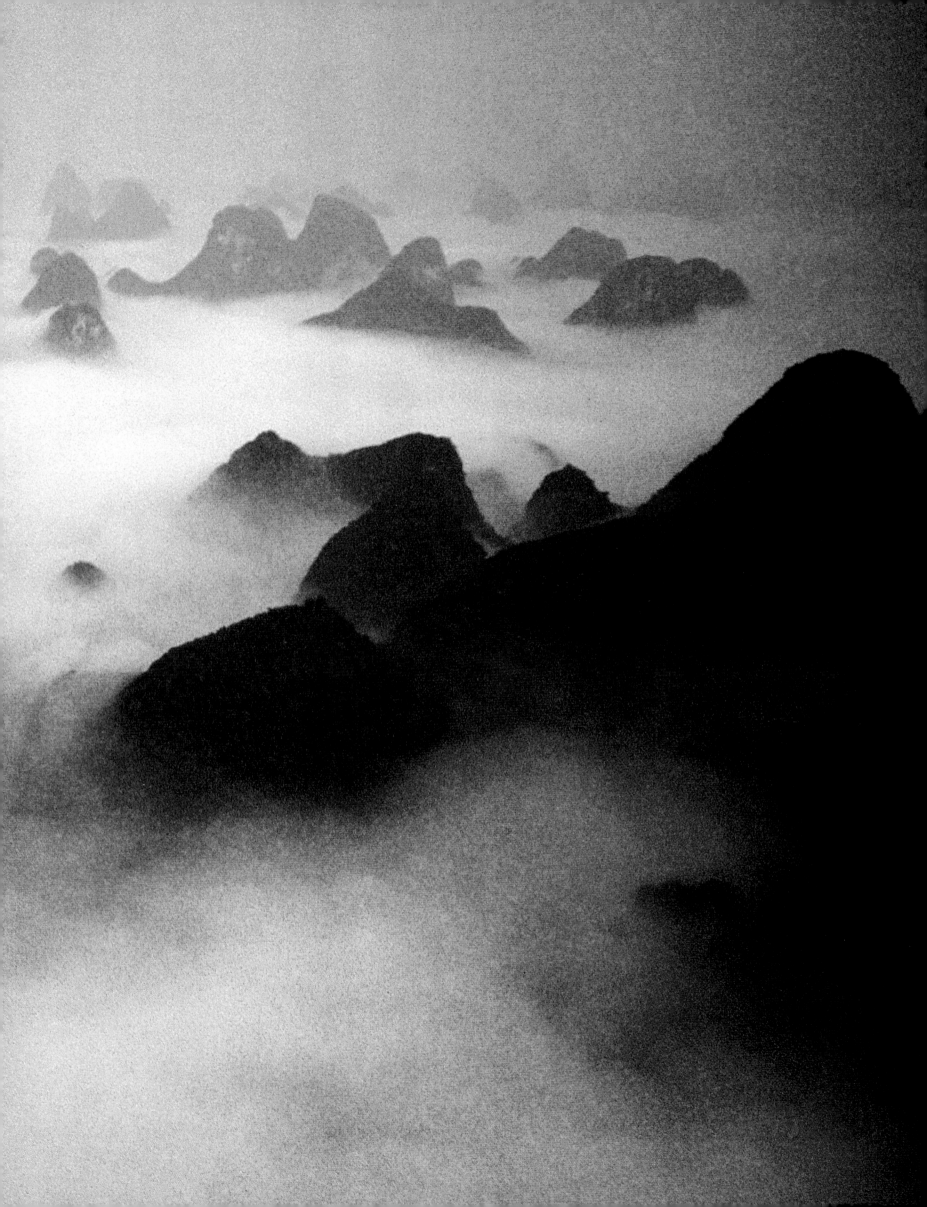

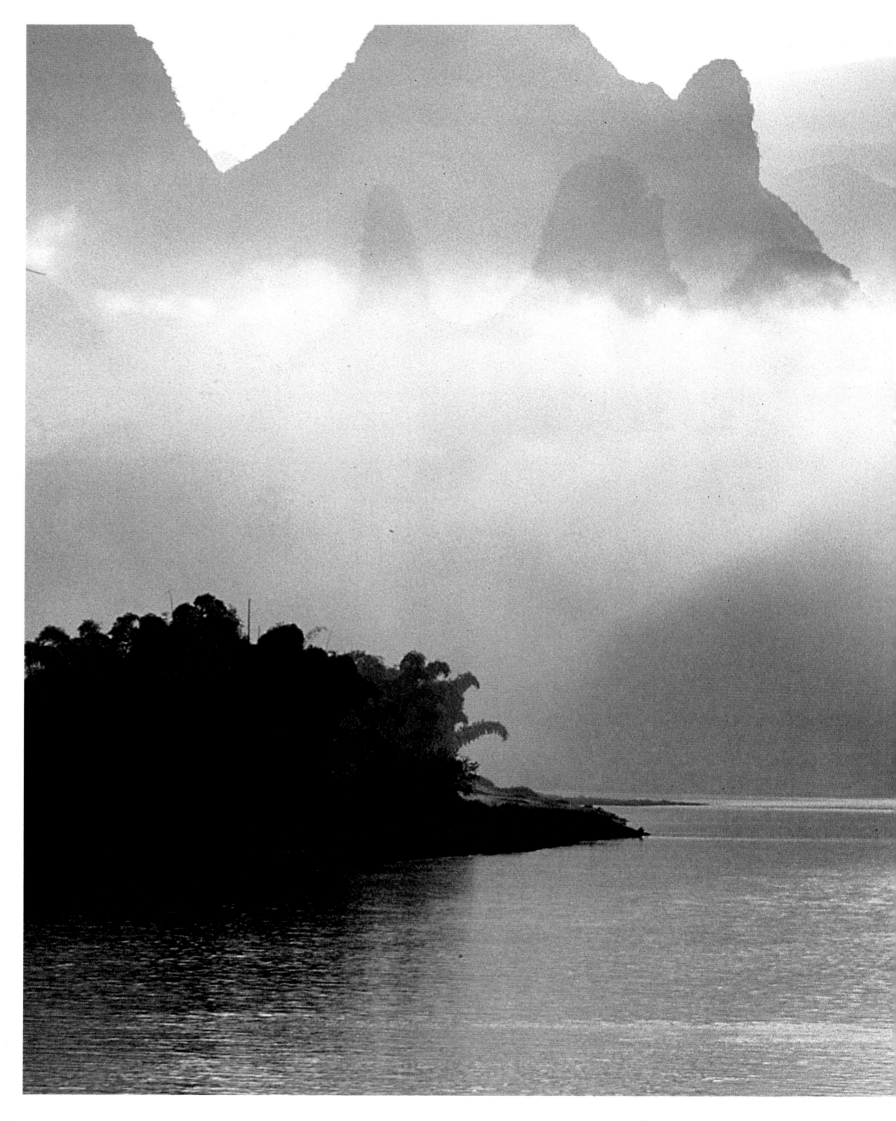

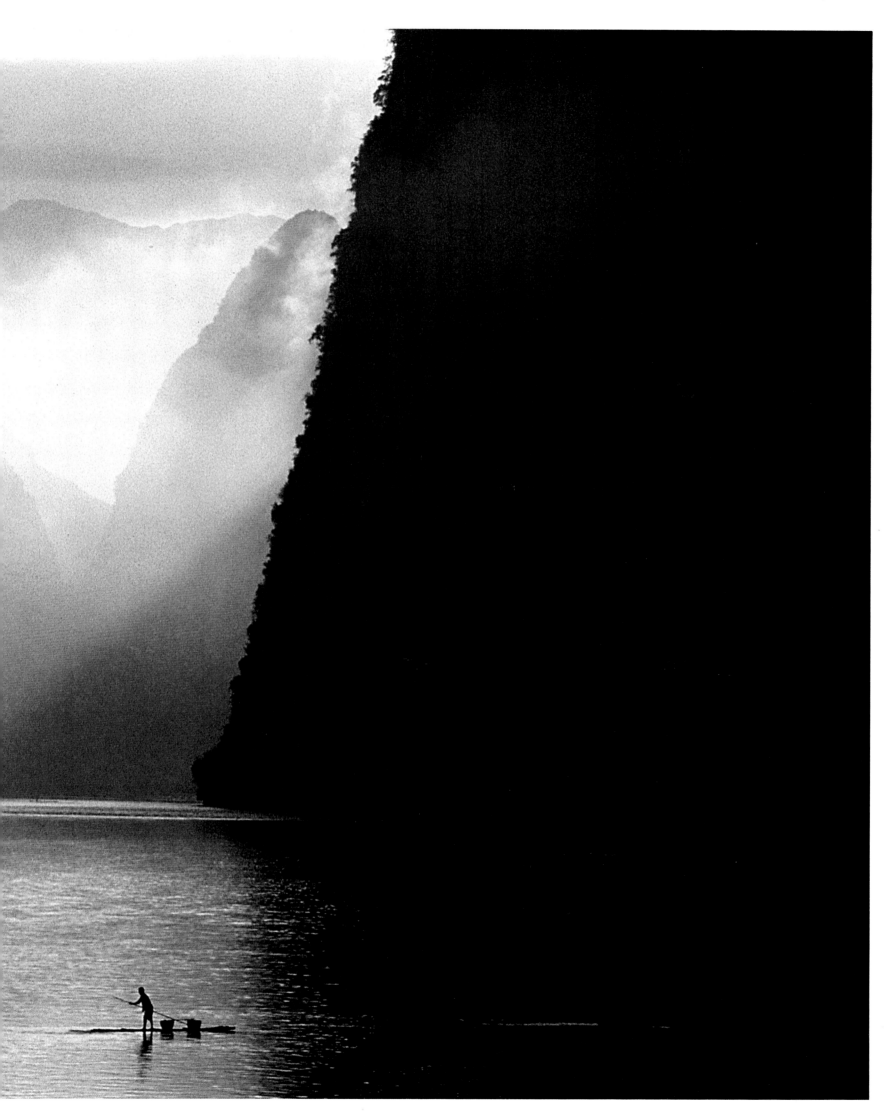

Early morning on the Li-Jiang River. There is no bridge at this point, so people ford the river on bamboo rafts.

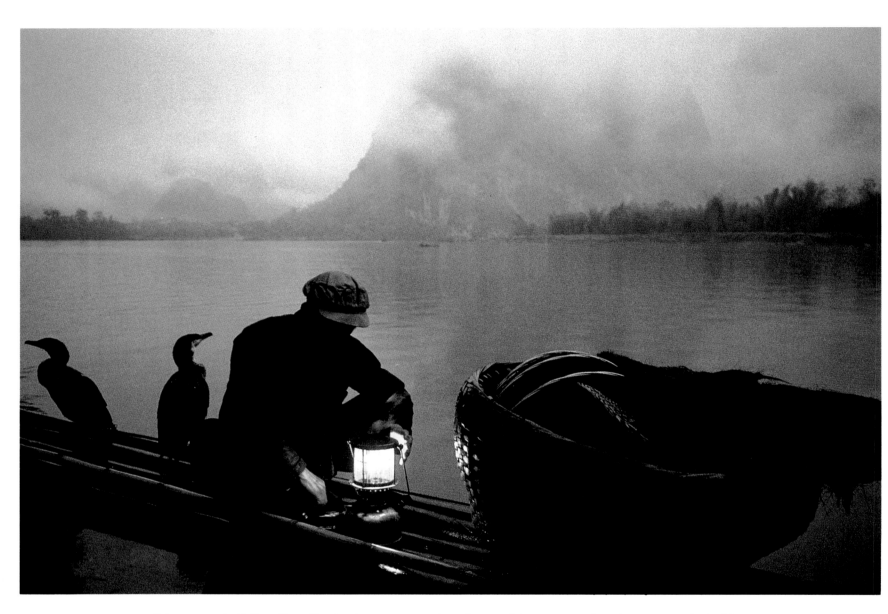

Fisherman on the Li-Jiang River. The river bottom is very rocky, making net fishing impractical, so the cormorants do the fishing.
The fishermen tie the necks of the birds so that they are able to grasp the fish in their beaks, but unable to swallow them.

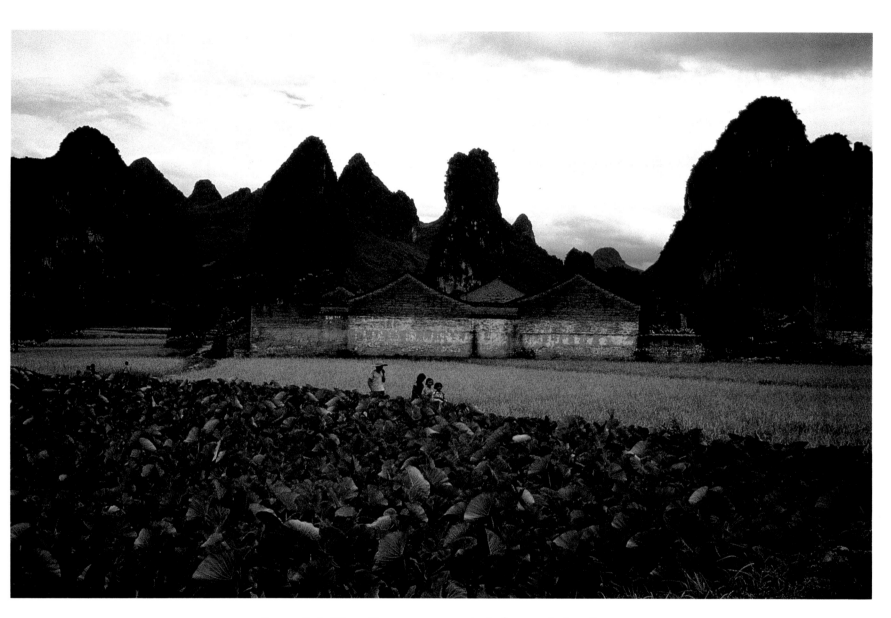

Strange Peaks Village. The green vegetation in the foreground is lotus flower.

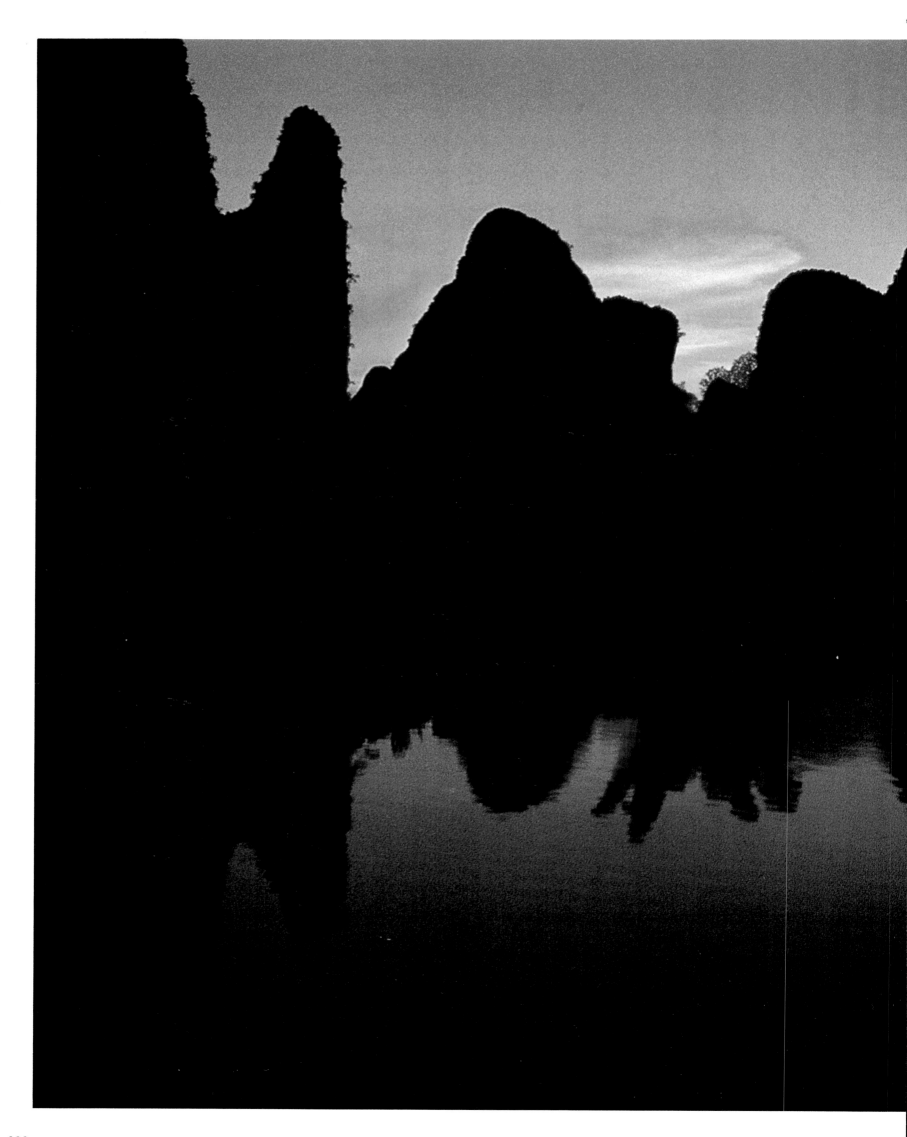

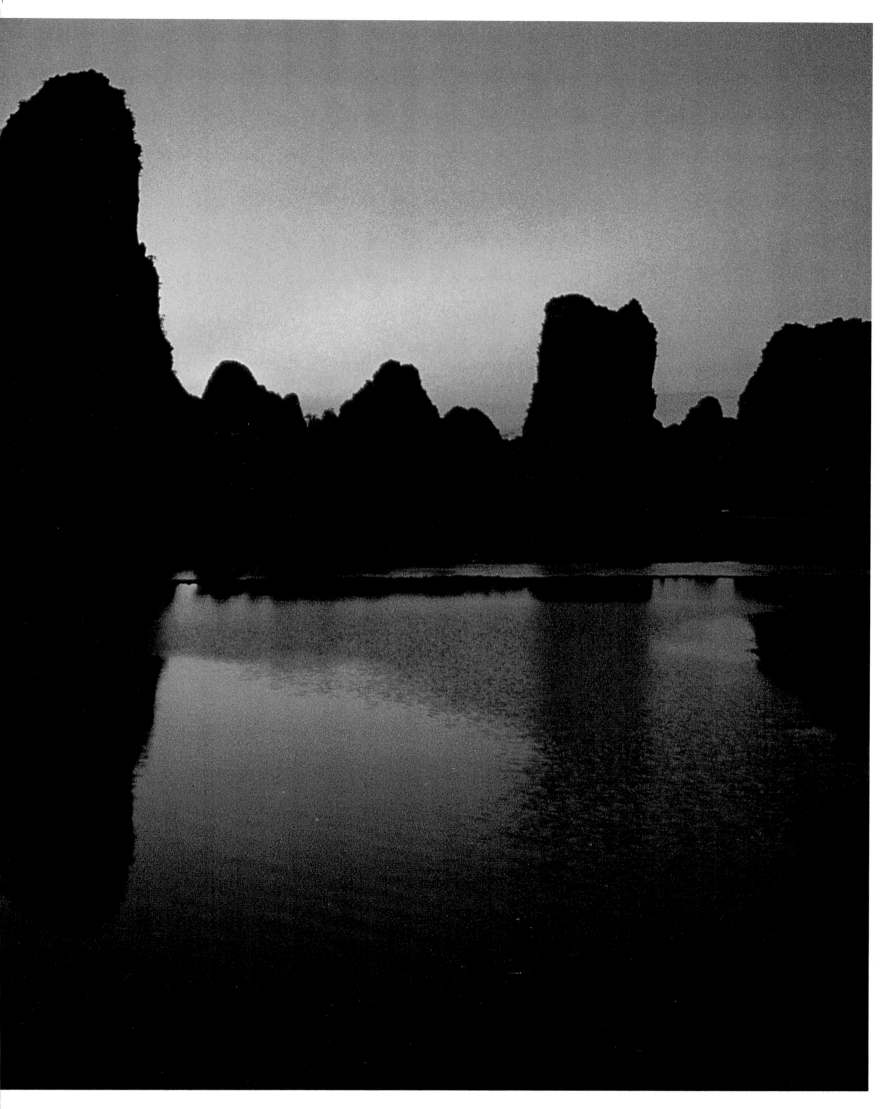

Gaotian sunrise. The color is very unusual for this area due to the high humidity. I only saw this color once in all the time I was in Quelin.

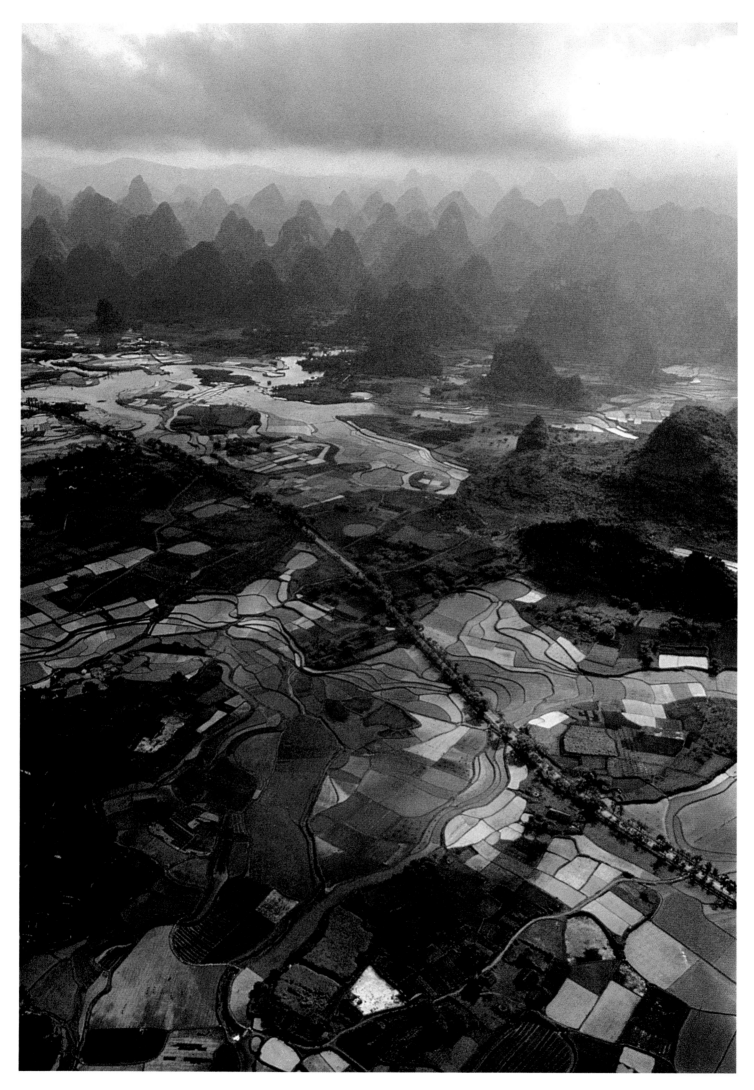

North of Yangshuo.

NEW YO

JAY M

RK CITY

AISEL

After a visit to New York a tourist hails a taxi and asks the cabbie, "Can you take me to the airport or should I just go to hell?"

New York is a tough city—too hot in summer, too cold in winter, crowded, noisy, expensive, and dangerous. I've never wanted to live anywhere else.

Its beauty lies in its vitality and diversity. The pace and the energy is staggering to me and *I'm* a native. I treasure a walk in my neighborhood; the view from my home is spectacular. I live in a city which has not only a downtown, but a midtown and an uptown—all different and all full of visual delights.

I've taken my camera worldwide, but New York is my first love. Photographing New York is like trying to take a bite out of an elephant. It's the one place that can truly be called bigger than life. Into its physically tiny boundaries

are packed spectacle and change unmatched anywhere.

Buildings disappear, new ones sprout; neighborhoods change quality, cabbies change nationality; senior citizens get older, cops get younger, and the rents always soar. The New Yorker, battle-scarred by strikes and blackouts, survives in the heartland of the cynic, the skeptic and the paranoid. New Yorkers think they're sophisticated, but they still retain the awestruck wonder of children.

New York is dream and nightmare, beautiful and ugly, with thousands of wonderful special events and a totally decaying infrastructure. The light and the skyline can break your heart. The visual power is special, like no place on earth.

To a true New Yorker, no matter where you are in the world, if you're not in New York, you're "out of town."

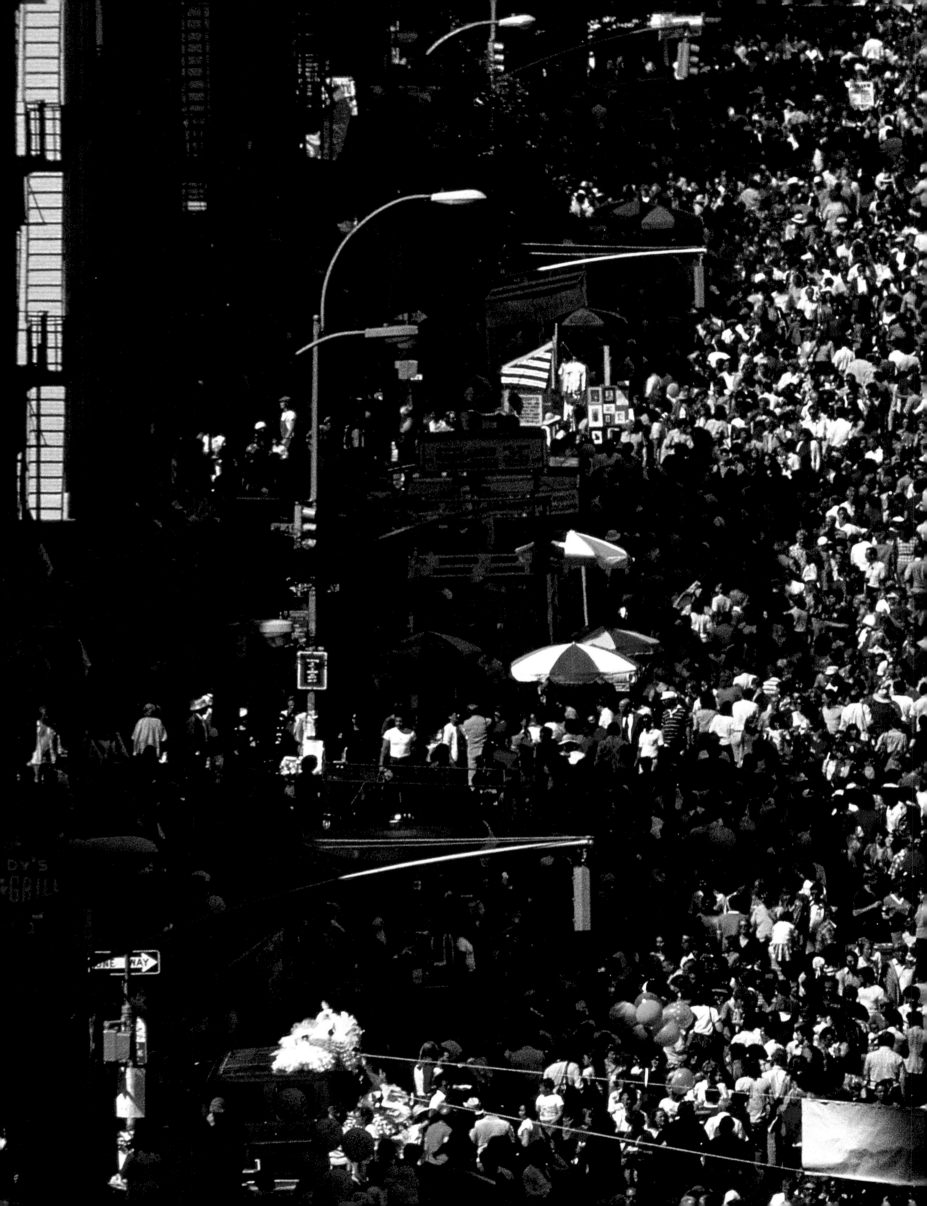

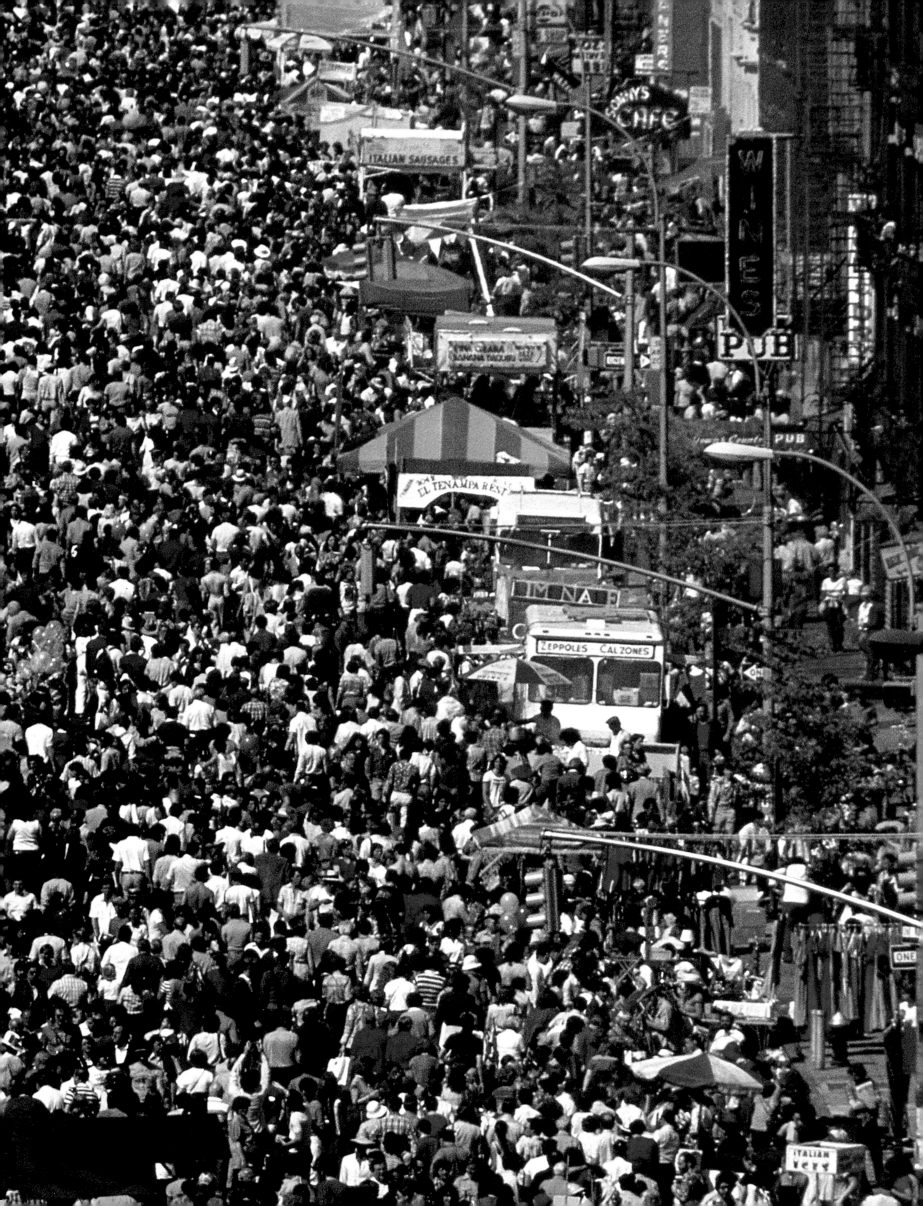

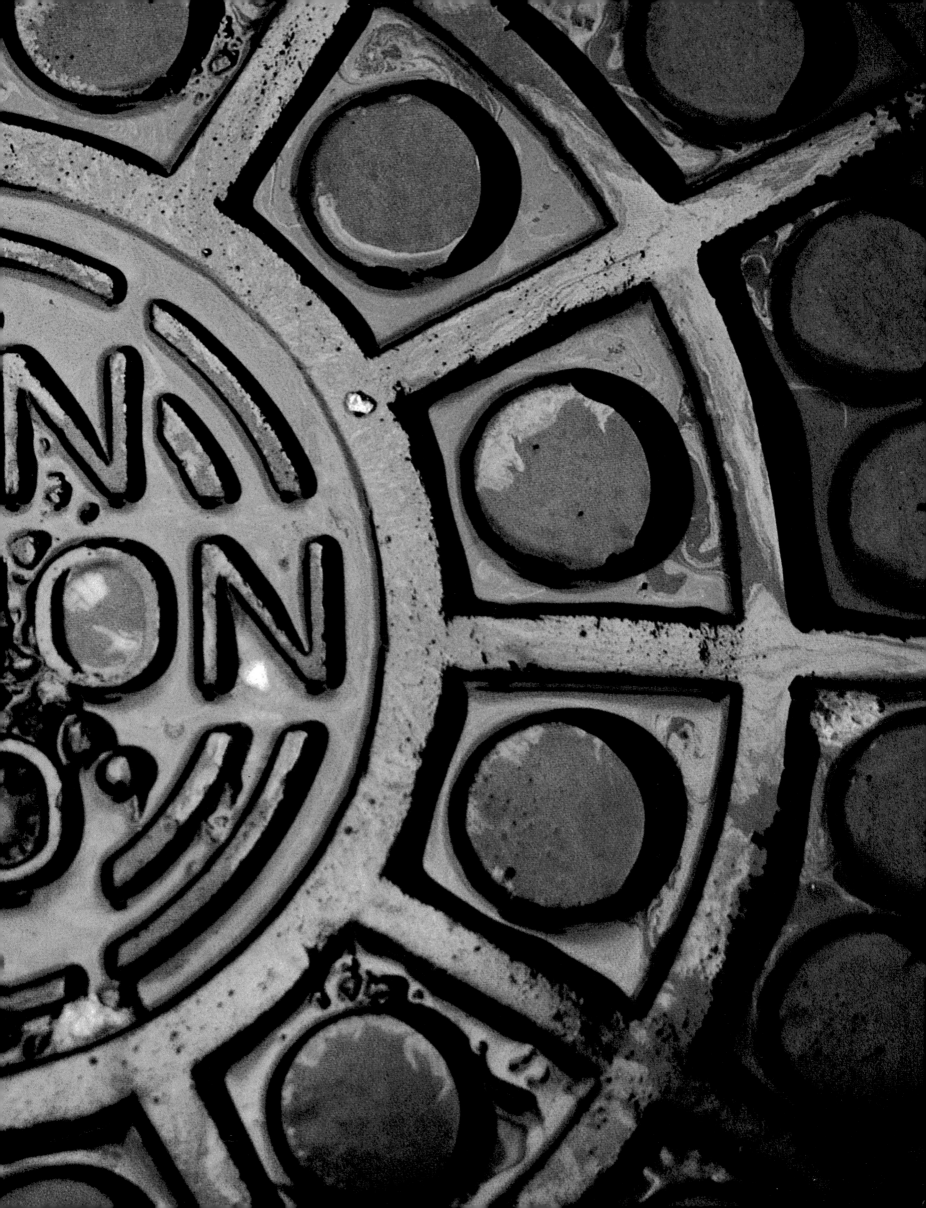

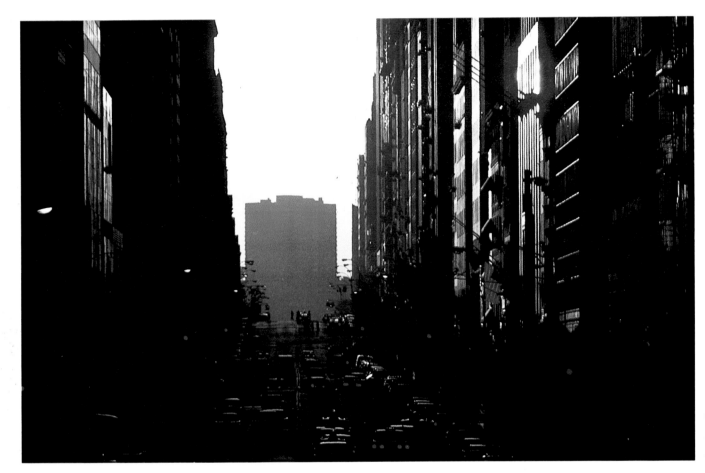

Telephoto of 57th Street looking west, summer's day.

Golden City from Weehawken, New Jersey.

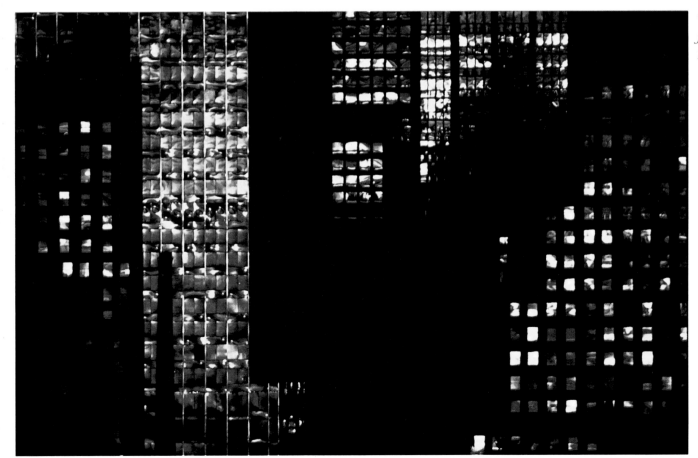

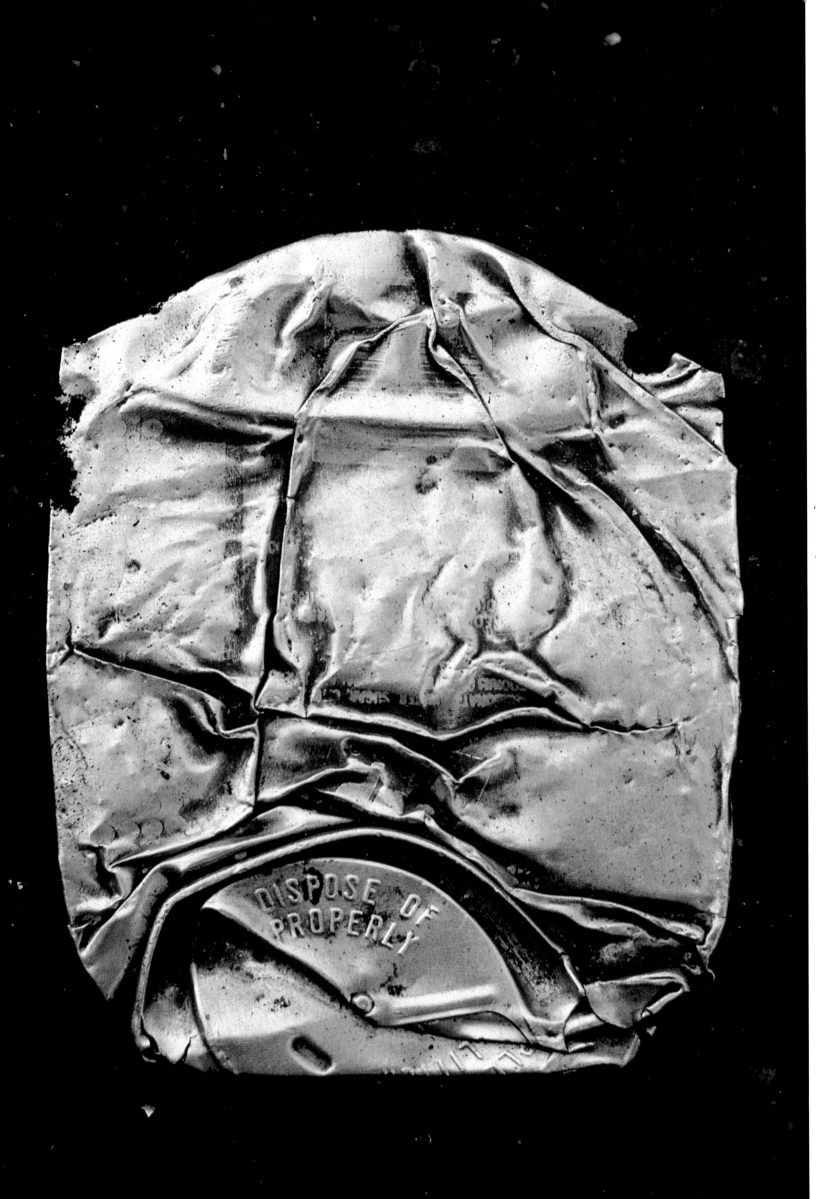

"Dispose of properly" from series on looking down.

Next page: Multiple image, Fifth Avenue department store window.

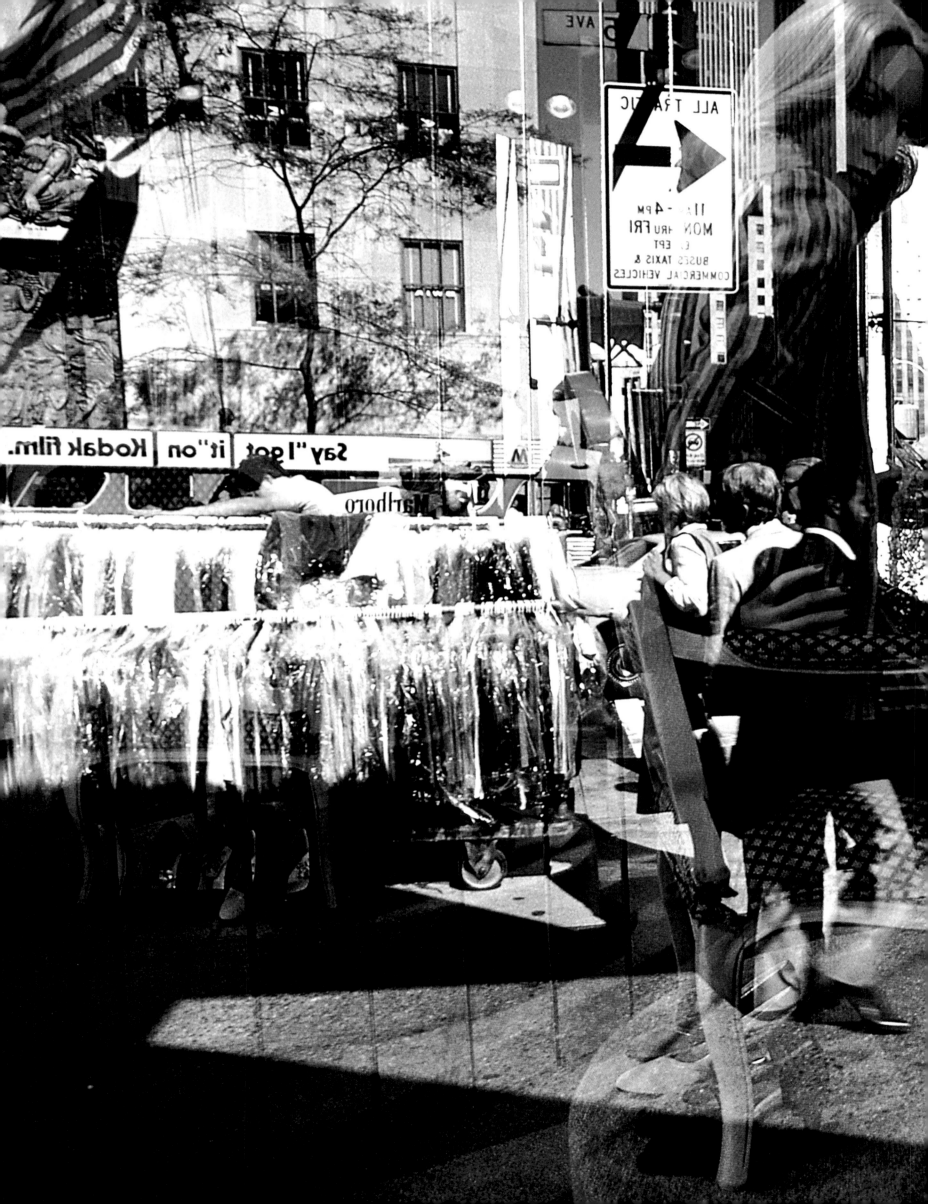

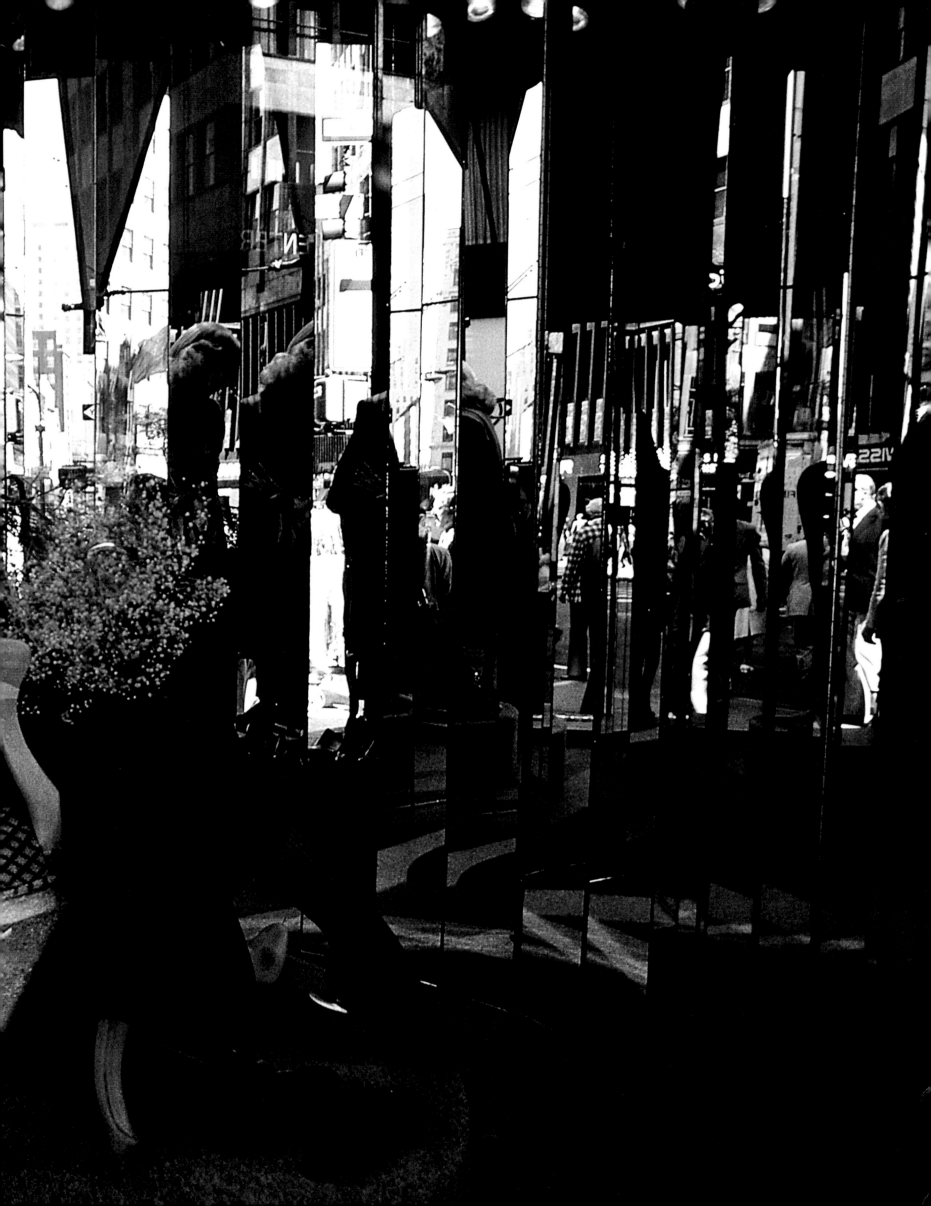

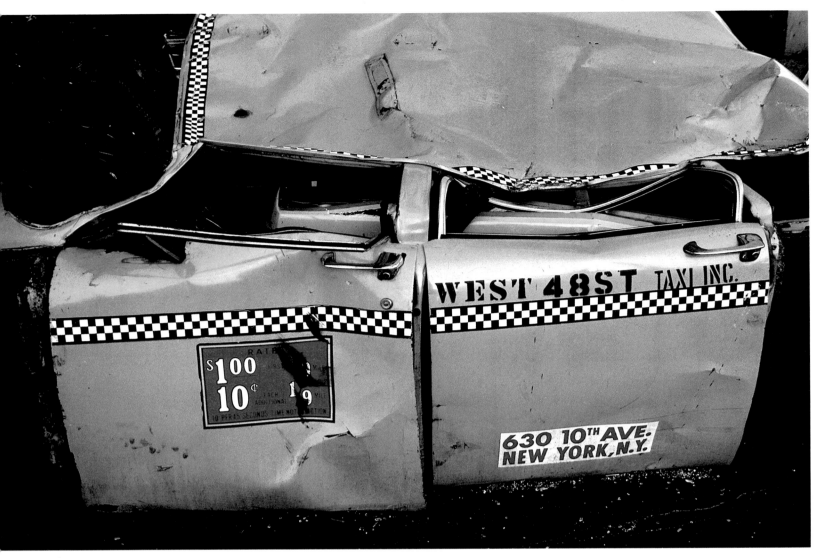

Crushed taxicab.

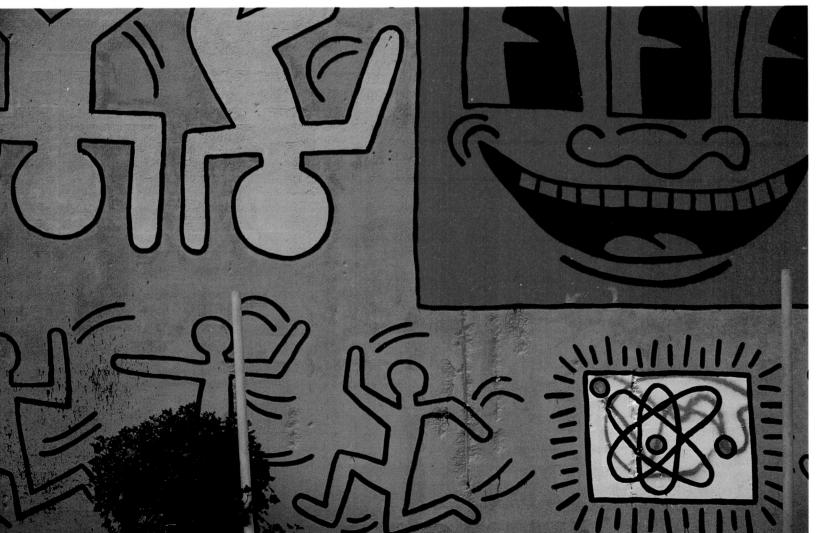

Keith Haring wall mural at the corner of Houston and Bowery, since destroyed and replaced with something far less beautiful.

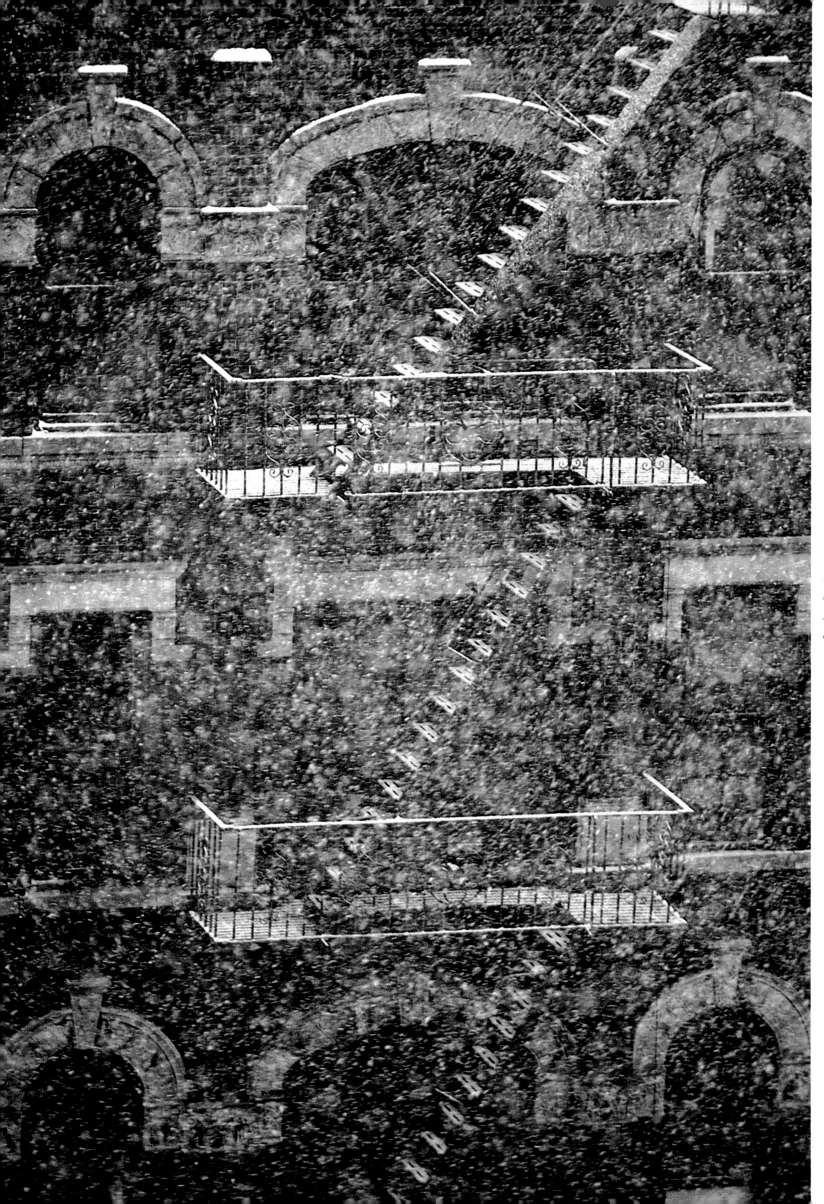

Snow in the city adds a softening quality.

239

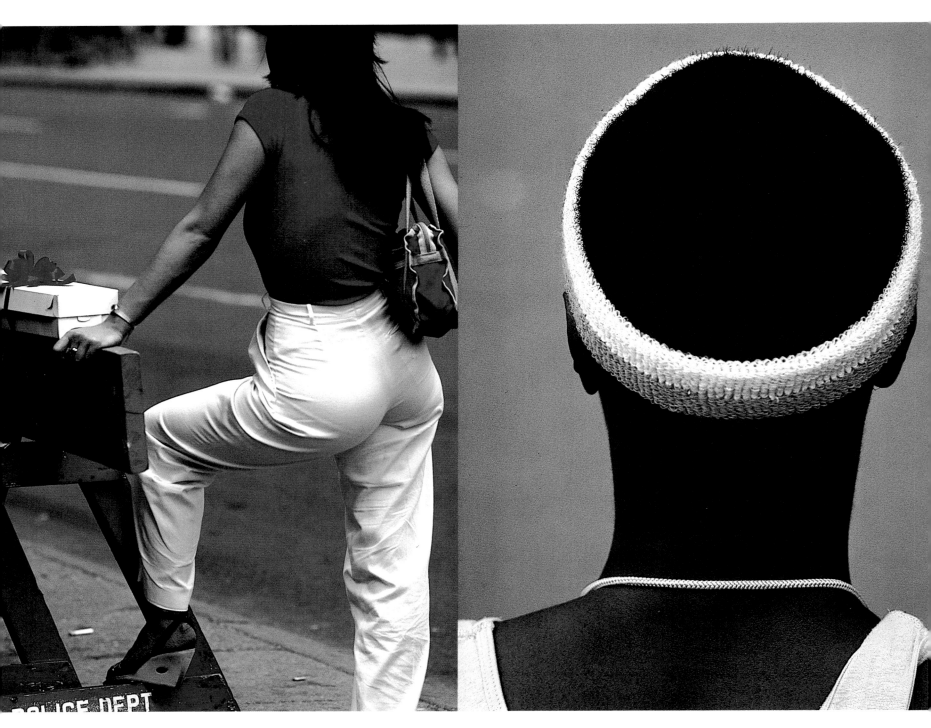

*Woman with
birthday present,
Chinatown.*

*Man with
headband,
Washington Square.*

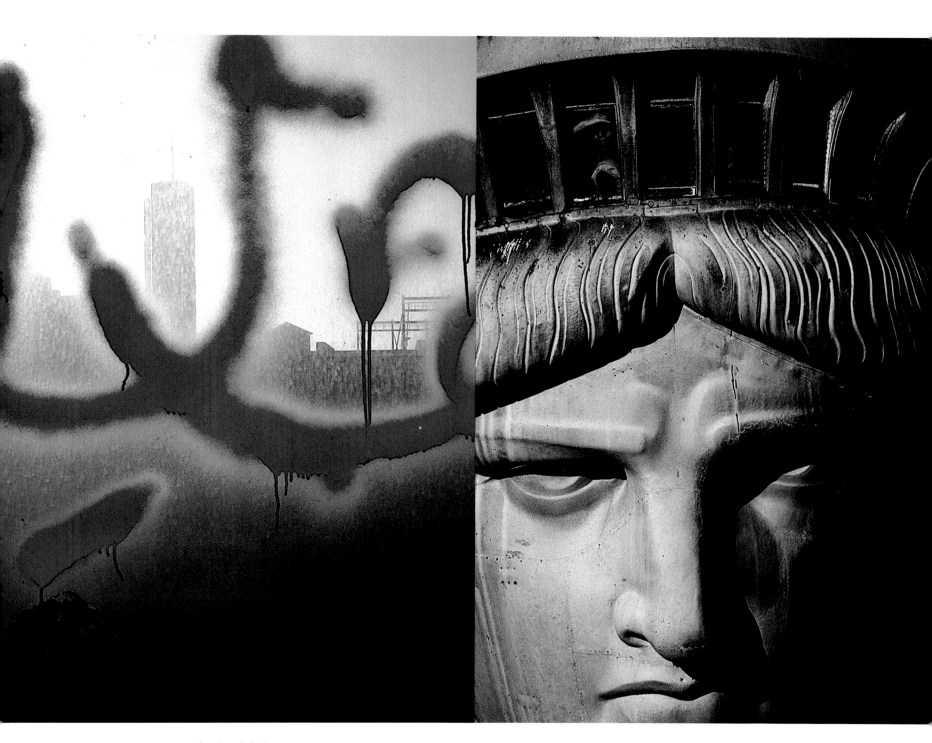

An abandoned dock
near Canal Street
(now destroyed)
that a group of
avant-garde artists
took over for their art.

The Statue of Liberty.
All photographers
are preoccupied with
how close they
can get.

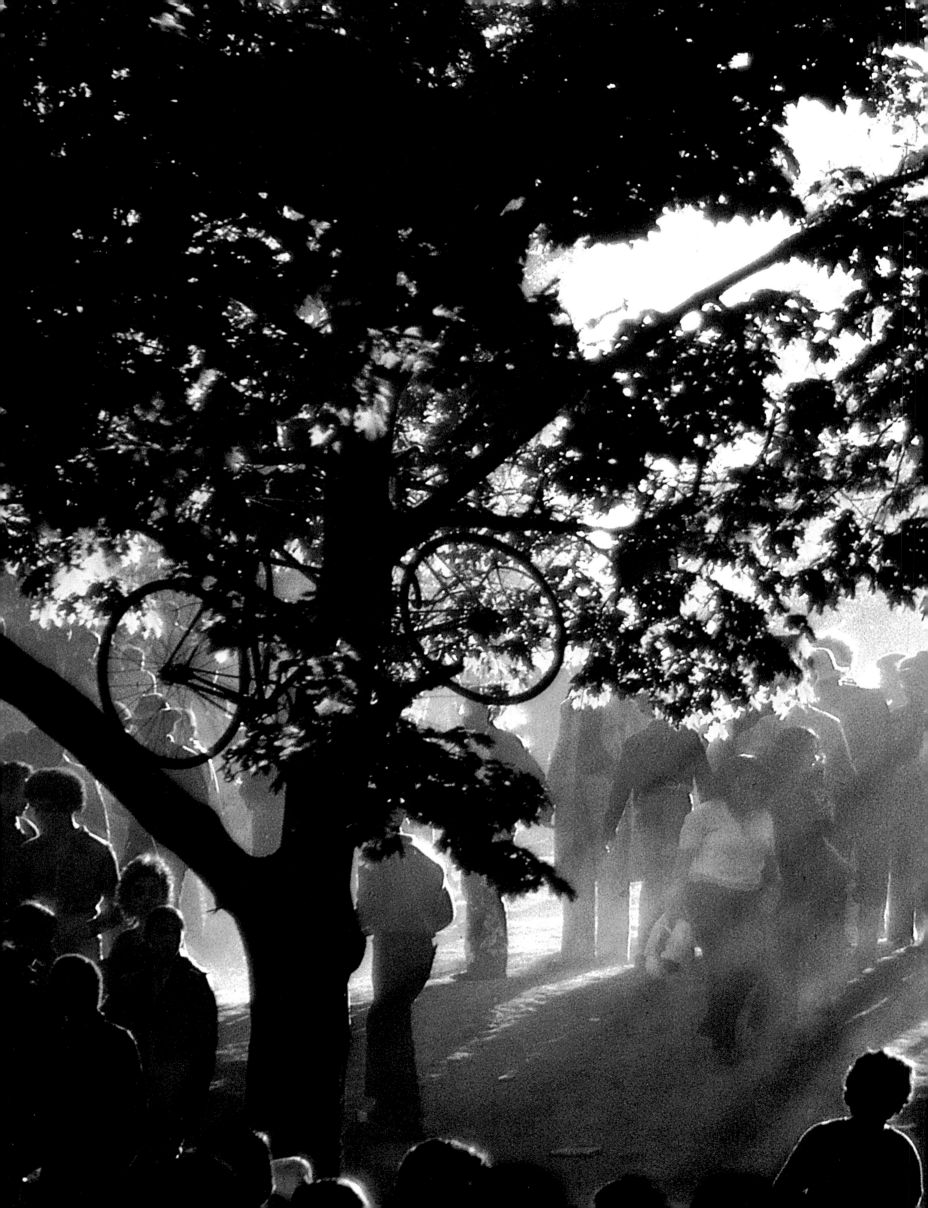

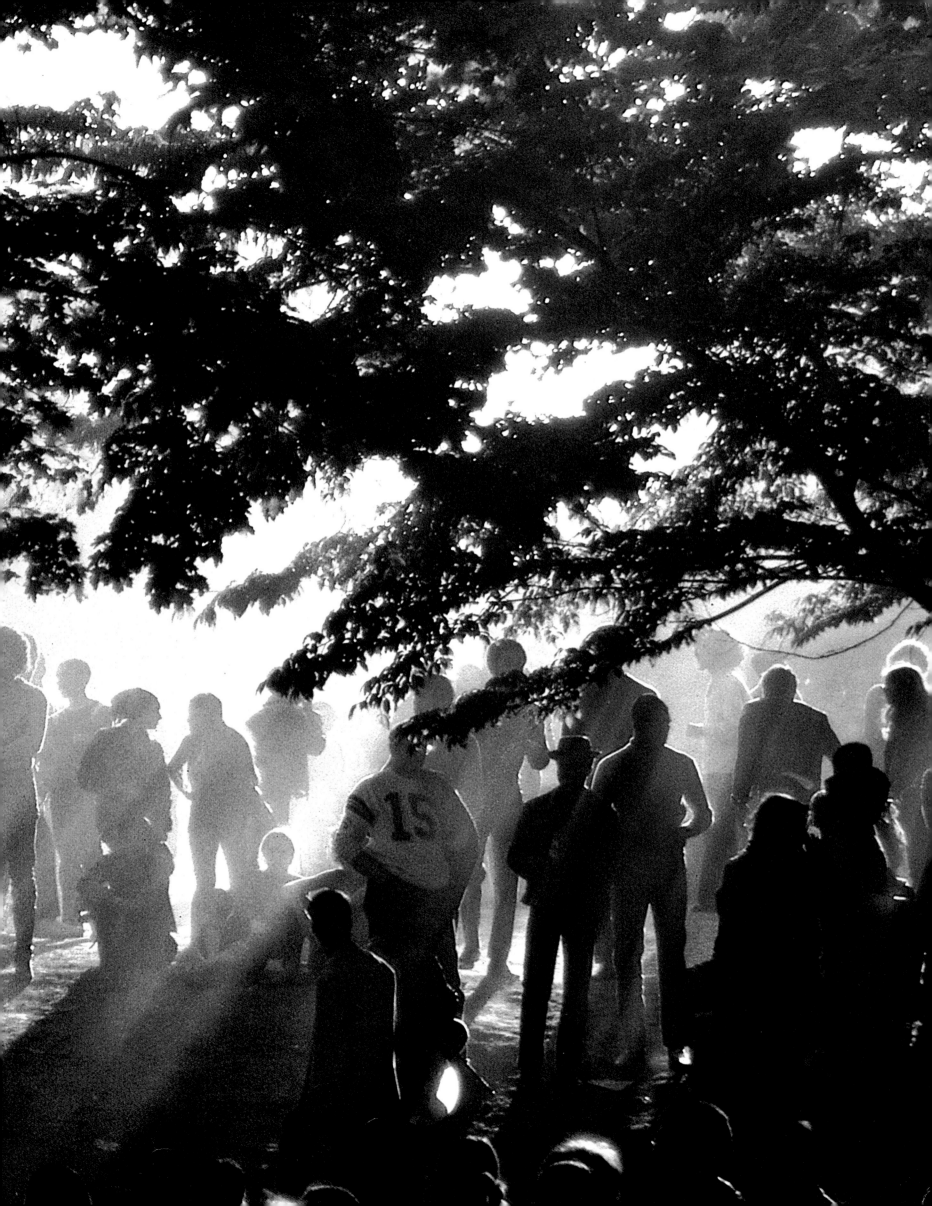

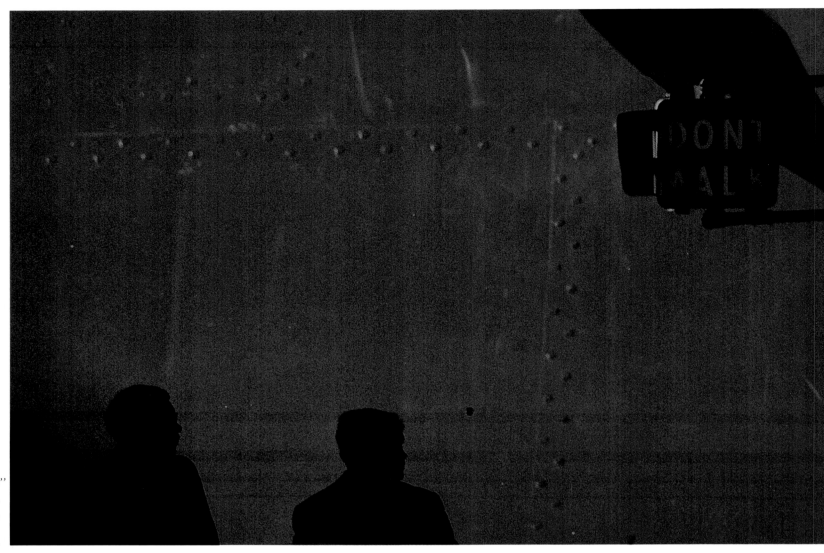

"Don't Walk"
sign on a corner
near the World
Trade Center.

A view from
42nd Street and
Third Avenue.

Preceding page:
Sunday in
Central Park.
New Yorkers
understand that
the bike's in
the tree so it
won't get stolen.

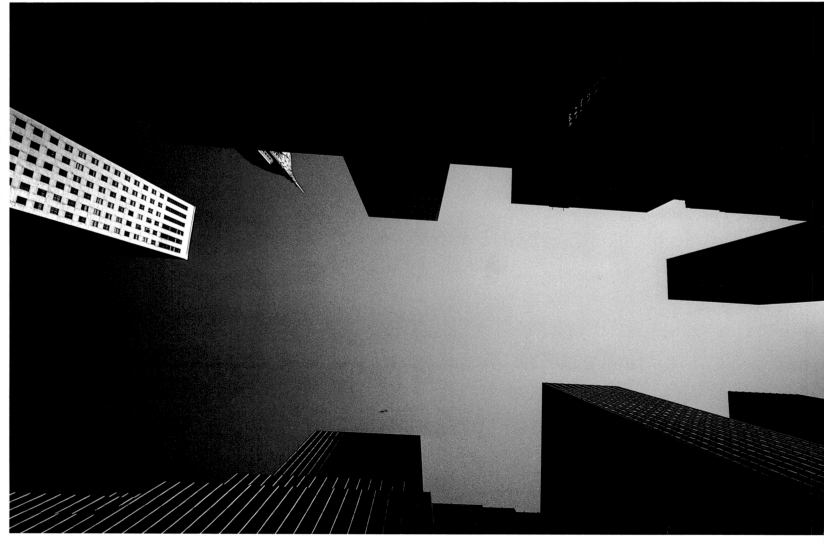

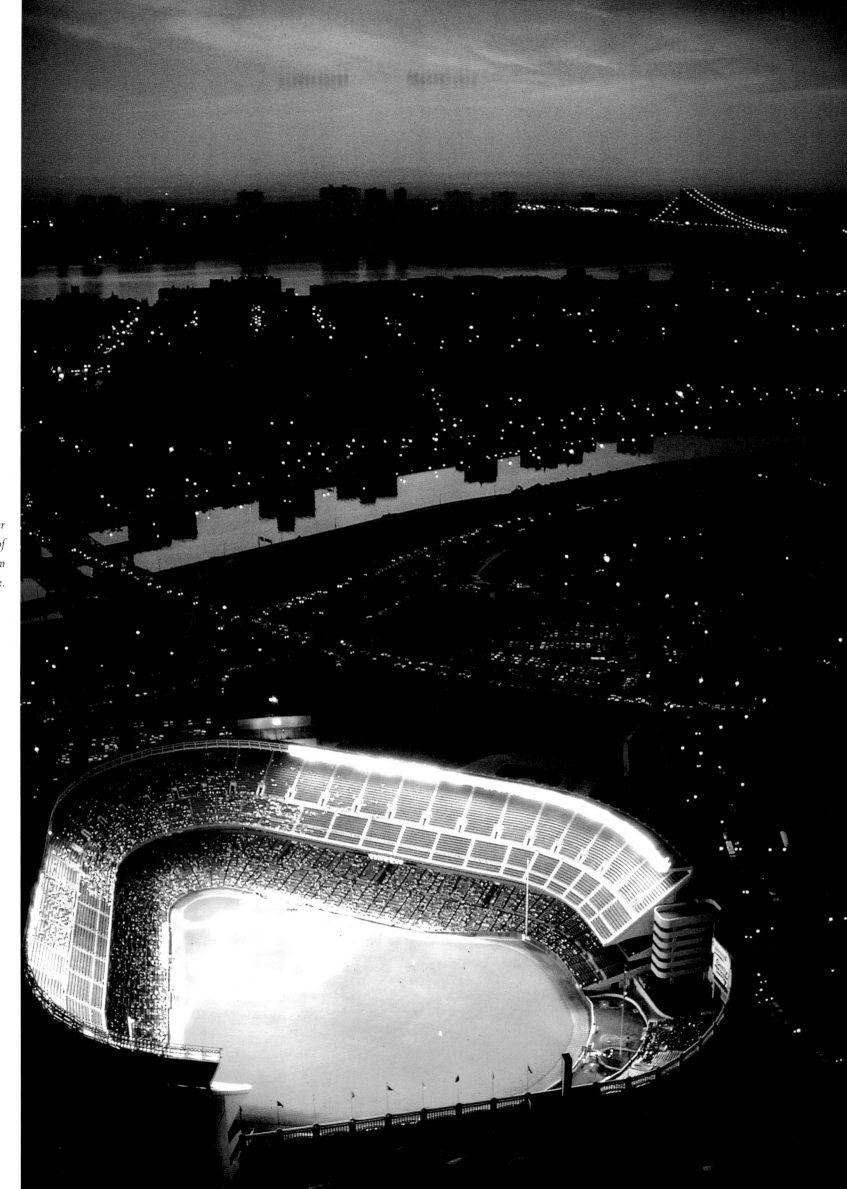

Helicopter view of Yankee Stadium at dusk.

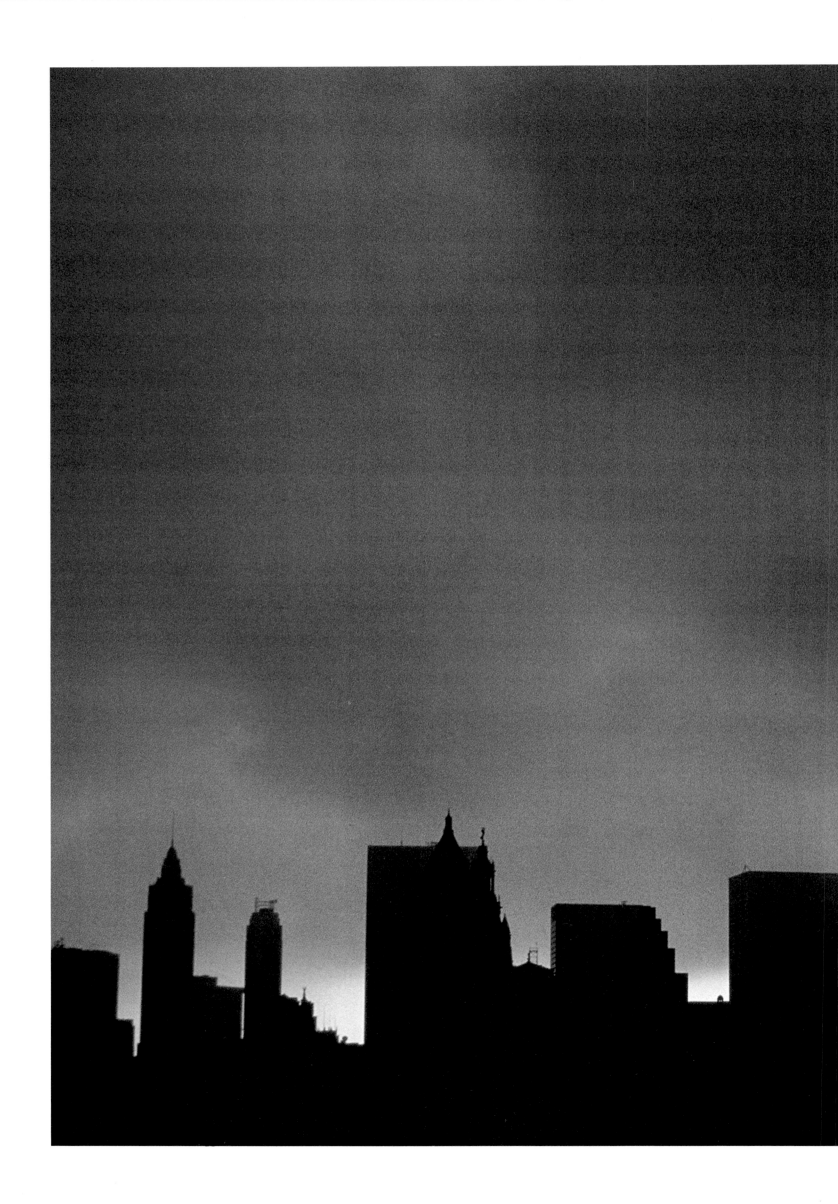

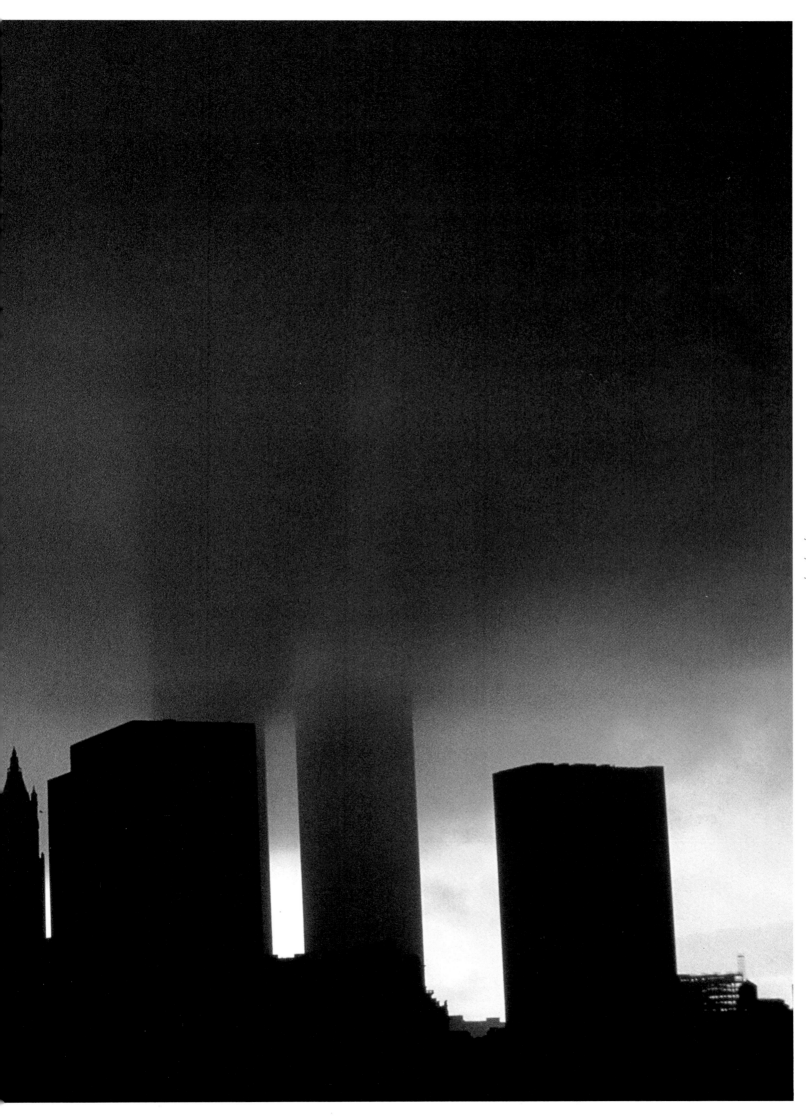

*I've been
shooting the city
from the sixth
floor of my studio,
for over
seventeen years.
This one was a
magic moment.*

A wall in the West Village where color and shadow become abstraction.

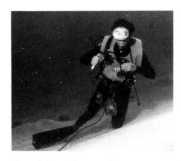

David Doubilet was born in 1946. He began snorkeling at the age of eight in the cold green waters off the north coast of New Jersey. By the age of thirteen he was taking black and white underwater photos with his first camera— a pre-war Leica.

After attending a pilot course in underwater photography at the Brooks Institute in Santa Barbara, he began to pursue his career. Since then he has traveled to all the waters of the world, most often for the National Geographic society, but also for Time, the New York Times Magazine, Skin Diver, Stern, and Mondo Sommerso.

He is one of the most honored photographers in his field, winning awards from organizations all over the world, and his work has appeared in countless exhibits and books featuring the underwater world.

David Doubilet lives in New York with his wife Anne (also a diver/photographer) and their eighteen-month old daughter.

Georg Gerster was born in Winterthur, Switzerland in 1928. After receiving a Ph.D. in Literature and Philology, he began free-lancing as a writer-photographer in 1956.

Since then he has traveled extensively for magazines such as National Geographic, Geo, Time-Life, The Sunday Times Magazine, Match, Zoom, Graphis, Epoch, and Omni. He has contributed to nineteen books; the latest is entitled Below from Above *(Abbeville Press), published in 1986.*

He has had one-man exhibits in Basel, Paris, New York, and Tokyo.

*Burt Glinn first became known for his spectacular color coverage of the South Seas, Japan, Russia, Mexico and California, each a complete issue for Holiday magazine. He has since worked on major assignments for magazines such as Life, Geo, Esquire, Travel and Leisure, and has appeared in foreign magazines all over the world. With author Laurens van der Post, he has produced two books—*A Portrait of All the Russias *and* A Portrait of Japan.

Glinn has won awards from Harvard College, the University of Missouri, the Overseas Press Club, and two gold medals from the Art Directors Club of New York. He has served three terms as president of Magnum and is currently Chairman of the Board of that organization.

He is married to Elena Prohoska and has a son, Samuel Pierson, who was born in 1982.

Farrell Grehan studied at Pratt Institute and the Art Students League. In 1953, he bought his first camera, and a few years later became a working photographer.

Grehan was one of the select contract photographers for Life magazine and produced many memorable photo-essays, especially on art, modern dance and ballet. Aside from Life, he has been published in Sports Illustrated, Fortune, The Saturday Evening Post and National Geographic.

Farrell Grehan lives in Piermont, New York, on the west bank of the Hudson.

*Harry Gruyaert was born in Belgium in
1941 and moved to Paris twenty years later. He
first became a fashion and advertising photographer,
working for magazines such as Elle.*

*In 1965, he visited Morocco and began to
take up reportage.*

*Aside from his many trips to Morocco, he
has photographed all over the world including
India, Europe and the United States. His work has
appeared in such magazines as Geo, Zoom, and
Photo. He has had exhibitions in Paris, Stockholm,
Tokyo, the International Center of Photography in
New York, and the Walker Art Center in
Minneapolis.*

*In 1976, he was awarded the prestigious
Prix Kodak for his work on Morocco.*

*Ernst Haas was born in Vienna, Austria in
1921. He attended medical school, but his strong
artistic bent led him to the camera. In 1947 he
held his first exhibit in Vienna. In 1949 Haas
joined the cooperative photo agency Magnum, and
launched his memorable "Returning Prisoners of
War" story.*

*Since coming to the United States in
1951, Haas has had one-man exhibits of his work
at the Museum of Modern Art, Asia House, the
IBM Gallery, Rizzoli Gallery, and the
International Center of Photography. Haas also
wrote, directed and narrated a series of four half-
hour programs entitled "The Art of Seeing,"
which were aired on WNET-TV in 1962.*

*Photo-essays of his have appeared in
leading magazines and photo journals, including
Life, Look, Stern, and Geo. Haas is the author of*
The Creation, In America, In Germany, *and*
Himalayan Pilgrimages *and has contributed to
the Time-Life Book Series, including* Venice *for
the Great Cities Series.*

Hiroji Kubota was born in Tokyo in 1939. He began his career as a photographer in 1965 and spent the next three years covering the United States. In 1968 he began to travel all over the world and, in 1971, he became associated with the Magnum agency. In 1975, he covered Pnom Penh and the final battle of Saigon. Since 1979, his career has been spent photographing China.

Kubota's work has appeared in Geo, The New York Times, Newsweek, Look, Life, National Geographic and other major international publications. In 1985, a major exhibition of his China photographs took place at the International Center of Photography in New York, and in Japan and China. His book, China *(W.W. Norton) was published in 1985.*

Jay Maisel was born in 1931 in Brooklyn, New York where he studied graphic design with Leon Friend at Abraham Lincoln High School. For one year he studied painting with Joseph Hirsch. After graduating from Cooper Union he worked at Yale with Josef Albers on color and with Buckminister Fuller on geodesic domes.

In 1954 he switched from painting to free-lance photography. Since then he has done editorial, corporate, advertising and personal photography. His work has been exhibited widely and his fine art prints are in private, corporate, and museum collections. Books include Jerusalem, San Francisco, Baja California, *and* America, America.

Of many awards, he is proudest of the St. Gauden's Medal from Cooper Union, and the Outstanding Achievement in Photography Award from the American Society of Magazine Photographers.

In 1986 he is scheduled for a one-man show in China and New York which will coincide with the publication of a book on his photographs of America.

Kazuyoshi Nomachi was born in the Kochi prefecture of Japan in 1946. He took up photography in 1969 and began freelancing in 1971. He has made several trips to North Africa, Sinai and Central Asia, which resulted in the books Sahara *and* Sinai, *published in five languages.*

Between 1980 and 1982, Nomachi photographed the entire Nile river, from its headwaters to the Mediterranean, which, in 1983, resulted in a book, exhibition, and featured articles in Life, Stern, Figaro, Oggi, and others. A second book on the Sahara was also published in 1983. In 1984, he was awarded the prestigious Ken Domon prize for his book and exhibition on the Nile. In 1985, his book on the famine in Ethiopia was published.

Galen Rowell was born in Berkeley, California in 1940. He began serious mountaineering while in his teens. Since then he has participated in expeditions to Everest and K-2, made the only one-day ascent of Denali and Kilimanjaro, and accomplished the highest complete ascent and descent of a mountain on skis.

As a full-time photojournalist, he has made ten journeys to Alaska, eleven to the mountains of Asia, and many other trips to ranges in Africa, Canada, New Zealand and Norway.

He has worked for magazines like National Geographic and has published six books, including Alaska: Images of a Country *(text by John McPhee) and* Mountains of the Middle Kingdom.

Rowell's work has been exhibited in the International Center of Photography, the Los Angeles County Museum, the Denver Museum and in a major exhibition, now on national tour, entitled "Mountain Light."